HARLE

MIND

HARLEM

CULTURAL CAPITAL OF

EDITED & WITH A NEW INTRODUCTION BY ALLON SCHOENER

ON

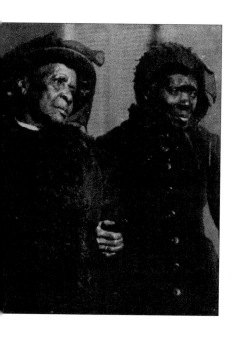

THE

NEW

PRESS

NEW

YORK

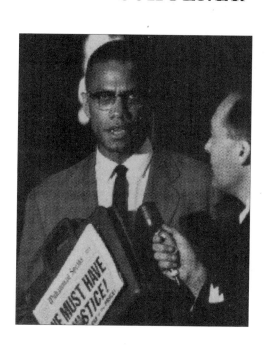

AND WITH A NEW FOREWORD BY HENRY LOUIS GATES JR.

MY MIND

BLACK AMERICA, 1900-1968

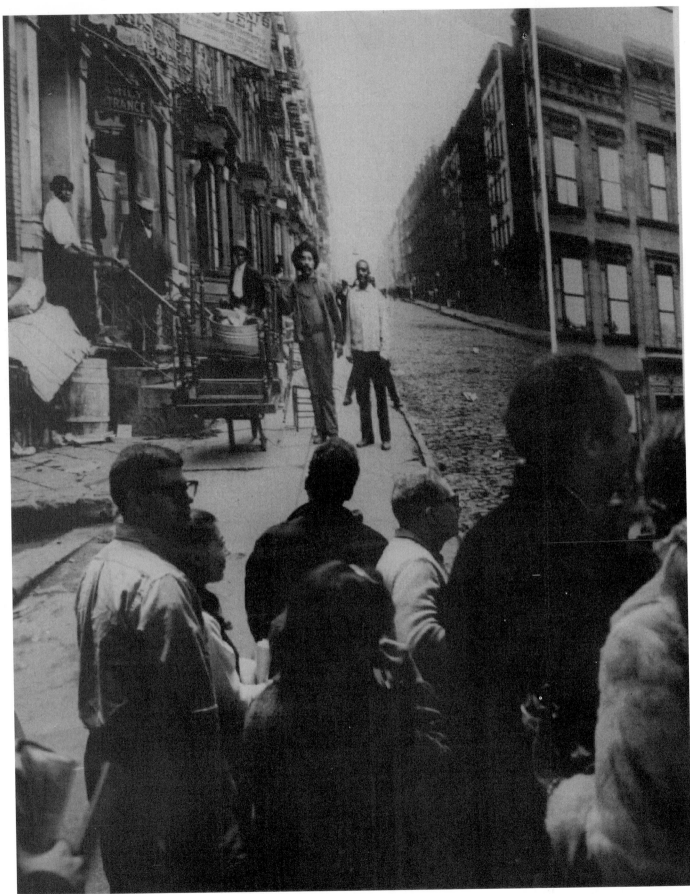

EXHIBITION AT THE METROPOLITAN MUSEUM, 1900–1919 SECTION / AUTHOR'S COLLECTION

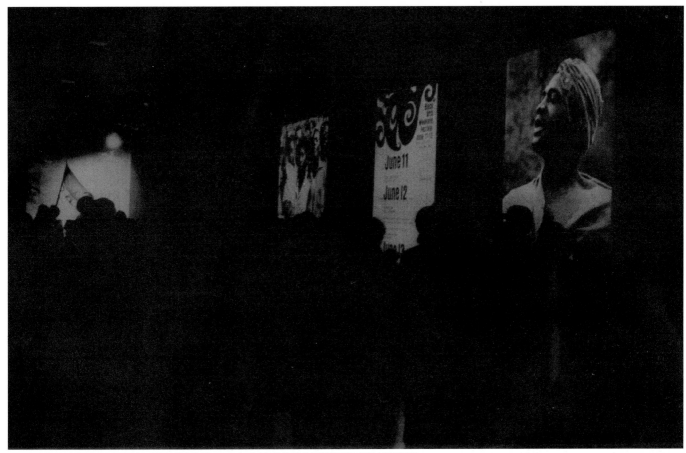

EXHIBITION AT THE METROPOLITAN MUSEUM, 1960–1968 SECTION / AUTHOR'S COLLECTION

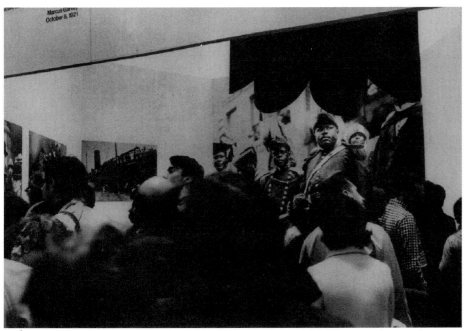

EXHIBITION AT THE METROPOLITAN MUSEUM, 1920–1929 SECTION / AUTHOR'S COLLECTION

Library of Congress Cataloging-in-Publication Data
Harlem On My Mind: Cultural Capital of Black
America, 1990-1968 / edited by Allon Schoener;
preface by Thomas F. Hoving; introduction by
Candice Van Ellison.
 p. cm.
"Metropolitan Museum of Art exhibition."
Originally published : New York: Random House,
1968.
ISBN 1-56584-266-9
1. Harlem (New York, N.Y.) – History. 2. Afro-
Americans – New York arts – New York (N.Y.) –
History. 3. New York (N.Y.) – History. 4. Afro-
American arts – New York (N.Y.) – History. I.
Schoener, Allon. II. Metropolitan Museum of Art
(New York, N.Y.)
F128.68.H3S3 1995
974.7'1–dc20
94-41800
CIP

Acknowledgements
Copyrighted material is reproduced with
permission from: *New York Amsterdam News,
The New York Times,* W.C.C. Publishing Co., and
Bell and Howell Co. An article entitled "195
Hurt, 500 Held in Looting" from the August 2,
1943 issue of the *New York Post* is reprinted by
permission. Copyright 1943 by the New York Post
Corporation. An excerpt from "Bop" by Richard
Boyer, is reprinted by permission of *The New
Yorker*. Copyright 1948 by The New Yorker
Magazine, Inc. To the following organizations and
individuals: Gumby Collection of the Columbia
University Library, Schomburg Collection and
Newspaper Division of The New York Public
Library for text research sources; Mr Irving
Berlin for a song called "Harlem On My Mind".

Originally published in 1968 by Random House.
Published in the United States by The New Press,
New York. Distributed by W. W. Norton &
Company, Inc., New York.

Established in 1990 as a major alternative to the
large, commercial publishing houses, The New
Press is the first full-scale nonprofit American
book publisher outside of the university presses.
The Press is operated editorially in the public
interest, rather than for private gain; it is
committed to publishing in innovative ways works
of educational, cultural, and community value
that, despite their intellectual merits, night not
normally be commercially viable. The New
Press's editorial offices are located at the City
University of New York.

Original production and art direction
 by Harris Lewine
Original design by Herb Lubalin/Ernie Smith
Production management by Kim Waymer
Printed in the United States of America

95 96 97 98 9 8 7 6 5 4 3 2 1

To the people of Harlem—past, present and future—as a record of their achievements.

Contents

EDITED AND INTRODUCTION TO NEW EDITION BY ALLON SCHOENER
NEW FOREWORD BY HENRY LOUIS GATES JR.
PREFACE BY THOMAS P. F. HOVING
INTRODUCTION BY CANDICE VAN ELLISON

227 1960-1968 Militancy and Identity

Foreword

If "The Negro," as Richard Wright famously observed, is America's most salient metaphor, then Harlem—that resonating symbolic space north of Central Park—is the metaphor for African-American culture itself. And few events in the first three-fourths of this century proved to be as pivotal to unveiling this role of Harlem as both the repository of, and symbol for, so much that has been truly sublime in African-American arts and letters as has Allon Schoener's exhibition "Harlem On My Mind," which opened at the Metropolitan Museum of Art in 1969.

As the Visual Arts Program Director of the New York State Council on the Arts, Schoener persuaded the new Director of the Metropolitan, Thomas Hoving—whose tenure in the post, if anything at all, will always be recalled as bold and innovative—to mount a different sort of show, a show not devoted primarily to the high art of such great artists as Romare Bearden and Jacob Lawrence, but rather a virtual documentary history of the arts, letters, and social and cultural institutions, through which African-Americans defined themselves between the turn of the century and 1968. The accompanying catalogue, which we are reprinting here, remains, even a quarter of a century later, one of the richest and most comprehensive records of the history of the African-American in the twentieth century, as well as of the diversity of voices and faces of those who, collectively, made that history—a history at once separate from, yet paradoxically inextricably linked to, the history of the larger American society.

What is astonishing to a contemporary reader is both the boldness of the catalog's claims as well as its naïveté. Thomas Hoving's preface astonishes by its frankness about the primitive state of social relations across the color line: "Any thought of making a confrontation on a peer basis with a Negro," he writes of American social life in the forties and fifties, "was almost ludicrous. Any suggestion that we meet as equals and just talk just couldn't come up." Few curators today, moreover, would dare any action as politically risky as openly admitting their own ignorance about the thought and feelings of blacks, including "a wonderful maid of sunny disposition" and "a thin, sour chauffeur who drove me to school in moody silence." Through the exhibition's splendidly eclectic yet detailed contents, blacks themselves unmask and unveil images and stereotypes such as these. Equally startling are the opening sentences to Schoener's foreword, in which he feels the need to declare, albeit boldly, that "There is an urban black culture in America. Harlem is its capital. White America's mores and values are not universal."

So much has changed in American cultural and social relations since 1969, yet so much remains the same. Since the day the Met's exhibition opened, the size of the middle class has quadrupled; simultaneously, however, almost 45 percent of all black children live at or beneath the poverty line. Blacks have made a degree of socioeconomic progress scarcely dreamed of in 1969; yet, antiblack racism, the legacy of slavery and Jim Crow segregation, remains the indelible dye that stains the fabric of American democracy. And through it all, African-Americans not only "endure," as James Baldwin was fond of saying, we have contributed fundamentally and centrally to the creation of a truly American culture, one multiple in its cultural roots and branches, one that has been multicultural since the day the first African slave set foot on these shores. *Harlem On My Mind* vividly recalls, and records, the complex heritage of life along the color line—a line at once imposing yet permeable—and the cultural capital that blacks produced in the first seven decades of this century.

HENRY LOUIS GATES JR.
CAMBRIDGE, MASS.
FEBRUARY 1995

Preface

Times change, bodies change, minds change. When I grew up in New York and when I was a boy of eight, nine, ten, eleven, twelve, there was a Harlem. And Harlem was with me and my family—a wonderful maid of sunny disposition and a thin, sour chauffeur who drove me to school in moody silence.

To me and my family, living on 84th Street and Park Avenue, Harlem was a light-year away, uptown. And that was good. For behind the vague misty thoughts concerning *other people* that came through members of my family down to me, Negroes—colored people—constituted an unspoken menace, the tribe that must not be allowed to come down the Avenue.

My mother went to Harlem from time to time. To the clubs, carrying the delightful sense of slumming and far-off danger, a titillation of the perilous possibility that never came to pass.

To me, as a kid, Negroes were people. But they were happy, foot-twitching, smiling and sunny. They were not to be (and when they were, it was a problem) sour, moody, bitter, silent and mad like Frank, the chauffeur. "Why can't he be like Bessie the maid? Always friendly, always gay and warm?"

Negroes, as human beings, did not exist in any real sense when I was eight, nine, ten, eleven. And they didn't really exist as far as my parents were concerned. If anybody—at least to my family—had said twenty-six years ago, "You know, black is proud and beautiful and a black man is strong and creative and male," or "Negroes have one of the strongest, most personal, persuasive and enriching cultures of any minority group in the United States," well, everybody would have been puzzled, flabbergasted. What silly notions!" we would, I suppose, have said.

And any thought of making a confrontation on a peer basis with a Negro was almost ludicrous. Any suggestion that we meet as equals and just talk just couldn't come up. To me *Harlem On My Mind* is a discussion. It is a confrontation. It is education. It is a dialogue. And today we better have these things. Today there is a growing gap between people, and particularly between black people and white people. And this despite the efforts to do otherwise. There is little communication. *Harlem On My Mind* will change that.

This exhibition is an unusual event, particularly at the Metropolitan Museum of Art. Some people will see it, read it and listen to it, and their lives and minds and bodies will change for the better. Others will reject it and criticize the wisdom of indeed even having such a show at the Metropolitan. Why not strict art? they will cry out; why not have this environmental and overall cultural show at some armory or some other place? Some will wield the word *political* at the show and attempt to bludgeon it.

I could quote the original Charter of the Metropolitan and state that there is every good reason to have a show such as *Harlem On My Mind* here, because one of the stated missions of the museum is to relate art to practical life, and practical living to art. I could cite precedents or near-precedents for a show of this kind. But that, it seems to me, is academically interesting but irrelevant. We have this remarkable show because the city and the country need it. We put it on because this great cultural institution is indeed a crusading force attempting to enhance the quality of our life, and to support and buttress and confirm the deep and abiding importance of humanism. *Harlem On My Mind* is Humanism.

Many dedicated individuals, both within and without the Metropolitan Museum, worked hard on this landmark exhibition. Of that significant number, I would like to thank specifically Allon Schoener, Donald Harper, Reginald McGhee, A'Lelia Nelson, Jean Blackwell Hutson, John Henrik Clarke, Regina Andrews, James Vanderzee, and Melvin Patrick. Without the sensitivity, understanding and generosity of the Henry Luce Foundation, the members of its board and the efforts of its excellent executive director, Martha Wallace, this confrontation would never have occurred.

THOMAS P. F. HOVING, DIRECTOR
THE METROPOLITAN MUSEUM OF ART
NEW YORK CITY, AUGUST 1968

Introduction to the New Edition

The *Harlem On My Mind* exhibition at The Metropolitan Museum of Art in 1969 was the most controversial exhibition presented in an American art museum in the last 100 years. It transformed museums, compelling them to open their galleries to subjects and audiences they had excluded.

The exhibition generated such controversy because it brought African-American history and culture to one of the world's preeminent art museums and placed it on a par with the established icons of the Western tradition. The interpretation of minority American cultures had until then been relegated to ethnographic museums, where they were presented as "primitive." The Metropolitan was the first American art museum to schedule a major exhibition devoted to the accomplishments of the living people of a non-Anglo, so-called minority culture. That alone was enough to provoke vociferous reactions from traditional supporters of elitist cultural institutions—an elite that would have preferred to see the museum remain a dusty warehouse where only the cognoscenti could observe and contemplate great works of art.

The original book *Harlem On My Mind,* which served as the exhibition catalogue, became a flash point because of statements considered to be anti-Semitic in the introduction, written by a seventeen-year-old Harlem high school student. This ignited a now-familiar political phenomenon: tension between blacks and Jews. Reactions became so intense that the New York City Council threat-ened to cut off funds to the Metropolitan unless the catalogue was withdrawn from sale. After selling a thousand books a day for fourteen days, the Museum capitulated and relegated them to storage in the basement.

How did I get involved with Harlem and the exhibition? In 1966 I created at The Jewish Museum *The Lower East Side: Portal to American Life,* an exhibition which documented the lives and experiences of Eastern European Jews. The director of the New York City Commission on Human Rights asked me to take two Harlem ministers through *The Lower East Side* exhibition. When they left, I said to myself, if blacks are interested in the history of the Lower East Side, everyone will certainly be interested in the history of Harlem. If telling the story of poor immigrant Jews in the former Warburg mansion at 92nd and Fifth Avenue was of interest, telling the story of blacks in Harlem should also be of interest, and should happen at the Met.

Thomas Hoving, a medieval scholar turned populist, was Mayor John Lindsay's parks commissioner. He was revitalizing parks throughout the city and bringing people back in record numbers. I became acquainted with Hoving when I wrote an article for *New York* magazine in which I argued that Huntington Hartford should not be permitted to build a restaurant at the southeast corner of Central Park. Hoving used my article to support his rejection of the pavilion. When appointed director of the Metropolitan Museum, Hoving promised to bring new life to this slumbering giant. In an impromptu telephone conversation, I described the Harlem exhibition to him in early 1967 and he said, "I'll buy it."

While thinking about the exhibition, I also began planning a book. I approached Harris Lewine, art director of the *Lower East Side* book, with my proposal to do a Harlem book. Together, we presented it to Arthur Cohen, my editor at Holt, Rinehart and Winston, who said he would like to publish it.

These were heady times for the New York white community. Anything seemed possible; everything was being questioned; experimentation was rampant. There was optimism, long hair, miniskirts, gays and lesbians coming out, all while the Vietnam War dragged on and protests continued. The New York art scene burgeoned with energy, ideas, and possibilities. The Abstract Expressionists had reached their zenith and Pop Art, personified by Andy Warhol, demonstrated a sea of changing values.

The Lower East Side show created a new exhibition aesthetic. The museum's galleries were converted into orchestrated information environments utilizing photo blow-ups, with film projections accompanied by amplified sounds complementing the still images. Tony Schwartz, the wizard of recorded sound, had a library of Lower East Side sounds; he made a series of tapes appropriate for each room. We made a film of Zero Mostel reading *Bintel Briefs,* letters to the editor of the *Daily Forward,* in which immigrants

described the traumas and joys of their lives. Instead of sitting in a movie theater watching projected images with a sound track, museum visitors could experience similar sensations moving through three-dimensional spaces. Although there had been a gallery of paintings in *The Lower East Side* exhibition, I felt that they detracted from the kind of experience I wanted to create, and decided to use only photographs in the Harlem exhibition.

I wanted to bring a similar exhibition aesthetic to bear on *Harlem On My Mind*. Tom Hoving never deviated in his support of my view of the exhibition as a communications environment, without artifacts, depicting the history of Harlem. Although we never discussed it, I assumed that we both saw the exhibition as an opportunity to change museums. They were elitist institutions that catered to limited audiences. I wanted to see them expand their range to embrace subjects and people they had excluded. This meant making white cultural institutions more accessible to blacks and providing black professionals with new opportunities within museums. Museums were then seen as places for contemplation of works of art. I wanted them to become an active crossroads for all sectors of the community, where cultural phenomena were interpreted through the use of communications technology. This exhibition, one of the first to use such technology, generated a considerable amount of hostility in 1969; it has since become an accepted norm.

1967 was a turbulent year. The anti–Vietnam War movement was growing; there were riots in black communities across the country and the Civil Rights movement was transforming American consciousness. Within some segments of the white community there were both respect for the struggle for equality and the desire to embrace black society by opening the doors of the "establishment" to black citizens. Within the black community, racial discrimination, unemployment, crime, poverty, and police brutality remained; frustration with the political process was rising.

Having witnessed and participated in sit-ins, hunger strikes, selective-buying campaigns, boycotts, and freedom marches in the South, blacks knew that they had to take matters into their own hands in order to effect any meaningful change in the status quo. Anger was evident; a new militancy akin to Southern slave rebellions and the Garveyites in the twenties emerged. Groups like the Congress of Racial Equality proposed change through legal means; the Black Panthers advocated violence, if necessary, to achieve their objectives; and the black Muslims' message of economic self-sufficiency attracted supporters.

Although it was courageous for the Met to announce an exhibition on Harlem, it was not inappropriate. Nor was it outrageous for The Henry Luce Foundation, another bastion of conservatism, to provide $250,000 to produce it. The museum's press release dated November 16, 1967, stated:

At no time in this country's history has there been a more urgent need for a creative confrontation between white and black communities than today. In the belief that The Metropolitan Museum of Art has a deep responsibility to help provide the opportunity for such an exchange, an exhibition of Harlem's rich and varied sixty-year history as the cultural capital of black America will be shown in the Museum's major exhibition galleries. In announcing the exhibition . . . at a press conference with the Honorable John V. Lindsay, Mayor of the City of New York, [and] Percy E. Sutton, President of the Borough of Manhattan, Thomas P. F. Hoving, Director of The Metropolitan Museum said, "The role of the Museum has always been to make people see with their eyes. Today we must ask people to look searchingly at things that have to be looked into—such as our communities and our environment . . . And hopefully it will generate a continuing situation in which white and black people can confront each other with more respect for each other's roles in American life.

"There is no difference between this show and one of Rembrandt or Degas," continued Mr. Hoving. "Through their works, these artists reveal their individual worlds to us. The Harlem community becomes the artist in this case, the canvas the total environment in which Harlem's history was formed."

Reaching out to the black community was entirely new and unfamiliar for white cultural institutions. They had plenty of experience excluding blacks, but not many ground rules for inclusion. There were black janitors at the Met, but no black administrators or curators.

My experiences with blacks had been limited and remote. As Visual Arts Program Director of the New

York State Council on the Arts and as exhibition coordinator, I wanted members of the Harlem community to serve as advisers. But my approach turned out to be more of the window dressing about which complaints were so often heard. With the guidance of Jean Blackwell Hutson, curator of the Schomburg Center for Research in Black Culture, I assembled a three-person research advisory committee consisting of herself, Regina Andrews, a board member of the National Urban League and associate of many Harlem Renaissance figures, and John Henrik Clark, a left-leaning polemicist who was then director of the Haryou-Act Heritage Program. Although advisors, they were never engaged in the direct planning and production of the exhibition or book.

From my perspective as a museum professional, it seemed to make more sense to have active black participation from the core exhibition staff. Of the seven-member staff, three were blacks. Don Harper, an electrical engineer from Chicago who had worked with photographer Bruce Davidson and had made documentary sound recordings of the Civil Rights movement in the South, was associate research and media director. A'lelia Nelson, a respected member of the Manhattan black community, was community research coordinator. Reggie McGhee, a photojournalist from Milwaukee, was director of photographic research.

It was Reggie who discovered James VanDerZee's incredible archive. Although known to a few jazz writers as a source of inexpensive photos, VanDerZee was hardly appreciated outside Harlem. I will never forget the day in December 1967 that an excited Reggie came into my office with a report of his first visit to VanDerZee's studio at 272 Lenox Avenue. "You won't believe what I found," he said. "A master with thousands of glass-plate negatives of every major figure in Harlem: Father Divine, Marcus Garvey, Daddy Grace, Joe Louis, Florence Mills, and Bill Robinson!" VanDerZee had set up his studio in 1908. Over the next sixty years he photographed virtually every major politician, musician, entertainer, minister, and hundreds of ordinary people to create one of the most astonishing photographic records of any community.

Although not an official member of the staff, Mel Patrick, community board coordinator for Borough President Percy Sutton, was a valued adviser. At Mel's recommendation, prior to inviting members of the black community to a reception at the Met, a party was given at A'lelia Nelson's house on Martha's Vineyard, where we sought the endorsement of the "black bourgeoisie." Here we formed the nucleus of our thirty-four member Community Advisory Committee, which included Katherine Aldridge of the *Amsterdam News,* actor Robert Hooks, singer and educator Dorothy Maynor, Judge Constance Baker Motley, State Senator Basil Paterson, Assemblyman Charles Rangel, and Reverend Wyatt T. Walker. Although we had several meetings with members of this committee and they often sug-gested subjects or individuals not to be overlooked, we never involved them in anything that could be described as a fundamental policy decision.

In a time of outspoken demands for "black power," as a white male directing the exhibition and editing the book, I was certainly aware that I was doing what was then considered a "black man's thing." With two recent successes, *The Lower East Side* show and an exhibition for the New York State Council on the Arts (aboard a canal boat that toured upstate New York communities) commemorating the 150th anniversary of the start of construction of the Erie Canal, where Irish and Italian immigrants played significant roles as the laborers who constructed the canals, I considered myself to be an effective interpreter of American ethnic culture. Like an actor who can project himself or herself into the personality of the character he or she portrays, I honestly believed that I could identify with the American black culture I was depicting. For a very short period of my life, I believed that I could see things from a black perspective and believed that I was tuned in to values that were important to blacks.

With several advisory groups, the exhibition staff operated from three different offices. The New York State Council on the Arts Visual Arts Program office, where I worked, was in midtown. We had an office opposite the Met at 1001 Fifth Avenue, where Louise Broecker managed production. To maintain contact with the Harlem community, we had an office in the

Schomburg Center on 135th Street. A'lelia Nelson, Don Harper, and Reggie McGhee worked from that office.

Romare Bearden and Norman Lewis, two respected Harlem-based artists, met with me in 1968 to express their dissatisfaction with the conception of the exhibition. They said that if the Met wanted to open its doors to Harlem, black artists should show there. I defended my conception of the exhibition as a documentary exhibition without original works of art, but expressed my understanding of their concern. I conveyed their message to Tom Hoving and recommended that there should be an exhibition by black artists in another part of the museum at the time of our exhibition. He began to investigate possibilities for having such an exhibition of Harlem artists. James Sneed, a black curator, was given responsibility for organizing the exhibition. Ultimately, he was unable to satisfy both the Met and the Harlem artists. The show never took place. This failure demonstrated the Met's lack of commitment to that request. The exhibition's cancellation left in its wake a sense of distrust on the part of the artists in Harlem who should have been our logical allies.

Resentment in general against white artists, intellectuals, and writers dealing with black subjects was increasing. Although white photographers had taken thousands of photographs in Harlem throughout the 1960s, many of which appeared in the exhibition and this book, they were no longer welcome to roam the streets of Harlem with their cameras. From a white perspective, Harlem was becoming a hostile and difficult place.

When Dr. Martin Luther King Jr. was assassinated in Memphis in April 1968, black anger again erupted across the country; riots ripped apart every major American city with a sizable black population. Areas of Detroit, Newark, and Washington were devastated. Widespread violence occurred in Harlem and Brooklyn's Bedford-Stuyvesant. The unfulfilled goals of the Civil Rights movement led to frustration. Martin Luther King Jr.'s death fueled a new resistance to white promises of change, and led the black community to take the initiative and exercise power on behalf of its own objectives. "Black power" was evident across the country, from street corners to college campuses.

This combative mood made itself evident in New York in the fall of 1968 when the issue of community control of public schools erupted in the Ocean Hill-Brownsville section of Brooklyn. The stage for confrontation had been set in June 1968 when Governor Nelson Rockefeller signed a bill authorizing school decentralization for New York City. He said that while "it may not be satisfactory to all persons concerned, it sets a framework for proper action before the end of the 1968–69 school year." In an attempt to enhance his liberal image as a Republican presidential contender, Rockefeller lit the fuse for what was to become one of the most bitter and most racially charged labor disputes in New York City's history.

In August, Albert Shanker, president of the United Federation of Teachers, said that the Board of Education's tentative plan for decentralization violated the collective bargaining agreement between the teachers and the school system; he threatened a teachers' strike. Meanwhile the Board of Education proceeded with decentralization plans creating thirty-three community units with authority over the operation of their districts. In September, the union demanded that the Ocean Hill-Brownsville Demonstration School District in Brooklyn reinstate ten teachers dismissed by the local board. The union, which represented 55,000 of the city's 60,000 teachers, voted overwhelmingly to walk out.

Although there was a lot of posturing on all sides, the issue under contention was clear. A large percentage of the teachers were Jewish and an equally large percentage of the students were black. Black parents wanted to have black teachers for their children. Day by day, week by week, the strike continued. Bitterness increased on all sides. Nearly one million public-school students were without classes. In defiance of the strike, some parents and teachers created "free schools."

Responding to the escalating hostility between blacks and Jews, leaders of both communities established dialogues in which black anti-Semitism and Jewish racism were examined. They found that a number of issues had exacerbated tensions. Jews and blacks had joined forces in the Civil Rights movement. As black militants

moved to take control of their own movement, they excluded whites, including many liberal Jews. On a neighborhood level, blacks were moving in to what had once been Jewish neighborhoods. Increasing numbers of blacks were joining professions like teaching and social work, where Jews had been dominant. Black militants were joining the Muslim faith, carrying with it antagonism between Jews and Arabs. Another irritant was Jewish shopkeepers in black neighborhoods. The American Jewish Congress conducted a survey of a ten-block area in central Harlem and found that fifty percent of the stores were owned by blacks and thirty percent by Jews. When the teachers' strike was finally settled at the end of the year, bitterness gripped the entire city.

Announced in the previous year, *Harlem On My Mind* had been one of Tom Hoving's favorite projects. As a museum innovator, he saw the exhibition's potential for influencing museums around the world. The exhibition could be a vehicle for building a public image that might have lead to horizons beyond the museum world. When the teachers' strike deepened, he became more distant and less enthusiastic about the exhibition. He seemed to view it more as a burden than a delight. Having been a member of the Lindsay administration, he obviously had a better sense of the political climate than I did. Perhaps he anticipated trouble?

On November 23, 1968, the *New York Times* reported "Harlem Cultural Council Drops Support for Metropolitan Show." Edward Tay-

lor, the council's executive director, cited a "breakdown in communications" between itself and the Metropolitan, stating further that "they haven't really begun to consult us. We're expected simply to be rubber stamps and window dressing." In our attempts to involve the community, Ed Taylor's organization appeared to be a likely collaborator; therefore, we made him a member of the exhibition's executive Community Advisory Committee. When Ed Taylor demanded a position as director of the exhibition, I refused, igniting his anger.

Although Ed Taylor was correct in saying that we used members of the Harlem community as "rubber stamps and window dressing," this was not our original intention. Given the mood of the times, community participation was a genuine objective; implementing it was another matter. No one in the museum profession knew anything about community participation. With limited experience working in black communities, I was not qualified to identify black leaders. Therefore, I relied on the black members of the staff to obtain advice from the black community. Dissension emerged, particularly when Jean Hutson and John Henrik Clark, members of the research advisory committee, complained that the three committee members, who had lived in Harlem for over 30 years, were being ignored while two black out-of-towners, Reggie McGhee and Don Harper, were being consulted.

When the Harlem Cultural Council story broke, I had a conversation with Martha Wallace,

executive director of The Henry Luce Foundation, an experienced Time-Lifer. She said, "We're in trouble. This story dictates how the exhibition will be represented by the media from this point." As we had plenty of information to rebut Ed Taylor and excuses for Jean Hutson and John Henrik Clark's criticisms, I thought that we would be given our inning to respond. That never happened. It was the end of November and we had two more months in which to finish the exhibition, so community relations took a back seat while completing the exhibition was a priority.

Looking back, I realize that as much as I wanted to create an exhibition about Harlem, I wanted to demonstrate new ideas about how museums could become information environments that inundated people with images and sounds rather than artifacts. The era of museums as places for silent contemplation of works of art had ended. In my foreword to the catalogue, I wrote that our world had been transformed by communications; therefore I conceived the *Harlem On My Mind* exhibition as an environment that would parallel the sensations we experience in our own lives—a deluge of information stimuli.

We were given fifteen huge galleries—18,000 square feet—on the second floor. With exhibition designer Robert Malone and graphic designer Martin Moskof, the exhibition was a meticulously planned 60-minute experience. Using theories of fluid dynamics, we calculated the total number of people that could be accommodat-

ed in the space back-to-back, and came up with a capacity of four thousand people per hour. Our calculations were correct; at its peak, attendance approximated this figure. We assigned a time factor to each gallery and planned the information presented there within those limits. We had at least a hundred projectors, amplifiers, speakers, tape decks, and video monitors. Every space had a sound track. There were 700 photographic enlargements, ranging in size from 11 x 14 inches to 18 x 50 feet with explanatory text panels and another 500 projected images.

Decade by decade Harlem's history unfolded. At the entrance of each section, there was a slide projection summarizing Harlem and black history. People stood, watched, and moved on. Blacks had been in New York since 1624. The first gallery offered a panorama from slavery through emancipation to the beginning of the twentieth century, when approximately 60,000 blacks lived in the city. The next two galleries depicted Harlem's transformation from a white to a black community. Built as a fashionable white middle-class residential area with some tenements for working-class Jews and Italians, many of the buildings constructed at this time still remain in Central Harlem. Suspended in the middle of one gallery were banks of video monitors showing an interview with "Mother Brown," a legendary 106-year-old former slave who had lived in Harlem since 1907 and recalled the influx of Southern blacks into Harlem. The 1920s required three galleries for the

Harlem Renaissance, politics, work, business, religion, families, social clubs, schools, music, and legendary Harlemites like Dr. W. E. B. Dubois, James Weldon Johnson, Langston Hughes, and Florence Mills. Standing in front of huge photos of Marcus Garvey and members of his Universal Negro Improvement Association, you could hear Garvey's voice.

It was here that James Van-DerZee's genius shone. We made blow-ups from his sharp glass plate negatives. One was an enlargement fifty feet long and eighteen feet high of the 1925 Sunday school graduating class of the Abyssinian Baptist Church, with Reverend Adam Clayton Powell Sr. officiating. The largest space was a simulated nightclub with eight projectors throwing two hundred images of bands, performers, clubs, and record labels on screens suspended from its thirty-foot ceiling. There were potted palms, tables and chairs, and the sounds of 1920s jazz filling the room. We hoped people would dance; some did.

Moving from the gaiety and prosperity of the twenties to hard times in the thirties, we created a silent narrow corridor with the repeated image of a breadline. Walking through it, you felt like you were in a line surrounded by hungry people. In the next gallery, the bitter mood was conveyed by images of the unemployed, protests and strikes supplemented by text panels carrying quotations like this one from Billie Holliday:

We lived on 145th Street near Seventh Avenue. One day we were so hungry we could barely breathe. I

started out the door. It was cold as all-hell and I walked from 145th Street to 133rd down Seventh Avenue, going into every joint trying to find work.

Another from Adam Clayton Powell Jr.:

The slave market still exists. Here (Prospect Avenue and 181st Street or Southern Boulevard and Weschester Avenue in the Bronx) lined along the walls each morning can be found, dejected, tattered, young and old Negro women . . . begging to be employed. Garrulous, mercenary females haggle with them over the price (15 cents) per hour.

There was this quote from the *Report of the Mayor's Commission to Investigate 1935 Harlem Riot*:

Discrimination against Negro workers on the part of private enterprise is shown either in the restriction of the Negro to certain menial jobs or in his total exclusion from all types of occupations.

We also showed life among Harlem's middle class on "Sugar Hill" as well as photographs of celebrities such as Joe Louis, Father Divine, and Bill "Bojangles" Robinson.

To reflect the mood of the forties, where agitation, not solemnity, was evident, we designed the space with a series of large hanging structures carrying huge photos and more text statements. Rather than look at images on walls, you had to weave your way through congested space. Huge blow-ups of Gordon Parks's and Helen Levitt's photographs dominated. A. Philip Randolph's statement evoked what we wanted to convey:

Negroes made the blunder of closing ranks and forgetting their grievances in the last war. We are resolved that we shall not make the same blunder again . . . If the Presi-

dent wants us to stop our agitation, then let him stop discrimination.

Photographs of the "March on Washington" movement and the 1943 riots illustrated two different manifestations of black frustration, one attempting to reform the system, the other combating it.

For the fifties, we changed the spatial configuration again and created one long billboard in the center of the gallery, with plastered photographs and text statements on both sides. The Muslims, the rise of Malcolm X, and the presence of Reverend Martin Luther King Jr. were contrasted. There was the hint of more militancy to come.

For the sixties, we made a contemporary room that pulsated with the energy found on the streets of Harlem. No more than twenty feet wide and sixty feet long, the walls were covered with nine ten-foot mylar screens, one devoted to each year of the decade. Life-size images flashed on both sides, loud black pop music engulfed the space. It was not a disco, but a new type of museum experience where information, not art, dominated.

Because I never saw the exhibition as a one-way street, I wanted to build dialogue into it. I wanted to have video cameras in the galleries and in the heart of Harlem, on the corner of Seventh Avenue and 125th Street, so that people in both places could talk to each other. Although the exhibition was happening at 82nd and Fifth Avenue, only thirty blocks south of Harlem, the museum was a formidable and distant place. If the museum appeared on the streets of Harlem,

that would have demolished a barrier that might have kept many people from coming. Though it would have worked technically, to make it happen, we needed additional funding. We never succeeded in finding the money.

After a sixty-minute barrage of images, text, and sound, the last room—a hall of heroes—was for contemplation. Huge portraits of well-known and not-so-well-known African-Americans from all decades covered the walls, serving as an evocative summary of the content of the other fourteen galleries. On exiting, you went directly into galleries with Greek antiquities. I was pleased because this demonstrated that Harlem was a major culture like others displayed in the museum. A'lelia Nelson, Don Harper, and Reggie McGhee had final approval of everything that went into the exhibition. When interviewed by *New York* magazine just before the exhibition opened, Don said:

I couldn't have worked on this show if I had to compromise . . . I wanted a part in making the show the way it ought to be. It is about a very modern people—black people in this country are only several hundred years old as a cultural entity . . . I want to be sure it doesn't turn out to be a begging show that relives how black people have been downtrodden. This show is going to say that ours has been a decidedly rich and productive culture. Even when bogged down in completely technical problems, I've tried to keep imagining what I'd be impressed by if I was a Harlem kid coming through the galleries; how he'd relate to what's happening; how to show him why black people have taken as much as they've taken. He should know that

we haven't been just a bunch of Uncle Tom's for the last century.

In the same article, Reggie McGhee said:

Through this show . . . I want to take ghetto kids and orient them to thinking toward professionalism. I want to teach them how to take a camera and go out in the streets and record their neighborhoods in a meaningful way. I was talking to a group of kids in Harlem the other day, and they were saying, "Hey man, that Stokely is really militant . . . that Huey Newton is really militant." I said to them, "Listen, anybody can rig up a firebomb and toss it; that's not militancy. Militancy is getting at the white power structure with your talent, which you can do today."

In November, Martha Wallace's prediction that the *Times* article that had reported Ed Taylor, Jean Hutson, and John Henrik Clark's dissatisfaction would set the tone by which the media would perceive the exhibition proved to be true. Seen as troubled, *Harlem On My Mind* was fair game for anyone and everyone to attack. The Sunday before the exhibition opened, the *Times'* chief art critic, John Canaday, devoted his entire column to condemning the exhibition because "it includes no art." He said further, "I cannot see that an art critic has any business reviewing . . . the exhibition unless he is also sure of himself as a sociologist, which leaves me out." Two weeks later, another *Times* art critic, Hilton Kramer, repeated Canaday's lament, saying that the exhibition "hardly seems a proper subject for criticism," going on to devote the rest of his piece to a blistering personal attack on Tom Hoving for "politicalizing the Metropolitan Museum." He said, "No

doubt in the future Mr. Hoving will learn to improve upon the kind of audio-visual entertainment he has currently mounted in the name of 'relevance.'" This tone of criticism was echoed over and over again because the Harlem exhibition threatened an exclusive world that these critics and others like them wanted to preserve.

In an interview with another *Times* critic, Grace Glueck, I arrogantly said, "I think that this whole thing should be evaluated in terms of whether people really like the show. If it stinks, let them crucify us. If the performance is good, I'd like to be there with the rest of the team getting bunches of roses."

On the night of the press preview, a group of fifteen black and white demonstrators led by Benny Andrews, an artist, Henri Ghent, director of The Brooklyn Museum's community gallery, and Ed Taylor of the Harlem Cultural Council, said that the exhibition had been organized "by whites who do not begin to know the black experience," and complained that black artists had not been represented. On opening day, William Booth, the black chairman of the city's Human Rights Commission, toured the exhibition. He said, "We have had complaints that the show was one-sided. From what I've seen here today, I can't see the validity of that complaint. Both the up and the down of Harlem are in this exhibit. From my point of view it shows both the good and the bad. It is a rounded view." Commissioner Booth commented that about 15 percent of those at the show were black, about six or seven times the

average number of blacks who ordinarily went to the Met. Crowds swelled, protests continued, and the media had a heyday.

Two days before the exhibition was scheduled to open to the public, ten paintings in the Met's galleries, one of them a Rembrandt, were defaced. The paintings had relatively small and easily removed *H*s scratched into their varnish surfaces. It was questionable what the *H*s meant—Harlem or Hoving? It was never determined who had done it or why. The damage to the paintings made me sick. Having been trained as an art historian and museum curator, I had learned to preserve works of art, not destroy them. It was later determined that the paintings could be restored and the damage eliminated.

Given the full treatment of a major museum exhibition, there was a black-tie opening, but it was not like any other opening at the Met. There was a large crowd of demonstrators, mostly black artists protesting their exclusion, yelling at the arriving invitees, many of whom were black. Mayor Lindsay spoke, praising the museum and lauding the exhibition.

The next day, without any reference to his remarks of the evening before, Mayor Lindsay charged that the introduction to the catalogue was "racist" and that it should be withdrawn. His characterization of this book left an indelible mark which, until this day, is often repeated. In her introduction, which she wrote as a term paper when she was a seventeen-year-old student at Theodore Roosevelt High School in the Bronx, Candice

Van Ellison said:

Anti-Jewish feeling is a natural result of the black Northern migration. Afro-Americans in Northeastern industrial cities are constantly coming in contact with Jews. Pouring into lower-income areas in the city, the Afro-American pushes out the Jew. Behind every hurdle that the Afro-American has yet to jump stands the Jew who has already cleared it . . . Thus, our contempt for the Jew makes us feel more completely American in sharing a national prejudice.

Why and how did a young black woman's high school term paper become this book's introduction? In March 1967, when I first proposed the Harlem book to my editor, Arthur Cohen of Holt, Rinehart and Winston, he suggested that the introduction be written by someone like sociologist Kenneth Clark or novelist Ralph Ellison. I never liked that idea because they represented an older generation who were already expressing themselves. I wanted to find a younger person who had something fresh to say. As whites began to open up to blacks, they wanted to discover black talent. Candy Van Ellison came to the New York State Council on the Arts as a member of our Ghetto Arts Corps. Assigned to work with me, she brought her high school term paper for me to read. I decided that it was just the kind of introduction I wanted from someone who was young, black, and talented. At about this time, Arthur Cohen decided not to do the book. In a letter to my agent, Lynn Nesbit, he said, "Moreover it is my feeling, in checking with some of my Negro friends their own reaction to the book as a concept, that

there is going to be one helluva lot of political hostility generated by the show and the book." Shortly after that, Lynn Nesbit arranged for me to see Jim Silberman, executive editor at Random House, who decided to publish it. Because I wanted the book to be accessible to as many people as possible, I arranged for the Met to buy 40,000 paperback copies to be sold as the exhibition catalogue at a retail price of $1.95, an unbelievable price for a 256-page paperback book. The hardcover book sold for $12.95.

Tom Hoving insisted on seeing and reading everything that went into the exhibition and the book. I remember the day that A'lelia, Don, Reggie, and I sat at the round table he used as a desk, listening to his reactions to Candy's introduction. He underlined the contentious phrases saying, "This really bothers me." I assured him that anyone who had association with the Civil Rights movement had been exposed to black anti-Semitism. Since he raised the issue, we decided to discuss it as a staff. A'lelia, Don, Reggie, and I met in our office at the Schomburg, read it, talked about it. At this time, Jean Hutson was still functioning as an adviser, so we consulted her. She said that Candy's statement reflected a pattern of tensions arising between succeeding waves of ethnic groups that was characteristic of New York. When the Jews arrived, the school teachers were Irish. Now, the Jews were teachers and blacks were students. Reflecting on our collective experiences, we decided that what Candy had written was true and

that it should stand. I informed Tom of our decision, and he was satisfied. Other people read everything in the book, including Jim Silberman, executive editor at Random House. Though he was Jewish, he didn't flag these statements.

From my own experience, what Candy wrote rang true. When Jean Hutson first introduced me to John Henrik Clark and we had lunch on 135th Street to discuss the exhibition, he told me of his experiences as a *shabbas goy* working for Lower East Side Jews on the Sabbath. He said, "If you're another downtown Jew who has come up here to rip us off, go away." Although there was no apparent hostility in his remarks, every time we had a staff meeting Don Harper would say, "Just like the Cotton Club, black talent and a Jewish boss." I assumed that in presenting facts, as I and my advisers experienced them, we were doing the right thing. This included expressing a form of collective resentment prevalent in Harlem. Little did I know how few would share our opinion. If naïveté can be a valid excuse, it's the only one I can offer. Having experienced it myself and having read about it frequently in the then-current newspaper articles related to the school strike, I assumed that everyone knew that black anti-Semitism existed. Unfortunately, I was completely wrong. Malcolm X had made statements critical of Jews in his autobiography, but that was completely different from a book published under the aegis of The Metropolitan Museum of Art, a major New York City institution.

From then on, we operated with

a siege mentality. Although there were two separate issues, the exhibition and the catalogue, they merged in the general public's perception. There were black artists picketing to protest the absence of black art, and there were Jewish Defense League pickets protesting the catalogue. Black and Jewish protesters with different issues were in front of the museum, in the newspapers, and on radio and TV. The Jewish Defense League even picketed outside my family's apartment building.

There was no consensus; there were people who supported the exhibition and others who condemned the book. Reverend Adam Clayton Powell Jr. praised the exhibit in a sermon before his congregation at the Abyssinian Baptist Church and Reverend Henry Dudley Rucker, pastor of the New White Rock Baptist Church, condemned it, reading a statement on the front steps of the museum. Mrs. Ida Cullen Cooper, widow of Harlem Renaissance poet Countee Cullen, said, "The exhibit will also help people realize the strengths, the desires and accomplishments that the black people have made and attained, even through the worst kind of trauma and denial of their dignity and just rights." The venerable Meyer Schapiro, art historian and professor at Columbia University, said that it was a mistake for the museum to have sponsored the exhibition and that it would have been better to "have found a space for it in Harlem or in an armory elsewhere under Negro auspices, with the support of a committee of white friends, and

given Harlem the satisfaction of producing its own great show." Black archivist and historian M. A. (Spike) Harris said, "Any idiot can scrawl a sign and crawl around in reaction to what someone else dared to venture. Such 'critics' hold themselves up to contempt when they fail to meet a challenge. It is possible that sometime in the future *Harlem On My Mind* will be surpassed. When that happens, the fact cannot be obscured that the Metropolitan showed the way and set a standard for others to follow." Architect Hugh Hardy said, "The opening up of a great public institution to the larger community is both courageous and justified. It is precisely because this exhibition stands in the Metropolitan that it is effective. (What difference would 10,000 photographs of Negroes make if displayed in Grand Central?) Although one understands the public need for the illusion of stability and the 'permanent' values of art, the Black-White confrontation is too corrosive and too destructive to be ignored. I do not see how you could have accomplished your purpose without controversy, and even though disheartened by the narrowness of public reaction, I am delighted to see your great grey institution come awake."

It was a no-win situation. Bowing to pressure, Tom Hoving claimed full responsibility in an apologia to be inserted in every catalogue. Reluctantly, I acquiesced to his pressure to persuade Candice Van Ellison to write her own statement, which was also inserted in catalogues. The controversy continued. Every New York paper car-

ried lead articles, every radio and TV station reported on it daily, every national magazine had its story, special interest magazines covered it; internationally it was picked up by *The Times* of London and *Frankfurter Allgemeine Zeitung*. As media exposure increased, everyone ran for cover. Bennett Cerf, publisher of Random House, said that he was "sorry about the Met catalogue" and that they would insert their own apology into the hardcover edition. Catalogues were flying out the door at the rate of a thousand a day. Attendance was breaking all records. In the first nine days, 72,793 people had seen *Harlem* in comparison with the previous high of 165,948 people in four weeks viewing the exhibition *The Great Age of Frescoes.*

Finally, after two weeks of unending pressure from the mayor, City Council, the media, and members of his board, Tom Hoving capitulated and withdrew the catalogue from sale. Although I knew that the fallout from the school strike had sapped his enthusiasm for the Harlem show, I felt, for the first time, that our relationship had soured. As the one person ultimately responsible for whatever went into the exhibition and catalogue, I never recanted, nor apologized. When I found out that he had withdrawn the catalogues from sale, I went to his office expressing my displeasure, calling him "a coward" for caving in to political pressure. Little did I know how excessive that pressure had been or what his board had decided. Although I had been warned by a friend that

there was a move to force the New York City Council to withhold funds from the museum if the catalogue was not withdrawn from sale, I never thought it would happen. It did. Later I learned that Tom Hoving's job was on the line. The museum board was dismayed with what Harlem had brought to the museum.

Then the editor of *Park East,* an Upper East Side neighborhood paper, determined that the controversial statements in Candy Van Ellison's introduction were derived from Daniel Patrick Moynihan and Nathan Glazer's 1963 book, *Beyond the Melting Pot*. On page 77, Moynihan and Glazer wrote:

Perhaps for many Negroes, subconsciously, a bit of anti-Jewish feeling helps them feel more completely American, a part of the majority group.

Here is what Candy wrote in her introduction:

Another major area of contact involves the Jewish landlord and the Black tenant. A large portion of Harlem's Black women serve as domestics in middle-class Jewish homes. Perhaps this would explain the higher rate of anti-Semitism among Black women than men. Even the middle-class Harlem Black who has managed to work his way up the ladder in government jobs comes in contact with Jews who have already climbed the same ladder and now maintain higher government positions. One other important factor worth mentioning is that psychologically Blacks may find that anti-Jewish sentiments place them, for once, with a majority. Thus our contempt for the Jew makes us feel more completely American in sharing a national prejudice.

In her original high school term paper Candy used quotations taken

directly from *Beyond the Melting Pot*. I asked her to remove the quotes and suggested that she use her own words because I didn't want her introduction to sound like a high school term paper. Professor Glazer said that it was ironic that her introduction was attacked as anti-Semitic when it was derived from a book that clearly was not. He thought that Jews, for the first time in many years, were worried about anti-Semitism. With the Anti-Defamation League taking the lead, every major Jewish organization condemned the book.

What would have happened if I had not suggested that Candy remove the quotations and footnotes? Tom Hoving said that had he known of the footnoted references to Moynihan and Glazer, he doubts that the political heat would have been as intense. Recently, Tom Hoving told me that,

> If the blame for these statements could have been directed to two distinguished social historians instead of a defenseless young woman, we would never have caved and suppressed the catalogues. Chances are that, no matter how enraged Lindsay's people would have been or the members of the City Council, they would not have blasted Moynihan and Glazer. Had I learned that the quotation marks and footnotes had been removed before the withdrawal of the catalogues, I would have put that in a press release and fought back.

That my decision to remove the quotation marks and footnotes would provoke such controversy came as a complete surprise to me. There were other surprises. I expected support from artists and intellectuals who should have been able to appreciate the breakthroughs we made; there were very few such supporters. I expected the New York Police Department to be up in arms over the endless number of photographs showing police officers beating blacks. That never happened. But there was also the expected: given the highly charged climate in which the exhibition was presented, I expected hostility and criticism. That John Canaday and Hilton Kramer, echoing the concerns of a conservative art establishment, launched brutal salvos came as no surprise. *Harlem On My Mind* transgressed the sacrosanct domain of the cultural elite by opening up the Met (and consequently other museums around the world) to new subjects and modes of presentation. I expected criticism from black artists because they had been excluded.

The Met sold 14,000 copies of the catalogue and buried 26,000 in the basement. By the end of February, Random House had sold only 5,000 hardcover copies. Like the Met, they inserted a disclaimer in their books. Random House president Bob Bernstein was under pressure to remove the book from sale. After a meeting with other Random House executives where he and Jim Silberman were the only supporters of the book, he decided to continue to sell it. The Book-of-the-Month Club bought 5,000 copies, which they never offered to their members and dumped on remainder houses in New York City. I tried to find another publisher to buy the Met's 26,000 copies, but that didn't work out. Not sold, after several years, the Met's copies were distributed through black organizations.

How do I assess the impact of the exhibition and book? As an Upper West Side neighborhood paper, *Manhattan Tribune,* said, "Good Show, Bad Scene." That is exactly how I felt. I knew that the exhibition was incredible in terms of its presentation of black life. It had achieved my expectations— depicting African-Americans as major contributors to our society, creating awareness of the richness and diversity of their culture using photographs, sound, and video to convey these messages, and in the process making museums recognize that they must become more relevant parts of our lives. I was proud of what I had accomplished, but dismayed to find that so many people were trapped by their devotion to traditional values. I was equally proud of the book because it reflected the quality of the exhibition in its interpretation of black life in Harlem.

Harlem On My Mind never escapes me. It's the most important show I've curated. During the intervening years, I have created exhibitions and publications for the Anti-Defamation League. The final irony occurred several years ago when I was developing a project for them on the history of anti-Semitism in the United States. While doing research in their archives, I found a file called *Harlem On My Mind*. I never opened it.

ALLON SCHOENER
NEW YORK CITY
DECEMBER 1994

Introduction

History of Harlem.

To fully understand the Harlem ghetto, one must examine the history of Afro-American settlement in New York. During the years preceding World War I, a slow but steady migration of Blacks from the Southern countryside to the Northern cities began. This period is generally referred to as the advance guard of the "Great Migration," which occurred during World War I. It is during this era that we find "the migration of the talented tenth" —the Blacks who came to the big cities to become lawyers, doctors, businessmen and politicians. Actually, these people represented only a small portion of the Southern migrants. The rest were young inexperienced "boys and girls," fresh off the farm.

These young people had lived on the sharecropper and tenant farms of their parents, they had been subjected to the initiation of a score of Jim Crow laws and the Ku Klux Klan. But worst of all, they saw their parents, who were content to submit to the abuses of a Southern caste society. In order not to lose all hope, they fled the land in which they were born, and sought the "freedom" of the Northern cities. The migrants' pet phrase, "I came North to better my condition," expresses simply the attitude of the Southern Black at this time. Now was the time for them to move, as the country's industrial expansion created economic opportunity for the rural people. So they began leaving the South in great numbers, and as they did, Southern cities reflected on their migration. In the minds of most Southerners, Negroes seemed racially adapted to agricultural life, permanently tied to the soil. To forsake farm life would necessarily lead to their degradation. This was their only "proper calling," their "proper place." Instead of creating conditions which would encourage Blacks to remain in the South, Southerners took the opposite view and made it almost impossible for Blacks to leave the farm.

Unfortunately, these Black migrants did not find their "promised land" in the Northern cities. Instead, they found the alienation and the "evil temptations" of the big city. In New York, Blacks made their way to the "Tenderloin" (Seventh Avenue and 34th Street area), and "San Juan Hill" (Columbus Circle area). These Black concentrations were overcrowded, dirty and expensive to live in.

Faced with so many perils in the big city, Blacks banded together to protect themselves. They established benevolent, fraternal and protective societies, and insurance pools and church groups (since they weren't allowed to worship in the city's white churches). It was quite natural, therefore, for the Black migrants to search for a place to form their own social community. This was the pattern of almost all immigrant groups in New York City. Form your own community and put another "crack" in the melting pot. Thus, the Black social community in New York City became Harlem.

At this time Harlem was a white upper-middle-class residential community — Manhattan's first suburb. Speculators were buying up land in Harlem every hour and becoming millionaires overnight.

"On the outskirts of this Utopian community, one would be amazed to see the dark marshlands inhabited by the Irish gangs of Canary Island, the 'Italian Colony' of East Harlem filled with marionette shows, organ grinders and garbage dumps, and 'a large colony of the poorest colored people' in Harlem's Darktown." In the latter part of the nineteenth century the construction of new subway routes in Harlem set off a second wave of speculation. It was this second wave of over-speculation which created the final "bust" in 1904 and 1905. Financial institutions no longer made loans to Harlem speculators, mortgages were foreclosed, the land depreciated, and prices lowered. These conditions of ruin created the proper atmosphere for Black settlement in Harlem. This was the start of the Black ghetto called Harlem.

Housing.

Today, one of the city's biggest "sore thumbs" is housing in Harlem. The problem is simple—the annual average income of Harlem residents is not high enough to support competitive private housing. Greedy slumlords control the maze of Harlem's tenements. The City Building Department receives some 500 complaints a day about falling

plaster, holes in walls, rats, hazardous plumbing and unsanitary facilities. Housing Court can do little more than levy fines against apathetic slumlords. Very often a slumlord will accept a fine one day, merely to continue to rake high profits from substandard tenements for the rest of the year. There are many cases of "absentee" landlords who have agents which collect the rent. The most frightening danger of these crumbling tenements is fire. Fires occur so frequently in Harlem that only the most spectacular are reported in the newspapers.

The city's only answer to this age-old problem is the Housing Authority. In 1962, more than 450,000 people were housed in city projects. City projects are such popular environments for the poor that they have become a worthy competitor for the slum. The kind of life created by these project complexes is a prime example of city planning. The Housing Authority not only builds apartment houses, it also attempts to create integrated housing communities among lower-income families. This isn't easy. In Harlem's city projects, such groups as poor Italians, Irish, Puerto Ricans and Blacks are huddled together in "planned communities" which are surrounded by familiar slums. A large portion of these tenants are on welfare. Fear and suspicion are widespread, and there is constantly the feeling of isolation. The project community is permeated by surrounding slums and eventually begins to look like

them. Street gangs begin in order to strengthen ethnic ties. Although incinerators are present, garbage is constantly thrown in the hallways. Apartment walls are so thin that one cannot sleep for the noise in the next apartment. Project apartments number from one to three bedrooms. What happens to the Puerto Rican family of twelve?

The city housing system cannot be considered a complete failure when viewed in the light of the city tenements. City projects are considerably cleaner, cheaper and more attractive than any city tenement. They also represent a kind of equalizer for all the lower-socioeconomic groups in the city.

Education.

It has been said that "Afro-Americans do place a high value on education." In Harlem there are many elementary schools, a few junior high schools and one high school. The major, qualm about "the area's" elementary schools is lack of integration, both in the staff and student body. The junior high schools also suffer from lack of integration and modern facilities. In the community's one high school, Benjamin Franklin, the 1966 senior class contained approximately 2,000 seniors, 1,000 June graduates, and 38 graduating academic diplomas.

The city's answer to this problem was "free transfer" programs, community cultural programs, after-school study programs and vocational training programs. In

February 1961, the first enactment of the city's new transfer program began. "P.S. 197, a new school surrounded by middle-class housing projects in the Harlem area—Riverton and Lenox Terrace showed the highest percentage of requests." It was in this year that my best friend, Deborah Whittington, was granted a transfer from P.S. 197 to the all-girls finishing school—Elizabeth Barrett Browning Junior High School. One year later I was also transferred, on a two-year "S.P." program. We found the predominantly Jewish school quite different from our own "cozy" elementary school in Harlem. Competition was keen and we were no longer the "teacher's pet." The widest "gaps" between elementary and junior high school appeared in math and language. Fortunately, we managed to keep up. As we were leaving the school in 1964, it was rumored that a large influx of Lower East Bronx and Harlem students would be coming in in the next year. Some of the teachers complained that "the school is going to the dogs."

Today, Harlem civic groups have organized to "prod" city education. They have managed to establish a busing system for elementary students. They have also managed to incur the wrath of many of the community's educators by making a number of unreasonable demands. Many of the community's middle-class families still prefer to send their children to private or parochial schools — "they'd rather switch than fight."

Politics and the Church.

What are the political objectives of Harlem voters? The basic problems considered in national Black protests do not always apply to New York's Afro-Americans. In New York there are already laws against discrimination in employment and housing (although their administration has proved wholly inadequate). The Board of Education actively tries to integrate the city's schools, and in higher education there is practically no discrimination at all. There is probably little or no discrimination in hotels and restaurants. In other words, there are no easy problems left for Blacks in New York City, nor easy solutions. Improvement of the Afro-American's economic position in the city requires radical changes in the nation's power structure. It is evident that this can only be attained through more political positions for Afro-Americans. Congressman Powell in 1960 demanded that Blacks should get 21 per cent of the jobs in a Democratic city administration, since 21 per cent of the enrolled Democrats in Manhattan are Black. At present, Blacks hold only 6 per cent of the high political posts, and yet they are still doing considerably better than Blacks in other large cities. It is easy to demand political positions, but not quite as easy to find capable Black political leaders to fill these positions.

In Harlem the history of political leadership leads directly to the church, in which the Black minister was projected as both the political and spiritual leader of the Black community. Harlem ministers have a long tradition of political involvement. In the past it has always been the Black minister who acted as a political liaison between the downtown bosses and the Black people. These political ministers are no longer dependent upon the downtown bosses for orders. It is true that many ministers still need the financial support of the city's white community, but it is also evident that those politicians (or ministers) who are most popular in Harlem are those who advocate Black exclusivism and nationalism. This is a highly emotional concept, which advocates the advancement of Black people through the efforts and actions of Black people, excluding all white liberals. These political leaders call for unity of the Black community from the pulpit of their church. This combination of religion and politics serves several important purposes. First, large numbers of the Black community can be reached, influenced and educated through the church. Second, these secular gains attained by political ministers help strengthen the belief in religion and the moral codes advocated by it. Yet there are religions which advocate the advantages of unified self-defense. For example, at the height of Malcolm X's career, he could be seen on almost any Sunday afternoon preaching Black unity and self-defense on the corner of 125th Street in Harlem.

Depending upon the era and area of Harlem in which they preach, self-defense or peaceful demonstration will be the slogan of the Harlem politician. It has been said that in this second stage of the Black civil rights movement, peaceful demonstration is no longer the answer. If this is the case, then Harlem's political voices may be preaching street riots from the pulpits.

Intergroup Relations.

Black-white relationships in Harlem are poor, to say the least. This of course is part of a much larger national problem. We would do well to examine the specific factors which have influenced racial tensions in Harlem.

First, consider the racial tensions between the Blacks and the Irish in Harlem. It is true that only a small portion of Harlem's population is Irish, yet a strong Irish influence is exerted on Harlem through the city's police force. As early as 1900, when the city's main poverty concentration was in the Tenderloin, a bloody three-day riot was sparked when an Afro-American named Arthur Harris knifed and killed an Irish policeman who was manhandling his girl. This incident was just the spark needed to set off the already strained Irish-Afro-American relations. The numerous tales of police brutality in the riot ranged from policemen merely looking the other way while mobs attacked Blacks, to the arresting of Negroes and beating them senseless inside the precinct. This incident was only one indication of an underlying attitude between

Afro-Americans and Irish. The Irish at that time were immigrants in the city. Yet it is amazing how quickly they caught on to white America's .tradition of hatred for Blacks. It was also disconcerting that Blacks, who were actually American citizens, could never have gotten the jobs on the city's police force as the Irish immigrants so easily managed to do. Harlem riots between Afro-Americans and policemen have reoccurred in 1935, 1943 and 1964. Although the Irish no longer hold a complete monopoly over New York's police force, it is definite that damage created by them in past riots will not soon be forgotten.

The next intergroup relationship to be examined is that between the Afro-Americans and Jews of Harlem. Anti-Jewish feeling is a natural result of the Black Northern migration. Afro-Americans in Northeastern industrial cities are constantly coming in contact with Jews. Pouring into lower-income areas in the city, the Afro-American invariably pushes out the Jew. Behind every hurdle that the Afro-American has yet to jump stands the Jew who has already cleared it. Jewish shopkeepers are the only remaining "survivors" in the expanding Black ghettoes. This is especially true in Harlem, where almost all of the high-priced delicatessens and other small food stores are run by Jews. The lack of competition in this area allows the already badly exploited Black to be further exploited by Jews.

Another major area of contact involves the Jewish landlord and the Black tenant. A large portion of Harlem's Black women serve as domestics in middle-class Jewish homes. Perhaps this would explain the higher rate of anti-Semitism among Black women than men. Even the middle-class Harlem Black who has managed to work his way up the ladder in government jobs come in contact with Jews who have already climbed the same ladder and now maintain the higher government positions. One other important factor worth noting .is that, psychologically, Blacks may find that anti-Jewish sentiments place them, for once, within a majority. Thus, our contempt for the Jew makes us feel more completely American in sharing a national prejudice.

The third major group of racial relations in Harlem are those between Afro-Americans and Puerto Ricans. If Blacks invariably find themselves bumping into Jews ahead of them, they just as invariably find themselves bumping into Puerto Ricans behind them. In all of the major areas in which Blacks have fought so hard to prevent discrimination, newly arrived Puerto Ricans are now benefiting. In the city's great housing complexes, Puerto Ricans command a large proportion of the apartments. With so great an influx of Puerto Ricans into the Harlem community, Blacks are left with only three choices—fight them, ignore them or welcome them.

Employment.

Prior to the mass unemployment of the late 1950's and early 1960's, Black men found it much easier to obtain jobs in the Midwest than in New York. Still, it was easier for the Black woman, who did not have to depend on manual labor for an income. Working conditions in New York were much better for women because they were ideal employees for the city's non-unionized banks, insurance companies, "communications" industries, and retail stores. This resulted in better jobs for women than men at the lower levels of skill. According to statistics compiled in 1960, the median income for Black women was 93 per cent of the median for white women; for Black men it was only 68 per cent of the white median.

Oddly enough, the problem of Black employment in America is a problem of the Black male, rather than the female. In the past Black women were always the first to be taken into the white man's house to work as maids and cooks. It was easy for the white world to accept a Black woman because she offered no physical threat and could always be kept in her "proper" place. It was always the Black woman who was exposed to the white world and received the favors from them whenever they were forthcoming. It is this particular problem of Black employment, which has been of primary concern to the present Afro-American community. The creation of a somewhat

matriarchal society in Harlem is largely the result of Black employment patterns in New York City.

In the past, Blacks emerging from slavery found themselves devoid of both money and business experience. Thus, even after the destruction of slavery the Afro-American became basically a hired laborer or servant. These positions offered little chance for business experience. Unlike the other immigrant groups who came to New York with some particular skill or trade, the migrant Afro-Americans from the South had nothing to sell but themselves. They tended to depend on themselves, and therefore did not form many close business ties. Thus, Afro-Americans have attained a history of unskilled labor since they arrived in the New World. Even today, those young people who do manage to go on to higher education reject wholly the idea of skilled labor. Yet so few do complete the college and graduate level that there are thousands left to the mercy of that rapidly disappearing market of unskilled labor.

At present Harlem's principal anti-poverty program is Haryou-Act. Whatever its purposes and failures, Haryou-Act has managed to do one important thing— that is, to employ a large number of Harlem residents in an area that is sorely in need of economic stability.

Harlem is not an isolated Black ghetto; it is connected by the bonds of poverty, filth, illiteracy and unemployment to all the other Black ghettoes throughout the United States. In order to understand the problem of the Afro-American in America it is necessary to understand the environment in which he lives. Harlem is one such environment, and its problems have too long been ignored.

<div style="text-align: right">CANDICE VAN ELLISON
HARLEM, MAY 1967</div>

Editor's Foreword

There is an urban black culture in America. Harlem is its capital. White America's mores and values are not universal. These realities can no longer be avoided. *Harlem On My Mind*— both the Metropolitan Museum's exhibition and this book—document the struggle to establish an urban black culture in the midst of our twentieth-century industrialized society. As apparent as the problems and difficulties involving black and white relations may be, neither the exhibition nor this book proposes panaceas or social reforms. This documentary history of the Harlem community is presented as it has not been seen before—either by its residents or by outsiders. Exposure to the facts which shaped Harlem can benefit black and white America.

Facts — presented effectively —can be more interesting than fiction. We live today in the midst of a communications milieu. Radio, television, telegraph and telephone provide instantaneous contact with events as they are happening everywhere on this planet and within the areas of outer space contacted by human beings. Twentieth-century citizens are immersed in a world of transmitted fact. The *Harlem On My Mind* exhibition was conceived as a communications environment — one that parallels our daily lives in which we are deluged with information stimuli. Images and sounds — documentary in character — have been organized into a pattern of experiences re-creating the history of Harlem as it happened.

Didactic educational methods —based on the principle that one source of information transmits its output to a recipient — have dominated our thinking for centuries. In our present world of overloaded stimuli, such techniques no longer have continuing validity. We don't respond, as we once did, to an orderly progression of facts thrust at us in a fixed order. Because we are surrounded by a bewildering variety of choices, each individual assumes a unique role. He is not compelled to respond to information emanating from one source, nor is he a captive of the person who organizes the patterns of data directed to him. From all of the information available from a variety of sources, each person selects what he wants for himself and reacts to it. He tunes in on what he wants to and tunes out on

what he doesn't care about. Instead of being a passive recipient who digests what is directed to him, the individual becomes an active participant by making his own choices. As a result of his unique reactions, the individual who responds to an experience becomes as important in the communication process as the one who organizes it. In other words, the audience itself becomes a creative force. Participation implies more effective communication.

This suggests a new aesthetic hierarchy. It is time to think about such things. Electronic mass communication media transmit information effectively on all levels to people with a variety of backgrounds. This exhibition and book have been guided by a new aesthetic—that it is possible to communicate to individuals as unique and differentiated factors within a mass audience. Communication pattern (more information than can be received by an individual within the fixed time available) has replaced communication message (a clear, precise set of facts stated in a logical order).

This book is an extension of the exhibition. It is not necessary to see the exhibition to appreciate the book, but if one has, the structure and technique of the book are recognizably parallel. In both there is a selective barrage of information. In the exhibition, it is images and sounds; in the book, it is text and pictures. No attempt has been made to describe the sixty-eight-year history of Harlem as a continuing sequence of events. It is presented through a cluster of documentary newspaper stories and photographs assembled as units interpreting the character of each decade. Thus, without being rewritten, the history of Harlem does fall into a pattern of distinct sections.

The visitor to the exhibition can move through it as quickly or as slowly as he chooses. The reader of this book can use it as he chooses. He can skim through it and get the essential outlines of Harlem's history, or he can read slowly and extract details. As the editor, I hope that everyone uses this book differently. I hope that each person injects some of his own personality and style into the way that he reads it. The book accommodates itself to people; it does not dictate to them. It functions as an element in today's communications experiences, and it should serve as an invitation to probe further into this subject.

The objective of this exhibition and book is to prove that the black community in Harlem is a major cultural environment with enormous strength and potential, that there is a continuing leadership tradition, that there is a stable social community which supports civic and social institutions, that this community has made major contributions to the mainstream of American culture in music, theater and literature, and that there is an enormous reservoir of untapped talent. If the white community can stop expiating its guilt by rebuilding Harlem to mirror a white middle-class image, both black and white America will be happier.

Human attitudes are not inflexible. They can be influenced by a variety of circumstances and conditions. The attitudes governing social behavior in America can be questioned because the problems which confront us today are not being resolved. We are in the midst of a period of fundamental change. Where do we go from here? If we—both black and white—can accept the reality of Harlem as an important fact in our lives, we will have accomplished something.

ALLON SCHOENER

FROM WHITE TO BLACK HARLEM 1900-1919

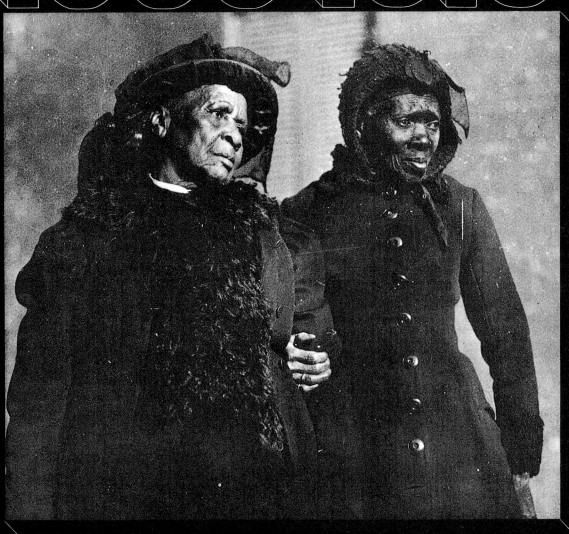

Race Riot: Set Upon and Beat Negroes
Policeman's Murderer Arrested
The Negro in New York
Negro Districts in Manhattan
Changes in Housing Market
Apartments Increase Harlem Population
Negroes Move into Harlem
Nail and Parker "Pull Off" Big Deal
Loans to White Renegades Who Back Negroes Cut Off
New York City Has Colored Police Officer
The Negro's Contribution to the Music of America
Interest in New Plan Shown
Fight Against Raised Rents
Union Will Not Protect Negro Strikebreakers
118,000 Negroes Move from the South
"No Better Troops in the War"
Madam C. J. Walker—Beauty Culturist Succumbs

THE NEW YORK TIMES, AUGUST 16, 1900

RACE RIOT: SET UPON AND BEAT NEGROES

For four hours last night Eighth Avenue, from Thirtieth to Forty-second Street, was a scene of the wildest disorder that this city has witnessed in years. The hard feeling between the white people and the Negroes in that district, which has been smoldering for many years and which received fresh fuel by the death of Policeman Thorpe, who was stabbed last Sunday by a Negro, burst forth last night into a race riot which was not subdued until the reserve force of four police precincts, numbering in all over 100 men, headed by Chief Devery himself, were called to the scene and succeeded in clearing the streets by a liberal use of their night sticks.

As a result of the riot a considerable number of wounded Negroes were attended to by surgeons at the Roosevelt Hospital. The greater number of those who were injured, however, preferred to remain in their houses, being afraid to trust themselves to the mercy of the crowds on the streets while on the way to a police station or hospital.

Every car passing up or down Eighth Avenue between the hours of 8 and 11 was stopped by the crowd, and every Negro on board was dragged out, hustled about and beaten until he was able to break away from his assailants and escape into a house or down a side street. The police contented themselves with trying to protect the Negroes, and it was remarked by many witnesses of the riot that they made little or no attempt to arrest any of their assailants. The police of the West Thirty-seventh Street station first tried to stop the disturbance by urging the crowd to move on, but were finally forced to charge upon the crowd with drawn clubs.

NEW YORK TRIBUNE, AUGUST 17, 1900

POLICEMAN'S MURDERER ARRESTED

Arthur Harris, the Negro who killed Policeman Thorpe, was arrested in Washington, D.C., on Wednesday night about the time innocent colored men were being chased through the streets in this city. Arrangements were made here to get the proper requisition papers and have Harris brought back to this city as soon as possible. Reports from Washington stated that Harris was arrested at the home of his mother at 832 E Street, S.E. Washington, nearly opposite the Fifth Precinct police station. Harris had been known as a boy to some of the older officers of the precinct, but he had been away from home several years. The request for his arrest was received from the New-York Detective Bureau.

Harris had told his version of the trouble that occurred when he used his penknife on the policeman. He was at Forty-first Street and Eighth Avenue on Sunday night, he said, with his common-law wife, as he called her, and he left her to go to a restaurant for a cigar. When he returned, he said, the officer, who was in citizen's clothes, had hold of the woman, and he (Harris) walked up and asked:

"What are you doing with my wife?"

"Don't meddle with me!" is what he says the policeman told him.

Harris said he took hold of the officer, not knowing of his official character, and when he did so the latter struck him. "Then," he said, "I pulled out my penknife, and I think I cut him twice." He thought he cut him in the chest and stomach. He said he had no idea that he had killed the policeman, and, not wanting to get locked up, he got on a train and went to Washington. It was not until after he had been put in a cell that he was told of the officer's death.

HARPER'S WEEKLY, DECEMBER 22, 1900

THE NEGRO IN NEW YORK

The prospect for the Negro in New York City is not very encouraging. His race is not numerically very strong in the metropolis, and the number is not rapidly increasing either by births or by migrations from the South. The

riot of August, when a mob attacked Negroes in the streets without much, if any, restraint from the police, was even more of a surprise than it would have been at almost any time during the preceding quarter of a century. There have been no times when the Negroes in New York were increasing with rapidity. At this time the opportunities of Negroes are less in New York than they have ever been, and there does not seem any likelihood that present conditions will be immediately changed. This riot, however, has directed the attention of the people to the Negro population, and if the truth be disclosed it may be that their present hard lot may in time be ameliorated.

The Negro is not a newcomer in New York. He has been here for two centuries and a half. In the beginning and until 1785 he was a slave, but even during the time of bondage his condition was not much worse than now. The slavery that existed in New York was of a very mild sort, and the amiable Dutchmen who were the first slave owners were very good and considerate masters. The English were not so gentle, and in the first half of the eighteenth century there were two severe disturbances, each marked with a loss of life. In 1709 there was so much traffic in slaves that a slave market was opened in Wall Street, and black men and women were dealt in as though they were cattle or swine. The Negroes were quite numerous in proportion to the white popula-

tion, and there was always apprehension that there might be a slave uprising. In 1712 a house was burned, the slaves attacked the whites, and after killing several, were suppressed by the Royal troops of the garrison. For twenty-nine years there was comparative quiet, though one-fifth of the population was black. In 1741 there were ten thousand inhabitants of New York. Of these, two thousand were Negro slaves. There was an epidemic of incendiary fires. The investigations were not more scientifically judicial than the witchcraft trials in Salem. The most improbable and contradictory stories were believed, and many Negroes were condemned in consequence. Some were hanged and some were burned at the stake. It was an anxious time in the little island city, and the officers of justice seem to have lost their heads pretty completely. This anxiety made slavery itself unpopular, and in 1785 the new State was quite willing to abolish the institution. At that time there were about 22,000 Negro slaves in the State, a considerable proportion of these being held in and around the city. This abolition of slavery in New York did not cause the death of the slave trade, however, for this was participated in by New York merchants until the whole wretched business was wiped out by the Civil War and the Emancipation Proclamation. Free Negroes continued to live in

New York from the time of the abolition of slavery until now, but they have always kept very much to themselves, living in colonies and engaged in a few special occupations in which they were reasonably prosperous. In 1850, when New York had a population of 515,547, there were 13,815 Negroes in the city. This was not a formidable proportion, only about two and a half per cent, but the Negroes then in the city were in many regards much better off than their successors are fifty years later. At that time the chief caterers of the city were Negroes, as they continued to be in Philadelphia till a very few years ago. There were many barber shops manned by colored men. The whitewashing trade belonged almost exclusively to Negroes. Negroes also were the private coachmen of the town, and not a few drove public hacks. The bootblack business was theirs, and very many, if not most, of the hotel dining rooms and restaurants had Negro waiters. This was half a century ago, when the opportunity for Negro employment in New York was at high-water mark. From that mark it has been receding ever since. At first slowly, but in the past dozen years very rapidly.

In the decade between 1850 and 1860 the Negro population in New York actually decreased. This was due to the immense influx of foreign population and the subsequent competition in all the unskilled branches of labor, and also to the prejudice against the race incident to the fierce political passions which culminated in the Civil War. In 1860 the population of New York was 805,-

651, while of Negroes there were 12,472, or one and a half per cent. The occupations of these colored people were just about what they had been ten years before. And, indeed, there was no appreciable change in this until after 1880. During the decade ending in 1870 there was a slight increase in the colored population, but a decrease in the percentage. The whole population was 942,292, and the Negroes numbered 13,072, or one and one-third per cent. By 1880 the number had increased to 19,663, which was a little in excess of one and a half per cent of the total population of 1,206,299. This was the period when the decline in the industrial opportunities of the Negroes in New York became very apparent. Nevertheless, they increased during the next decade both in numbers and in percentage of the whole. In 1890 the city's population was 1,515,301, and that of the Negroes 25,674, or one and seven-tenths per cent of the total. By this time there were few callings open to the men of the race, and the women who worked were chiefly employed in domestic service. But the increase up to the present year was steady, and the population now is estimated at 35,000. The census of this year puts the population of the borough of Manhattan (all of these figures have had to do with this borough and not with Greater New York) at 1,950,000, so the percentage is now slightly higher than it was ten years ago, having increased about one-tenth of one per cent.

It will be seen from the figures given above that the Negroes in New York do not constitute a very considerable proportion of the population. The Irish, the Germans, the Italians, the Russians and even the Scandinavians outnumber them, in the order given, while they are about as numerous as the French. Why there should be any race feeling against such an insignificant element of the population seems superficially strange. It is quite true that the Irish seem to have a natural antipathy to the Negroes, but the other north-of-Europe races seem to have no natural feeling of repugnance and the Italians are quite devoid of it. The strangest thing about this strange problem is that so many native Americans should feel hostile—not actively hostile, but in sympathy with the lawless Negro-baiters. I heard many native Americans, even New Englanders, say after the riot that they would have been glad if many of the Negroes had been killed.

Property is not rented to Negroes in New York until white people will no longer have it. Then rents are put up from thirty to fifty per cent, and Negroes are permitted to take a street or sometimes a neighborhood. There are really not many Negro sections, and all that exist are fearfully crowded. Nor are there good neighborhoods and bad neighborhoods. Into each all classes are compelled to go, and the virtuous and the vicious elbow each other in the closest kind of quarters. This is a great source of moral contagion, and vice spreads with

great rapidity among the women of such quarters. During the day the decent men are at work. Then the vicious and the idle have full sway. If it were possible to make a census of the Negroes and go into this phase of their social condition I have no doubt that it would be found that more men of the race are idle and without visible means of support in proportion to the total number than in any other neighborhood in the world except those frankly given over to the criminal classes.

The testimony of clergymen and other religious workers among the Negroes is to the effect that the harm done by this crowding is so serious that it is always threatening to undo the good work of the churches. This is very disheartening to the more intelligent among the Negroes, and they see no remedy so long as this dreadful overcrowding continues. One clergyman said to me that when he saw the dreadful discomforts of the places that Negroes in New York had to call home he could not in his heart blame them for drinking, if that mitigated the hardships of their unwholesome dwellings.

The landlords undoubtedly treat the Negroes with very little kindness. They charge enormous rentals for very inferior houses and tenements, which yield more when the Negroes have taken possession than they did in time of seemingly greater prosperity. Of course Negroes in a neighbor-

hood put a blight upon it, but the owners get a very large reward by reason of the higher rentals. Moreover, they make no repairs, and the property usually goes to rack and ruin. The Negroes are not responsible for this, even though they are the cause. I knew a Negro adventurer who took advantage of this prejudice against his people and made profit out of it. He would select a promising land-and-improvement scheme and through a white man would buy a lot. After a dozen houses had gone up, he would appear on the scene with a gang of Italians and begin digging a cellar. The neighbors, always interested in new improvements, would ask who was to build. "I am," the Negro would reply. "I am building a home for myself and family." In a little while there would be consternation in that neighborhood, and the promoter of the scheme would be visited. His scheme would be ruined if the Negro persisted. The Negro would express great determination to go ahead. Then in self-defense the promoter would buy him out at a handsome profit to the Negro. He did this half a dozen times in as many years, making in the aggregate a handsome profit. As a rule, however, the Negroes in New York are not beholden to the property owners for anything except discomfort and extortion. If they stay in New York, they are compelled to live in places where health, decency and privacy are all but impossible. Housed as they are, it is wonderful that they should be as good as they are; it is wonderful that they are not all entirely worthless. —J. G. SPEED

❖ ❖ ❖

THE NEW YORK TIMES, NOVEMBER 17, 1901

NEGRO DISTRICTS IN MANHATTAN

The distribution of the Negro population of New York City presents many curious features. Conceive a large rectangle through which Seventh Avenue runs lengthwise. Let this be bounded on the south by a line near Sixteenth Street and on the north by Sixty-fourth or Sixty-fifth Street. On the east, let the boundary be a wavering line between Fourth and Seventh Avenues, and on the west the river. In this quadrangle live over 20,000 Negroes, a third of the total population. Others live around the north end of the Park and further north, while 18,000 live in Brooklyn. The remaining 10,000 are scattered here and there in other parts of the city.

The migration of the black population to its present abode in New York has followed the growth of the city. Early in the eighteenth century the Negroes lived and congregated in the hovels along the wharves, and of course in the families of the masters. The center of black population then moved slowly north, principally on the East Side, until it reached Mulberry Street, about 1820. Crossing Broadway, a generation later the Negroes clustered about Sullivan and Thompson Streets until after the war,

when they moved northward along Seventh Avenue. From 1870 to 1890 the population was more and more crowded and congested in the Negro districts between Twenty-sixth and Sixty-third Streets. Since then there has been considerable dispersion to Brooklyn and Harlem districts, although the old centers are still full.

❖ ❖ ❖

NEW YORK HERALD, AUGUST 2, 1903

CHANGES IN HOUSING MARKET

Harlem, of course, cannot be called a private-residence section. Believers in the section freely acknowledge that it is upon flats, apartments and business structures that the present prosperity of Harlem realty is based. And, too, it is not likely that this condition will be radically changed in the years to come. Still, it is noteworthy that there are scores and even hundreds of private dwellings located in this populous part of New York which compare favorably with the homes of citizens living in the private residential sections farther downtown.

Just here may be noted, in general, the keynote of Harlem's history in the last decade. Dwellings ten years ago were scarce, also rather high-priced in the park section, and there was only a small demand for them. The situation now is that dwellings are more plentiful, cheaper and meet with a larger demand. To size up the situation in a few words, there is a large demand for Harlem residences in the sections which have acquired or retained a certain residential character, but the demand produces only moderate prices.

The flat-house and apartment tendency came on speedily. The flat furore seized upon these residential sections. And so it is today that many really high-class dwellings are intermingled with rather ordinary flat houses. This has meant a decrease from the old rents of the dwellings in most cases, and the boarding-house keeper often holds full sway in such localities. Some portions of Manhattan, Lenox and Seventh Avenues bear witness to this.

NEW YORK HERALD, AUGUST 20, 1905

APARTMENTS INCREASE HARLEM POPULATION

Fifth Avenue in Harlem, from 111th to 120th Streets, constitutes a retail-business section the like of which does not exist anywhere else in the Avenue. Within the section of the thoroughfare named are many single and full-sized stores which are supported entirely by the large population in the cross streets adjacent to that part of the Avenue. This population has vastly increased during the last two years, and store rentals in the Harlem section of Fifth Avenue have also increased as a consequence. Stores are very seldom vacant there and they are occupied by all kinds of businesses.

In the old buildings there are only two apartments, of five and six rooms each, to a floor; while in the latest built flat houses there are four and five apartments, of four and five rooms each, to a floor. Old apartments rent for from $30 to $35 a month each, and new apartments rent from $27 to $30 a month each. Rentals of the apartments in the old buildings, which, by the way, are not precisely antiquated, stand the strain of competition with newer apartments in the vicinity very well so far.

NEW YORK HERALD, DECEMBER 24, 1905

NEGROES MOVE INTO HARLEM

An untoward circumstance has been injected into the private-dwelling market in the vicinity of 133rd and 134th Streets. During the last three years the flats in 134th Street between Lenox and Seventh Avenues, that were occupied entirely by white folks, have been captured for occupancy by a Negro population. Its presence there has tended also to lend much color to conditions in 133rd and 135th Streets between Lenox and Seventh Avenues.

One Hundred and Thirty-third Street still shows some signs of resistance to the blending of colors in that street, but between Lenox and Seventh Avenues has practically succumbed to the ingress of colored tenants. Nearly all the old dwellings in 134th Street to midway in the block west from Seventh Avenue are occupied by colored tenants, and real estate brokers predict that it is only a matter of time when the entire block, to Eighth Avenue, will be a stronghold of the Negro population.

As a result of the extension of this African colony dwellings in 133rd Street between Seventh and Eighth Avenues, and in 132nd Street from Lenox to Eighth Avenues, have depreciated from fifteen to twenty per cent in value, especially in the sides of those streets nearest to 134th Street. The cause of the colored influx is inexplicable.

THE NEW YORK AGE, MARCH 30, 1911

NAIL AND PARKER "PULL OFF" BIG DEAL

A Harlem wag heard about the million deal recently made by Nail & Parker, the real estate dealers that deal in real estate. "The difference between Nail & Parker and many another of the big ones," sprung the wag, "is that they are swapping houses while many are swapping stories."

The deal pulled off by this progresssive pair of what Charles W. Anderson, the unfailing observer, calls "the youth of the thing," involving the huge sum of $1,000,070, not only puts this firm at the very front but influences the life of the colored people of New York as nothing of the kind has done in many a long year. It puts on the books of St. Philip's Church the wealthiest colored

church corporation in the country, the best property owned by colored people in Manhattan or in any other borough, and it opens up to colored tenantry the best houses that they have ever had to live in—and the colored people of this town are better housed than the colored people in any other town in the country.

In almost every window of the great row of apartment houses on the north side of 135th Street, between Lenox and Seventh Avenues, is displayed the sign, "For Rent, Apply to Nail & Parker." Until a few days ago in the office of the renting agents in the same houses stood the insulting board, "The agents promise their tenants that these houses will be rented only to WHITE people." The old promise broke "square in two" when Nail & Parker threw themselves against it. The houses are the ten new-law apartment houses running from 107 to 145 West 135th Street, covering three-fourths of the block, abutting the public library on the east, and but three doors removed from Seventh Avenue on the west. They were built five years ago, and are finished in high style from entrance to roof, the halls being decorated lavishly. These houses are situated on plots 40 x 100 each and are six stories high, accommodating four families to a floor.

There is a humorous side to the deal. Several weeks ago several light-brained people who say that they are "white" signed up a big piece of foolscap to the effect that

the owners of the houses in the two blocks in 136th Street, between Lenox and Eighth Avenues, would neither sell nor rent to colored people. The new houses now opened to colored people occupy the south side of one of those blocks, and if the colored people were given to revenge they might let loose on instruments of music sometimes and show their friends to the back of them what a blessed thing it is to be happy. But they will live in peace with their neighbors.

HARLEM HOME NEWS, APRIL 7, 1911

LOANS TO WHITE RENEGADES WHO BACK NEGROES CUT OFF

"Three months from now the Negro invasion, so far as this part of Harlem is concerned, will be a thing of the past," said John G. Taylor, president of the Property Owners' Protective Association of Harlem, to a *Home News* reporter last evening.

"How will this be brought about?" he was asked.

"By making it impossible for white renegades to borrow any more money for the purpose of backing Negro speculators in their value-destroying ventures," replied Mr. Taylor, measuring each word as he spoke.

"Then the Negroes are not altogether responsible for present conditions?" suggested the reporter.

"Quite right," said Mr. Taylor, "the nigger in the Harlem prop-

erty woodpile is a white man. We harbor no ill will toward the colored people, and we feel that the honest and disinterested among them will readily admit that our position is sound. We do object, however, to the operations of the Negro gambler and the unscrupulous saloon keeper, who are the white renegade's tools.

"Look deep into this Harlem situation," continued Mr. Taylor, "and you will find the unclean hand of the white deserter, the man who backs the Negro saloon on the lower West Side, and the man who breaks up homes in Harlem. He thinks we don't know him, but we do. Our retribution will come when we expose him, as we intend to do very soon.

"The situation is really serious," continued Mr. Taylor. "Ten years ago there were only a few Negro families in Harlem; now there are thousands in the shake-up. Many white people have lost homes and money—in some cases the savings of a lifetime of self-privation—the colored people as a class have not been benefited, and only a few unprincipled white renegades have richly profited. What has happened in this locality can happen in other localities. People put money in real estate because they believe it to be the safest form of investment; but, because of the Negro invasion, real estate investment has proved a disaster to more than one Harlemite. Values are subject to enough unavoidable fluctuations without adding any that are avoidable as well as unfair. Property owners everywhere are

studying the machinations of the white syndicate in Harlem, and they realize what a menace it is. Not knowing what neighborhood is going to be sandbagged next by these real estate holdup men, all neighborhoods are alarmed. Real estate men throughout the city want the problem solved in Harlem, and therefore they are going to back up the Property Owners' Protective Association of Harlem in its fight to withhold further financial support to real estate pirates."

"Well," interrupted the reporter, "the colored people must have some place to live, what about them?"

"We believe," said Mr. Taylor, "that real friends of Negroes will eventually convince them that they should buy large tracts of unimproved land near the city and there build up colonies of their own. That would be better for all concerned, and movements of that kind would be given unlimited financial support."

"What action, if any, will your association take in reference to those ten double-flat buildings on the north side of 135th Street between Lenox and Seventh Avenues, that the trustees of St. Philip's Colored Presbyterian Episcopal Church bought last week for $620,000?" asked the reporter.

"New problems require new methods of handling," smiled Mr. Taylor. "We will hold a meeting during the weekend and make a decision. No matter what happens, however, the residents on the south side of 136th Street will stick absolutely. If necessary a new dead line will be established.

This will be done by erecting a 24-foot fence in the back yards of the houses on the south side of 136th Street.

"The chances are, however," Mr. Taylor went on, "that the Negroes will not stay long in the new apartments. Real estate men do not know how colored people can possibly afford to pay the rents the new owners will have to charge to make the investment pay. In order to insure themselves against the possibility of loss, we have been told, the church people favored allowing the white people to remain in the 135th Street flats at increased rentals. Nail and Parker, the Negro agents, fearing that white people would not care to do business with Negro agents, protested, we were informed, and succeeded in having their views accepted.

"We understand there is $400,-000 in mortgages on the property, $160,000 of which will be due in the next eight months, and if the program to keep colored people in the apartments is carried out, we fail to see where the church is going to borrow the money."

❖ ❖ ❖

THE NEW YORK AGE, JUNE 29, 1911

NEW YORK CITY HAS COLORED POLICE OFFICER

The *Age* has won its fight, inaugurated over two years ago, for colored police. Samuel J. Battle, a resident of New York City, was appointed a member of the police department Tuesday, having successfully passed the mental and physical examination required by law.

For several months the *Age* has been interested in securing the appointment of Mr. Battle as a member of the police force, as the following correspondence will indicate:

Hon. William J. Gaynor,
City of New York
My Dear Mr. Mayor:

Under date of December 3, I sent you a letter with physician's certificates, inviting your attention to the matter of Samuel J. Battle, and I have your kind acknowledgment of December 8 that you would look into the matter. I am quite sure, Mr. Mayor, that you will see that Mr. Battle gets a square deal. He passed the examination for the position of a policeman, and it would be regretted to have it thought that those in control of such matters were unfavorable to the appointment of Negro policemen on the force. As you know, there are colored policemen in Brooklyn who have rendered most efficient service, and I think that you looked with friendliness at the time they were appointed. Your general reputation for fairness leads me to believe that you will see that Mr. Battle is given that consideration to which he is entitled, and as the police department is under your control, I shall hope to see Mr. Battle appointed.

Wishing you continued improvement in health, I am,
Yours very truly,
Fred R. Moore, Editor

The following letter was received from Mayor Gaynor:

City of New York
Office of the Mayor
February 21, 1911
Dear Mr. Moore:

Your letter is at hand and will be carefully considered. I do not under-

stand that the man you mention is in danger of discrimination whatever. Do you not merely imagine that the contrary is the case?

Sincerely,
W. J. Gaynor, Mayor

Mr. Battle will be put in uniform. He has not yet been assigned to duty. It is said that other appointments will follow.

❖ ❖ ❖

THE CRAFTSMAN, FEBRUARY 1913

THE NEGRO'S CONTRIBUTION TO THE MUSIC OF AMERICA

New York was given a real awakening last May, when the city learned to see what the Negroes had themselves accomplished in music utterly without the aid, instruction or even the knowledge of white citizens. Few white people had ever heard of the orchestra of the "Clef Club," a band of a hundred and twenty-five members organized a few years ago by the colored people themselves, at whose head now stands James Reese Europe, a man with a strong sense of organization and discipline, and with pronounced musical ability. For the benefit of the Settlement School, this orchestra and several other colored musicians volunteered their services at a great concert of Negro music given on May second in Carnegie Hall. I mention the date because this concert really formed an epoch in the musical life of the Negro and also in the development of Negro music. Hardly a day passes that the influence of that concert is not felt in some phase of Negro life in this city, for our eyes were then opened as never before, not only to the Negroes' ability, but to the importance of the step that the School had taken in appealing to the higher nature of the colored people through their own talent and in helping them to turn that talent to the good of our whole country. For music is certainly one of the distinct contributions that the Negro has to offer to our American life.

It was an astonishing sight, that Negro orchestra (a sort of American "Balalaika") that filled the entire stage with banjos, mandolins, guitars, a few violins, violas, celli, double basses, here and there a wind instrument, some drums, eloquent in syncopation, and the sonorous background of ten upright pianos corresponding in efficiency to the *cymbalom* of the Hungarian band. Europe uplifted his baton and the orchestra began (with an accuracy of "attack" that many a greater band might envy) a stirring march composed by the leader. It was the "Pied Piper" again, for as one looked through the audience, one saw heads swaying and feet tapping in time to the incisive rhythm, and when the march neared the end, and the whole band burst out singing as well as playing, the novelty of this climax—a novelty to the whites, at least—brought a very storm of tumultuous applause. After that, the audience settled back with a broad smile of enjoyment.

Most of these Clef Club men play by ear; two-thirds of them could not read a note when they first joined the organization. They have "picked up" the ability to play an instrument, and like the Hungarians and the gypsies, when they have caught the melody they are quick to catch by ear their own orchestral parts also, or even to fill in and improvise the harmonies—but always subject to the criticism and leadership of the conductor, who corrects and drills his musicians carefully at rehearsals. These Negro players, who sing also, think nothing of playing a bass part and singing tenor at the same time, or of playing alto and singing bass! Yet these are men with only odd hours for practice—many of them being waiters, porters, elevator boys, barbers, employees or tradesmen of different kinds. Even as the Negroes in the South sing naturally in four-part harmonies at their work in field or factory, so too these Negroes in the North, almost equally untrained musically, play and sing by virtue of sheer natural ability.

The program on May second was made up entirely of the modern work of Negro musicians, most of the composers taking part in the performance. There were in the audience many of New York's best white musicians, and also contributors to our Philharmonic and Symphony orches-

tras; and the musical editors of the New York papers had come in order to give this enterprise serious consideration. Never before had the Negroes had such an opportunity.

An unexpected force for better understanding between whites and blacks has been liberated in this conscious admission of the Negro into our musical life. Music has always sprung from people who labor out of doors —simple people who sing as they work and pray and dance. Whether the Negroes, any of them, will develop into great artists is not the present question; what we hope is that the Negro of today shall carry into his free industrial life in ennobling form the same love of song that upheld him spiritually in the days of bondage and made slavery bearable. For us, the fact is here that the untaught Negro has already unconsciously given to this country the elements of a type of music that the people love, while the Negro with a little education now gives us the promise of a development of that type. The folk song of the Negro has something to give to art—something that is original and convincing because it speaks directly from the heart. Like all music born of the need of song in a people, it appeals to the listener with that elemental truth of feeling in which race has no part and humanity is one.

If anything can bring harmony from the present clashing of the two races during this difficult period of problem and adjustment, it might well be the peace-giver—music!
—NATALIE CURTIS

❖ ❖ ❖

HARLEM HOME NEWS, JANUARY 28, 1914

INTEREST IN NEW PLAN SHOWN

The Committee of Thirty of the Property Owners' Improvement Corporation, composed of some of the most prominent local real estate operators and businessmen, held another mass meeting at the Harlem Y.M.C.A., 5 West 125th Street, last night, to hasten the organization of the proposed body by means of which the economic redemption of Harlem is to be accomplished. More than 500 Harlem property owners crowded into the auditorium to listen to speeches by Ransom E. Wilcox, chairman of the committee, Edward J. Dowling, Charles Blandy, Meyer Jarmulowsky, Harry Goldstein, Dr. J. Gardiner Smith and the Rev. Dr. Robert Bruce Clark, who urged the audience to come out in support of the project financially and morally.

The meeting was even more enthusiastic than the first, held about a month ago, and the frequent applause by the audience showed the men back of the movement that it is steadily gaining in popularity and strength among the rank and file of the people of Harlem.

The sentiment of the gathering was best expressed by Dr. Clark, pastor of the Church of the Puritans, who declared that better times are coming and advised all property owners to hold on to their property and to be prepared for the time when living conditions in Harlem will be better than at present. "For years," Dr. Clark said, "we have been hop-

ing for a movement such as this, believing that only a similar undertaking could work our economic salvation. Now we have it—the movement to organize this corporation. It is just what we want. It is a sane, safe and salutary proposition. If we give it the proper support, I believe Harlem will be reclaimed," added Dr. Clark, amid great applause, and continued: "Harlem has not lost all its attractions. Personally I believe that we have seen the worst days, that the tide is turning and conditions have been growing more favorable for the last two years.

"I believe with you that the colored people are entitled to proper living conditions, but I also firmly believe that our motto should be 'The greatest good to the greatest number.' We, the white people, are entitled to say who shall live next door to us, and no one can convince me that we are not in our right in this contention."

"Right," echoed several persons in the audience.

"So I want to urge every resident of Harlem, white or black," continued Dr. Clark, "to give this project his financial and moral support."

❖ ❖ ❖

THE NEW YORK AGE, OCTOBER 5, 1916

FIGHT AGAINST RAISED RENTS

Residents of the block on West 143rd Street, between Eighth and

Seventh Avenues, who are up in arms because of the abnormal increase in rentals for houses in that block recently opened to colored tenants, as told in last week's issue of the *Age*, are determined to fight to the last ditch to prevent real estate agents from continuing this unjust and unfair procedure. A Neighborhood Association has been organized and meetings are being held not only to create sentiment but also that funds may be raised to finance a campaign against the extortionate rentals which are being forced upon them by both colored and white agents.

As stated in last week's *Age*, 109 names were signed to a petition of protest, and that protest has been sent to the owners of property in that block, to real estate agents and to the newspapers. In addition, white tenants in that block, objecting to being forced to move to make room for colored tenants at increased rentals, have circulated a petition among themselves for signatures, in which they are requesting the owners of the houses in which they live to permit them to continue as tenants. They declare in their petition that they consider it unfair to be forced to move when they have no objection to living in adjacent houses to their colored neighbors. They declare also that if any white tenants care to move, others will be found to take their places.

❖ ❖ ❖

THE NEW YORK AGE, NOVEMBER 2, 1916

UNION WILL NOT PROTECT NEGRO STRIKEBREAKERS

When the Italian hod carriers, members of the International Hod Carriers', Building and Common Laborers' Union of America, at 201 East 125th Street, became grieved on account of some differences with their officers and withdrew from that organization, a strike was precipitated which affected building operations on many buildings in Manhattan, the Bronx and Brooklyn. Many of these buildings were in the Riverside Drive district. The striking Italians formed an independent organization, called Local No. 110, but the international body refused to recognize the men. The boss masons could not recognize this new union because of their working agreement with the international organization.

As a solution of this labor problem, two of the construction companies, the Mayho Construction Co., erecting a building at Post Street and Academy Avenue, Riverside Drive, and the Peerless Products Co., erecting a building at 169th Street and Shakespeare Avenue, sent representatives to the office of the National Urban League, and requested that colored men be furnished to take the place of the striking Italians. This was done, and colored men, both members and non-members of the union, were sent to these jobs. The non-members were made members of the union before being put to work, the construction companies facilitating this by paying for them the initiation fee of $5 per man. Colored men to the number of from two hundred to three hundred thus became members of the union and were put to work on these construction jobs throughout Greater Manhattan, other construction companies following the example of the two already mentioned. They were paid union wages, $3.40 per day of eight hours.

Naturally, the striking Italians objected to this procedure, and they swarmed in large numbers around the buildings trying to induce the colored men to quit work. Finding milder methods unavailing, they resorted to threats of Black Hand bombs and dynamite. The striking Italians numbered approximately 6,000, and greatly outnumbered the Negroes at work. As a consequence the colored men thought it best to have an understanding with their employers in regard to the protection to be afforded. Mr. Dreyfus, a representative of the Mayho Construction Co., called on James Christian of 552 Lenox Avenue, who acted as spokesman for the colored men, and assured him that protection would be given the colored workmen. Under this assurance, all the men stayed on the job.

At 12 o'clock on Friday, October 27, without previous notice, it was announced that the companies had reached an agreement with the striking factions, and the colored men, notwithstanding

that they were regular members, in good standing, of the International Hod Carriers', Building and Common Laborers' Union of America, were discharged from all of the jobs. The men are very much disappointed at the failure of the union to ensure the permanency of their work, but it appears that no effort was made by the union officials to protect them. As soon as terms of adjustment were agreed upon with the striking Italians, every Negro employed on the various jobs, union member though he be, was incontinently discharged.

❖ ❖ ❖

THE NEW YORK WORLD, NOVEMBER 5, 1917

118,000 NEGROES MOVE FROM THE SOUTH

Atlanta—Since the first of last April, 118,000 Negroes have gone from the South to West Virginia, Pennsylvania, New York, New Jersey, Ohio, Indiana, Missouri, Illinois, Michigan and Connecticut to accept work. They went to take places vacated by thousands of unskilled foreign laborers who returned to Europe after the outbreak of the Great War. This Negro migration to the North, East and West has recently assumed such gigantic proportions that it threatens the very existence of some of the leading industries of Georgia, Florida, Tennessee and Alabama, which have borne the burden of the exodus. The *World* correspondent, after interviewing hundreds of

Negroes and white people in this section of the country, has found the chief reasons for the tremendous flow of colored citizens to the North to be:

1. The natural desire to get a promised increase of wages, accompanied by a free ride to the new field of labor.

2. To gratify a natural impulse to travel, and see the country.

3. To better the condition of the Negro by a freer use of schools and other advantages offered in the North, East and West.

4. The desire of some Negroes to escape the persecution of thoughtless and irresponsible white people who mistreat them.

5. To see the fulfillment of a dream to be on a social equality with white people.

6. The Negro who is educated wants to go where he can vote and take part in running the Government.

The dominant reason for the migration is more money. The alluring tales of the labor agent have made the Southern Negro long for the North. He is in a state of unrest. Every sane Negro in the states of Florida, Georgia, Alabama and Tennessee has heard of the "recruiting man" from the North who has come South to take the Negro to his "real friends."

Great excitement prevails in the entire cotton belt. Crops are short and many Negroes will be idle until spring unless they leave the cotton plantations. The boll

weevil and floods destroyed thousands of acres of cotton on the Mississippi this year and left hundreds of Negro families penniless. That is why the call for labor met such a ready response in some regions. The following figures, showing the number of Negroes leaving the various States, indicate the extent of the transfer of labor from the South to other sections of the country: from Alabama, 60,000; from Tennessee, 22,000; from Florida, 12,000; from Georgia, 10,000; from Virginia, 3,000; from North Carolina, 2,000; from Kentucky, 3,000; from South Carolina, 2,000; from Arkansas, 2,000; from Mississippi, 2,000.

It is estimated that ninety-five per cent of the Negroes who have left the South in this movement are men. The demand is for laborers for freight and section-hand work on railroads, miners for coal and iron mines, and unskilled workmen for general outside work at industrial plants throughout the Middle West and North. Most of the black men are now doing the heavy work done by Italians, Montenegrins, Roumanians, Greeks and other foreigners before the European war broke out. The reports of the Bureau of Immigration of the Department of Labor show that during the fiscal years of 1915 and 1916, 169,300 Italians returned to Italy; 2,170 Bulgarians, Serbs and Montenegrins; 3,622 Germans; 18,500 subjects of Great Britain; 8,096 Frenchmen; 1,400 Roumanians; 1,000 Russians and 1,600 Japs to their native countries.

Last spring, when the business of the railroads and the mines began to prosper as they had not done before in years, the demand for unskilled labor increased rapidly. The freight congestion in and about New York caused a pressing demand for truck hands. In former years the railroads had called on Europe and Asia for extra supplies. Labor agents and steamship companies cooperated to fill orders for thousands of men for rough work. This year, when they could not get people from the war zone, they returned to the South. The present movement of colored labor from the cotton States of the South to the great industrial centers of the North, East and West was started by the Erie and Pennsylvania Railroads in a legitimate way. The agents of these roads commenced their efforts to increase their operating forces by appealing to the Federal Department of Labor's distribution office, connected with the division of information. The roads took advantage of Secretary Wilson's plan to land the "jobless man" in the "manless job." The first call was made on Florida and Georgia. It was made known at Jacksonville and Savannah that these two great roads would pay 22 cents an hour, seven days a week, and use the men overtime. It was announced that bunkhouses made from boxcars, or railroad hotels, would be provided for the Negroes, and that food would be sold to them at the rate of $2 a week.

It was stated that an able-bodied hard-working Negro man could earn from $70 to $85 a month, laboring for the Erie or Pennsylvania Roads. This appeal started the ball going; the news of the desire for labor spread throughout both States. But the final inducement that reached all of the idle Negroes, and most of the busy ones, was the offer of a "free ride" or a ride on "credit." When it became known that the railroads would not only provide jobs at good wages but would haul the Negroes free, the entire colored population of Georgia and Florida became excited. Farm hands who had driven their employers' teams into towns left their wagons in the streets, and caught outgoing labor trains. Sawmills that had a full corps of laborers when they stopped for the noon hour were deserted without notice, and when the operators investigated they found that their "hands" had gone "North" without a moment's notice. Every industry was affected. A half-dozen doctors in Jacksonville lost their drivers the first day of the "free ride" call.

The conditions in Georgia and Florida were duplicated in Alabama and Tennessee. Soon the movement spread to other States and is still spreading. Many of the first Negroes to migrate have written back and told of the glorious land beyond the Mason-Dixon line. John Suggs, a Florida Negro who was sojourning in Georgia when the labor agent got him, wrote back to a brother from Wheeling, West Virginia: "Dear Tim: Get on the first train for West Virginia. We come here to work in the mines. We get 25 cents an hour, and gin and whiskey flow like water. I am going with a lot of Georgia Negroes to Pittsburgh Sunday. It don't cost much and I may not come back here. In Pittsburgh the coal and iron men are paying $2.50, $3 and $3.50 a day. And here the people don't call you "nigger" but "mister." Every community from which the first batches of Negroes went is receiving similar letters and appeals. The laborers who went before and are doing well write back to their kith and kin. The higher wages of the North, East and West are being advertised in every Negro home of Florida, Georgia, Alabama and Tennessee.

This Negro movement was well under way before the white people of the South realized what it meant. Jacksonville, Birmingham and Savannah began to protest. The Department of Labor soon stopped its efforts to get the "manless job" of the North, East and West, and a "jobless man" from Florida, Georgia or Alabama. Senators Fletcher and Bryan took the matter up with Assistant Secretary Post of the Department of Labor. The Government agent at Jacksonville was instructed to desist. The city of Jacksonville passed an ordinance taxing all labor agents operating inside the corporate limits. The efforts to hold the Negroes served to advertise the movement, and some of the labor agents had "labor specials" stop

just outside of the city limits and pick up the men who wanted to go "North." Negro preachers and Negro women were paid to urge the men to go North and get better wages. Pictures showing the homes of Negro men with white wives in Chicago and other Western communities were stealthily exhibited. The prospective recruit was told that in the North, East and West his children would go to school with white children and have ten months of school training each year. He was told that he could go to the "white" moving picture shows, and that he could sit anywhere in a streetcar or railroad train, as there are no "Jim Crow" laws outside of the South. All the seductive arguments known to cunning man have been used in Georgia and the neighboring states.

❖ ❖ ❖

THE NEW YORK WORLD, SEPTEMBER 1, 1918

"NO BETTER TROOPS IN WAR"

With the American Forces in France, August 31—There is a certain Negro regiment (369th Infantry — "Harlem Hell-Fighters") over here in France to whom, were they to march down Fifth Avenue today, every hat in New York would be off. They constitute the first Negro force Uncle Sam has sent to the European battlefields. Today many thousands of their race have donned the uniform of their country and been ferried across the Atlantic. But to the first outfit

that came belongs the glory of proving that New York Negroes can fight as ably and valiantly for democracy as their white comrades.

I visited the rest billets to which the regiment had just been ordered after more than four months on the firing line. Everybody, white officers and Negro men, were eager to tell what the outfit had done, and everybody had something of interest to say. There was a great change in their outlook since I had seen them last, three months before. Then they were greenhorns in one of the quietest sectors of the front, with a knowledge of warfare confined to little patrol encounters in no man's land. Now they are seasoned soldiers to whom attack and counterattack, the crushing strain of incessant bombardment, the stealthy horrors of poison gas, wholesale carnage, sleepless nights and foodless days are all in the day's work. I asked the regimental commander, whom New York remembers best as a Public Service Commissioner, what he thought of his men. (Colonel William Hayward, commander of the old 15th National Guard, New York, was formerly a Public Service Commissioner.) "What I have always thought," he said with a contented grin, "that they're just as good soldier material as the United States can produce. I guess a good many others take the same view now, after the regiment's showing in the offensive of July 15. There were doubters, even in the regiment. Lots of people thought the Negro would flinch under heavy shelling or under gas or when *boche* bayonets were tickling his ribs. Well,

since July 15 my boys have endured what the French say is the most colossal artillery preparation the Germans have ever made, all kinds of gas, bayonets by the thousand and every other kind of punishment the enemy has in stock. They've stood up under it all, done everything that was demanded of them—a good deal sometimes too—and come through with colors flying and spirits high. I don't believe there are many better soldiers in this war than these Negro boys. I haven't seen any."

❖ ❖ ❖

THE CHICAGO DEFENDER, MAY 31, 1919

MADAM C.J. WALKER—BEAUTY CULTURIST DIES

After an illness which first developed more than two years ago but became acute recently, Mme. C. J. Walker, the country's wealthiest woman of our Race, died at 7 a.m. Sunday, May 25, in her beautiful country home, Villa Lewaro, Irvington-on-Hudson. Immediately after Mme. Walker was pronounced dead, Major H. W. Ward and Dr. J. Arthur Kennedy of Chicago, the attending physicians present when the end came, said death was caused directly by uraemia, due to Bright's disease (nephritis), from which the Madam had suffered two years.

Inside the handsome villa that the dead woman had built at a cost of $250,000, all was hushed.

In the big hall on a table, among other things the reporter noticed a leather-bound set of resolutions which had been presented the Madam by the Indianapolis Y.M.C.A. when she was leaving that city to take up residence in New York, as a token of that organization's love and respect. The beautiful furniture, which cost $100,000, seemed desolate in its richness. In the drawing room the $8,000 pipe organ, the handsome gold lamp, gold Victrola and gold grand piano seemed to mock the quietness of the place. In the conservatory too, off the drawing room, all was deathly still; so likewise was the beautiful dining room, breakfast room and library, all on the same floor. Outside, the sunken garden, with its bits of vegetation just creeping up out of the ground, gave the only shadow of life there was to the big mansion.

Fifty-two years ago, in a little village, Delta, Louisiana, there came into the world a little girl. Her advent was nothing then—just another "Colored" baby in a typical Southern town. Born of parents who had been slaves (Owen and Minerva Breedlove), the outlook for this little baby was anything but promising, and when the child reached the age of 6 both her parents had died, leaving her an orphan to get on in the world, at that tender age, as best she could, Thus handicapped, the little child, who later became the world-famous Mme. Walker, began to shift for herself. Next came a few precarious years until, at 14

years, the child married C. J. Walker, from whom, at the age of 20 years, she was divorced, though not before she had become the mother of one child, Lelia. Always ambitious, the young mother, still receiving the hard knocks of life, set about to get what education she could.

At the same time her only means of livelihood was the washtub, and many a day did she put in at the unromantic work of washing clothes. But even a quarter of a century ago Mme. Walker realized that the washtub would never lead to riches, so with the little daughter she went to Denver, Colorado. After working laboriously there a few years, she was inspired by a dream to make a preparation that would improve the texture of the hair of Race people. She made the goods and began selling it from house to house. Those who knew Mme. Walker intimately would not hesitate in saying that her first thought in her preparation could have been as much for the betterment of her Race as for the betterment of herself financially, for always she has been with and for her Race in all things. Her capital at the start of her business consisted of the sum of $1.25. Today in Indianapolis the Walker preparations are manufactured in one of the largest plants in the big western city. As she toiled along in the old days soliciting trade for her goods, she often dreamed of the days when thousands of agents would be handling them. Today there are more than 15,000 Walker agents throughout the country. The success of the one preparation led the Madam on to several

others, among them her famous straightening comb. At last, after superhuman work, a company was formed, with offices in Indianapolis, Mme. Walker herself being president.

As the dollars rolled in to the former washerwoman she never became any the less human. Always a shrewd businesswoman, she was at the same time an ideal entertainer. When she decided to move from Indianapolis to New York, the people of the former city tendered her many testimonials of their love and grief at her leaving. About three years ago she erected at 108 West 136th Street her New York home, and at 110 West 136th Street the most completely equipped and beautiful hair parlor that members of our Race have ever had access to was opened. Continuing to prosper, two years ago she bought the property on Broadway, at Irvington-on-Hudson, and built the beautiful mansion on it, which Enrico Caruso, the famous Italian tenor, named Villa Lewaro, after the daughter, Lelia Walker Robinson. This act created a furore, for one of the Race was invading the sacred domains of New York's most sacred aristocracy. But Mme. Walker's unassuming ways kept down any possible friction that might have arisen due to her presence at Irvington. Instead of dislike, her neighbors learned to respect her and today the townspeople of Irvington are loud in their expressions of regret over the loss of the Madam.

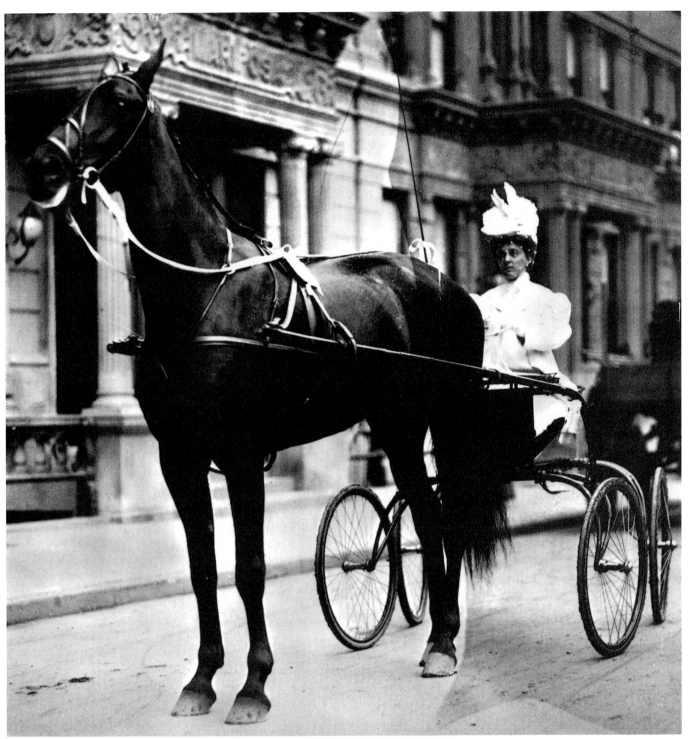

WOMAN WITH SURREY, c. 1900/BROWN BROS.

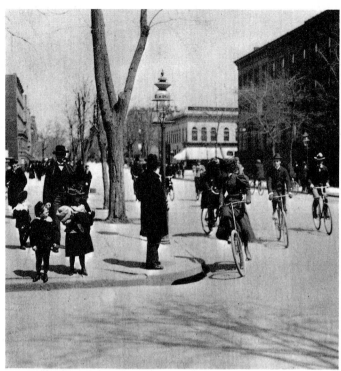

BYRON/BICYCLING ON FIFTH AVE. AND 124TH ST.,
1897/MUSEUM OF THE CITY OF N.Y.

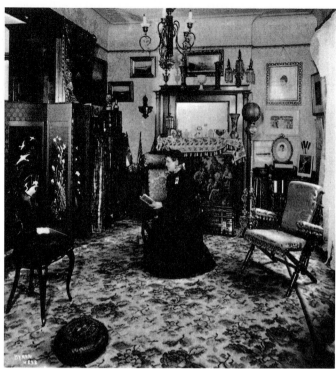

BYRON/MRS. HAUGHLEY'S SITTING ROOM, MANHATTAN AVE. AND 117TH ST.,
1898/MUSEUM OF THE CITY OF N.Y.

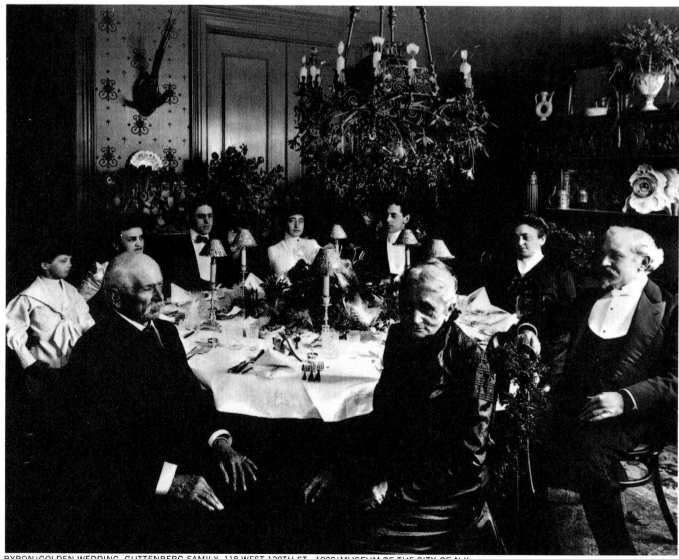

BYRON/GOLDEN WEDDING, GUTTENBERG FAMILY, 118 WEST 120TH ST., 1902/MUSEUM OF THE CITY OF N.Y.

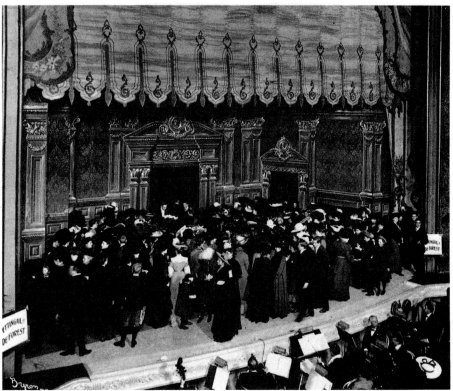

BYRON/ITALIAN ORGAN GRINDER,
c. 1897/MUSEUM OF THE CITY OF N.Y.

BYRON/RECEPTION, PROCTOR'S THEATER, 125TH ST., c. 1906/MUSEUM OF THE CITY OF N.Y.

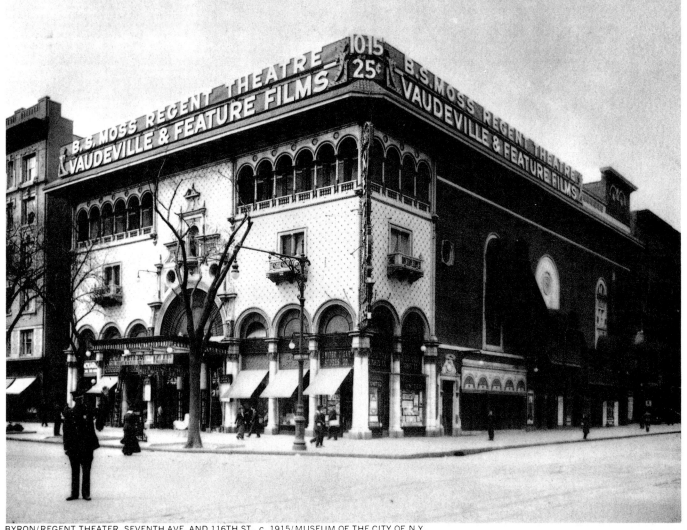

BYRON/REGENT THEATER, SEVENTH AVE. AND 116TH ST., c. 1915/MUSEUM OF THE CITY OF N.Y.

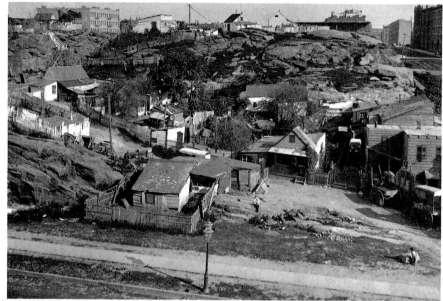

EDWARD WENZEL/FIFTH AVE. AND 116TH ST., 1893/THE NEW YORK HISTORICAL SOCIETY

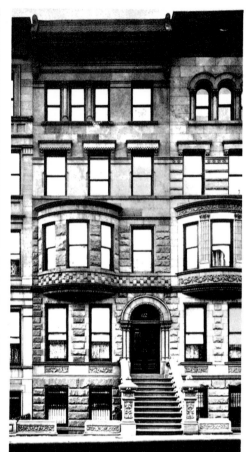

NO. 122 WEST 121ST ST.,
1912/NEW YORK PUBLIC LIBRARY

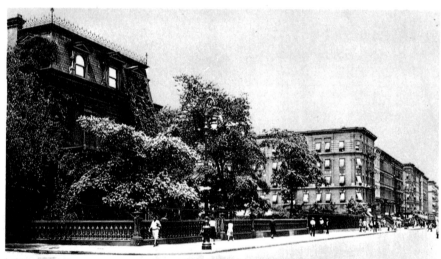

FIFTH AVE. AT 130TH ST., c. 1917/NEW YORK PUBLIC LIBRARY

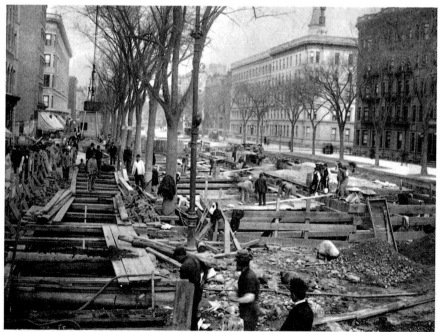

SUBWAY CONSTRUCTION, LENOX AVE. AND 113TH ST., 1901/NEW YORK PUBLIC LIBRARY

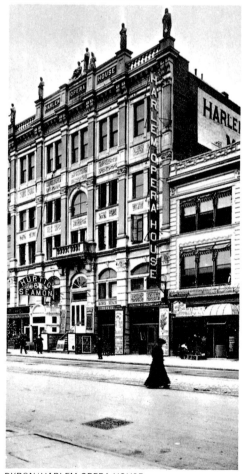

BYRON/HARLEM OPERA HOUSE,
c. 1906/MUSEUM OF THE CITY OF N.Y.

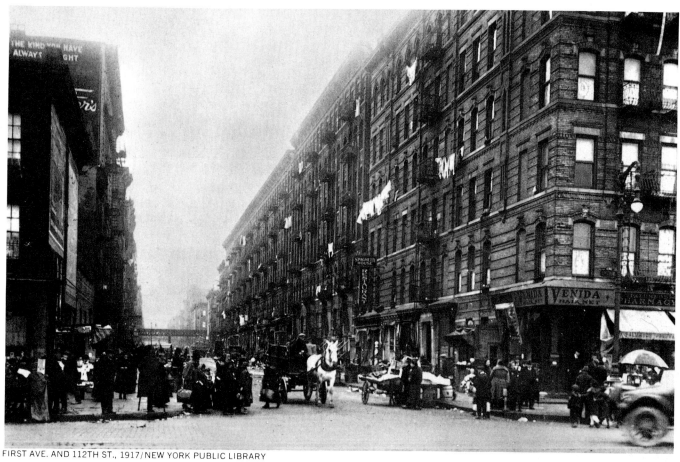

FIRST AVE. AND 112TH ST., 1917/NEW YORK PUBLIC LIBRARY

LADIES DAY ON HARLEM RIVER, c. 1902/UPI

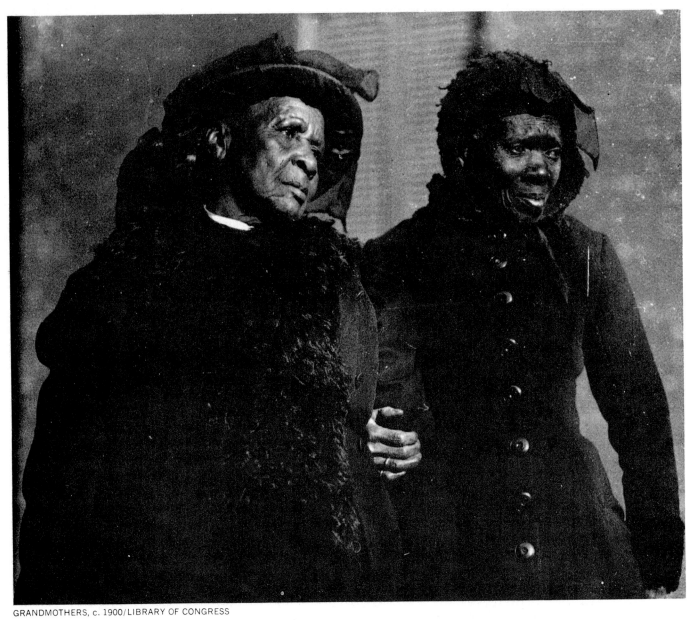

GRANDMOTHERS, c. 1900/LIBRARY OF CONGRESS

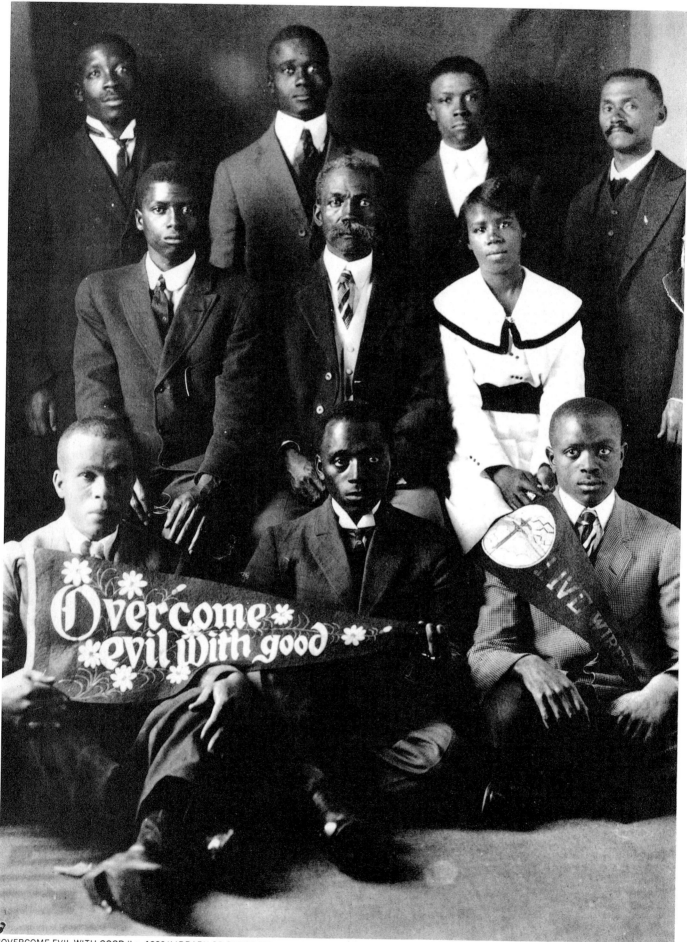

"OVERCOME EVIL WITH GOOD," c. 1909/LIBRARY OF CONGRESS

39

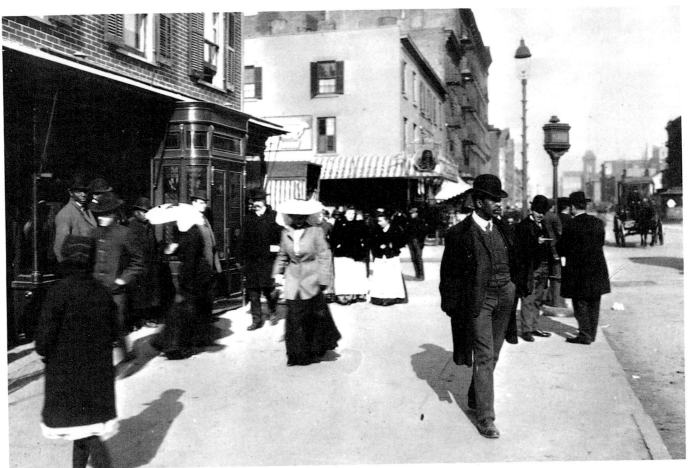

BYRON/SEVENTH AVE. AND 30TH ST., 1903/MUSEUM OF THE CITY OF N.Y.

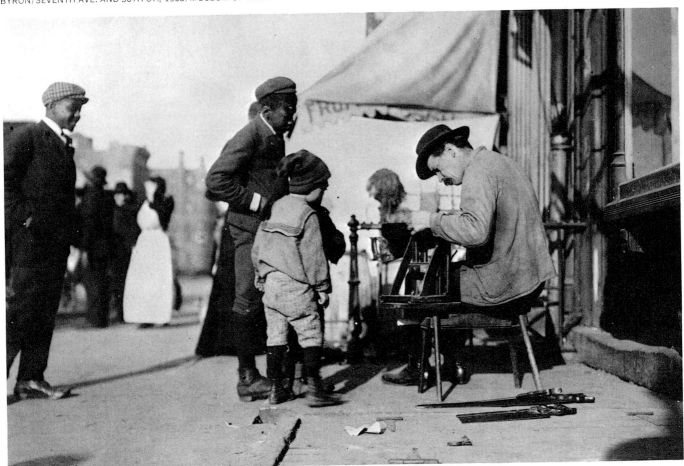

BYRON/SEVENTH AVE. AND 30TH ST., 1904/MUSEUM OF THE CITY OF N.Y.

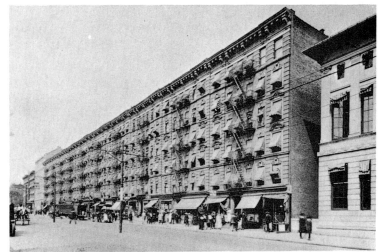

"NAIL AND PARKER'S BIG DEAL," WEST 135TH ST.,
c. 1915/SCHOMBURG COLLECTION, NYPL

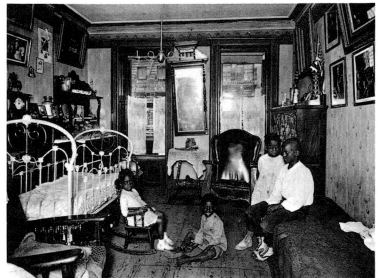

INTERIOR, c. 1915/BROWN BROS.

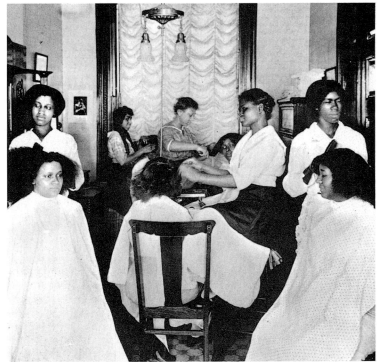

BYRON/MRS. ROBINSON'S BEAUTY PARLOR,
c. 1919/MUSEUM OF THE CITY OF N.Y.

41

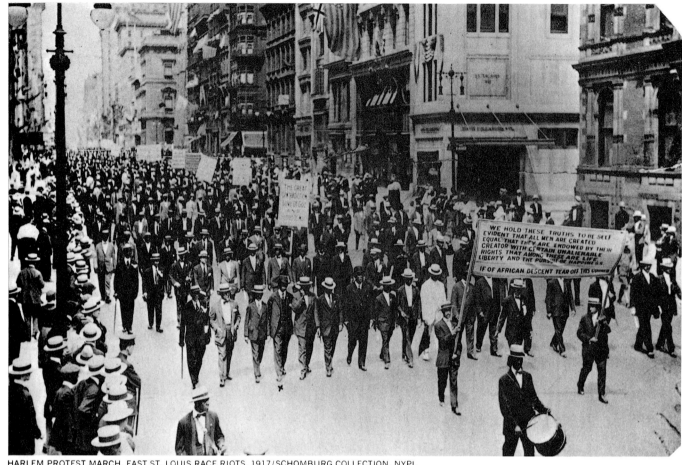

HARLEM PROTEST MARCH, EAST ST. LOUIS RACE RIOTS, 1917/SCHOMBURG COLLECTION, NYPL

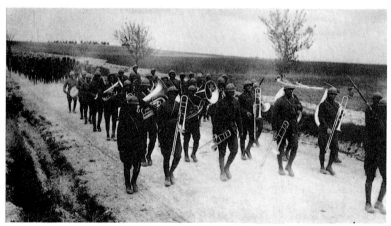

"HELL-FIGHTERS" IN FRANCE, 1918/NATIONAL ARCHIVES

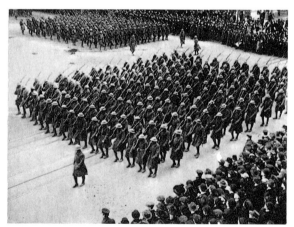

"HELL-FIGHTERS" ON FIFTH AVE., 1919/NATIONAL ARCHIVES

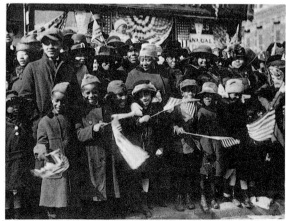

"HELL-FIGHTERS" REACH HARLEM,
1919/UNDERWOOD AND UNDERWOOD

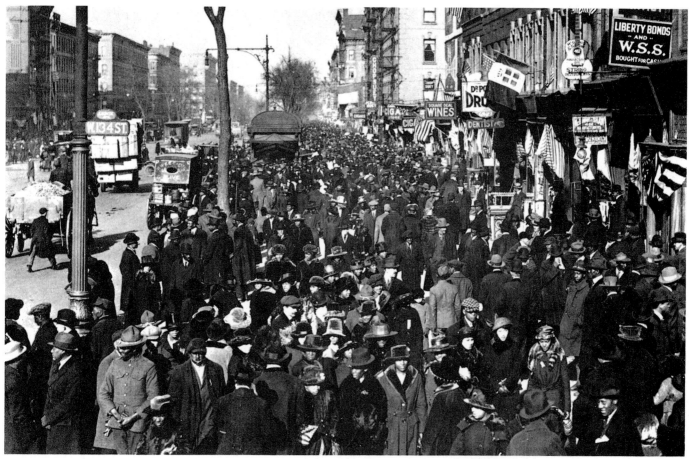

ARMISTICE DAY, LENOX AVE. AND 134TH ST., 1919/NEW YORK PUBLIC LIBRARY

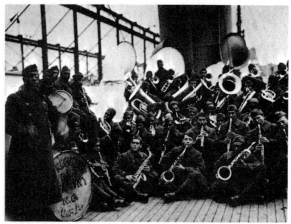

RETURNING—JIM EUROPE'S "HELL-FIGHTERS" BAND,
1919/NATIONAL ARCHIVES

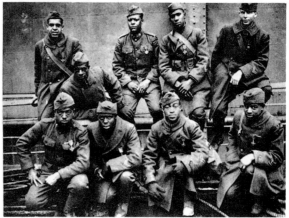

RETURN OF REGIMENT, 1919/NATIONAL ARCHIVES

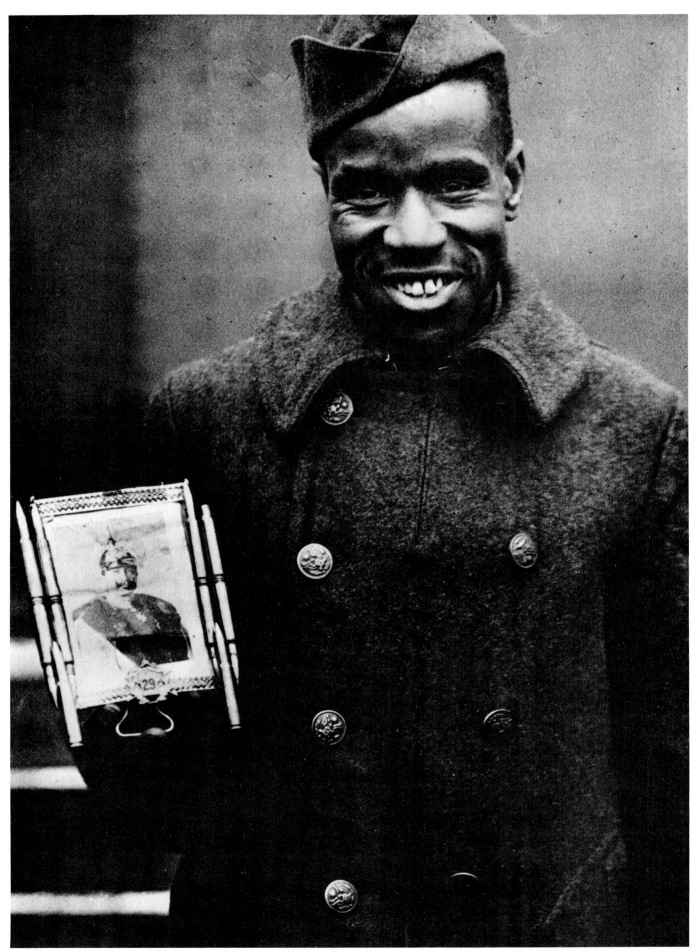

CORPORAL FRED McINTYRE, 1919/NATIONAL ARCHIVES

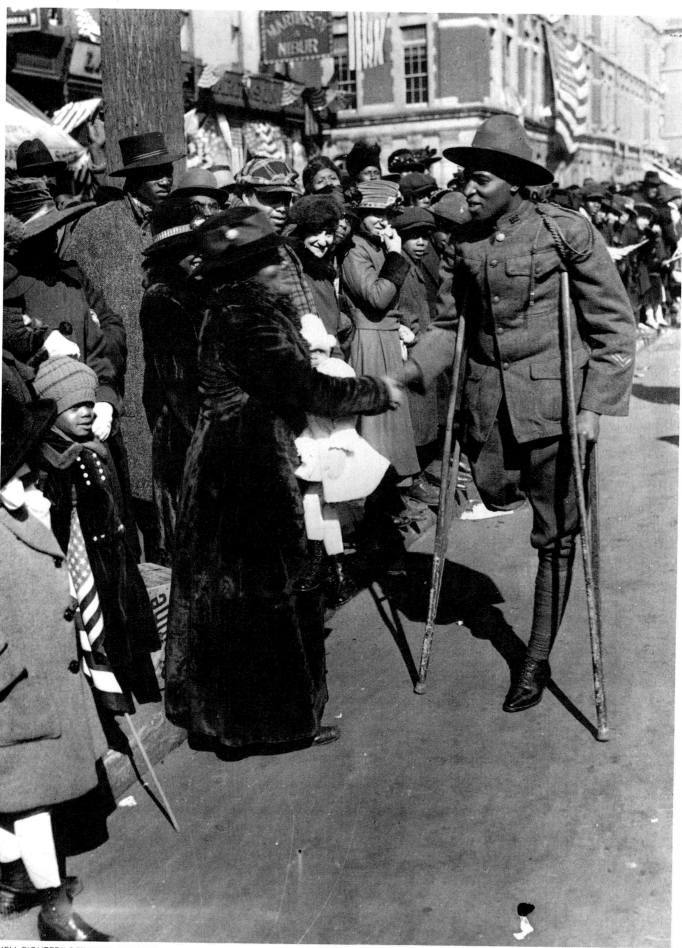

"HELL-FIGHTER" RETURNS, 1919/UPI

45

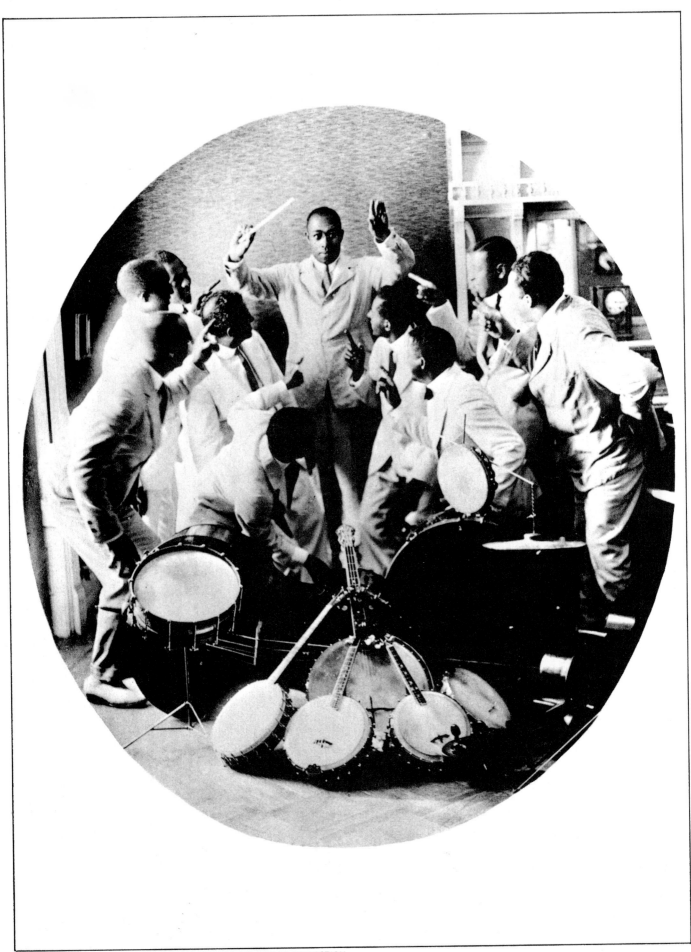

JAMES REECE EUROPE'S CLEF CLUB BAND, 1914/FRANK DRIGGS COLLECTION

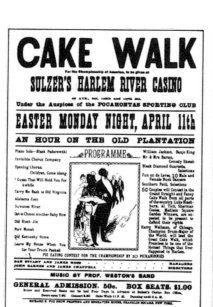

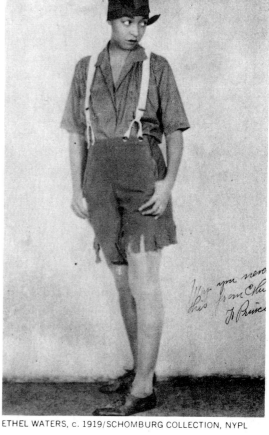

ETHEL WATERS, c. 1919/SCHOMBURG COLLECTION, NYPL

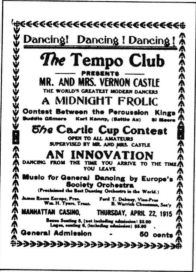

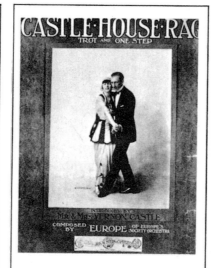

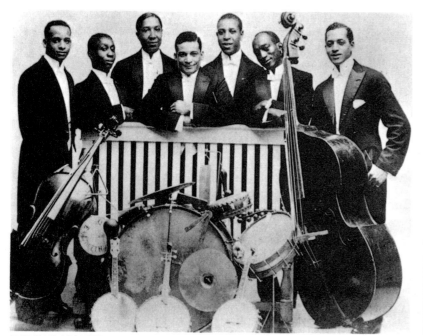

CLEF CLUB ORCHESTRA, 1915/FRANK DRIGGS COLLECTION

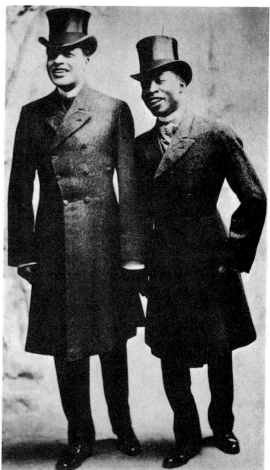

BERT WILLIAMS AND GEORGE WALKER, "TWO REAL COONS,"
c. 1905/SCHOMBURG COLLECTION, NYPL

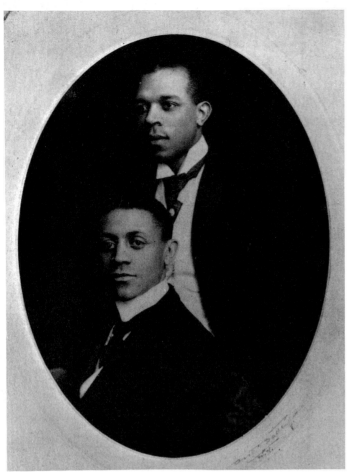

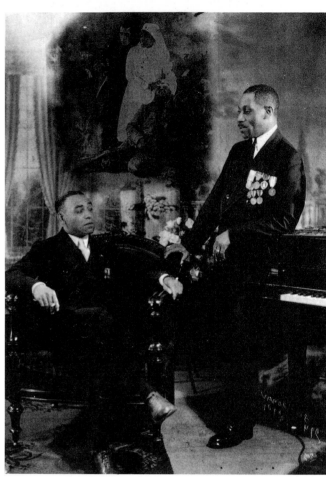

COMPOSERS BOB COLE (STANDING), J. ROSAMOND JOHNSON (SEATED),
c. 1905/SCHOMBURG COLLECTION, NYPL

JAMES VANDERZEE/"LOOKING BACKWARD" TO WORLD WAR I,
1932/G.G.G. STUDIO

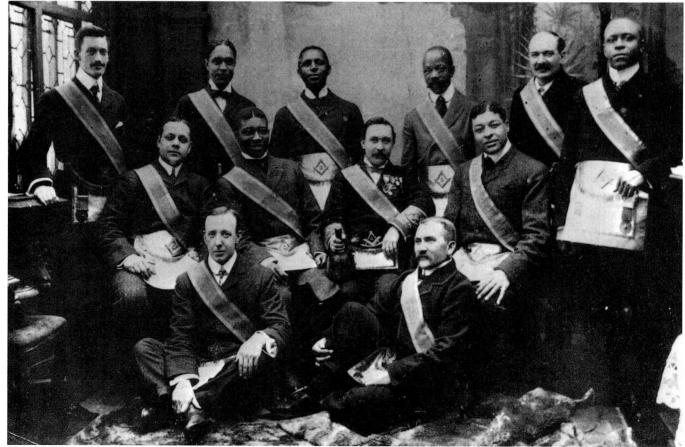

FRATERNAL GROUP, BERT WILLIAMS (SEATED), EXTREME RIGHT, c. 1910/SCHOMBURG COLLECTION, NYPL

AN URBAN BLACK CULTURE 1920-1929

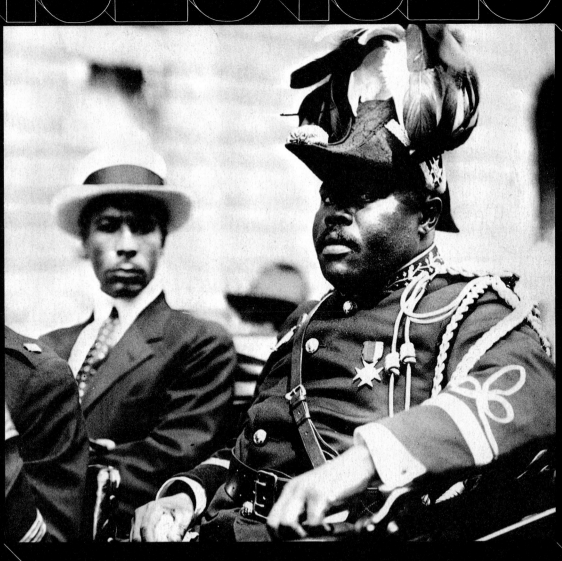

THE NEW YORK TIMES, JANUARY 27, 1920

LANDLORD BRINGS IN NEGROES TO GET HIGH RENTS

Witnesses told the Lockwood Committee yesterday a story of how Charles Klein of 164 St. Nicholas Avenue, "a professional lessee," had altered a quiet residential section of Harlem by turning nine apartment houses into one-room lodgings for Negroes who paid $100 and $125 for apartments that formerly rented for $40. Klein's action was taken, it was testified after he had tried to force Harlem property owners to buy him out on the threat that he would introduce Negroes into the houses, which he had on lease from Edward W. Browning, an extensive owner of realty. Klein was defeated in actions to increase the rents 100 per cent after Browning had increased them 50 per cent. Instead of accepting his defeat, Klein advertised in the newspapers of Newark and Baltimore for Negro tenants and sent the clippings to the white tenants.

When Adolph Kopple, vice president of the Central Savings Bank, pleaded with Browning to prevent Klein from "inflicting a great wrong" on the people of the neighborhood, Browning, who was said to be receiving a profit of 65 per cent from the property, replied that Klein could not maintain the lease unless he rented to Negroes. To a tenant who also pleaded with him, Browning said: "Ever since Abraham Lincoln liberated the colored man he has been on the same footing as the white. If white people won't pay Klein his rent he will get it out of the colored people." Both Browning and Klein were subpoenaed to give their version of the affair, but they were excused from testifying when they refused to waive immunity.

Goodstein, a Harlem property owner, said that his association learned that in November, 1919, Browning bought the property from the Central Savings Bank, investing about $60,000 in cash and taking a mortgage of $275,000. Browning immediately increased the rent from $40 to $60 and $65 on the promise to make some repairs. There were only white people in the houses, some of whom had lived there fifteen years. Then the property was leased to Klein, who demanded $100 and $125 of the tenants for their apartments. The tenants refused to pay and Klein was defeated in the actions he brought in court.

Klein then approached Goodstein and said he "would get square." He continued: "Now, if you want to save your property and if the other neighbors want to save their property, you'd better buy my lease and if you don't I am going to ruin the neighborhood." Klein told Goodstein, the witness swore, "I am going to get colored people into this property and I am going to fill it up with the cheapest kind of people I can find, and I will ruin this section. That is just as sure as you are born."

Goodstein told him that his threat was practically blackmail; Klein insisted he was in earnest, and then began to carry out his threat. First he had one tenant ejected under the law which permits an owner to obtain an apartment for himself. Klein moved into the apartment, remained for a month or two and then moved out and rented the apartment to Negro lodgers. Some of the white tenants moved out and their places were rented to Negroes. The houses were converted into single-room apartments with one or two beds in each room, and then Klein placed the following advertisement in Newark and Baltimore newspapers:

"Colored people: Chance of a lifetime to acquire elegant, newly furnished rooms, single or en suite, in the beautiful Garden Courts, occupying nearly one whole square block on St. Nicholas Avenue, 118th Street and 119th Street; over 650 rooms to be turned over to the use of colored people; electric light, steam heat, hot and cold water; handsomely decorated, marble stairs, tiled bathrooms, etc.; near subway and Eighth Avenue elevated station. Call at once in office of Charles Klein, 164 St. Nicholas Avenue, corner 118th Street."

❖ ❖ ❖

NEW YORK HERALD, APRIL 4, 1921

CHARGES OF GRAFT, NEGLECT HIT HARLEM HOSPITAL

It was learned yesterday that Commissioner of Accounts David

Hirshfield and Assistant District Attorney Ferdinand Q. Morton are conducting an inquiry into charges of graft, ill-treatment and neglect which have been made in affidavit form against internes, nurses and orderlies attached to Harlem Hospital, Lenox Avenue and 136th Street. The inquiry, which Commissioner Hirshfield began a few days ago by holding a secret hearing in the hospital and questioning members of the staff, has been ordered by the Mayor as a result of protests from residents of the Negro settlement in Harlem, who charge they have been victimized or mistreated in the hospital and are urging appointment of physicians of their own race to the medical and surgical boards of the institution. It was learned yesterday that some of the affidavits submitted to Commissioner Hirshfield and to the District Attorney by a committee including Alderman George W. Harris of 135 West 135th Street and Dr. Allen B. Graves of 202 West 137th Street, president of the Manhattan Medical, Dental and Pharmaceutical Association, are of a startling nature.

One made by Miss Helen Heidt of 135 West 140th Street charges that Miss Heidt called at the hospital on December 5, 1920, and asked that an ambulance be sent to her address for a Mrs. Edith Robinson. An interne is alleged to have replied that the ambulance could not be sent out because it was Sunday. The affidavit charges that on payment of $10 to the interne he caused an ambu-

lance to be sent for Mrs. Robinson, who later appealed to Miss Heidt for money to give to nurses, and obtained $15 for this purpose, saying she could not get proper attention otherwise. Mrs. Robinson died December 9, in the hospital. In another affidavit Bernard Duval of 135 West 140th Street charges that while undergoing treatment for rupture he was forced to pay $65. It is alleged that $10 went to an interne who arranged for his operation, $15 to orderlies and $40 to nurses.

When a reporter for the New York *Herald* made inquiries in the hospital yesterday he was referred to the superintendent of nurses, who said she was not at liberty to discuss the case. Dr. George O Hanlon, general medical superintendent of Bellevue and Allied hospitals, told the reporter that complaints had been lodged with the board of trustees about six weeks ago, but that in most instances they had failed to name persons accused. In one case where a member of the hospital staff was specifically referred to as having taken graft, he said, the hospital officials had endeavored without success to get the complainant to visit the hospital and make an identification. Alderman Harris told the reporter that the hearing held by Commissioner Hirshfield dealt principally with the case of Allen Russell of 508 Lenox Avenue, who charged that when he took his wife to the hospital in critical condition on February 19, she was at first refused admittance by someone who stated that the maternity ward was quarantined. In the midst of a row in which a police-

man was called in and threatened Russell and his wife, it is asserted that a doctor made his appearance, and on learning of the woman's condition directed that she be admitted to the maternity ward, which was not quarantined.

Other affidavits charging mistreatment are signed by Sarah Benson of 28 West 136th Street, Hazel Pinder of 112 West 137th Street and Hayward J. Payne of 5 West 132nd Street. Mr. Payne accuses persons connected with the hospital of having neglected his eleven-year-old niece, who is suffering from the effects of a hypodermic needle which broke off and remained in her flesh. Hazel Pinder charges that one interne directed that her eighteen-month-old godchild be X-rayed because of an injury to her shoulder, but that when she presented the slip for the X-ray she was told the apparatus was broken, and that "besides, no one could take X-rays on a Monday." She says the interne afterward tore up the slip.

Alderman Harris said the appointment of Negro doctors to the staff of the hospital would give the Negroes confidence in the institution, which they have not got at the present time. "It is not a color question," he said. "It is a municipal problem. The colored people now go to the hospital as a last resort, because they anticipate discrimination. By postponing going to the hospital they often imperil other persons of the community to whom they may communicate their disease."

SUNDAY NEWS, MAY 8, 1921

IRVING BERLIN BORROWED CHANTS FROM SOUTH

I know where the musical comedies come from. I was there last week. Happy Rhone, with an orchestra of a hundred sonorous instruments operated by the elite of Harlem's colored musicians, played for 4,500 of his brethren as they writhed about the floor of the Manhattan Casino in the throes of the latest dance step, known as "Steppin' on the Cootie." A week later I heard faint echoes of the impulsive rhythms of Happy Rhone's players in the sounds that rose from the orchestra pit in front of *Two Little Girls in Blue*, the new thing in the George M. Cohan Theatre. And, a night later, I had a mild memory of the muscular commotion involved in "Steppin' on the Cootie" when I saw the dancing of a band of eight trained girls in the new *Princess Virtue* in the Central Theater.

It took a trained musical professor to discover that Irving Berlin borrowed lilts from the chants of the country Negroes of the South. Any ordinary man about town may discover that the pure source of a good deal of what will make this year's musical comedies slightly different from those of last year is the town Negro, the rhapsodic flat-dweller of the upper reaches of Harlem. The man who guided me about the floor

and galleries of the Manhattan Casino on the night of the Grand Annual Ball with Favors discoursed on this year's fashions in music. He told me that Mr. Rhone had specialized in oboes. The congested nasal note of the oboe is prominent among the tones that come out of the orchestration of the score of *Two Little Girls in Blue*. "The oboe," lectured Mr. Rhone's spokesman, "makes 'em crazy. The minute Mr. Rhone put an oboe in his orchestra and played for a dance the other night, 'Steppin' on the Cootie' just occurred spontaneously." And I looked out over the packed and swaying mass of the Casino floor and saw 2,250 couples crazed with dancing, and agreed with my informer.

The originals in the Manhattan Casino of the novelties of last week's music shows were grosser but infinitely more vital than their downtown imitations. The oboe in the orchestra which plays Rudolf Friml's tunes to *Two Little Girls in Blue* is merely a tonal perfume of the melodies. Even so, it adds a restive element to the orchestra. It animates some moments which otherwise would drag. *Two Little Girls in Blue* is a modest production. They tempered the immodest reed to fit the play. Mr. Rhone, having to do more directly with the fundamental passion of rhythm, uses it more immodestly. The result was "Steppin' on the Cootie." This new convulsion probably will spread among the musical comedies and ballrooms. Its plot is in two movements. First you shimmy lightly. Then you step on the cootie. Repeat. You may see the innovation in modified form in a step used by the eight girls in

green who are called "Eight Little Nobodies" in the program of *Princess Virtue*. It will be a sorry day for the purveyors of musical comedy when the town Negroes lose their musical impulse. The Harlem dance halls are frequented now by wise stage directors in search of new sensations for something in rehearsal.

—JAMES WHITTAKER

❖ ❖ ❖

THE NEW YORK AGE, MAY 28, 1921

BELLEVUE TO OPEN DOORS TO COLORED NURSES

As soon as the preliminary arrangements can be perfected, at least six colored graduate nurses will be admitted to Bellevue Hospital for postgraduate work, according to a letter received by Alderman Charles H. Roberts from Dr. George O'Hanlon, general medical superintendent of that institution. Dr. O'Hanlon's letter was in reply to a communication from Alderman Roberts in which the matter of colored nurses for Bellevue was taken up. Dr. Roberts has been active in his endeavors to secure opportunities for advanced work for the colored trained nurse, and this letter from Dr. O'Hanlon refers to a conference held two years ago between himself and Dr. Roberts, at which time a policy was outlined.

❖ ❖ ❖

53

THE NEGRO WORLD, OCTOBER 8, 1921

MARCUS GARVEY: THE RACE WANTS STRONG-MINDED STATESMEN AND STAUNCH LEADERS

The hour for constructive thinking and action has arrived. We have labored in the wilderness of agitation, petitions and profitless noise for many decades and have achieved nothing. The various organizations we have formed within the last fifty years have done nothing more than hold mass meetings, asked for and received interviews and sent up petitions, all without any real beneficial results. The Universal Negro Improvement Association, being tired of the methods of the past, is determined to initiate a new program, that of constructive accomplishment.

Some people ask, "Why hasn't the Universal Negro Improvement Association protested against so-and-so, and why hasn't it sent a telegram to the President denouncing lynching; why hasn't it asked for interviews from Congressmen and Senators over the question of injustice to the Negro?" Why should you want to do this when other organizations have been doing this for the last twenty years without any result?

The time has come for us as a people to stop skylarking with ourselves and allowing others to make mimics of us. Little groups of individuals fighting against themselves can represent only themselves, they can accomplish very little in the interest of a great race scattered over the country, and for that matter, scattered over the universe. If conditions are such as to affect the race generally, then the race must organize generally to bring about a change in the conditions. It is no use ten, one hundred or one thousand out of a group of fifteen or two hundred or four hundred millions getting together and saying, "We alone can do this thing, therefore we will ask interviews of Congressmen and Senators, telegraph the President, and by so doing, bring about a cessation of the injuries done to the race as a whole."

The Universal Negro Improvement Association has a wiser plan. Our purpose is to have the race solidly organized, to have Negroes in the North, the South, the East and the West, not only of America, but of the entire universe, linked up with one determination, that of liberating themselves and freeing the great country of Africa that is ours by right. When we make a demand we do not expect it to be refused, because our determination will be backed up by the financial, educational, industrial and physical strength of the entire race. This is our answer to those who are ask-

ing us why we do not send up petitions and hold mass meetings and send telegrams to the President. We have no time to waste.

Some Negroes who claim to be leaders do more harm to the race by their continuous meddling and mixing up of things than otherwise. Let us take the Ku Klux Klan exposé for an argument. For years the Negro has been outraged by the Ku Klux Klan. Nobody said anything about it; nobody raised a voice of protest sufficiently strong as to have caused the nation to make a stir in putting down this national menace. And why? Simply because only the Negro was affected by it. The Klan was ostensibly organized to put down "imaginary Negro domination." If it were for such a purpose only, nobody would have said anything about the Ku Klux Klan as far as the national voice goes. But when it comes down to attacking Jews, Catholics and white aliens, then it was time for our big daily papers and our statesmen to expose this great menace and to call upon the President and Congress to put it down immediately. Whilst the attempt is being made with all earnestness to destroy the menace of Ku Klux Klan, for Negroes and everybody to be benefited, here pop up insignificant non-impressive Negroes making big demonstrations against the Ku Klux Klan, going to see the President, making demands on Congress to investigate the Ku Klux Klan, thereby giving an argument to Colonel Simmons and his associates to say, "Are you going to encourage the inso-

lence of the Negro? Are you going to encourage Negro domination by destroying the only organization in the United States of America that seeks to keep the Negro in his place? Why, do you not see what these people are up to? See how outraged they are because our intention toward them is exposed, are you going to encourage them to believe that they should become the dominators of this country and the equal of the white man?

The very argument that Simmons will put up is the argument that will appeal to 90 per cent of the white people of this country: to let the Ku Klux Klan continue its operation so long as it cuts out its anti-Jew, Irish, Catholic and white-aliens program.

Who would have been the cause of the continuous existence of the Klan but those Negroes who bob in without any influence and give everybody to understand that the Negro is against the Ku Klux Klan. Nobody cares whether the Ku Klux Klan kills Negroes or not, and if it were not for Negroes, the Ku Klux Klan would become as powerful as the Government itself.

Our leaders do not know when to interfere and when not to interfere; they muddle up everything and some do it simply because they want notoriety; they want everybody to read in the press that Mr. So-and-so called on the President, and Mr. So-and-so was in Congress and interviewed certain Congressmen. For the sake of this notoriety the whole race must suffer.

This is the kind of leadership we have had for the last fifty years. We want strong-minded statesmen, men who will not jeopardize the interest of the race by their own selfish whims and caprices, but who will study the situation so closely as to move only when it is to the better interest of the entire race. Negroes, keep quiet and let those who have the power, who are equally prejudiced against you, crush the Klan for their own purpose. We benefit thereby.

You will not expect the Universal Negro Improvement Association to mix up in everything simply because it may be popular to hold mass meetings and send petitions. The Universal Negro Improvement Association is biding its time, when it can render useful service to the entire race. We want, therefore, a strong organization, we want the fifteen million Negroes of the United States, each and every one, to become members of the Universal Negro Improvement Association. We want the four hundred million Negroes of the world to be active members of this great organization, and by the unity of our strength, financially, educationally, industrially and physically, we will compel the recognition of the world. Therefore, let us concentrate on organization; organization is the power that moves the world; without organization we will become like a drifting vessel tossing about on the turbulent waves in the raging storm.

As a people we must unite everywhere; we must forget the narrowness of nationality and insularity. We must remember that

we are oppressed because of our economic and political undevelopment in race. We will never be respected and given our rights until we rise above the universal stagnation in race.

We have to start out now building ourselves into communities of progressive men and women and ultimately launch out to the bigger ideas of empire.

Parochialism, insularism and narrow nationalism as lived under alien leadership will never save this Negro race of ours, will never solve the great Negro problem. Only when we strike out toward empire on our own account, and by our own achievement build up a permanent culture and civilization of our own, will the world say to itself that the Negro is a man and will accept him as such. Let us, therefore, waste no time over petitions and mass meetings in our little separate and distinct groups, let us come together now, let us join hands together and with one big pull drag ourselves into the consciousness of self through a united purpose.

Why can't the Negro give to the world, especially at this time, statesmen of the type of Napoleon, the Duke of Wellington, Garibaldi, Mirabeau, Pitt, Gladstone, Bismarck and Washington. Every race and every nation at some time or the other presents a statesman who ultimately be-

comes the savior of the race or the nation. How long must we wait for such leaders? Have we not profited by the lessons of civilization? Have we not taken in the beautiful illustrations and examples of history? Then why wait for another decade? Why wait for another century to do what should be done now? Rise, men of the Negro race and let us have our Washington, let us have our Napoleon, let us have our Bismarck, let us have our Garibaldi, let us have our Count Leo Tolstoi, and we can have these men now if we will but sink our individualism, if we will throw away our narrow nationalism and insularism, if we will say, "Now is the time for us to get together and be one."

The ends we serve that are selfish will take us no further than ourselves, but the ends we serve that are for all in common will take us even into eternity. The truly great never die, they live forever; yes, even today we sing the songs of the immortals; men who have passed from the stage of human action, twenty, ten, five centuries ago, their memories are to us today as fresh as if they died but yesterday. Why? Because of the great deeds done by them not for themselves alone, but for all humanity, for all of their race and their nation. When will this race of ours rise to the heights of human service and not selfishness? When will our leaders sink individualism and make the common good the ambition of each and every one? The Universal Negro

Improvement Association is endeavoring to help us on to destiny; a new history is to be written and in that history we hope to record the deeds and exploits of our statesmen, our sages and our savants, our philosophers through whose lead and through whose light we shall march on to the goal of freedom and everlasting peace.

May I not ask you, therefore, fellow-men, to become members of the Universal Negro Improvement Association; can I not ask you to join the greatest Negro movement in the world? Why should you keep out when we need your individual as well as your collective help to bring about a change in the conditions that affect the race? You can help the Universal Negro Improvement Association by supporting its program. We desire to link up the four hundred million Negroes of the world into one solid body, moving towards the glorious objective of a free and redeemed Africa. Will you help us? Do so now by subscribing to the "African Redemption Fund," sending to the organization at 56 West 135th Street, New York City, whatsoever you can afford to contribute to the great cause of the African liberty.

It can be $5, $10, $20, $100, $500 or $1,000 to whatsoever extent you value liberty and whatsoever your means will allow you; you should subscribe to this great cause of African freedom, and we are asking you again to support the great industrial enterprise of the Black Star Line Corporation, the desire of which is to float ships on the seven seas, to carry

the commerce of the Negro from country to country and make him one of the great industrial captains of the age. You can support the Black Star Line by buying shares at $500 each. You can buy five, ten, twenty, fifty, one hundred, two hundred. You can further help the Universal Negro Improvement Association by subscribing to its Construction Loan, through which it seeks to build factories, mills and industrial institutions among Negroes everywhere so that millions of our race can find employment under their own leadership.

Now is the time for each and every member of the race to play his and her part in the readjustment of the affairs of the race. Again I ask that you put not off for tomorrow that which you can do today to help this great cause of world organization among Negroes. Do so immediately by writing to the Universal Negro Improvement Association and the Black Star Line, 56 West 135th Street, New York City.

❖ ❖ ❖

AMSTERDAM NEWS, JANUARY 31, 1923

RACE SUPERIORITY BUNK, SAYS BOAS

Professor Franz Boas of Columbia University, America's fore-

most distinguished anthropologist, spoke to a large and appreciative audience last Thursday night at the 135th Street Branch of the Public Library. Professor Boas, who is the author of *The Mind of Primitive Man*, has done more than any other in the United States to destroy the theory of race superiority. In his address, he said that there is no evidence whatever to prove that the white man is inherently superior to any other, or that the Negro would not have accomplished all the white race has if he had been placed in the same environment or had the same opportunities.

"When you investigate the white race," he said, "you'll find persons of low will power and low moral standing precisely as in the other races. There is absolutely nothing to show that there is potential racial inferiority."

"Race," he went on to say, "is a very elusive term to define, since there are no hard and fast lines between them. Similar characteristics are to be found in races that are supposed to be widely apart, and there are certain characteristics that are common to all humanity. A race may be different at certain periods of its history. For instance, there is a big difference between the Englishman of a thousand or even 150 years ago from the Englishman of the present day," he said.

NEW YORK EVENING POST, APRIL 7, 1923

CALL OF INDUSTRY LURES NEGROES NORTH

Jackson, Miss. — An increasing demand for common labor, brought about by the revival of industry, is effecting momentous changes in the most important race problem in the United States, changes so gradual that they are passing almost unnoticed in spite of their grave consequences. European sources of labor are almost closed, and facing a crippling shortage. It is natural that the industrial world should turn to the South and its Negro population for relief. The Negro race is the largest body of common labor left in the country. It remained almost entirely unmolested until the World War shut off immigration and speeded up industry to a point where there was urgent demand for manual workers. That situation brought about a great exodus of Negroes from the agricultural regions of the South to industrial centers of the East and Middle West. The high price of agricultural products during the period acted as a check, but the Negroes came North by the thousands and no matter what the more optimistic Southerners said or thought about it, the vast majority of them remained.

The movement suffered a definite check during the period of depression that followed the war. A secondary exodus is under way now and there are few sections of the agricultural South today where the labor situation has not reached an acute stage. In some, farming operations have suffered severely. In the more prosperous sections, enough Negroes remain to make crops on the better-managed plantations, although the margin even there is scant. The pull of industry is not the only influence at work. The boll weevil has complicated successful farming in the South to a point where the average tenant farmer, never earning more than enough for a bare living, has found himself running further and further into debt each season, with very little chance of ever paying up. Negroes in cotton-growing regions of the South have had it very hard the past few seasons; whole families have gone through a year on $60 worth of "furnishing," store-bought necessaries of life, and when the crop was gathered have found themselves unable to pay even that small amount. That there has not been acute suffering among these "sharecroppers" is more to the credit of the genial climate in which they live than to any economic reason. By raising practically everything they eat and wearing a minimum of clothing, they have managed to live— exist is a better word. Is it any wonder, then, that when the opportunity presented itself they have hurried away by the trainload to factory towns, or to large cities where steady work with a good income was assured?

THE NEW YORK WORLD, FEBRUARY 3, 1924

JAMES WELDON JOHNSON ON ANGLO-SAXON SUPERIORITY

Is the Negro dangerous to white culture and to the white race? Is it true that "Anglo-Saxon culture" is threatened by aliens? Is it true that "Anglo-Saxons" are the only group fit for leadership, cultural and political, in America?

Yes, seems to be the answer to these questions by the "Anglo-Saxon Clubs" of which Mr. John Powell of Virginia wrote in the *World* of Dec. 2. To the specific questions raised by Mr. Powell and the "Anglo-Saxon Clubs," I am glad, in response to the request of the Editor of the *World*, to make reply, as Secretary of the National Association for the Advancement of Colored People, as a Negro and, primarily, as an American.

The attitude exemplified by Mr. Powell is a common one. At its extreme it results in the Ku Klux Klan and its alleged protection of Anglo-Saxondom. At its mildest it issues in such a program as the one Mr. Powell outlines, maintaining virtually the same creed as the Klan, minus the violence. This attitude is grounded on assumptions about what makes an American, what is dangerous to an American, what American culture is and who created it.

. . . The original American stock, the American Indian, is almost extinct. The white original stock includes settlers from almost every part of Europe, including Hessians, Scotch, Irish, English, Dutch, French and Spanish. Furthermore, the Negro must be included among the original stock, because he first came to the American Continent in 1525 with the Spaniards. His first coming to the English colony was in 1619, one year before the Mayflower landed at Plymouth. The Negro continued coming, or being brought forcibly and against his will, until the early part of the nineteenth century. None have come in any quantity since then. The Negro is certainly part of the original American stock, whether Mr. Powell likes it or not.

Many of the best things in America have been created here or brought by people whom Mr. Powell and the Anglo-Saxon Club group would doubtless look upon as aliens. The mythical Anglo-Saxon—and by that term I assume Mr. Powell means people of English descent, though he himself confesses he does not know what it means—the mythical Anglo-Saxon, and his culture as well, never existed. If Mr. Powell means merely people of English descent, they are among the late comers to America, later than French, Spanish and Negro. This leads me to question Mr. Powell's idea of culture. What is culture anyhow? Is it something that belongs to someone, like an automobile? Is it the color of your hair, the pride of family tradition? Is being elected to office a sign of culture?

. . . If Mr. Powell wants to go back far enough, to Puritan days in New England, for example, one of the traditional American virtues was a willingness to take part in the burning of the witches, men and women; and other virtues and principles included such intolerance as made the settlers fine, flog and imprison people for being members of the Society of Friends, better known as Quakers; and drive out Roger Williams from Massachusetts. Those virtues were perhaps understandable in those days, in which a rigid social organization was necessary to meet frontier conditions. No one but a maniac would maintain that they would be suited to the years in which we live. So when Mr. Powell talks about the original American stock and weeps a tear over its submergence; when he orates about the original American principles and virtues, he had better be a little more specific as to what he means.

The Negro's case is not so dissimilar from that of other aliens, insofar as culture is concerned. Mr. Powell deplores the "polyglot boarding house" aspect of America with its foreign-language newspapers, its racial and national traditions maintained by immigrants. I say it is better to encourage these people to bring here their cultural heritages, to give us in America the benefit of their songs and dances and literature and customs, than to try to force them to conform to some Anglo-

Saxon idea of what is American.

The "Anglo-Saxon" acts as if he had something to fear. He behaves like a coward. The American does not have to. He can receive the contribution of any spirit, any nation and any race. If he cannot, then he had better say so. He had better stop twaddling about democracy, liberty and what-not. Let him then come out boldly and say: This is a country for people who call themselves Anglo-Saxons without knowing what they mean; people who intend to make America their own cozy little club where everyone else can exist on sufferance only.

❖ ❖ ❖

THE NEW YORK TIMES, MAY 25, 1924

BARRON D. WILKINS SLAIN

Barron D. Wilkins, Negro proprietor of a well-known Harlem cabaret and a tower in the Harlem "Black Belt," was shot to death last evening because he refused to give "getaway money" to a man who had just killed another Negro. The shooting was in front of Wilkins's cabaret, the Exclusive Club, 198 West 134th Street at Seventh Avenue. For hours after Wilkins was killed his place was surrounded by more than 500 Negro men and women, weeping and wailing over the loss of the man many of them termed "the finest man that ever lived." When a rumor was spread that "Yellow Charleston," the man accused of the slaying, was still in Harlem,

scores of Negroes began patrolling the streets in search of him.

The man shot to death just before Wilkins was killed was John Parker, 32 years old, address unknown. Parker, "Yellow Charleston" and four other Negroes were playing in a dice game in a basement at 129 West 134th Street. "Yellow Charleston" went broke. He asked Parker, a heavy winner, to make him a loan. Parker insisted that those who went broke in the game remain out of it. According to the other players, "Yellow Charleston" drew a pistol and fired a shot into Parker's abdomen. "Yellow Charleston" fled to the street and toward the cabaret. He shared the general knowledge that Wilkins often helped with money those in desperate need of eluding the police. Outside his cabaret, Wilkins was chatting with a Negro named Benni C. Parker, known in the neighborhood as "Yum Yum." "Yellow Charleston" ran to them, gasping. "I just shot a guy and need $100 for a getaway." "I haven't got that much money," replied Wilkins.

According to witnesses, "Yellow Charleston" drew his pistol and fired four times at Wilkins. Three bullets entered his body. The fourth went wild. Wilkins, who was six feet tall, broad of shoulder and of great strength despite his 63 years, fell to the sidewalk unconscious. "Yellow Charleston" set about doing his job thoroughly. He pressed the pistol against Benni Parker's face and pulled the trigger. But there was no explosion, and "Yellow Charleston," waving the pistol at a passing taxicab chauffeur, leaped into the car and fled. Patrolman William Cannon of the

135th Street police station, who was on the next block, ran up and started in a taxicab after "Yellow Charleston." Just then, however, a number of Negroes ran up to him and announced that a man had been killed in the basement at 129 West 134th Street. Cannon abandoned the chase and hurried to that address. John Parker, unconscious, had been led to the sidewalk. He was bundled into a taxicab. In the same machine they placed Wilkins. The two were hurried to Harlem Hospital, a block away. They died shortly after reaching the hospital.

Police reserves of the West 135th station, two blocks away, were called out. Detectives Stephen Donohue and Emil Panevino of the Homicide Squad hurried to Harlem, as did Assistant District Attorney Morgan A. Jones. Half a dozen Negroes were taken to the police station. From them it was learned that "Yellow Charleston" was a Brooklyn Negro. Detectives immediately were sent to the Brooklyn "Black Belt."

When it became known that Wilkins was dead, the neighborhood for blocks around was rent with the wails of Negro friends of the cabaret owner. For hours groups stood in doorways and under umbrellas recounting Wilkins's good deeds. Wilkins was known as a backer of sporting enterprises as well as for the many resorts he conducted in this city

and in Atlantic City for decades. At one time he was financial backer of Jack Johnson, former heavyweight champion of the world. For many years Wilkins financed in whole or in part all of the Negro baseball teams of this city. In Harlem he was a power among the Negroes. His influence was particularly strong at elections. He was indifferent in politics, swinging between the Democratic and Republican parties as the mood suited or as his private interests dictated. The police said that his influence was built largely on his practice of extending a helping hand to those who required emergency financing. Wilkins was a pioneer among the cabaret men of the city, having conducted a series of such places for 40 years and finally achieving, in his Exclusive Club in Harlem, a Negro cabaret which attracted large numbers of white patrons and which became one of the best-known cabarets in the city.

His early enterprises after coming to New York from Norfolk and Washington, D.C., were downtown. For many years he conducted a resort in Thirty-seventh Street near Eighth Avenue which was the social headquarters of Jack Johnson. This place annoyed the police so much that it was raided scores of times. The frequent raids, however, failed to discourage Wilkins and he never closed up shop. His business acumen led Wilkins in this place to build a balcony from which pa-

trons might view Jack Johnson being served on the floor below. The police received so many complaints about brawls in the place that in July, 1910, a Supreme Court injunction was obtained by the police as a means of closing it, numerous raids having failed of that purpose. Wilkins obtained a stay. When the injunction period expired, Wilkins said he would not seek to renew his license, as he did not need it. He continued business despite many more raids.

Wilkins moved to Harlem in 1903. His brother, Leroy Wilkins, established a cabaret for Negroes at Fifth Avenue and 135th Street. But while the entertainers in Barron D. Wilkins's place were Negroes, his patrons, to a large extent, were white. He was known to Negroes as "the man with the big bankroll." He made large bets on horse races and in crap games. He always denied that he paid graft to the police. His intimates said that he had often loaned money to "Yellow Charleston." The latter was described by the police as a gambler and a drug addict. James Samson, his Negro secretary, said that Wilkins's last act of charity was yesterday afternoon when he mailed a check for $25 to Sam Langford, Negro pugilist of other years. He also sent Langford an order on a downtown tailor for a suit of clothes. Langford is in New York for an operation to save him from blindness and is penniless. Wilkins's wife left yesterday afternoon for Lakewood and returned last night when notified of her husband's death.

❖ ❖ ❖

THE DAILY STAR, JULY 5, 1924

"CHAMPION DAREDEVIL" PARACHUTES TO TENEMENT

"Lieutenant Hubert Julian, M.D., World's Champion Daredevil Parachute Jumper," as his business cards describe him, did a death-and police-defying parachute leap a thousand feet or more above the College of the City of New York yesterday to advertise a Harlem five-and-ten-cent store. He was promptly served with a summons, charging violation of the Sunday law.

Serving the writ wasn't so easy as all that, however. In the first place, the champion daredevil is a Negro; in the second place, he landed on a tenement-house roof in the outskirts of Harlem's "Little Africa"; and in the third place, he wore scarlet tights. The police had to force their way through a crowd that choked 140th Street and that had smashed show windows by sheer pressure, to reach the "daredevil" from the shoulders of hysterical admirers.

It was about 5:30 p.m. that three airplanes coming from the west began to circle high above the college grounds in the vicinity of 142nd Street and St. Nicholas Terrace. Half of Washington Heights saw the soaring airplanes, but to make certain that

none should miss the five-and-ten-cent-store advertising stunt, one of the airplanes released two bombs, which exploded far above the housetops. At once motorists on St. Nicholas Avenue began a hideous din of squalling horns. Men, women and children poured from the tiered apartment houses of the Heights. From the Negro district to the east, where the event had been widely advertised by word of mouth, surged a horde intent upon seeing the exploit undertaken by one of their race. One of the airplanes separated from its fellows and something shot downward from it, arresting its plunge as a parachute opened and revealing the scarlet-clad Hubert Julian dangling from a bar below the billowing parachute.

At the sight of the magnificently arrayed "Daredevil," the crowds went wild. Those from the Heights shuffled eastward in massed formation, eyes aloft, quite heedless of the hundreds of automobiles with sky-staring drivers which wended their ways among them. Westward rushed the population of the Negro district even more intent upon the descending figure. They converged in 140th Street between St. Nicholas Avenue and Eighth Avenue. The figure that had been so tiny was now full-sized, clearly discernible and hovering just above the housetops on the north side of the street. Hubert Julian was making frantic efforts to pull his parachute down to the roofs across which he was drifting rapidly, just too high to let go. It seemed certain for a moment that he would be carried beyond the

last house in the row and drop to the elevated tracks or the pavement in Eighth Avenue.

Patrolman Braveman, of the West 135th Street police station, and two probationary patrolmen who had been on the lookout for Hubert Julian all the afternoon, forced a slow passage through the crowd and reached the tenement doorway just as Hubert Julian emerged, resplendent in scarlet suit and leather helmet. The nearest Negroes snatched him up and passed him from hand to hand above the heads of the crowd. The patrolmen, wallowing after the still-flying airman, at last overtook him, pulled him down and served him with the summons to appear today in Washington Heights police court. Then Hubert Julian departed with a large and enthusiastic escort to deliver "a mysterious message to the public of Harlem," he said, from the five-and-ten-cent store.

❖ ❖ ❖

THE NEW YORK WORLD, NOVEMBER 23, 1924

DREAM REALIZED AS RACE PLAYS BROADWAY

The long-cherished dream of Williams and Walker, Cole and Johnson and Ernest Hogan to see a colored musical comedy success-

fully playing in the very heart of Broadway is at last a reality, coming at a time when but one of these famous comedians — J. Rosamond Johnson — is alive to witness this evolutionary step. For years these Negro stars labored and sacrificed to gratify an ambition now being realized by Florence Mills, who is scoring a pronounced hit in *Dixie to Broadway* at the Broadhurst.

In the vain hope of producing a Negro show on the Rialto, the mental and physical health of both George Walker and "Bob" Cole became seriously impaired. For the same reason Ernest Hogan fell a victim to tuberculosis from which he never recovered. After the death of his partner, Bert Williams headed a colored company in *Lode of Koal*, which tarried but a short time in Columbus Circle. Low both in spirit and finances, the inimitable Bert joined the Ziegfeld Follies, winning additional fame and for the first time in his career receiving a salary commensurate with his worth as a box-office attraction. At his death he was the star of a company of which he was the only Negro.

The impressive success of Florence Mills and her company shatters some deep-rooted theories heretofore existing relative to colored musical companies. "No colored musical show can be a financial and artistic success on Broadway," has been a saying for years and regarded as incontrovertible. The line of argument advanced by the theatrical powers

was that white amusement seekers would not patronize a colored show as a legitimate theatrical proposition but desired to regard Negro entertainment merely as a lure for slumming parties; that to create the proper atmosphere it was necessary to house a colored attraction in a theater off Broadway on the fringe of the theatrical district. That "art knows no color line" is substantiated by the conquest Miss Mills and her associates are making in a recognized Broadway house, and gives corroboration to the assertion often made by those who have said Broadway would take off its hat to any theatrical attraction that measured up to the high standards set with respect to class, cleanliness and merit.

Even after Miller and Lyles and Sissle and Blake had hung up an unprecedented record in *Shuffle Along* at what is now known as the 63rd Street Music Hall, they later on found that forbidden precincts closed tight against them. Last season, before Miller and Lyles could make their New York debut in *Runnin' Wild*, their managers found it necessary to lease the Colonial Theatre, formerly a vaudeville house at Broadway and 62nd Street. It was not until Miller and Lyles closed their metropolitan engagement that it was made possible for Sissle and Blake to come to town with their new production, *The Chocolate Dandies*, although repeated attempts were made to break through the proscribed theatrical deadline.

It was, therefore, a piece of startling and unheard-of news when word was first given out that the *Dixie to Broadway* company had been booked by the Shuberts to open at the Broadhurst Theatre for an indefinite run—and at a most desirable period of the new theatrical season. Nevertheless, this invasion of Broadway did take place, and with gratifying results to the public, managers and actors. For fifteen years or more, colored musical shows have led a precarious existence. During the seasons of 1906–1907, 1907–1908 and 1908–1909, they were in the height of their popularity. Williams and Walker, Cole and Johnson and Ernest Hogan starred in companies appearing in the larger cities of the North, while the *Smart Set* with S. H. Dudley, and the Black Patti Troubadours toured the South and also played to Northern audiences.

Then came the movies, which started the large colored musical shows on the toboggan. One after another the houses of the Stair and Havlin Circuit changed it policy, finding it more financially productive to run pictures than the presentation of musical comedy and melodrama. Unable to obtain booking over the Klaw and Erlanger and Shubert circuits, and with little or no consecutive dates without making big jumps, the colored attractions with Broadway aspirations were forced to disband. At the time these theatrical organizations were in their zenith, their nearest approach to reaching Broadway was by filling engagements at the Majestic Theatre, later named the Globe, in Columbus Circle. At this large and well-appointed playhouse William and Walker enjoyed their greatest success, *Bandanna Land*, in 1908, and had a few seasons previously made their premier in the spectacular production *Abyssinia*. The enforced retirement of Hogan, Walker and Cole, and their subsequent deaths, were severe blows to the colored theatrical profession, for in their passing the stage lost three comedians of marked ability who possessed vision and fighting spirit. Bert Williams pluckily shouldered the responsibility of carrying on the good work, but upon finding the odds too great became a luminary of importance in white musical companies.

In the succeeeding years promoters interested in the Negro in the realm of the footlights put out colored musical shows with Broadway as their objective, but without success. In 1915 Miller and Lyles, appearing under my management, exerted every effort to find refuge in a theater on the Gay White Way, but even the presence of Charles Dillingham, F. Ray Comstock, Irving Berlin and other Broadway celebrities at the Lafayette Theater on opening night, and the kindly consideration they personally manifested failed to bring about a change in the theater address of the company from Harlem to Times Square. Similar futile endeavors to reach Broadway were also made by Negro comedians of lesser reputations. Bent on reviv-

ing the popularity of the colored musical show, Miller and Lyles and Sissle and Blake organized the *Shuffle Along* company in the spring of 1921, with John Cort as manager. The attraction opened at the Howard Theatre, Washington. With the outlook none too bright, E. C. Brown, a Negro banker of Philadelphia, and at the time president of the Quality Amusement Corporation, which was operating theaters and organizing colored musical and dramatic companies, appeared in the role of a friend in need.

—LESTER A. WALTON

❖ ❖ ❖

SURVEY GRAPHIC, MARCH 1925

ENTER THE NEW NEGRO

In the last decade something beyond the watch and guard of statistics has happened in the life of the American Negro, and the three Norns who have traditionally presided over the Negro problem have a changeling in their laps. The Sociologist, the Philanthropist, the Race Leader are not unaware of the New Negro, but they are at a loss to account for him. He simply cannot be swathed in their formulae. For the younger generation is vibrant with a new psychology; the new spirit is awake in the masses, and under the very eyes of the professional observers is transforming what has been a perennial problem into the progressive phases of contemporary Negro life.

...A main change has been, of course, that shifting of the Negro population which has made the Negro problem no longer exclusively or even predominantly Southern. Why should our minds remain sectionalized, when the problem itself no longer is? Then the trend of migration has not only been toward the North and the Central Midwest, but cityward and to the great centers of industry—the problems of adjustment are new, practical, local and not peculiarly racial. Rather they are an integral part of the large industrial and social problems of our present-day democracy. And finally, with the Negro rapidly in process of class differentiation, if it ever was warrantable to regard and treat the Negro en masse it is becoming with every day less possible, more unjust and more ridiculous.

...To all of this the New Negro is keenly responsive as an augury of a new democracy in American culture. He is contributing his share to the new social understanding. But the desire to be understood would never in itself have been sufficient to have opened so completely the protectively closed portals of the thinking Negro's mind. There is still too much possibility of being snubbed or patronized for that. It was rather the necessity for fuller, truer self-expression, the realization of the unwisdom of allowing social discrimination to segregate him mentally, and a counterattitude to cramp and fetter his own living—and so the "spite wall" that the intellectuals built over the "color line" has happily been taken down. Much of this reopening of intellectual contacts has centered in New York and has been richly fruitful not merely in the enlarging of personal experience but in the definite enrichment of American art and letters, and in the clarifying of our common vision of the social tasks ahead.

...More and more, however, an intelligent realization of the great discrepancy between the American social creed and the American social practice forces upon the Negro the taking of the moral advantage that is his. Only the steadying and sobering effect of a truly characteristic gentleness of spirit prevents the rapid rise of a definite cynicism and counterhate and a defiant superiority feeling. Human as this reaction would be, the majority still deprecate its advent, and would gladly see it forestalled by the speedy amelioration of its causes. We wish our race pride to be a healthier, more positive achievement than a feeling based upon a realization of the shortcomings of others. But all paths toward the attainment of a sound social attitude have been difficult; only a relatively few enlightened minds have been able, as the phrase puts it, "to rise above" prejudice by mental passive resistance, in other words by trying to ignore it. For the few, this manna may perhaps be effective, but the masses cannot thrive on it.

Fortunately there are constructive channels opening out into which the balked social feelings of the American Negro can flow freely.

Without them there would be much more pressure and danger than there is. These compensating interests are racial, but in a new and enlarged way. One is the consciousness of acting as the advance guard of the African peoples in their contact with twentieth-century civilization; the other, the sense of a mission of rehabilitating the race in world esteem from that loss of prestige for which the fate and conditions of slavery have so largely been responsible. Harlem, as we shall see, is the center of both these movements; she is the home of the Negro's "Zionism." The pulse of the Negro world has begun to beat in Harlem. A Negro newspaper carrying news material in English, French and Spanish, gathered from all quarters of America, the West Indies and Africa, has maintained itself in Harlem for over five years. Two important magazines, both edited from New York, maintain their news and circulation consistently on a cosmopolitan scale. Under American auspices and backing, three Pan-African congresses have been held abroad for the discussion of common interests, colonial questions and the future cooperative development of Africa. In terms of the race question as a world problem, the Negro mind has leapt, so to speak, upon the parapets of prejudice and extended its cramped horizons. In so doing it has linked up with the growing group consciousness of the dark peoples and is gradually learning their common interests. As one of our writers has recently put it: "It is imperative that we understand the white world in its relations to the non-white world." As with the Jew, persecution is making the Negro international.

—ALAIN LOCKE

❖ ❖ ❖

SURVEY GRAPHIC, MARCH, 1925

YOUTH SPEAKS: THE ARTISTIC VANGUARD

Negro genius today relies upon the race-gift as a vast spiritual endowment from which our best developments have come and must come. Racial expression as a conscious motive, it is true, is fading out of our latest art, but just as surely the age of truer, finer group expression is coming in—for race expression does not need to be deliberate to be vital. Indeed at its best it never is. This was the case with our instinctive and quite matchless folk-art, and begins to be the same again as we approach cultural maturity in a phase of art that promises now to be fully representative. The interval between has been an awkward age, where from the anxious desire and attempt to be representative much that was really unrepresentative has come; we have lately had an art that was stiltedly self-conscious, and racially rhetorical rather than racially expressive. Our poets have now stopped speaking for the Negro—they speak as Negroes. Where formerly they spoke to others and tried to interpret, they now speak to their own and try to express. They have stopped posing, being nearer to the attainment of poise.

The younger generation has thus achieved an objective attitude toward life. Race for them is but an idiom of experience, a sort of added enriching adventure and discipline, giving subtler overtones to life, making it more beautiful and interesting, even if more poignantly so. So experienced, it affords a deepening rather than a narrowing of social vision. The artistic problem of the young Negro has not been so much that of acquiring the outer mastery of form and technique as that of achieving an inner mastery of mood and spirit. That accomplished, there has come the happy release from self-consciousness, rhetoric, bombast, and the hampering habit of setting artistic values with primary regard for moral effect—all those pathetic overcompensations of a group inferiority complex which our social dilemmas inflicted upon several unhappy generations. Our poets no longer have the hard choice between an over-assertive and an appealing attitude. By the same effort, they have shaken themselves free from the minstrel tradition and the fowling-nets of dialect, and through acquiring ease and simplicity in serious expression, have carried the folk-gift to the altitudes of art. There they seek and find art's intrinsic values and satisfactions—and if America were deaf, they would still sing.

But America listens—perhaps in curiosity at first; later, we may be sure, in understanding. But— a moment of patience. The generation now in the artistic van-

guard inherits the fine and dearly bought achievement of another generation of creative workmen who have been pioneers and path-breakers in the cultural development and recognition of the Negro in the arts. Though still in their prime, as veterans of a hard struggle, they must have the praise and gratitude that is due them. We have had, in fiction, Chestnutt and Burghardt Du Bois; in drama, Du Bois again and Angelina Grimke; in poetry, Dunbar, James Weldon Johnson, Fenton and Charles Bertram Johnson, Everett Hawkins, Lucien Watkins, Cotter, Jameson; and in another file of poets, Miss Grimke, Anne Spencer, and Georgia Douglas Johnson; in criticism and *belles lettres*, Braithwaite and Dr. Du Bois; in painting, Tanner and Scott; in sculpture, Meta Warrick and May Jackson; in acting, Gilpin and Robeson; in music, Burleigh. Nor must the fine collaboration of white American artists be omitted; the work of Ridgeley Torrence and Eugene O'Neill in drama, of Stribling, and Shands and Clement Wood in fiction, all of which has helped in the bringing of the materials of Negro life out of the shambles of conventional polemics, cheap romance and journalism into the domain of pure and unbiased art. Then, rich in this legacy, but richer still, I think, in their own endowment of talent, comes the youngest generation of our Afro-American culture: in music, Diton, Dett, Grant Still, and Roland Hayes; in fiction, Jessie Fauset, Walter White, Claude McKay (a forthcoming

book); in drama, Willis Richardson; in the field of the short story, Jean Toomer, Eric Walrond, Rudolf Fisher; and finally a vivid galaxy of young Negro poets, McKay, Jean Toomer, Langston Hughes and Countee Cullen.

These constitute a new generation not because of years only, but because of a new aesthetic and a new philosophy of life. They have all swung above the horizon in the last three years, and we can say without disparagement of the past that in that short space of time they have gained collectively from publishers, editors, critics and the general public more recognition than has ever before come to Negro creative artists in an entire working lifetime. First novels of unquestioned distinction, first acceptances by premier journals whose pages are the ambition of veteran craftsmen, international acclaim, the conquest for us of new provinces of art, the development for the first time among us of literary coteries and channels for the contact of creative minds, and most important of all, a spiritual quickening and racial leavening such as no generation has yet felt and known. It has been their achievement also to bring the artistic advance of the Negro sharply into stepping alignment with contemporary artistic thought, mood and style. They are thoroughly modern, some of them ultra-modern, and Negro thoughts now wear the uniform of the age.

But for all that, the heart beats a little differently. Toomer gives a folk-lilt and ecstasy to the prose of the American modernists. McKay adds Aesop and irony to the social novel and a peasant clarity and naiveté to lyric thought, Fisher adds Uncle Remus to the art of Maupassant and

O. Henry. Hughes puts Biblical fervor into free verse, Hayes carries the gush and depth of folk-song to the old masters, Cullen blends the simple with the sophisticated and puts the vineyards themselves into his crystal goblets. There is in all the marriage of a fresh emotional endowment with the finest niceties of art. Here for the enrichment of American and modern art, among our contemporaries, in a people who still have the ancient key, are some of the things we thought culture had forever lost. Art cannot disdain the gift of a natural irony, of a transfiguring imagination, of rhapsodic Biblical speech, of dynamic musical swing, of cosmic emotion such as only the gifted pagans knew, of a return to nature, not by way of the forced and worn formula of Romanticism, but through the closeness of an imagination that has never broken kinship with nature. Art must accept such gifts, and revaluate the giver.

Not all the new art is in the field of pure art values. There is poetry of sturdy social protest, and fiction of calm, dispassionate social analysis. But reason and realism have cured us of sentimentality: instead of the wail and appeal, there is challenge and indictment. Satire is just beneath the surface of our latest prose, and tonic irony has come into our poetic wells. These are good medicines for the common mind, for us they are necessary antidotes against social poison. Their influence means that at least for now the worst symptoms of the social distemper are passing. And so the social promise of our recent art is as

great as the artistic. It has brought with it, first of all, that wholesome welcome virtue of finding beauty in oneself; the younger generation can no longer be twitted as "cultural nondescripts" or accused of "being out of love with their own nativity." They have instinctive love and pride of race, and, spiritually compensating for the present lacks of America, ardent respect and love for Africa, the motherland. Gradually too under some spiritualizing reaction, the brands and wounds of social persecution are becoming the proud stigmata of spiritual immunity and moral victory. Already enough progress has been made in this direction so that it is no longer true that the Negro mind is too engulfed in its own social dilemmas for control of the necessary perspective of art, or too depressed to attain the full horizons of self and social criticism. Indeed, by the evidence and promise of the cultured few, we are at last spiritually free, and offer through art an emancipating vision to America. But it is a presumption to speak further for those who have spoken and can speak so adequately for themselves.

—ALAIN LOCKE

❖ ❖ ❖

THE NEW YORK TIMES, MAY 24, 1925

CHARLESTON A HIT IN HOME, DANCE HALL AND BALLROOM

"Can you Charleston?" is the question, but with unconcealed anxiety these days, by womenfolk seeking a cook or wielder of mop and duster from the ranks of Negro household workers. For the Charleston, as the latest dance innovation is called, is all the rage both for ballroom and exhibition, and being of African origin, is naturally best known by darkies.

Proprietors of employment agencies are being importuned to supply cooks, waitresses, laundresses and maids "who can Charleston." Women who employ Negro servants adept in the combination wing and step are implored by friends to obtain for them servants similarly skilled. The domestic helper who works by one day and "sleeps out" and she who is always at hand and "sleeps in" need offer no excuses for tasks uncompleted if they can show their employers how to do a passable Charleston. The visiting laundress will hear no complaint about her slowness if she can "shake a leg." Burned food, late luncheon or dinner, dust in the corners and even forays on the icebox and the disappearance of the remains of Sunday's ham intended for Monday consumption are forgiven if the offender can only impart to her mistress that elusive winging movement of the legs without which there is no authentic Charleston.

The mistress humbles herself in her own domain and seeks with eagerness as a pupil the approval of her social inferior. Broom and vacuum cleaner gather dust instead of routing it while the rug is turned back, the music machine is started and maid and matron, holding their skirts above their knees, go through the evolutions of a modern version of a form of primeval jungle ritual.

The new excuse which greets the husband inquiring why dinner is not on the table is, "Sally has been showing me how to do the Charleston."

Debutantes are practicing it at the Colony Club; society matrons are panting over it in Park Avenue boudoirs; department store clerks are trying to master it in the restrooms at the lunch hour; the models of the garment industry dance it together in the chop suey palaces at noontime; the flats of the West Side and the tenements of the East Side are not immune to the contagion. Wherever there's a pier glass, in front of it is a feminine or masculine form striving with the utmost earnestness to make both legs simultaneously and at the same time step forward, back or to the side. Many a man has forsaken his daily dozen for the Charleston. Darky youth and pickaninnies dance it on the street corners for both profit and pleasure. Even sharks of the bridge table trump each other's tricks while listening to an exposition of the fad of the hour. "My maid is teaching me the Charleston," is a cry of triumph sure to rouse heartburnings of envy.

What is this dance in which amateurs and professionals are competing for ballroom and stage prizes, which just now is danced almost to the exclusion of all others with varying degrees of proficiency in public dance hall, cabaret, night club and private as-

semblies, and is sending a new crop of pupils to the studios of instructors? It is kin of buck and wing, of turkey trot and fox trot, a relative of all the dances of peculiarly Negro origin which have from time to time been modified and adapted to ballroom and stage. It may be danced as a solo by individual or couple in either exhibition or social dancing. It is danced to jazz music played either in 2-4 time and one-step rhythm or in the 4-4 tempo of the slow fox trot, as a part of which it is often introduced. In many of the smart dance clubs frequented by professional dancers, according to a committee designated to report on dance tendencies by the New York Society of Teachers of Dancing, a modified Charleston combined with the plain walking step of the one-step is the dance of the hour, while in the Broadway cabarets the straight Charleston is the ruling favorite, danced to the 4-4 time of a "blues."

As in all dances of this type where there are fundamental positions and movements, there is ample scope for individual invention and embroidery with the result that especially among exhibition dancers, there are many combinations of steps unrelated to the genuine Charleston. Nevertheless the opportunity for originating novel evolutions, which has made the fox trot of the present so different from the type which first bore that name, is one of the most alluring features of the Charleston, and already the college and high school youths

who devise the predominating movements of social dancing have put their wits and legs together in embellishing the figures of the dance which, as its name implies, first attracted attention and became labeled through its popularity at the social assemblies of Charleston's dusky society several years ago. In fact, the sudden fascination which the Charleston has exercised on white folks has surprised the colored population of Harlem, who gave it up for the fox trot but are now reviving their childhood lore and finding it a valuable asset.

THE NEW YORK TIMES, AUGUST 17, 1926

STRANGE CRIMES OF LITTLE AFRICA

That truth is stranger than fiction is exemplified by some of the curious crimes that occur periodically in Harlem's Little Africa. This great black area, by the way, in the northwest corner of Manhattan Island, is extremely orderly and a larger percentage of its population of 250,000 are honest, industrious, law-abiding citizens. But among so many people it is not strange there should be a criminal element. The settlement would like to be rid of it, since these bad Negroes are continually stirring up trouble. The black holdup man is no better nor worse than his white contemporary. He is actuated by the same sordid motives and is just as vicious and cruel, and he uses a gun with the same recklessness as his white brother. He, however, confines

most of his activities to the Black Belt or its immediate environs and has no desire to adventure into unfamiliar neighborhoods. Recently there has been an appreciable falling off in holdups in Little Africa. A few years ago, holdups there were all too common and storekeepers then lived in a perpetual reign of terror, not knowing when the black pestilence would descend upon them. White men, with visions of reaping a rich harvest, braved the danger and opened stores in the black area. Some of them were robbed and killed, and others survived. Today storekeepers breathe easier.

Sightseers of the sordid kind are continually visiting slummy neighborhoods in the Black Belt in search of thrills and sensations, and the criminals are always on the lookout for these jaded and misguided visitors. Occasionally they are seen in station houses, where their bruised and battered countenances speak eloquently of rough encounters with thugs and thieves of the district. Negroes resent the intrusion of this type of visitor and Negro crooks prey upon them.

A sailor and his companions once visited the Black Belt in search of adventure. Late at night they became separated and one of them was lured to the roof of a tenement where several Negroes proceeded to hold him up. He decided to give them a battle. He was a powerful fellow and he sailed into them in true pugilistic

fashion, slamming them right and left. He was getting the better of the fight when one of the Negroes knocked him unconscious with a club. Then they threw him from the roof and he crumpled lifeless on the floor of the concrete court below. The Negroes escaped over the rooftops. It was just an instance of the strange crimes that occur in the Black Belt now and then.

A Negro flew into a passion, killed his wife, and then soaked his flat with kerosene oil. After starting a blaze among a pile of papers which he had gathered, he shot and killed himself. Other tenants in the house barely escaped with their lives. When the firemen arrived and battered down the door they found the charred bodies of the man and woman, and later the police pieced together the details of the sordid tragedy.

A man and a woman who had lived together unwed decided to separate. The man went his way and the woman hers. But the woman took with her a pet dog to which the man was much attached. One night he visited her and claimed the dog as his particular property. The woman refused to part with it and neither of them could settle the matter to their mutual satisfaction. The man grew tired of the argument and decided to take away the dog, and the dispute became more intense. Finally the woman attacked the man with a pair of scissors and stabbed him to death.

In a similar case a colored woman called on a lover who had discarded her. She demanded property which she declared be-longed to her. Her former lover laughed at her and ordered her out of the house. She decided she would take her own time in leaving. At length she started to depart. He picked up a large bread knife and nearly cut her head off. Then he hurriedly packed his belongings and left for parts unknown.

Two Negroes were bitter enemies. One of them returned to the flat where he was a lodger, to find the other there. The latter, seated at the dining-room table, was playing cards with several others. The first Negro went to the kitchen and returned with a keen-edged butcher's cleaver which he kept concealed behind his back. Walking up behind his card-playing enemy, he struck him a terrific blow on the back of the neck with the cleaver. The card-player dropped dead at the foot of the table and his slayer calmly lighted a cigarette and went out the door. Needless to say, he did not return.

In another instance two Negroes had a bitter fight in a flat. One of them managed to get his hands on a pistol and fired a couple of shots at the other. The unarmed Negro was unharmed. He, however, pretended to be shot and fell to the floor closing his eyes. Meanwhile, tenants who had overheard the two quarreling had summoned the police. The Negro with the pistol barricaded the door and refused to open it when the police arrived. Seeing himself trapped and believing he had killed his former friend, he threw open the top-floor window and climbed out. He was hanging suspended to the sill when a policeman in an adjoining flat opened the windows and shouted to the Negro not to leap. By this time the door had been broken in. The Negro grinned at the officer. "You won't take dis heah bird to no prison," he cried mockingly. "Here goes," and releasing his hold of the window sill, he plunged to instant death below.

Negroes bent on crime are adept with any kind of weapon. And in this matter of weapons they have no especial choice. Sometimes they use a pistol; at other times they use a knife. The latter may be a razor, a pocket knife sharpened to a razor edge, an axe, or in fact any kind of a weapon that is sharp.

❖ ❖ ❖

THE NEGRO WORLD, AUGUST 21, 1926

150,000 HONOR GARVEY

Harlem, the largest Negro community in the world, paid a remarkable tribute today to the greatest Negro in the world. And the tribute took on added significance because of the fact that the object of the adoration and adulation of the populace was not present in person, but languishing in a white man's prison one thousand miles away from the scene of his triumph—imprisoned for using the United States mails to defraud in connection with the furtherance of the greatest program ever given to the Negro!

If Marcus Garvey, now hemmed in by the walls of Atlanta Penitentiary, Georgia, could have slipped by his guards and

appeared in New York and mingled with the crowd and heard the sincere and heartfelt comments of the multitude that was acclaiming him, he could have returned to his place of exile and considered himself fortunate that he was being made to suffer—knowledge of the silent, amazing revolution he had created in men's minds would have more than compensated him for his sacrifice.

As it was, Marcus Garvey, founder and leader of the Universal Negro Improvement Association, was in a felon's cell, and not only in New York City but throughout the world wherever black men and women congregate under the aegis of the Red, Black and Green, thousands were giving praise to God for Garvey, lauding his name, and doing their all to further the work so gloriously initiated and fostered by him in the interest of Africa and its scattered sons and daughters. Truly here was counsel extraordinary for those who vainly hug the hope that in the world today persecution of one man, even though he be the leader, can stifle the aspirations of a race.

The occasion was the opening-day exercises of the annual Convention of the Negro Peoples of the World. Every August since Marcus Garvey made his presence felt, Negroes assembled in New York from far and near to pool their intelligence and legislate for the future salvation of the race. Marcus Garvey was sent to prison in February, 1925, and it was decided that no international Convention be held that year.

Last March in Detroit, however, an extraordinary Convention was assembled, at which new officers were chosen to carry on the work of the organization under the guidance of the Honorable Marcus Garvey. But August still retained its deep significance, and so the Executive Council decreed that local Conventions be held under the auspices of the Association everywhere, beginning on August 15 and ending on August 21.

And so it was that the New York Division held high festival today, converting Harlemites into one acclaiming host of Garveyism. The first event on the day's programme was divine service at 11 a.m. This was followed by a parade through the principal streets of Harlem at 2:30 p.m., the day's proceedings being wound up with a great mass meeting at 8 p.m. It was the parade event which furnished the opportunity for the foremost Negro community in the world to openly and unreservedly attest its esteem for the foremost Negro leader. As the parade ended in front of the Association's headquarters on 135th Street, and the various units and marchers had passed in review before the Executive Officers, thousands thronged and choked the wide thoroughfare and sidewalks, raising cheer upon cheer for fully fifteen minutes for a man who was present only in spirit. Streetcars and vehicles of every description were forced to halt and the police who were assigned to the vicinity stood good-naturedly by and waited until the enthusiasm had subsided, moved out of them-

selves by the remarkable demonstration. At the top of the headquarters' steps was held aloft a life-sized portrait of Marcus Garvey which had been carried in the procession, and the eyes of all, streetcar motorman and policeman, truckman and passer-by, ardent member and erstwhile critic, were trained on this, as a band played the Ethiopian National Anthem and The Star Spangled Banner, and cheers for the absent leader rent the air.

But while demonstrating the high regard in which the people of New York hold Marcus Garvey, Sunday's proceedings served effectively to nail the lie that in New York there is a serious split in the ranks, the majority of the people forswearing their allegiance to the imprisoned founder of the organization. It is true that after Marcus Garvey went to prison, a conceited and overambitious lieutenant in the person of George A. Weston, vice president, by grace of Garvey, of the New York Division, aided and abetted by certain dismissed officials of the organization, and advised by a firm of white lawyers, thought of gaining control of the organization and laid plans to this end. But the pitifulness of the gentleman's pretensions was apparent to all but a few members of the local division and those who would like to see the organization destroyed. At the first opportunity the people showed in unmistakable fashion where they stood, and the white press, which for weeks before was disseminating news of the downfall (sic) of Marcus Garvey, had perforce to

remain silent in the face of a remarkable endorsement or haltingly to announce the truth.

The opening service was very impressive. The Right Honorable Fred A. Toote, acting president-general, who is also an ordained minister, officiated, assisted by Dr. J. G. St. C. Drane and Dr. J. H. Chase, of Elizabeth City, North Carolina. The last-named preached the sermon, while Dr. Drake said the lesson of the day.

The Commonwealth Casino could hardly accommodate the thousands who sought admission for the night meeting, even though an admission of fifty cents was charged. The chief item on the night's program was the reading of a message from the president-general, Honorable Marcus Garvey, which occasioned great enthusiasm.

❖ ❖ ❖

THE NEW YORK TIMES, APRIL 17, 1927

WHEN RURAL NEGRO REACHES CRUCIBLE

Newcomers to Harlem's "Little Africa" may be easily identified by their garments, speech and idiosyncrasies. They come here from all parts of the world; from foreign seaports and interior towns and cities, bringing with them the quaint customs of their fatherlands.

The new arrival from the South is perhaps most in evidence. He is a seedy, collarless, slouching fellow, wearing a battered old soft hat. Slow in motion, he is constantly buffeted by the swift black tides of the avenue that sweep past him. A stranger in the city, he is considerably bewildered by the sights that confront him. A product of the plantations, he shakes his head in puzzled fashion as he surveys the hurrying throngs and endless rows of brick and mortar. If he be friendless he is often willing to make friends with the first stranger who accosts him. Sometimes he falls into honest hands. But frequently he is a prey for unscrupulous members of his race who strip him of his few possessions. Whatever befalls him, he is not easily discouraged. Endowed with the happy-go-lucky spirit of the Negro, he accepts the world much as he finds it. He has come here as to a promised land where, a man of simple faith, he believes that somewhere he will find a Black Moses to lead him out of the paths of adversity. Often his Black Moses turns out to be a well-disposed colored pastor.

Most of these Negroes from the South who come here with golden expectations eventually manage to get a foothold on some kind of a job. A few of them, to be sure, who have no one to guide or help them, succumb to temptation and fall into evil ways. But a large percentage of them see their dreams realized. Frequently in less than a month's time the seedy, penniless Negro from the South undergoes a metamorphosis as startling as that of an insect. As he strolls jauntily along the avenue swinging a cane, with his head erect, his most intimate friends of the plan-

tation would not recognize him. Often in the space of a single day he has transformed himself into an entirely different individual. He has, in short, by a mere exchange of garments disassociated himself from his past and has become a new and different man, casting aside with his dull garments century-old habits and traditions. It is doubtful if anyone except a Negro could make this lightning-like change. The Negro has a positive genius for adaptation. In an incredibly short time he can adapt himself to new conditions. Accustomed all his life to the broad, sunny acres of the Southland, with plenty of free air, trees and flowers, he can make himself equally at home in a narrow, sunless flat. "The Negro," said a colored pastor, "can do this because he has a cheerful disposition and a vivid imagination. Never having very much, he is able to make the most of very little. He may secretly miss green meadows and flowers, but the representations of the flowers on the wallpaper are real flowers to him. He needs only to shut his eyes in order to smell their fragrance."

Strutting the streets of the "Black Belt" are Negroes of enviable physique, with slim waists and straight broad shoulders. Many of these have found jobs on the piers as stevedores. They receive good pay and can afford to wear good clothes. Some of them dress conservatively, live frugally and put their savings in the bank. Others like to dress up and appear the glass of fashion and the mold of form. And these "dressy" Negroes adapt themselves to bright

new raiment as easily as they do to other things. In the manner of dress they are different from their white brothers of the same taste except, perhaps, they run more to exaggerated styles and bright hues. Silk shirts, bright ties and gay spats and form-fitting garments of every mode may be seen on a Sunday afternoon on Lenox and Seventh Avenues north of 125th Street. Indeed, when the many churches disgorge their large congregations, men and women appear in the latest and newest creations of the tailor's and dressmaker's art. Every pleasant Sunday afternoon there is an "Easter Parade" on these avenues.

Next to the Southern Negro the West Indian is most conspicuous. He is as different in manner, talk and other characteristics as a New Englander is from a Middle Westener. When he appears at a police station to intercede for a friend who inadvertently has run afoul of the law, he gravely informs the desk lieutenant in a strong English accent that he is a British subject (as well as his friend), and that perhaps his friend, a newcomer, is not acquainted with the laws and customs of the State of New York.

❖ ❖ ❖

THE NEW YORK TIMES, AUGUST 24, 1927

30,000 NEGRO ELKS PARADE

Under lowering skies and through intermittent showers 30,000

drenched but smiling and gaily clad Negro Elks marched, charlestoned and cakewalked their way up Fifth Avenue from Sixty-first Street to Harlem yesterday afternoon in the four-hour parade of the Grand Lodge of the Improved Benevolent and Protective Order of Elks of the World. Assembling at 1 o'clock under the command of Grand Marshal Joseph Brown, members of 800 lodges from every state and many foreign countries fell into line with their twenty-five bands and passed perhaps 100,000 cheering onlookers, who lined the streets and crowded the windows of Harlem buildings, gay with bunting and banners of every description. Leaving Fifth Avenue at 110th Street, the marchers went west to Lenox Avenue, up to 125th Street and again west to Seventh Avenue, finally disbanding at 149th Street and Lenox Oval.

For an hour the procession passed in review before Grand Exalted Ruler J. Finley Wilson and his staff in the grandstand at Seventh Avenue and 145th Street. Feminine members, known as "Does," were almost as numerous as marchers of the other sex, while the leader of the women's band set the toes of marchers and bystanders tickling with the notes of "Charleston," "Ain't She Sweet" and "Me and My Shadow." A delegation of thirty Negro policemen from the West 135th Street station among the marchers received loud cheers and applause. White uniforms with purple trouser-stripes and collars were the fashion for the men, though tuxedo coats and

white flannels were also seen, with a heavy sprinkling of gold braid and brass buttons. One dignified group with top hats and cutaways followed a score of mounted policemen who were in the van. The women ran strongly to white and gold, with an occasional group in brown, cerise, purple and other colors.

Rules against singing, talking, chewing gum and dancing while in marching order were issued by the committee in charge of the parade, but the spirit of good will which prevailed found many dancing to the music of the bands and shouting to friends at the sides. A motion picture concern made use of the parade as a background for a film, while 300 policemen under Inspector Thomas D. Ryan found that they had little to do. Tonight there will be a band concert in the Manhattan Casino at 155th Street and Eighth Avenue and tomorrow will see the election of the Grand Exalted Ruler.

❖ ❖ ❖

THE NEW YORK SUN, AUGUST 24, 1927

"OBI" MEN BUSY IN HARLEM NOW

The old Tulia, the "Tulia Vieja" of the jungles, has crept into New York. It is whispered among island black folk, here to attend the Negro Elks' convention, that the

evil spirit of the woods has followed them here. Vendors of charms to fend off her curse—city-dwelling "obi" men they are—are engaged in secret and profitable mysteries.

In addition to the 2,000 visitors to the twenty-eighth annual convention of the Improved Benevolent Order of Elks of the World, there are in New York today more than 100,000 Negro visitors from all over the United States, Liberia, Cuba, the West Indies and South America. It is possible that the "Tulia Vieja" has come at the invitation of the resident "obi" men, for it is they, with swarms of incoming confidence men, who hope to gather a rich harvest from the credulity of the visitors.

The "Tulia Vieja" ranges the jungles from Cartagena north, up through Colombia and Central America eastward to the St. Lucien, Barbadian and Martinique islands. Ages ago, she murdered her child. For this, her body was turned blood-red and her feet were turned backward. To cross her trail is the most evil chance which may befall any human being. Endless misfortune will follow. Her cry at night, described as a long, shuddering wail, fills jungle folk with horror. They run to the "obi" man in terror. "Obi" men, not so designated but practicing various forms of witch doctoring, came to New York with the thousands of island Negroes attracted by high wages at the close of the war. They have flourished in Harlem, the Negro capital of the world, and today with the

big convention on, the various brands of mystagogs who thrive in the dark back rooms of the Black Belt have more than they can do. The rumor of the coming of "Tulia Vieja" was, of course, great fortune for them.

The prince and potentate of the witch mongers is either a St. Lucien or a Haitian Negro—no one knows which—who came to New York with the West Indian immigration. With the others of his profession he is the inheritor of the arts and practices of the voodoo priests. Soon after his arrival he became distinguished among all the practitioners of mystic rites as a merchant of potent love charms and powerful "orations" against evil visitations. His establishment, five floors up in a shabby tenement, is conducted much like a doctor's office. A Negro girl in a white dress receives visitors who have arranged for a consultation. There are no trappings of mystery save a somber black curtain which veils a chamber where, in extreme cases, "orations" are said. For lesser afflictions there are prescriptions of snakeskins, enchanted feathers and the like. San Cloud, bobbing in and out, has much professional manner, suggesting, however, a rather worried little Negro dentist, more than a real "obi" man. The throb of a hoist engine outside becomes the beating of a tom-tom, and the subway opening a cave where monsters may dwell. The jungle is creeping up among the skyscrapers.

While the witch doctors, running old established concerns,

stick to their old line, and make the most of the old Tulia's coming, the crooks who make a business of attending big Negro gatherings carry a full line of well-worn frauds, including even the ancient satchel switch. At the convention of the Negro Knights of Pythias in New York two years ago, Negro visitors were preyed upon by confidence men of every description. Word came in advance of the present convention that swindlers were coming not only from the old hometowns in the South but even from the islands and South America. The police have been picking them up as soon as they arrive.

❖ ❖ ❖

THE INTER-STATE TATTLER, OCTOBER 14, 1927

FLO OWES US SOMETHING

When Florence Mills returned home after a long and successful stay in Europe the masses of Harlem turned out and gave her a rousing ovation. The impressive feature of her welcome home was its spontaneousness. It was not a formal demonstration inspired by a reception committee working overtime to stir up artificial enthusiasm. It was a sincere and natural tribute to the woman all of us regard as a national (race) heroine. We feel sure this unprompted overflow of the people's affection meant more to Miss Mills than the postprandial en-

comiums she received at the formal receptions held in her honor.

The masses love Miss Mills. More, they adore her. It is not too much to say that some of us even worship her, for it is only a step from the pedestal of a heroine to the immortality of a goddess. People always expect good gifts from divinity. That is why we address Jehovah as "Our Heavenly Father"—because a father provides for his children. It is the duty and privilege of divinity to dispense gifts. It is Miss Mills' duty to give the people the one great gift within her power.

The people want a national, or if you please, a race drama. They are not asking Miss Mills for it in plain words. In fact, most of them do not even know they want it. Neither did they know they were craving Miss Mills' superb acting talent before she revealed it to them. It is the business of genius to know what the people want before they know it themselves. Miss Mills can do more than anyone else to satisfy the latent, unexpressed hunger for race drama. To do what she can will be merely to pay the debt genius inevitably owes humanity. Miss Mills may easily evade her responsibility. If she undertakes to perform the task she will not increase her popularity, for it is not probable that this generation can admire her any more than it does now. But helping to establish a real Negro theater and a genuine race drama will win her a warmer place in the hearts of posterity and more pages in the strangest of all books —history. ❖ ❖ ❖

THE NEW YORK TIMES, JULY 15, 1928

WHAT TEMPTS HARLEM'S PALATE?

If the Negro is to win New York to the fare he likes, as he has won the rest of the world to his jazz and his spirituals, what shall we be eating one of these days? Not the menu of his night clubs and cabarets, surely; that is syncopated French or Ritzful American. Harlem's exhibition restaurants for white folks have mammies who fry chicken Southern style and bake beaten biscuits. But such viands are like Chinese chop suey —all for customers of other racial strains. It is with food once strange to this city that Harlem beguiles its epicures. That on which Harlem feeds is mystery to the general public. Unusual vegetables are to be found there and fruits which savor more of jungles than orchards.

What New Yorkers call the main Negro quarter of their town is really a city of 300,000 souls, situated on upper Manhattan Island. It extends from 125th Street for twenty blocks to the north, from Eighth Avenue almost to the East River. Its chief north-and-south thoroughfare, Lenox Avenue, is really Harlem just as Fifth Avenue is Gotham or Michigan Boulevard is Chicago. Harlem is the cosmopolis of colored culture, of gaiety, of art, and the capital of Negro cookery. Harlem's visitors come from the Southern United States, the West Indies, from South America and even from Africa. In what it eats Harlem shows itself less a locality than an international rallying point. It is a haven where food has an odd psychology, where viands solace the mind as well as feed the body.

One of the foods of Harlem is the root of the tania, which resembles both the potato and the Jerusalem artichoke and smells not unlike a lily bulb. The "tanyan," as it is called in Harlem, is covered, in the Harlem markets, with a dark rich mud, which suggests black bottoms of rivers and the ooze of tropical swamps. Washing reveals a thin grayish skin and irregular ridges. It grows abundantly in parts of South America and the West Indies, and to a lesser extent in the Southern states. It has an esculent tuber as has the potato plant, and also edible foliage. A food of the tropics, the tania belongs to an ancient and honorable family. Its oldest relative is the colocasia, famed under many names and occurring in numerous varieties. There is taro, for instance, otherwise kalo, said to have been a native of India but now raised in other climes near the Equator and especially in the Pacific islands. The Hawaiians pound up its starchy roots, from which they make their characteristic dish, poi. They also prepare the leaves—huge heart-shaped growths not unlike rhubarb leaves in appearance. The same order includes the yu-tao of China, the sato imo of Japan and the oto of Central America.

In tanyan time Harlem is joyous, for residents and visitors relish this vegetable. Likewise they eat eddoes, a tuber which belongs to the same family as do tanyans. Eddoes have more of the oily quality than tanyans and a little less starch. Therefore they are much employed in soups and stews, to which they impart a flavor considered delicious by children of the tropics. The starch derived from all these tubers is very digestible, a fact which may account for their popularity. The Caucasian is likely to be repelled from tanyans, taroes and eddoes because in their raw state all are more or less acrid. Cooking, however, modifies the flavor. All these esculent roots are candidates for the American bill of fare.

More mysterious than tanyans and their kin are the crystal fines, as Harlem calls them. They are like combinations of small, thin-necked squashes and puffy cucumbers, and are covered with fibers of soft, whitish fiilaments. Inside are huge pits or seeds such as are found in alligator pears. Duly shorn and cut into strips, these strange looking vegetables give a body to soups and stews—particularly to gumbo.

The New Yorker does not appreciate the infinite variety of the yam and its congeners until he has made the rounds of the Harlem markets. There are red and yellow yams brought from the Southern states for the benefit of those who long for the food of the old plantation. Huge yams from the West Indies, as big as a man's head, are imported especially for Harlem. In some months they are sold for 50 or 60 cents a pound—more than the price of the choicest cuts of meats, because they are eaten as cures for homesickness. This region also consumes tons of sweet potatoes both from New Jersey and the Carolinas.

If jazz is to promote the love of Afro-American fare, then to collards we shall shortly go. Collards are said to have a peculiar affinity for the Negro palate. Along the line of Lenox Avenue are seen delectable collards foliaged as are cauliflowers, with just a tinge of light purple or lavender, giving warmth to the cool, pale green. What broccoli is to Park Avenue, the select collards are to the colony of upper Manhattan.

It is always taken for granted that American Negroes consider chicken the choicest of meats. But in Harlem, pork seems to be the leading article of flesh diet. It appears as "mixings" in the beloved collards and mustard greens or as a bacon to give a tang to tanyans. Some of these pork dishes are rather greasy, much too heavy for the palate of the average man. One experiences less of this too-evident richness in chitterlings than in any other form of the pork dishes in which Lenox Avenue Luculluses delight. Chitterlings in Harlem are boiled for at least four hours before being eaten and are kept simmering in hot water in the restaurants and delicatessen stores. They are cooked with a little salt and many choice spices, according to taste. Their savory odor is their chief lure to those who like them.

Every part of the hog finds its way into the Harlem kitchen, it would seem. One of the delights is pig snouts, cooked separately, and ranged in rows on a base of rice or of those small beans which are called "black eyes" because of a tiny black spot they bear on their middles. On bills of fare and in window signs one may often see the legend "Pig Snouts and Black Eyes." Pig tails are also served "simple of themselves"— half a dozen to a portion, and cooked until they are nearly ready to drop to pieces. All these pork products are eaten either with boiled beans or rice and their flavor is enhanced by a red-pepper sauce, so hot that it sears the white palate. West Indian Negroes and Mexicans can stand up under the blast of that sirocco condiment, but to the average Southern Negro this mixture can be taken only in the proportion of one drop to a pig tail.

On Saturday afternoons and nights the broad sidewalks of Lenox Avenue become groves and gardens and broad fields. Out of huge barrels loom red sugar cane, six or eight feet high, which later, cut in short lengths, is eaten as a stick candy by chi'dren. Plantains and bananas in all shades of green and yellow and dark red are ranged in inviting "hands." Pyramids of tanyans and eddoes loom; bushels of collards, and stacks of gigantic yellow and brown and reddish yams tempt the affluence of payday. One would go far before finding anything more colorful and picturesque than this weekly food exposition which Harlem stages in the spirit of happy-go-lucky carnival.

—JOHN WALKER HARRINGTON

AMSTERDAM NEWS, SEPTEMBER 19, 1928

DUNBAR BANK OPENS WITHOUT MIXED BOARD

The desire on the part of prominent and capable Negro businessmen of Harlem to have serving the community a bank with a white and colored board of directors has not been realized in the opening Monday of the new Dunbar National Bank, located in the Dunbar Garden Apartments at Eighth Avenue and 150th Street. Joseph D. Higgins and Arthur H. Thien, both white, formerly of the American-Irving Trust Company, are president and vice-president, respectively. With the exception of Roscoe Conklin Bruce, resident manager of the Garden Apartments, the entire board of directors is white. The new institution is being financed by John D. Rockefeller, Jr., who also built the apartments where it is located, at a cost of $3,000,000. George C. Loomis, white, formerly assistant auditor of the Federal Reserve Bank of New York, is cashier. The rest of the personnel is colored, including the paying and receiving tellers, bookkeeper, vault custodian, stenographer, the head of the thrift department, messengers and the day and night guards. Miss Helen M. McDuvall, white, is secretary to the president. A few weeks ago it was understood that several Negroes had been tentatively selected to serve on the board of directors of the Dunbar National Bank, but this hope has now been blasted.

In certain quarters the institution is described as "simply another Rockefeller Standard Oil bank to wheedle us into depositing our millions of savings in it to be used in Wall Street." A reporter asked Mr. Higgins on Monday why there were no Negroes on the board of directors except their own man, Mr. Bruce. "Negroes may in time become members of the board," he said. Several Negroes have been found by bank examiners to have the necessary qualifications to serve as directors of state and national banks.

Prior to the opening Charles O. Heydt, president of the Empire Mortgage Company, a representative of Mr. Rockefeller and a member of the board of directors of the new bank, gave out the following statement: "The Dunbar Bank is an experiment and we must move slowly in deciding upon our policies, and until we see the response of the representative Negro businessmen of Harlem to this effort to be of assistance to them, we have to delay the consideration of appointing any of them directors of the institution."

The new bank has an initial capitalization of $500,000, and surplus and undivided profits of $540,000. It is reported that it was originally intended to offer 50 per cent of the available stock for sale to the Negroes of Harlem in small lots. It is understood that the Rockefeller interests now hold 75 per cent of the stock. When questioned on this point Monday morning, Mr. Higgins declared that he knew nothing of this arrangement, and that the main office would have to be consulted in the matter. The reporter called at the main office the same day and was told to consult Mr. Heydt, but he was not in at the time. Mrs. Bruce, wife of the resident manager, shed some light on the matter, however, when she told the reporter that no stock would be placed on the market for sale until Mr. Rockefeller was sure that the bank would succeed, so as not to tie up the purchasers' money. Scores of people opened new accounts at the bank Monday and many of them inquired into the sale of stock.

It was estimated that 5,000 persons visited the bank when it closed its first day of business at 10 o'clock Monday night. The small lobby was piled high with flowers, sent by most of the large banks in the city. Letters and telegrams of congratulation were received from all over the country, and included messages from Alice Dunbar Nelson, wife of the Negro poet Paul Dunbar, after whom the bank was named; the Douglas National Bank, a similar institution in Chicago; the Interracial Peace Commission and others. A delegation of four members of the Negro National Bankers' Association was sent by the association in convention in Louisville, Kentucky, to New York to congratulate the officers of the Dunbar Bank.

❖ ❖ ❖

THE NEW YORK TIMES, SEPTEMBER 23, 1928

CASPER HOLSTEIN SEIZED: $50,000 RANSOM

With the questioning by the police of the West 123rd Street station late last night of three white men who had been taken into custody a short while before at the Commonwealth Sporting Club, at 135th Street and Madison Avenue, in the Negro district of Harlem, there came to light a story of the kidnapping early last Friday morning of a wealthy Negro by a group of white men who are demanding $50,000 ransom for his return.

Captain Louis Hyams, in charge of the detectives of the Sixth Division, had been keeping the report of kidnapping secret since last Friday, but when the three men whom the police suspect of being connected with the kidnapping were brought into the West 123rd Street station last night, he admitted that his men had been searching New York for the Negro for two days.

According to Captain Hyams, the Negro, Casper Holstein, who is well known throughout Harlem, prominent in sporting and racing circles and high in the Negro Elks, was attacked by four white men as he was leaving the apartment of a friend at 225 West 146th Street shortly after 1 o'clock Friday morning. Just as Holstein, who is 45 years old, stepped out of the door of the apartment house and started to cross the sidewalk to his automobile, in which his chauffeur was waiting, the four men seized him and threw him into another automobile, Captain Hyams said. Holstein's chauffeur gave chase but lost the car in which his employer was being carried away. He then reported the kidnapping to the police, who have since been trying to find Holstein.

Friday afternoon the kidnappers telephoned to the Turf Club, at 111 West 136th Street, of which Holstein is the president and demanded $17,000 ransom. Since then the demand has been twice repeated, the last time the kidnappers having asked for $50,000.

THE NEW YORK TIMES, SEPTEMBER 24, 1928

HOLSTEIN SET FREE BY ABDUCTORS

Casper Holstein, wealthy overlord of the Negro sporting world, came home to Harlem early today. His return was as mysterious as his disappearance just after midnight on Thursday and furnished the police with little additional information in their search for the kidnappers, who are alleged to have abducted and held him under a threat of murder unless $50,000 ransom was paid.

Holstein, with an expert eye for a winning horse, has amassed a fortune through spectacular plunges on the races. He is Harlem's favored hero, because of his wealth, his sporting proclivities and his philanthropies among the people of his race. His kidnapping was a three-day sensation, an unaccustomed mystery that aroused among his friends a feeling of dread that he would never again be seen alive.

According to the police, Holstein told them that he was kidnapped in front of the apartment building where he lives, in 144th Street, by five men who climbed out of a sedan as he reached the front of the building. All were white men, he said, and they drew revolvers and ordered him into the car. There were two white women inside, he said. When he demanded to know where he was being taken, Holstein said one man replied: "We're cops and are taking you to headquarters," whereupon Holstein said he answered: "My books are clean. I don't have to worry."

He was seated on the rear seat between two men, with the two women on the small "jump" seats in front of him and three men on the front seat, he said. When the sedan turned north in Seventh Avenue, Holstein said he realized it was headed in the wrong direction and began to struggle. Suddenly he felt a stinging blow in the forehead from a blackjack and he became quiet. His captors then took $72 from his pockets, blindfolded him and ordered him to sit

still. They rode for a time that he estimated at two hours, the automobile making numerous turns. He had no idea where he was taken, but when they stopped he was led up a flight of stone steps into a house.

He was gagged, his feet and hands were bound together with wire wrapped over cloth and he was seated on a chair near a bed. His captors examined his gold watch and chain and his ring, but returned them to him. They then left him, telling him he would be released "some night when it is dark." Saturday, he said, he was told he would be released "after dark," and when night came, was taken from the building, still blindfolded. There was a short ride to another house and then he was brought back to the same room. He heard women's voices several times, he said, and once heard somebody say that he (Holstein) was "getting a raw deal."

Yesterday, he said, he was again told that he would be released "after dark," and when he finally was placed in an automobile one of the men said: "The rats have given us the wrong steer. You are too good a fellow to be up here." He was then unbound but blindfolded, and another long ride ensued. Just before they reached Amsterdam and 140th Street one of the men sitting beside him said: "I like you and if you are ever broke I'll stake you to back the races." He was then given $3 and told to leave. He took a taxicab and rode to the police station. Only two men rode into New York with him, he said.

He caught a brief glimpse of them as the car rolled swiftly away. In addition to the elaborate pains that he took to convince the detectives of the good treatment accorded him, Holstein was equally insistent that no ransom or money of any kind had been demanded and that none had been paid. He couldn't think of any reason why he should be kidnapped, and his theory apparently left the impression that the abductors had no motive. The police, however, have a very definite suspicion as to the motive, based on several mysterious telephone calls put through to the Turf Club, in which the threat was made that Holstein would be killed unless the $50,000 ransom was paid.

There also was the call received yesterday afternoon by Denis Armstead, in the business office of the Monarch Lodge of Negro Elks, 236 West 135th Street, in which a husky voice—Armstead was positive it was the voice of Holstein himself—delivered this cryptic message: "Tell the police to get out of this case. All they can get will be my dead body." Holstein, questioned about this, denied that he had been permitted to use the telephone at any time.

There also was another discrepancy between Holstein's story and the account of the kidnapping as previously obtained by the police. He left the Turf Club at 11:40 p.m. Thursday after telephoning Mrs. Gomez Whitfield, a wealthy Negro, that he was coming to her apartment at 205

West 145th Street. His chauffeur dropped him at the apartment at 11:55, but Mrs. Whitfield said he never reached there.

❖ ❖ ❖

THE NEW YORK SUN, JANUARY 29, 1929

NEGRO SECT MIXES JEWISH AND CHRISTIAN RELIGIONS

Mr. M. Shapiro, a mild-mannered Jewish businessman, stopped to chat a few moments with his kosher butcher. The butcher was chuckling. "Funny thing," he explained. "Some colored people came in this morning and wanted some kosher meat. Real Negro people from up in Harlem. They say they are Jews." He laughed. "They say they are real Jews, and they've got a synagogue of their own up in Harlem. Negro Jews! Did you ever hear anything like it?" Mr. Shapiro said he hadn't. But being of an inquiring turn of mind and academically interested in religions of all sorts, he decided to investigate. The kosher butcher, still chuckling, gave him the approximate location, as he recalled it, of the "Negro Jewish synagogue" up in Harlem. Mr. Shapiro went up there, and by dint of inquiring of Negro people he met on the street, found the place. He found not only one but three separate Negro congregations which call themselves Jews; found also that they worship God as the Jews worship Him and that they have distinct historical and

ethnological reasons for so doing. He imparted his discovery to the *Sun* a few days ago and on Saturday last a *Sun* reporter was invited to one of the services. He took with him, as an interested observer also, W. B. Seabrook, author of *The Magic Island*, the Literary Guild's book of the month, which treats deeply and sympathetically of the religion of the Haitian Negroes which the white men call voodoo. Mr. Seabrook is a profound student of religions and a student of African ways and traditions. He was quite anxious to discover new manifestations, in Harlem.

The guide stopped before a faded old brownstone at 29 West 131st Street. A small sign swung in the wind: "The Commandment Keepers. Holy Church of the Living God. Pillar and Ground of the Truth. Services Friday, Saturday, Sunday, Bishop A. W. Matthews." Passing Negroes, shivering in the wind that swept up from the river, stopped to look curiously at the three whites ascending the steps. A door swung open, giving into a long, narrow, low-ceilinged room. Half a dozen Negro women, middle-aged and old, and a child were there, sitting, quietly talking. There were several rows of wooden seats. Oil stoves burned in two corners. At the far end on a dais was a pulpit covered with a rich velvet cloth, deep purple. Embroidered on it was the Star of David, in gilt. There were two short rows of seats to the left of the pulpit. Behind them a dusty

old organ. Facing it, on the other side of the room, a shiny piano. On top of it were several tambourines, a triangle, a pair of brass cymbals and a guitar. Behind the pulpit another guitar. In front of the pulpit a low golden oak table covered with a crimson cloth. On it embroidered, in gold, the word "Holy." Half a dozen Bibles lay there—and a shiny silver E-flat saxophone.

"They play those," said Mr. Shapiro, "in the service. It should start in a short while now. The women play the tambourines, the triangle and the cymbals. The Bishop plays one of the guitars. The Bishopess—at any rate, the lady in the white robe up at the piano now — plays the saxophone. Interesting, isn't it?"

"Odd," said the reporter.

"Not at all odd," interrupted Mr. Seabrook. "They have every biblical right to those instruments, and to play them in their services. What was it King David played as he danced before the Ark of the Covenant?"

"The *kynor*," said Mr. Shapiro. "That would be the saxophone. And the guitar would be the *nevel* and the tambourine the *tupim*, those being the Hebraic designations."

On one wall was the Hebrew alphabet. Bishop Matthews holds classes during the week to teach Hebrew. Near it a design of double triangles with an inscription in Hebrew. The Ten Commandments, in full. A blackboard with the inscription in unmistakable English: "$175 Needed at Once." Another placard: "Wait for the Power That Fell Pente-

cost." Another: "People Prepare to Meet Thy God. Jesus Saves." In the rear window a pane of stained glass with the Christian cross and the crown.

"This congregation," explained Mr. Shapiro, "is the most liberal of the three. They accept Jesus. Some of the people accept Him as one of the prophets, of the rank of Moses. Others of them, it seems to me, accept Him as divine. They believe that they are the pure, the original Israelites of the tribe of Judea and that the white Jews all are of the ten lost tribes."

"Undoubtedly they have a good basis for their belief that they are of Hebraic extraction," said Mr. Seabrook. "They are Abyssinians, are they not?"

"They say so," replied Mr. Shapiro.

"There is the biblical account of the visit of the Queen of Sheba to King Solomon," Mr. Seabrook continued, "and the legend that she was an Ethiopian."

"Yes, that is true," said Mr. Shapiro. "Bishop Matthews, who should be here any minute now, speaks Hebrew with an Arabic accent, something one hears very seldom. It is Palestinian Hebrew that he speaks; pure Hebrew.

"This congregation," he continued, "is at once unorthodox and orthodox. Its members eat only kosher meat. They keep the Sabbath on Saturday. They fast on Yom Kippur, eat matzos in Passover, and some of them send their children to Jewish schools.

But, as I said, they do not deny Jesus. The other two congregations do—the Congregation B'nai Beth Abraham, which has two houses at 17 and 19 West 129th Street, one of them a community house for teaching Hebrew to children and adults, and the Talmud Torah Beth Zion. The first is presided over by Rabbi Joshua Ford, and the second by Rabbi Israel Ben Newman. In all, they have a membership of some 2,000, of which more than 200 are converts—those who admit being not Abyssinians, but who accept Judaism and pass the requirements of such acceptance."

"How do the Jews themselves look upon them?" the reporter asked.

"Those of us who have approached them from a sympathetic and intelligent point of view," Mr. Shapiro replied, "do not deny them. They have, as a matter of fact, asked and received financial aid from some of the downtown synagogues."

❖ ❖ ❖

THE NEW YORK AGE, APRIL 6, 1929

DR. MOTON— DUNBAR BANK DIRECTOR

Officers of the Dunbar National Bank, operated by John D. Rockefeller, Jr., interests, at Eighth Avenue and 150th Street in the Paul Laurence Dunbar Garden Apartments, announce that Dr. Robert Russa Moton, principal of

Tuskegee Institute, has accepted their invitation to serve as a member of the bank's board of directors. Dr. Moton is the third colored member to be placed on the Dunbar Bank's board, the others being Roscoe C. Bruce, manager of the Dunbar Apartments, and Alderman Fred R. Moore, editor of the New York *Age.*

❖ ❖ ❖

AMSTERDAM NEWS, OCTOBER 23, 1929

IS THIS REALLY HARLEM?

We have with us today, ladies and gentlemen, that great friend of the Negro among white publications known as *Variety.* The claim of this publication to the friendship of men and women of dark hue is because we have yet to find an occasion wherein its writers ever wrote anything of a feature nature that could be construed as being something truthful about us and inspiring to those who mayhap might have a desire to see the Negro from a wholesome angle.

Representatives of the same *Variety* appeared recently in the offices of the *Amsterdam News,* and from their attitude it was taken that these learned gentlemen would return to Broadway and let the world see the better side of Harlem. Apparently it was not the intent of the gentlemen who so fully abused the spirit of hospitality manifested when they came, and had this writer been present on the occasion above referred to, either the tale would

have been better told or it would have been worse.

We are thinking that we would have reminded the gentlemen of *Variety* how when the last blurb appeared, which did great injustice to Negroes here, we personally advised the owner and editor-in-chief of the bent of his writers to distort when it comes to writing of what they so full-mouthedly usually term the "Black Belt."

This publication has given us something to think about, and while we must admit that everything said is not without some truth in some places in the article, we imagine that *Variety* appears always proud of an opportunity to write about a condition to which *Variety* should know white men make no small contribution and of which many intelligent members in the community are heartily ashamed. That idea of taking a residential community and making it the raging hell it is after dark is something that should arrest the attention of even ministers of the gospel—albeit we are told that one minister did look with favor on the condition because his son happened to have been employed in one of the cabarets.

We are without that civic pride that would drive these hells from among us. We are without the courage which would make it impossible for even *Variety* to from time to time heap its ridicule and questionable humor upon us. We are without all the elements that have seen white men dying if necessary for wholesome communities which have meant so much

in their onward march to progress, even though that same march is at times tinged with the ruthlessness of brutes. And until such time as we are prepared to make sacrifices towards securing those things which we want without making the true effort, we might as well stop kidding ourselves. So now let us read what *Variety* has to say of Harlem in its issue of October 16th, and well may ye who dwell therein weep:

Harlem has attained pre-eminence in the past few years as an amusement center. Its night life now surpasses that of Broadway itself. From midnight until after dawn it is a seething cauldron of Nubian mirth and hilarity. Never has it been more popular. One sees as many limousines from Park and upper Fifth Avenue parked outside its sizzling cafés, "speaks," night clubs and spiritual seances as in any other high-grade white locale in the country. A brand of entertainment is directly responsible for Harlem's present distinction. It has crashed the limelight and seems due to remain. When it comes to pep, pulchritude, punch and presentation, the Harlem places have Broadway's night clubs distanced. Celebrities in all walks of life "make" the Harlem joints every night. You'll likely see a Lady Mountbatten on the ringside of the Cotton Club, a David Belasco at another and a diplomat in the next.

In view of Harlem's rise as a playground after dark, a few of the more absorbing points of merit, demerit and interest are apropos.

It has eleven class white-trade night clubs: the Cotton Club, Connie's Inn, the Nest, Small's Paradise, Barrons, the Spider Web, the Saratoga Club, Ward's Swanee, the Catagona, the Bamboo Club and the Lenox. With a population of 250,000, the majority of whom are frequenters of night resorts, the actual number of colored cabarets of lower ranks exceeds 500, according to records in the Thirty-second Police Precinct, which station in the past year has had the second greatest booking for crime in the history of New York. This number is topped by statistics on apartment speakeasies called "buffet flats" by the Negroes. There is an average of two such joints for every apartment building in the Black Belt. Some of the "buffet flats" are called "whist clubs," "Democratic headquarters" and "parlor socials." Admission is two bits, the same for a drink.

Five out of every seven cigar stores, lunchrooms and beauty parlors in Harlem are "speaks" selling gin. More chop suey joints in Harlem than any other district of similar size in the country. Two and three to a block on every main road. Food is scaled very low and entertainment in but a few of them. Dancing permitted in all, however, to radio or phonograph. The dancing is plenty hot. The district between 132nd and 138th Streets and Fifth Avenue is the hottest sector for vice in Harlem. It is called "Coke Village." Many of the be-ermined and high-hat white gentry enter-

ing the area are on the bay for "hop." Harlem has 300 girl dancers continuously working in the joints. About 800 are always ready for an audition, of any sort. It has 150 boys, perhaps the best aggregation of tap and buck dancers extant. But 1,500 young men claim professional standing as dancers.

There are fifteen major bands and more than 100 others in action every night. Duke Ellington is the Paul Whiteman of the Black Belt. Bill Robinson is the idol of the district. Kid Chocolate runs second. Ethel Waters is the most popular and highest paid colored female entertainer in the world, succeeding the late Florence Mills. The Nick the Greek of Harlem is Casper Holstein, who operates the gambling tournaments. He is one of the six colored millionaires of the belt. The Reubens of Harlem is Tabbs, frequented by all the colored celebs. Two places, one on 132nd Street and the other on 137th Street.

The Campbell of Harlem is Granville O. Paris, whose embalming can't be tied, so they say. The Ben Rocke is Schwartz and Harrison, whose clothes are worn by all black sheiks with footlight aspirations. More than $30,000,-000 is spent a year in Harlem playing "numbers," the clearinghouse figures determining who are the winners each day. One chance in a thousand of copping first prize and 600. This game surpasses "craps" in popularity there.

Since Rye Beach has been denied the colored folks, Cape Cod is now their favorite out-of-town resort. A Negro going to Cape

Cod is on a par with a white man departing for Miami, Newport or Paris! The Park Avenue of the district is Strivers' Row, around 137th and 138th Streets. Among the colored notables residing there are Harry Wills, Fletcher Henderson, Miss Waters and Ed Small. But Strivers' Row is now getting a run for its money by "Sugar Hill" at Edgecombe and St. Nick. This spot has become fashionable since Jules Bledsoe moved in. Rents went sky-high!

❖ ❖ ❖

THE NEW YORK TIMES, OCTOBER 24, 1929

CONGESTION CAUSES HIGH MORTALITY

Representatives of city health and welfare organizations convened the first annual Harlem Health Conference yesterday and discussed plans for the improvement of living conditions in the Negro section, where the death rate as a result of congestion, it was said, is 40 per cent higher than the rate for the city as a whole.

When the program, which will revolve around the new model health center to be established by the Department of Health, is carried out, Health Commissioner Wynne told the conference, "we will be able to show a very definite decrease in morbidity and mortality in this heavily congested district." The health center, which has been approved by

Mayor Walker, will be erected at a cost of between $250,000 and $300,000.

Virtually all of the representatives of the six cooperating agencies at the conference testified to overcrowded conditions and disease resulting from congestion in unsanitary houses. The low economic position of the Negroes was held to account for the poor housing and bad health by Dr. Peyton F. Anderson of the Harlem Tuberculosis and Health Committee. At the morning session in the Y.W.C.A., 179 West 137th Street, Dr. Louis I. Dublin, statistician of the Metropolitan Life Insurance Company, said that while health conditions in Harlem were better than in the Negro sections of other large cities, the death rate was 17 per 1,000. "This high rate is primarily due," he said, "to the heavy congestion of 200,000 persons in the small area that Harlem covers. The population has doubled in the last ten years and Harlem is the most heavily congested area in the whole city. The increase in the mortality rate above that for the city is due to the higher infant mortality in Harlem."

Dr. Dublin said the infant mortality rate for Harlem for 1928 was 124 for every 1,000 births compared with 62 per 1,000 births among the white population of the city. The tuberculosis death rate in Harlem last year was 300 per 100,000 population as against 75 per 100,000 among the white population of the city. Pneumonia, he said, took three times as many lives among the Negroes as among white persons,

with 360 deaths per 100,000 as compared with 150 per 100,000 among the white population. The mortality rate in maternity cases, he said, was 10 for each 1,000 cases among Negroes as against 5 for every 1,000 cases among white persons.

Dr. Iago Galdston, of the New York Tuberculosis and Health Association, asserted that there was no such thing as racial susceptibility to disease from a biological viewpoint. Where there is a high percentage of tuberculosis among Negroes, he said, it is mainly due to environment. Dr. Galdston said the salvation of the Negro and his health problem would depend on the Negro himself. The leadership in improving environmental conditions, he added, should come from the medical profession.

❖ ❖ ❖

DAILY NEWS, OCTOBER 31, 1929

HARLEM BREAKFAST CAPS GOTHAM NIGHT

There are nine principal clubs in Harlem—three operated by whites, five by colored men, and one by a Chinese. Small's is the largest. The class of white revelers give their trade to Connie's Inn, at 132nd Street and Seventh Avenue, and to the Cotton Club, ten blocks farther north on Lenox

Avenue. But more in the spirit of the new Harlem is the Lenox Avenue Club, up one flight on the northeast corner of Lenox Avenue at 143rd Street. Here the crowd is usually about 90 per cent colored, and the 7 o'clock whistles that call the faithful back to work on Monday morning find the boys and girls of both races drinking briskly, with an hour or two yet to go.

Jeff Blount, a husky little colored man who owns a large piece of the place and acts as greeter, has hushed the 3 a.m. curfew law by getting a club charter. You will not enjoy the Lenox if you object to dancing shoulder to shoulder with colored couples—or couples whose color is mixed—on a floor that is a 5 o'clock subway rush put to music. You will not enjoy it if you blush at the dancing in the revue that suggests the end to which dancing originally was dedicated. You will not enjoy it if your ears are repelled by clamorous sound, and an occasional breath-taking snatch of unequivocal conversation.

But if you are not offended by any of these things, you may help yourself to Blount's establishment. You will be left as severely alone as you leave other people.

In its setting the Lenox is much like Small's—a large room seating about 400, with a fairly sizable dancing floor, a good colored orchestra and a hot revue. A rail runs around the dance floor, and if you are a really big shot, Jeff may seat you inside it, to give you a close-up at the show. If you are a big shot and at the same time a

poor ballplayer, you should, indeed, demand a ringside seat, for the noble custom of tossing rolled bills at the dancers as they gyrate about you is a strong tradition. And no one will approve of you if you have a weak arm.

The big event of the week at the Lenox is the Monday morning breakfast dance. With the place jammed at 3:30 or 4 a.m., the ringside tables occupied by colored entertainers from the downtown shows and other night clubs (who get their checks cut in exchange for doing their turn), Jeff orders the doors locked.

The revue gallops off the floor. The place rocks with the hilarity of 200 or more couples. A whispered word from Jeff, and an announcer steps out on the floor and claps his hands. "Folks," he calls genially, "we have a lot of nice people here this morning and we're going to see something swell, something real swell. Let's have the Bon Ton Buddies, boys, the Bon Ton Buddies from *Hot Chocolates*! Two tall, lithe colored boys, identically dressed, cast aside their napkins, take a last swallow of ginger ale and go into their tap routine. The crowd roars, raps on the table tops with glasses and little wooden hammers, and otherwise registers approval. The next act may be Jazzlips Richardson, one of the featured dancers from the same show—after him perhaps a singer —perhaps Ethel Waters, whose moaning torch songs have made her the queen of Harlem.

Around at the tables one sees

a scattering of the more sophisticated downtown night lifers. Walter Winchell, the swell scribbler, and Percy Hammond, the drama reviewer, visited for a while one night last week, just missing Harold Lloyd and his mother, who left early. Later on the same evening—or rather, morning—Betty Burnaugh, the lissome society dancer, dropped in with a party of friends. On these occasions Jeff pops from table to table, fraternizing with everyone and keeping the key of the party in the high register.

Jeff is beloved in Harlem because he gives the colored man a break. When a colored couple reaches the portals of the Lenox, the gentleman caller declares himself for so much money, and the parley between Jeff and his visitor might run something like this: "Well, I got $7, and I'd like to stay for three hours," the prospective customer explains. "How about that, Jeff, can I last?"

"I'll tell you what we'll do," Jeff will say. "You stay for three hours, and if the bill runs over your money, I'll cut the price of the ginger ale in half for you. How's that?"

"Okay, boy..." and the two troop up the stairs. —FRANK DOLAN

❖ ❖ ❖

DAILY NEWS, NOVEMBER 1, 1929

SOCIALITES MIX IN HARLEM CLUB

Should a blindfolded schoolboy poke a beanblower through the doorway of either Connie's Inn or the Cotton Club on any night after midnight and take a random

shot, he would be almost sure to pop a Broadway playboy, a rich bootlegger, an actress or a society favorite on the chin.

Connie's, on Seventh Avenue at 132nd Street, is the first white outpost on the uptown colored frontier, the first stop on the route of the downtown night clubbers. A wide red canopy stretches from the doorway to the curbstone, and once he has strolled on this tented way, the host to a party of four should be prepared to kiss a fifty-dollar bill a conclusive good-by. While at Small's Paradise the average check is only about $4 a person, at Connie's it is more likely $12, and possibly $15.

Walk down one flight of stairs and you are in this rendezvous, so low-ceilinged as to be cavelike. Around the dance floor is a three-foot barrier built in the semblance of a village, miniature bungalows and villas, and here and there a spired church, through the tiny windows of which comes the gleam of midget lights. If these lights in the windows remind any of the customers of home, sweet home, or of the little woman waiting up with a curled lip and a rolling pin, they certainly show no outward signs of such tender thoughts in Connie's. The tables are set so close together as to create an illusion of intimacy, so close, in fact, that a man must trail the waiter to his seat with extreme caution lest he slide into some haughty young thing's lap enroute.

Perhaps it wouldn't seem too cynical to remark here that Con-

nie and George Immerman, the reputed white owners of the Inn, had more than this "illusion of intimacy" in mind when they laid the tables out. It may have been that they planned to squeeze in as many suckers as possible. But even so, the place will only hold about 125 couples.

As in the Cotton Club, mixed parties are not permitted at Connie's. Colored parties with the necessary doubloons are welcomed, of course, but they look a bit lonesome, usually.

Around the ringside tables one sees many faces that have become familiar to both the Broadway and society journals. Close to the tiny-cottage rail a habitué can frequently identify the piquant Lenore Ulric, blonde Hilda Ferguson, stately beauty of "Follies" fame; he can on some nights during the off-European season see Michael Arlen, suave and smiling, rap-tap-tapping on his table in appreciation of a spine-rippling dance. Boyish Jack Pickford—Mark Hellinger and Gladys Glad, his bride—Max Schuster, the publisher—Gertrude Vanderbilt —they've all thrown a critical eye on Connie's revue. And, of course, Harry K. Thaw, without whose name no roster of night club customers would be complete.

You can tell Connie's is a high-class joint as soon as you sit down, because the waiter usually whispers that bottles should be carried in the pocket, and not be placed on the floor. Connie and George have installed their brother, Louie Immerman, as manager. Louie isn't mentioned in the list

of owners, but he probably has a slice of the melon, too. A very doggy place, this Connie's, but if you are looking for real Harlem atmosphere, it's one of the places not to go. It's merely Texas Guinan's with a colored orchestra and minus the ornate presence of La Guinan. And the guests (that's a nice word for customers, what?) are mainly graduates of the Guinan school of spending. All of which is a nice break for Connie.

The Cotton Club, on Lenox Avenue at 142nd Street, is an upstairs edition of Connie's. The same type of high-priced orchestra, the same type of revue, the same type of customers. Possibly the Cotton Club gets a little the best of it in the matter of clientele. It would seem so, at any rate, even if one passed snap judgment merely on the luxuriousness of the cars that park around the building during the whoopee hours. From time to time in the Cotton Club—especially good nights—one can call the roll of the guests from the Blue Book of Broadway and the Social Register. Emily Vanderbilt has enjoyed the show. So has the dimple-kneed Ann Pennington. Bobby Coverdale and Sailing Baruch Jr. have often played hookey from the Park Avenue drawing rooms to bask in the atmosphere. Paul Whiteman has steered his dinner-coated tonnage there many a time, and the pretty dancers have squirmed, on occasion, before the table of Mrs. Lydig Hoyt. Sid Grauman, West Coast movie

magnate, owner of the Chinese Theater in Los Angeles, knows the noises of the Harlem night. Hosts of other celebrities and near celebrities have killed the hours that lie between the last act on Broadway and poached eggs in the a.m., inside the Cotton Club's riotous precincts.

Herman Starks is the manager, and the ownership is said to be divided among a few picturesque Broadway characters who have had well-manicured fingers in many a white-light pie. These foresighted gentlemen saw the swing toward uptown jazzdom more than two years ago, and their opening of the Cotton Club has had much to do with creating the atmosphere that now pervades the new Harlem nights.

—FRANK DOLAN

❖ ❖ ❖

SUNDAY NEWS, NOVEMBER 3, 1929

"SPEAKS" WHOOP AFTER CLUBS PIPE DOWN

An important and interesting phase of the after-dark revelry that is rapidly transforming Harlem into the favorite midnight playground of the downtown spenders is the speakeasies. Peeping from the nooks and crannies of 100 blocks, these little nests of revelry offer a type of entertainment that is found neither within the precincts of the night clubs or before the bars of the downtown booze joints. Scattered throughout the district at least ten to the square block—to take the figures of a well-informed resident—the "lap joints," as they are called by the neighbors' children, cure the thirsts of thousands, white and colored, nightly. But they go beyond this function, which is the sole aim of their downtown prototypes.

With the instinct for entertainment that is inherent in the race, the colored speakeasy proprietor provides a show for those of his customers who can stay awake and listen, or watch. In the main, the speakies are patronized solely by colored men and women, but in the last year the so-called "better places" have made a strong bid for the white trade, the patronage of the man who becomes bored with the prancing of the cabaret revues.

There are about a dozen of this type, and we'll describe a few. (That's all right, Joe. I won't name exact locations. I used to be a speakeasy fan myself.) You drive up in front of a brownstone house, the doorman comes over and greets you with a deep salaam and a broad smile, which is Harlemese for saying: "Hello, dough. Come in and stay a while."

The doorman escorts you to a barred door. He has never seen you before in his life. Yet he rings the bell, a shutter is thrown back, and he whispers to the inside man: "Okay, Charlie. These people are all right."

A few steps, and suddenly you are in a small room, crowded with men and women. At one end stands a bar, behind which a tall, placid-looking colored man is working studiously. At the other end an old piano emits discordant howls of pain, wriggling beneath the punishing fingers of an ambitious local pride who someday hopes to get good enough for a regular cabaret. There is sawdust on the floor, and the ventilation is bad, holding in the tiny space the odors of the bar and the almost choking cigarette smoke. Several white women sit about without escorts. Over there is a sleazy blonde, lazily sipping something—possibly water.

Against the bar, carrying on an animated conversation with a colored hoofer out of work, another blonde leans and drinks. Mabel, the fat entertainer who sang so many mammy songs she sort of took on the contours, asks for a number. "Spruce," she says to the key-beater, "give me 'I'm Busy and You Can't Come In.'" By the way, "Spruce" is the word that Harlemites use to indicate a sucker. She sings with much tossing of the hips, and when she comes to the chorus a resident of the neighborhood who has been taking them straight jumps up from a nearby table and goes into a dance. You don't get away with any half-hearted applause with Mabel. She strolls over when the song is finished, and without any preliminaries says to the waitress: "Mine will be sherry, deary—on this gentleman." Mabel is a trouper.

The brand of rye served in most of the "good" places compares only poorly with the stuff at many of the downtown speakies.

The rye seemingly has been cut a few extra slashes, but now and then one finds a Harlem speaky in which it is drinkable—if one goes in for that sort of thing. All liquors at these better places are 50 cents a drink, including gin. And although it is generally understood that the colored drinkers go heavy for gin, bootleggers say there is very little market for it in Harlem now. The colored tipplers have switched from gin to rye and Scotch, just as the colored gamblers have switched from craps to stud poker.

Business in the speakeasies does not pick up generally until after 3 a.m., when the cabarets that have no charter close. There is one, however, that does a rushing business with clients of both races from midnight on. This place, which I will discreetly call Charlie's, for that is not its name, is fitted out in style. It is run by an Irishman who does his own bartending, being something of a conservative, and the class of the Harlem actors and actresses make it their hangout. The bar runs the entire length of the room—a room about sixty feet long—and in back of the bottles, whose labels assure you that Haig & Haig, Mr. Hennessy and Peter Dawson really aren't dead, after all, pictures of prize fighters in stilted attitudes go clear up to the ceiling.

We had a little talk with Charlie. He seemed a bit out of place. We discovered that far from being dissatisfied with his stand, he wouldn't swap it "for any place in the city," to use his own words.

"I get along great with colored people," he said. "I treat them right, and they treat me more than right. I serve good stuff, and when they go broke I let them run a tab, and when they need more money I let them have it. They like me."

The back room of Charlie's holds about fifteen tables, streak-marble-topped, and there the class of drinking Harlem assembles nightly and sips the merry varnish. Few white people patronize the place, but the prices are the same as at any of the downtown bars.

That's one side of the speakeasy situation. Here's another side. For every good speakeasy in Harlem—for every place that sells fairly drinkable stuff—there are four or five that peddle 'smoke,' that product of the Bowery that makes a wildcat out of a mouse. This stuff, a poor grade of alcohol mixed with water, sells for 15 cents a drink, and has plenty of fans among the poorer classes of the colored people.

Another rum racket is pulled under the innocent title "rent parties." These are thrown by men and women who have trouble making their salaries stretch to meet the demands of their landlords. Most everyone in the neighborhood is invited to the rent parties, and the usual procedure is to sell a cheap brand of liquor at 25 cents a drink until either the rent is made up or the patrons pass out.

The language of the speakeasy, which is the language of the real Harlem, is a strange one to the neophyte. The stranger who plans a complete tour of the night club circuit should know the following at least: **Kelt** means a white person. **Funkey** is used to describe the odor of perspiration, as "a funkey old man." **Bolido** is the gambling game on the New York clearing-house numbers. **Blue** means a very dark colored person. **Freakish** is used to describe an effeminate man or a mannish woman. **Dicty** is used to describe a high-class person — a good sport. **Honey man** is a man who is kept by a woman. **Sweet man** is the same as honey man. **Passing** is the act of a colored person passing for white. **A passer** is a person who can pass as white. **Boodle** means a lot of anything. **Dogs** mean feet. **Chitterlings** is a tripe-like food, made from the lining of a pig's stomach. **Snouts** are pickled pig's snouts, a popular delicacy. **Monkey-hugger** is used by American colored folk to describe the colored people who come from the West Indies. **Scronch** is a dance. **Eight-ball** is used to describe a very dark colored person. **Skip** means a dance. **Walk that broad** means show some pep in dancing with that girl. **Lap** is liquor. **Bird's-eye maple** is a light mulatto girl. **High yaller** is the same as a bird's-eye maple. **Spruce** means a sucker. **Getting high** means getting drunk. **High** means drunk. **Juice joint** is a speakeasy. **Working moll** means a prostitute. **Buzz cart** is an automobile. **Lammer** means automobile. **Gigwatny** is a colored person. **Fay** means a white person. **Unsheiking** is descriptive of a woman trying to get a divorce.

—FRANK DOLAN

❖ ❖ ❖

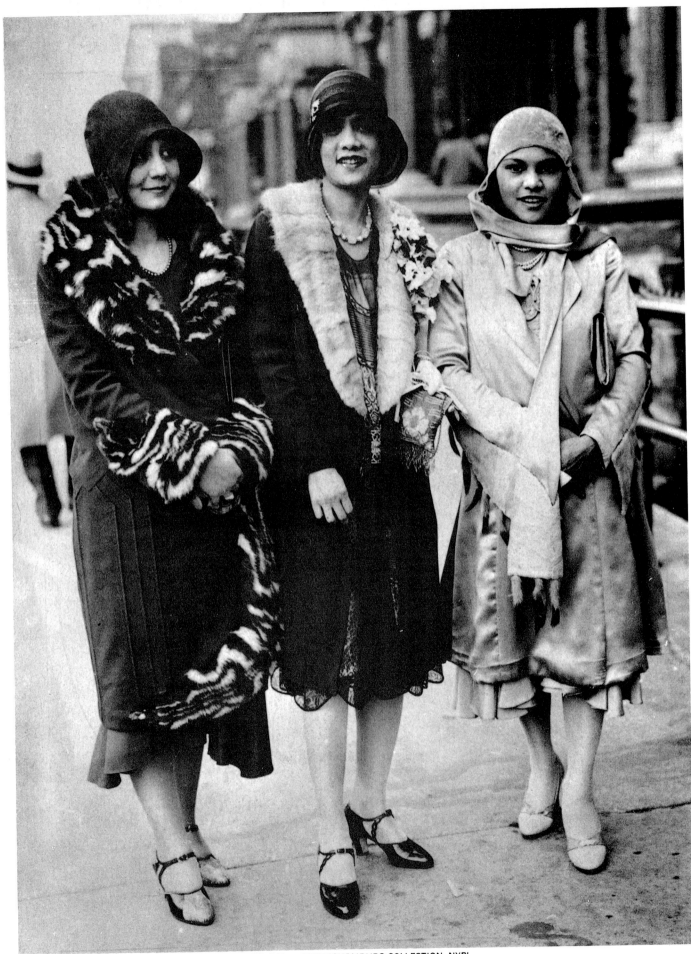

"THE GAY NORTHEASTERNERS" STROLLING ON SEVENTH AVE., c. 1927/SCHOMBURG COLLECTION, NYPL

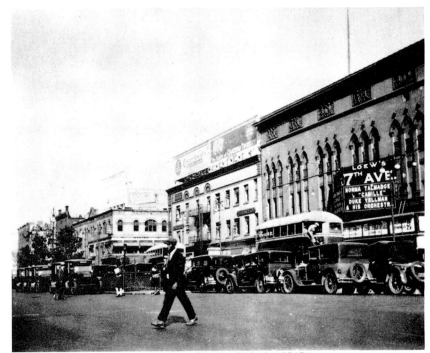

SEVENTH AVE. AND 124th ST., c. 1929/NEW YORK PUBLIC LIBRARY

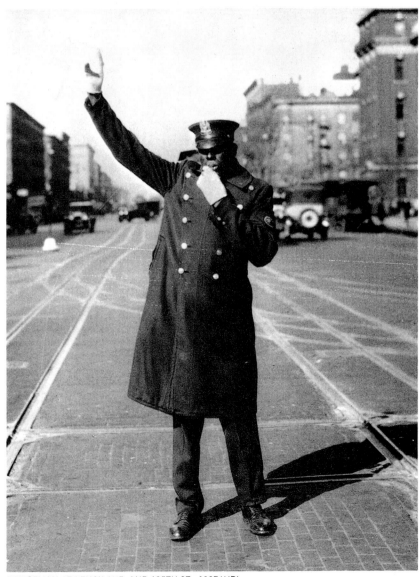

POLICEMAN AT LENOX AVE. AND 135TH ST., 1927/UPI

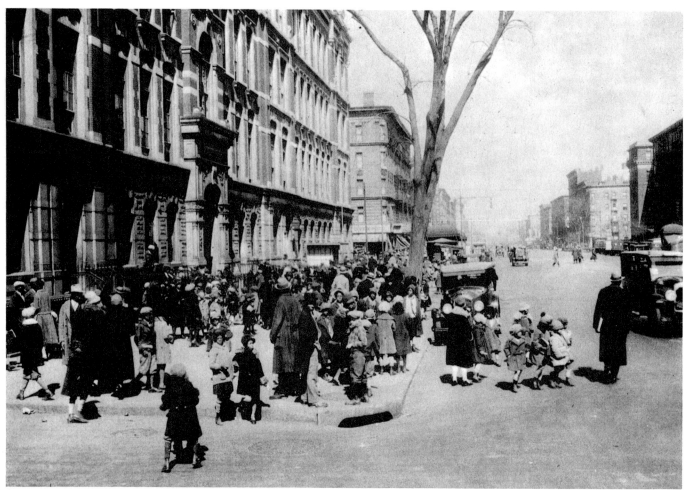

"SCHOOLS OUT," 1927 / UPI

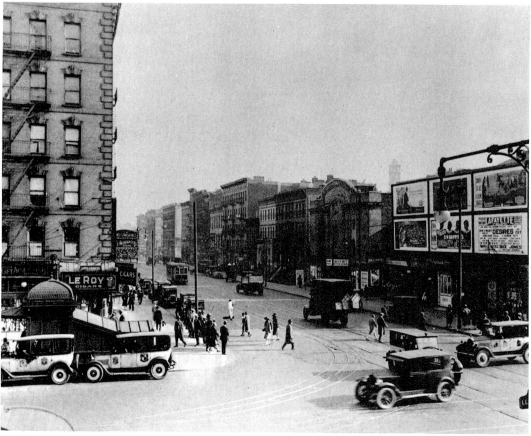

LENOX AVE. AND 135TH ST., 1927 / UNDERWOOD AND UNDERWOOD

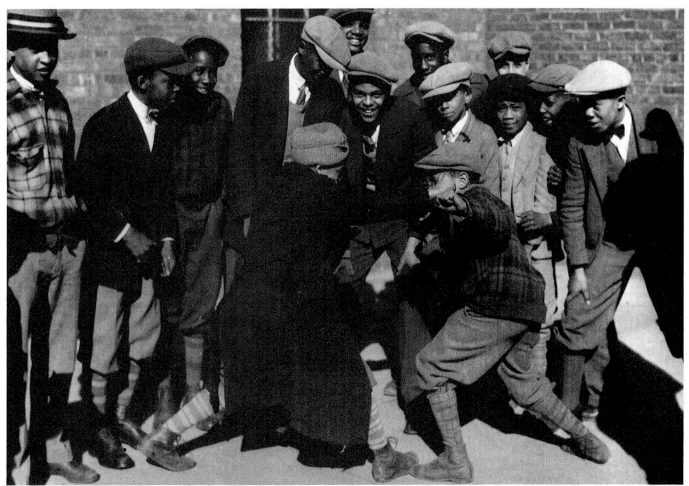

"A FRIENDLY DISPUTE," 1927/UPI

OTIS C. BUTLER/INTERIOR DECORATIONS SHOP, c. 1926/SCHOMBURG COLLECTION, NYPL

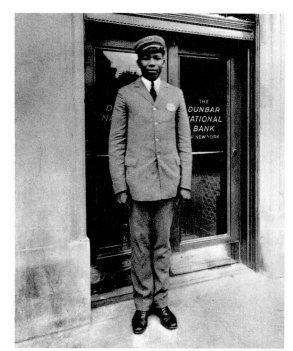

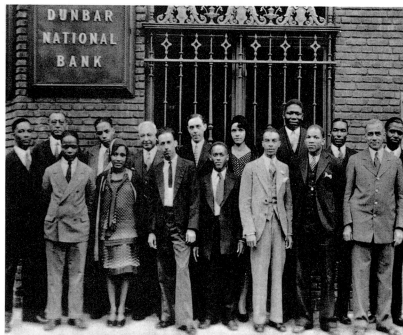

DUNBAR BANK GUARD, 1928/SCHOMBURG COLLECTION, NYPL DUNBAR BANK STAFF, 1928/SCHOMBURG COLLECTION, NYPL

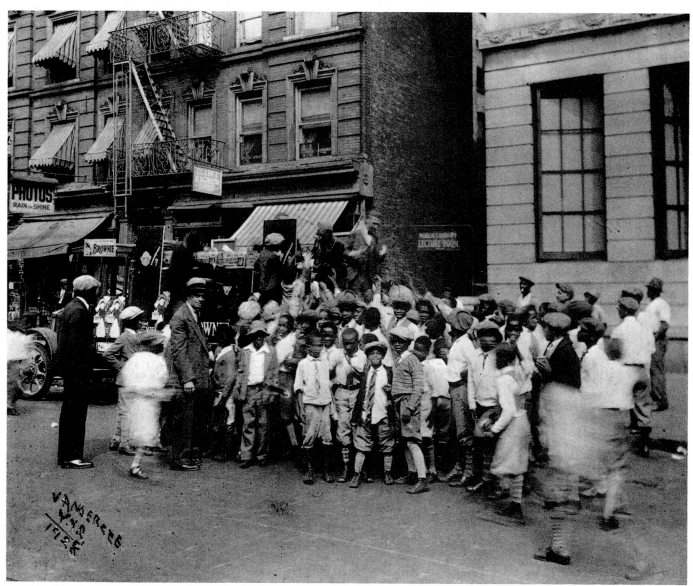

JAMES VANDERZEE/REFRESHMENT TRUCK ON 135TH ST., 1928/G.G.G. STUDIO

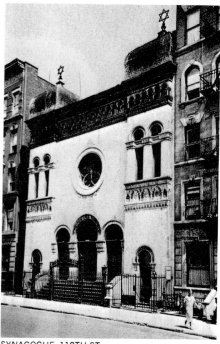

ST. ALOYSIUS ROMAN CATHOLIC CHURCH,
WEST 132ND ST., c. 1927
NEW YORK PUBLIC LIBRARY

CASA DEL POPOLO, 118TH ST.,
c. 1927/NEW YORK PUBLIC LIBRARY

SYNAGOGUE, 118TH ST.,
c. 1927/NEW YORK PUBLIC LIBRARY

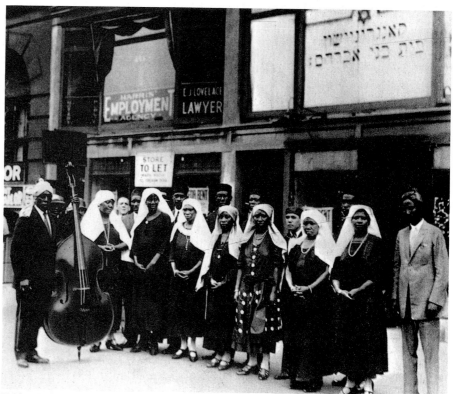

BLACK JEWS, 1929/UNDERWOOD AND UNDERWOOD

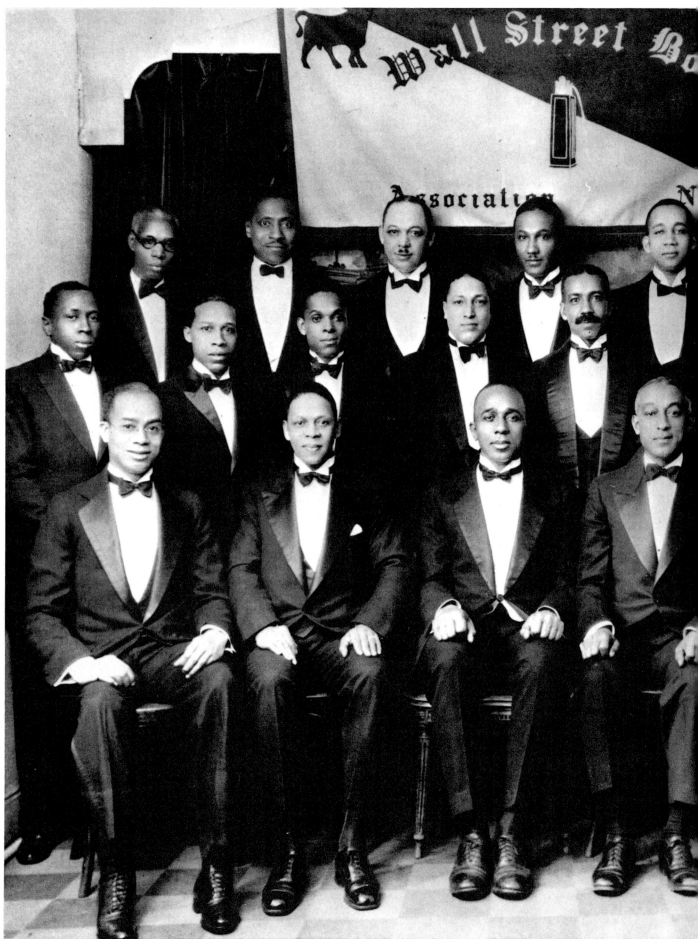

WALL STREET BOYS, c. 1925/SCHOMBURG COLLECTION, NYPL

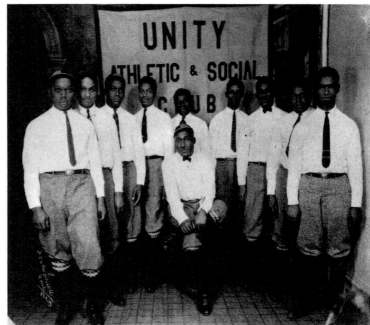

JAMES VANDERZEE/UNITY ATHLETIC & SOCIAL CLUB, 1923/G.G.G. STUDIO

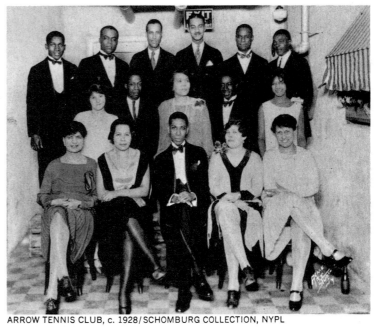

ARROW TENNIS CLUB, c. 1928/SCHOMBURG COLLECTION, NYPL

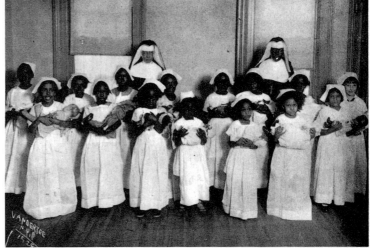

JAMES VANDERZEE/ST. MARY'S SCHOOL, 1928/G.G.G. STUDIO

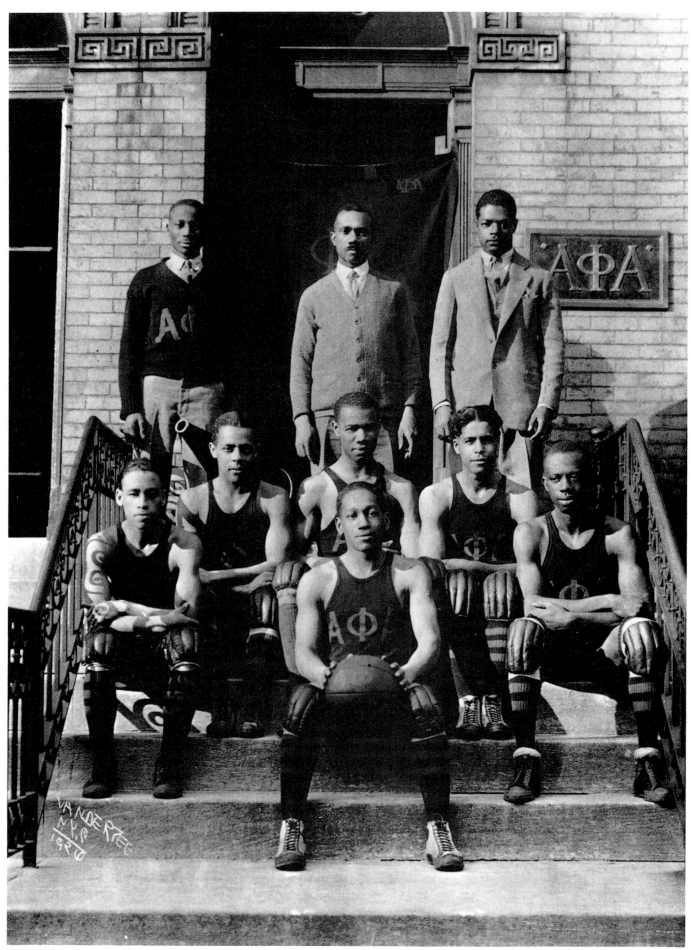

JAMES VANDERZEE/ALPHA PHI ALPHA BASKETBALL TEAM, 1926/G.G.G. STUDIO

94

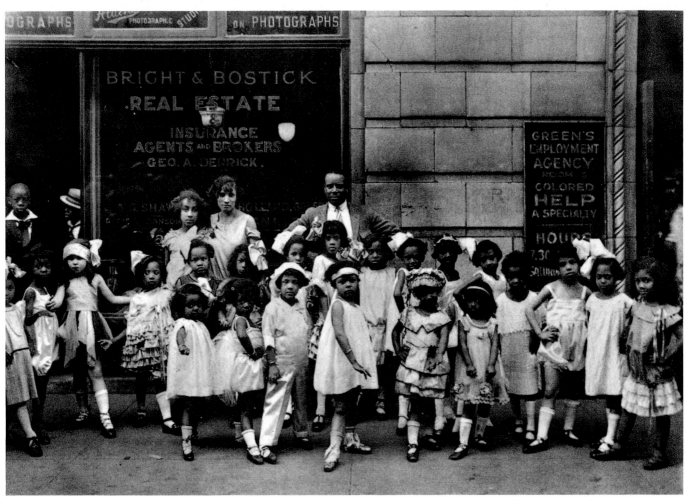

OTIS C. BUTLER/CHILDREN'S FASHION CONTEST, c. 1928/SCHOMBURG COLLECTION, NYPL

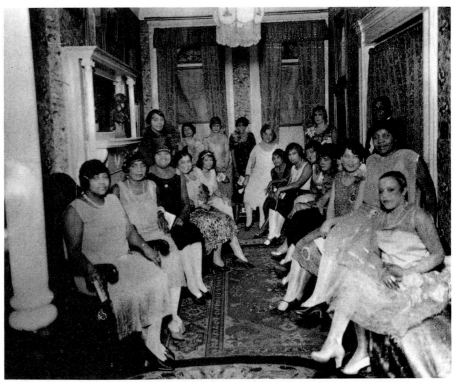

CASPER HOLSTEIN ENTERTAINING AT LADIES CLUB, c. 1923/SCHOMBURG COLLECTION, NYPL

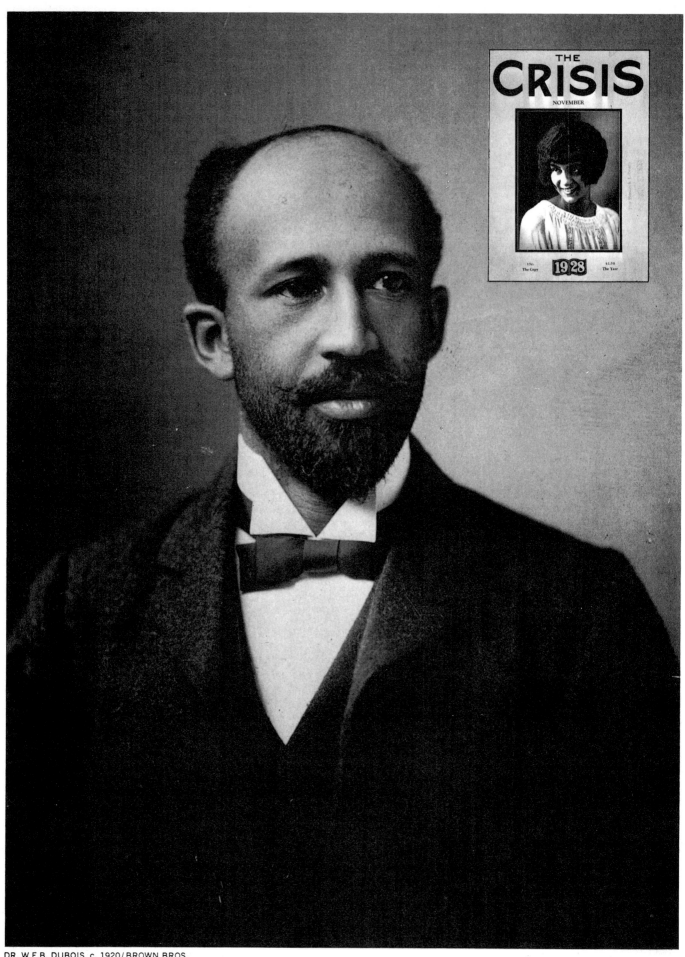

DR. W.E.B. DUBOIS, c. 1920/ BROWN BROS.
(INSET) THE CRISIS MAGAZINE, NOVEMBER 1928

LANGSTON HUGHES, BUSBOY, 1925
UNDERWOOD AND UNDERWOOD

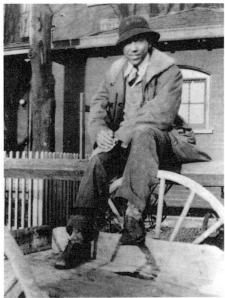

LANGSTON HUGHES, LINCOLN U., 1927
SCHOMBURG COLLECTION, NYPL

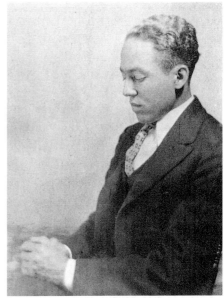

LANGSTON HUGHES, AUTHOR, 1929
SCHOMBURG COLLECTION, NYPL

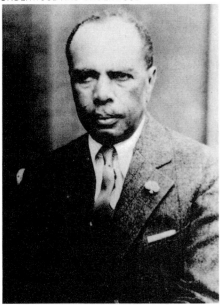

JAMES WELDON JOHNSON, 1928
NATIONAL URBAN LEAGUE

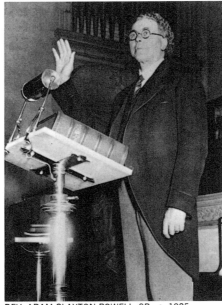

REV. ADAM CLAYTON POWELL, SR., c. 1925
UNDERWOOD AND UNDERWOOD

A. PHILIP RANDOLPH, c. 1928
SCHOMBURG COLLECTION, NYPL

SGT. SAMUEL J. BATTLE, 1926/UPI

CASPER HOLSTEIN, 1928/UPI

JAMES VANDERZEE/FERDINAND Q. MORTON,
1924/G.G.G. STUDIO

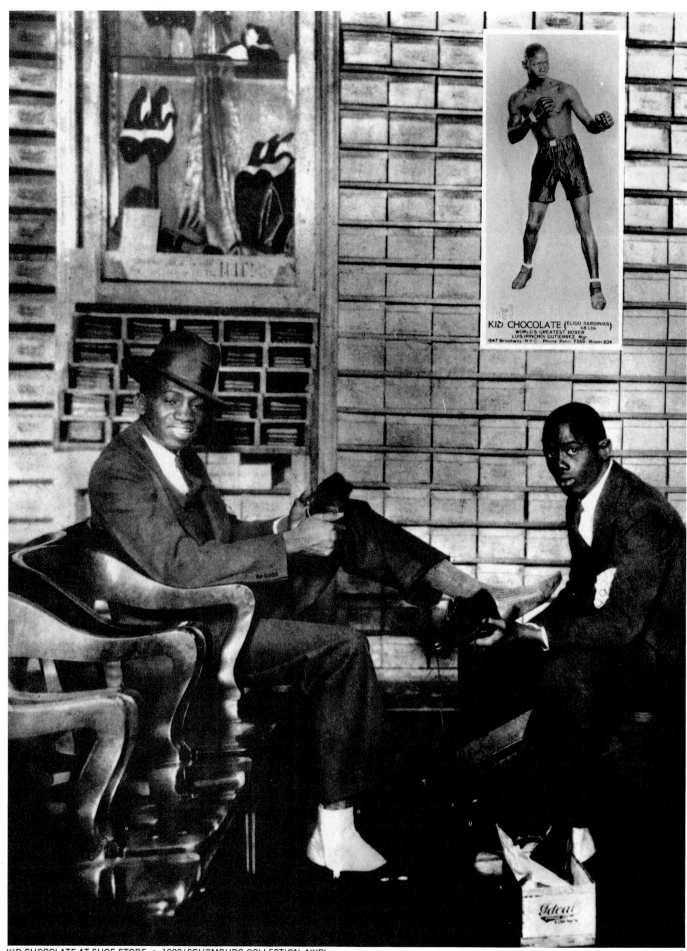

KID CHOCOLATE AT SHOE STORE, c. 1929/SCHOMBURG COLLECTION, NYPL
(INSET) KID CHOCOLATE POSTER, c. 1928/SCHOMBURG COLLECTION, NYPL

FLORENCE MILLS, 1927/SCHOMBURG COLLECTION, NYPL

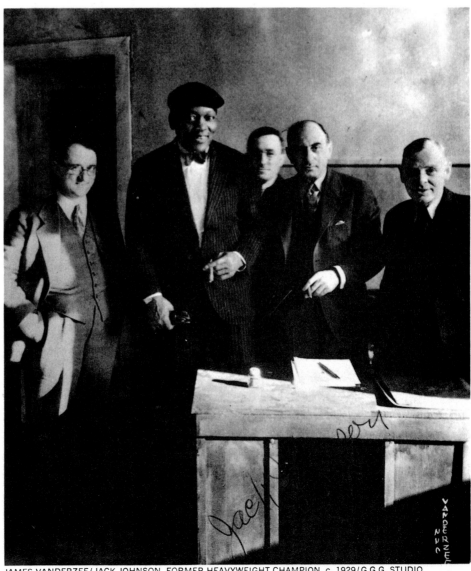

JAMES VANDERZEE/JACK JOHNSON, FORMER HEAVYWEIGHT CHAMPION, c. 1929/G.G.G. STUDIO

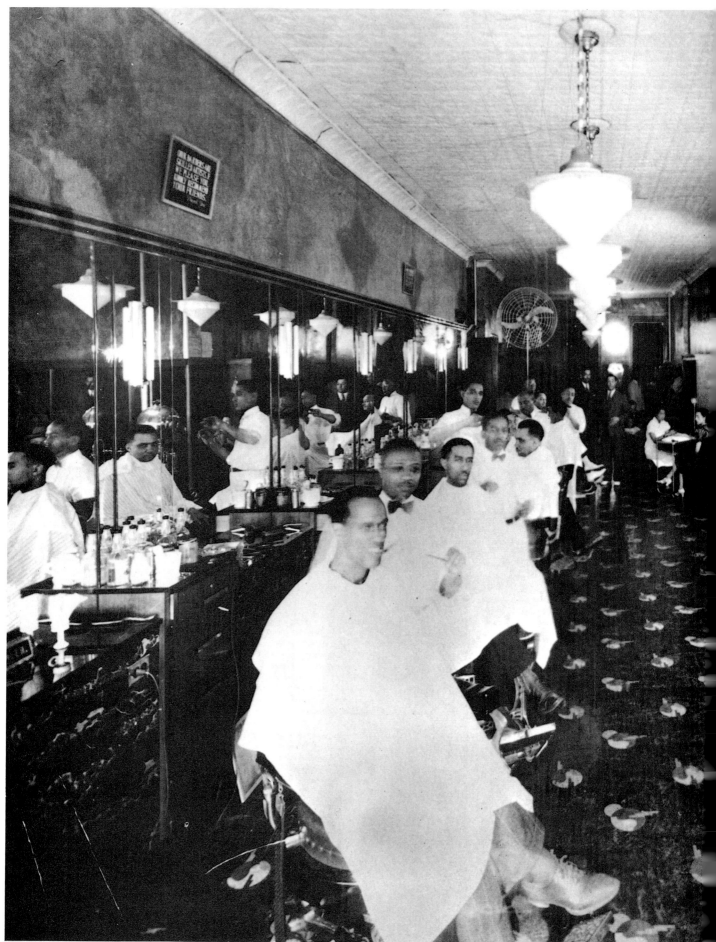

BARBER SHOP, c. 1929/SCHOMBURG COLLECTION, NYPL

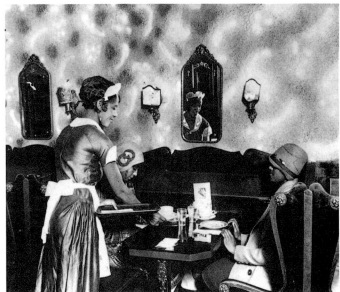

SODA SHOPPE, c. 1929/ UNDERWOOD AND UNDERWOOD

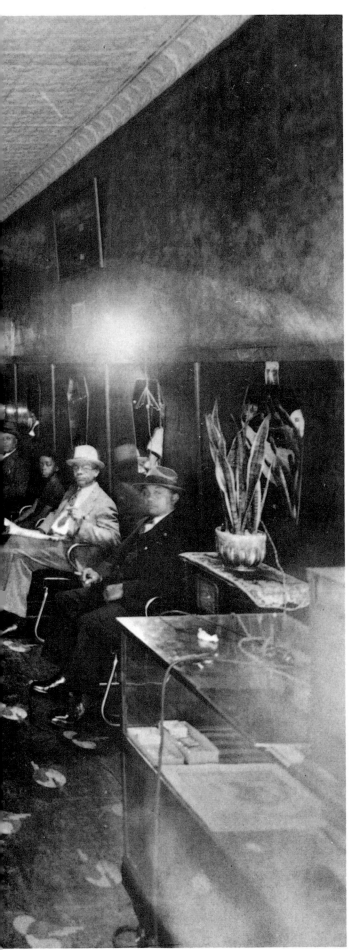

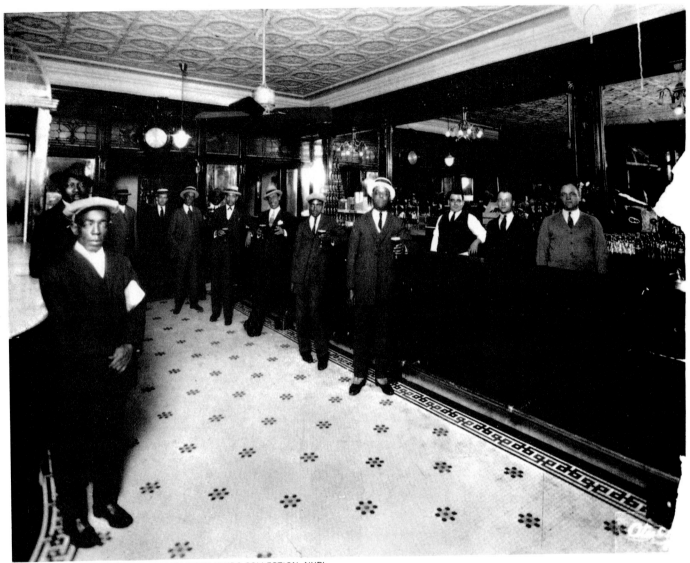

OTIS C. BUTLER/"A LAST DRINK," 1920/SCHOMBURG COLLECTION, NYPL

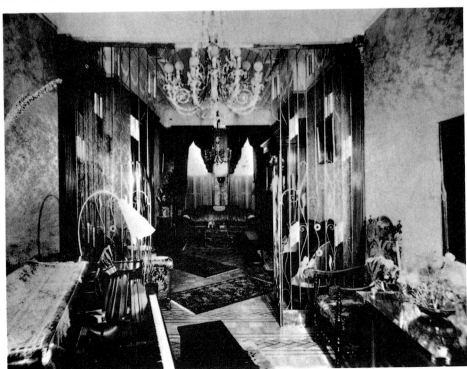

REV. BECTON'S HOME, c. 1925/SCHOMBURG COLLECTION, NYPL

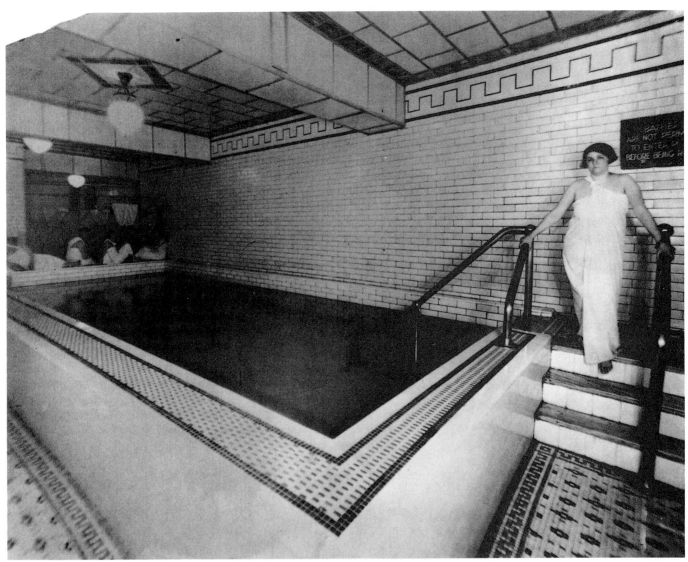

TURKISH BATH, c. 1926/SCHOMBURG COLLECTION, NYPL

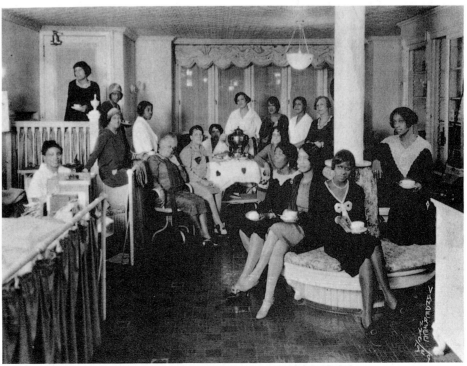

JAMES VANDERZEE/TEA TIME AT WALKER BEAUTY PARLOR, 1929/G.G.G. STUDIO

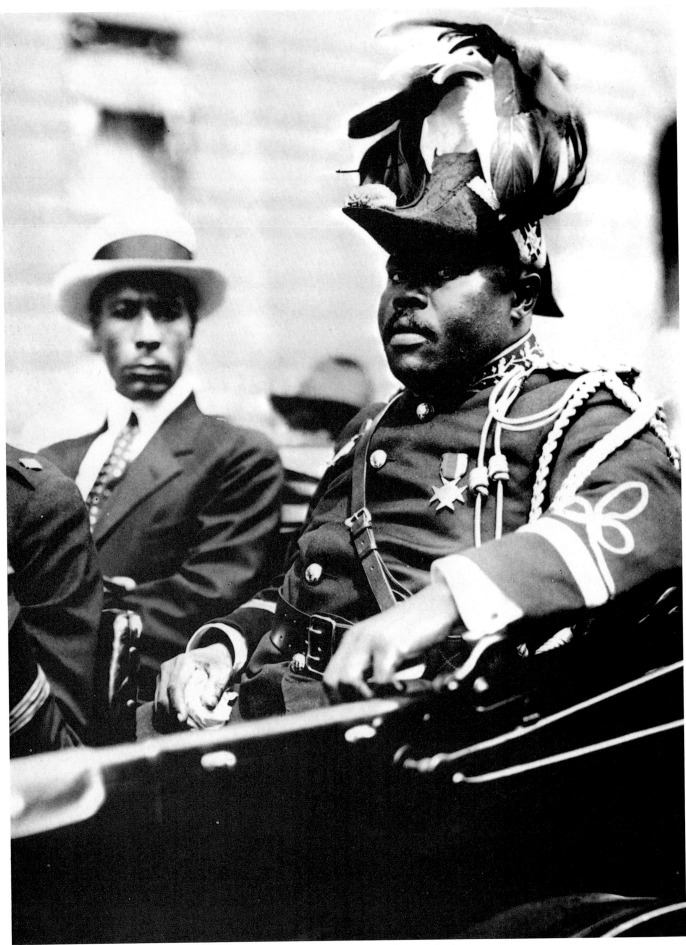

MARCUS GARVEY, c. 1922/N.Y. DAILY NEWS PHOTO

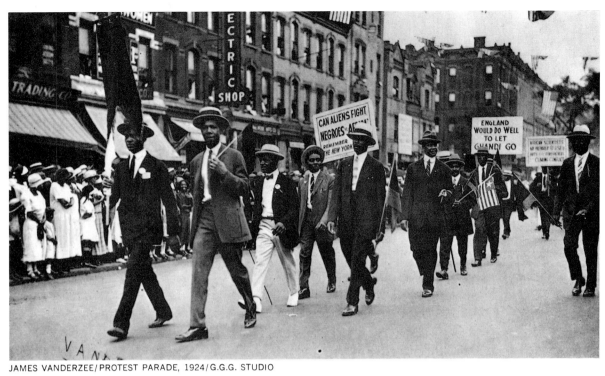

JAMES VANDERZEE/PROTEST PARADE, 1924/G.G.G. STUDIO

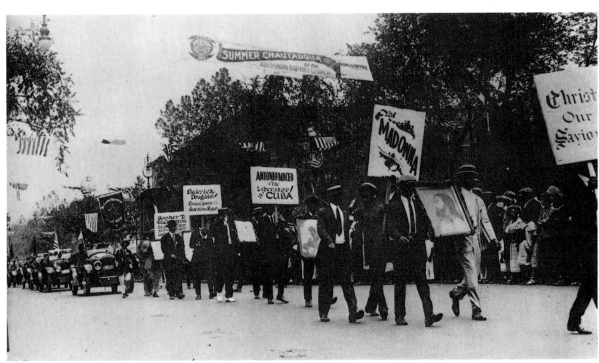

ABYSSINIAN BAPTIST CHURCH PARADE, 1924/UNDERWOOD AND UNDERWOOD

JAMES VANDERZEE/ GARVEY LADIES BRIGADE, 1924/ G.G.G. STUDIO

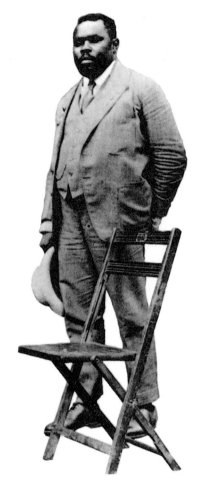

JAMES VANDERZEE/ MARCUS GARVEY: PORTRAIT, 1924/ G.G.G. STUDIO

JAMES VANDERZEE/ BLACK CROSS NURSES, c. 1924/ G.G.G. STUDIO

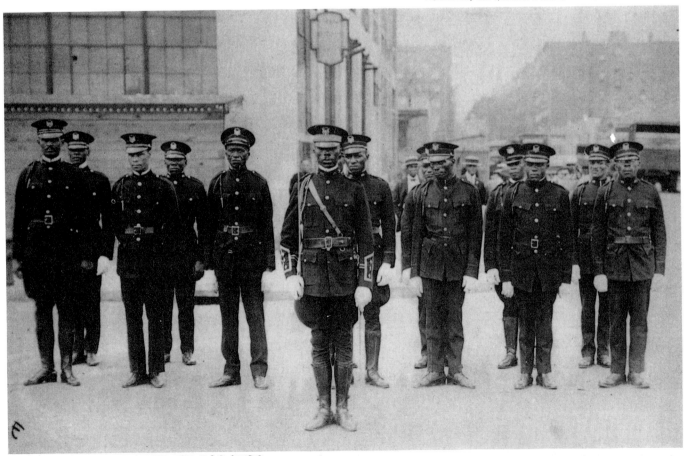

JAMES VANDERZEE/ GARVEY MILITIA, 1921/ G.G.G. STUDIO

106

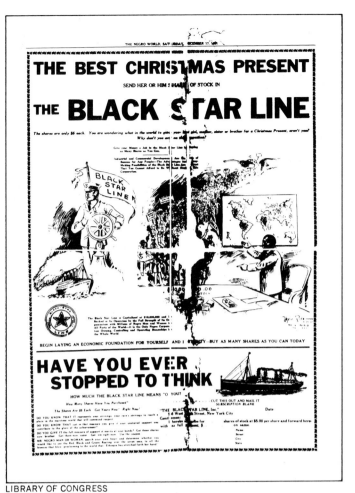

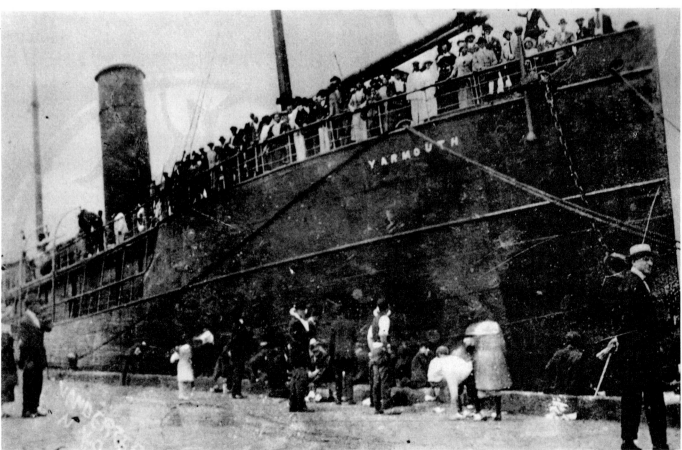

JAMES VANDERZEE/BLACK STAR LINE'S "YARMOUTH," c. 1924/G.G.G. STUDIO

PAUL BACON COLLECTION

PAUL BACON COLLECTION

FRANK DRIGGS COLLECTION

LES ZEIGER COLLECTION

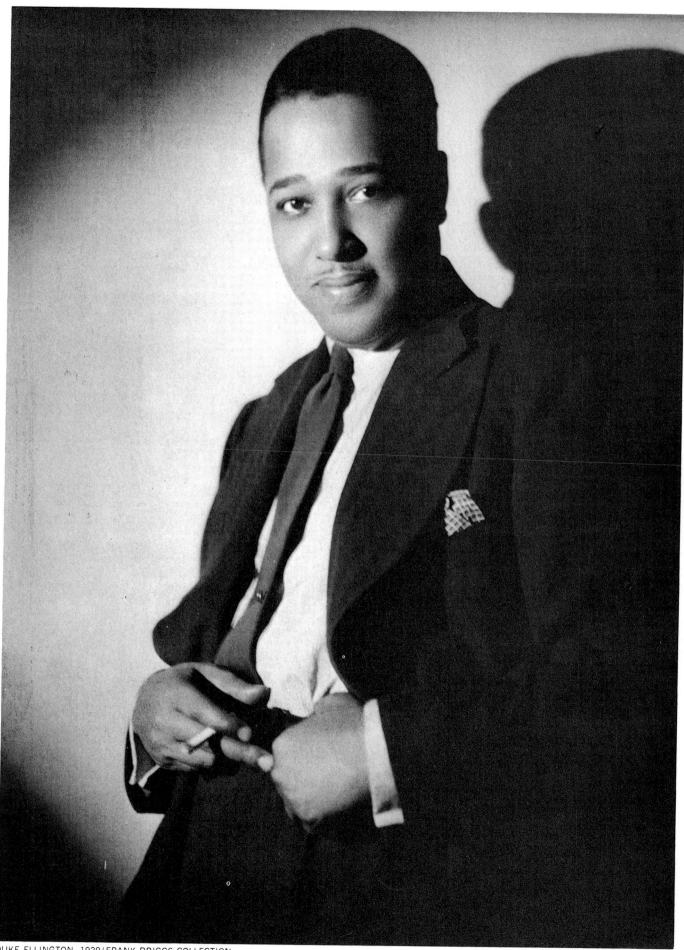

DUKE ELLINGTON, 1929/FRANK DRIGGS COLLECTION

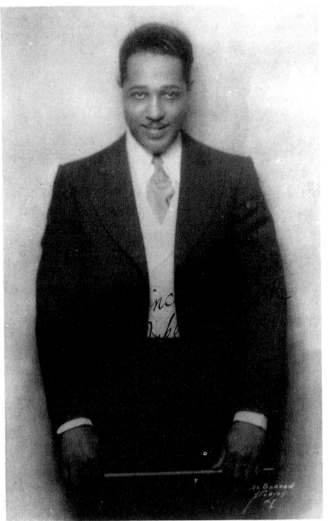

DUKE ELLINGTON, c. 1928/ERNEST SMITH COLLECTION

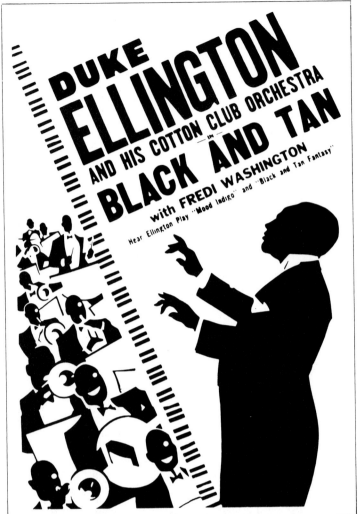

ERNEST SMITH COLLECTION

LES ZEIGER COLLECTION

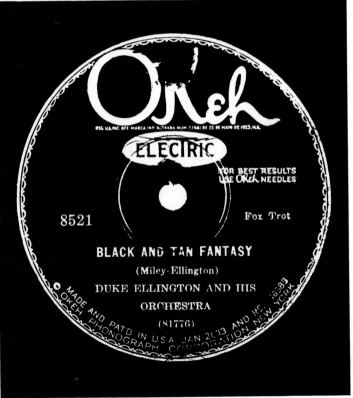

PAUL BACON COLLECTION

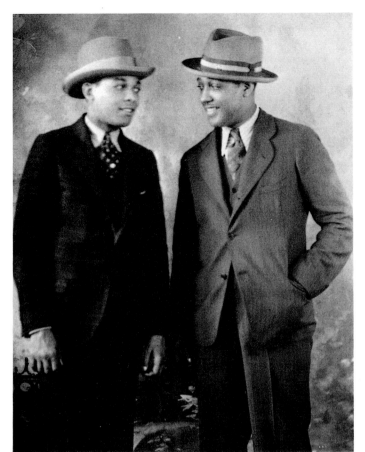

DUKE ELLINGTON AND BANJOIST FRED GUY, c. 1925
FRANK DRIGGS COLLECTION

NEW YORK PUBLIC LIBRARY

ERNEST SMITH COLLECTION

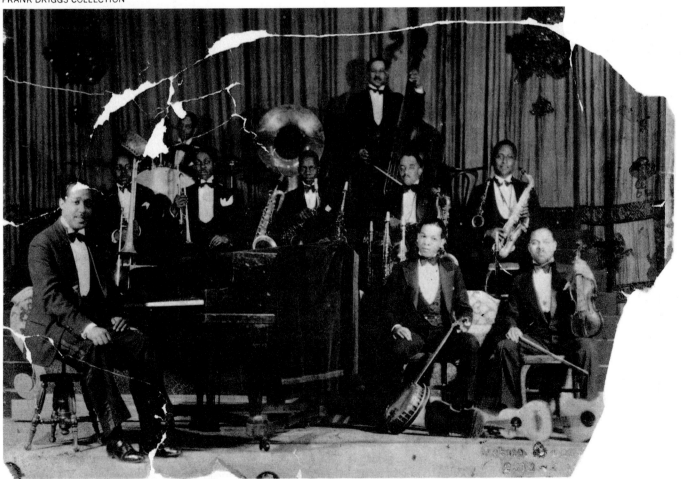

EARLY DUKE ELLINGTON ORCHESTRA, c. 1926/FRANK DRIGGS COLLECTION

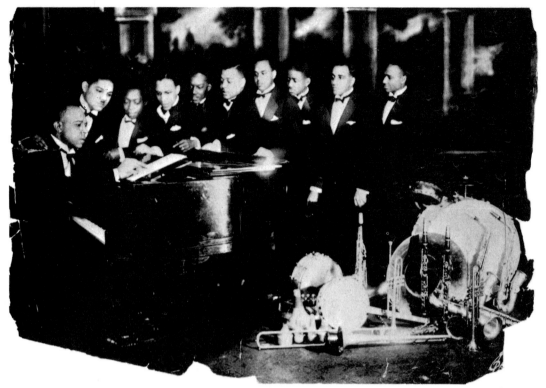

J. ROSAMOND JOHNSON ORCHESTRA—"HARLEM ROUNDERS," 1924/SCHOMBURG COLLECTION, NYPL

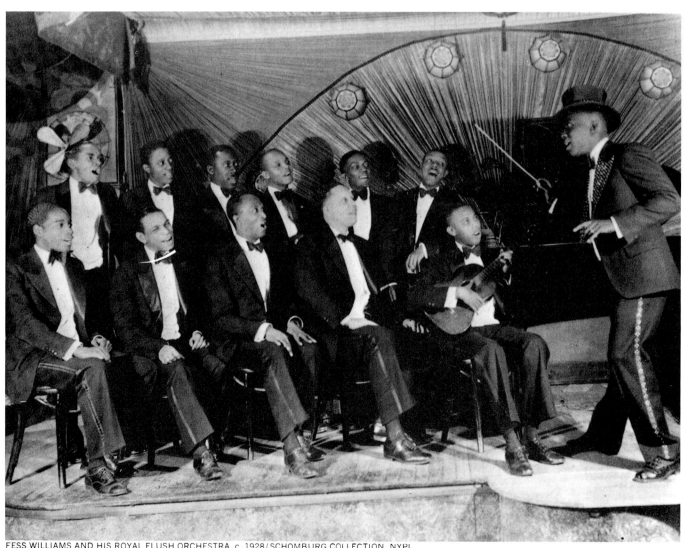

FESS WILLIAMS AND HIS ROYAL FLUSH ORCHESTRA, c. 1928/SCHOMBURG COLLECTION, NYPL

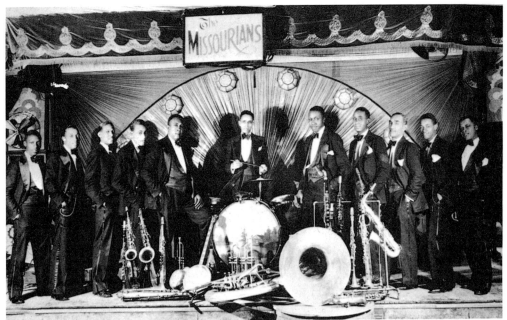

THE MISSOURIANS, c. 1926/SCHOMBURG COLLECTION, NYPL

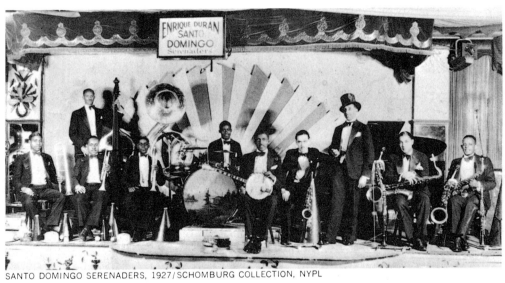

SANTO DOMINGO SERENADERS, 1927/SCHOMBURG COLLECTION, NYPL

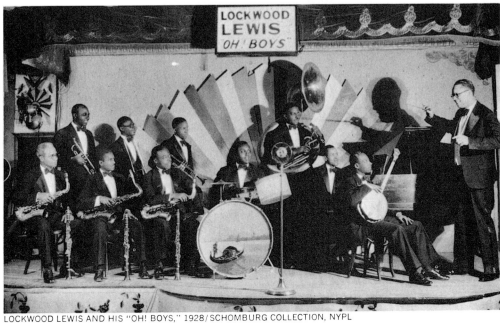

LOCKWOOD LEWIS AND HIS "OH! BOYS," 1928/SCHOMBURG COLLECTION, NYPL

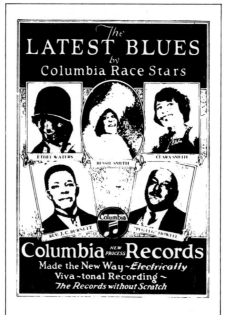

LES ZEIGER COLLECTION

LES ZEIGER COLLECTION

NEW YORK PUBLIC LIBRARY

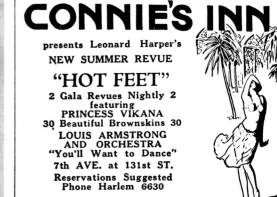

ERNEST SMITH COLLECTION

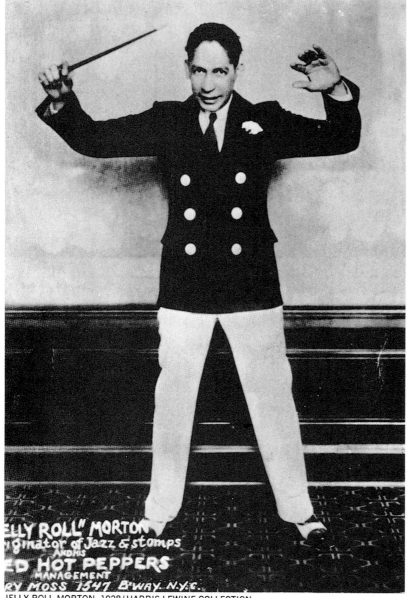

JELLY ROLL MORTON, 1928/HARRIS LEWINE COLLECTION

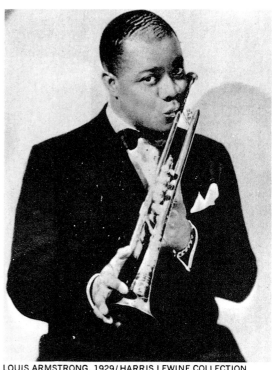

LOUIS ARMSTRONG, 1929/HARRIS LEWINE COLLECTION

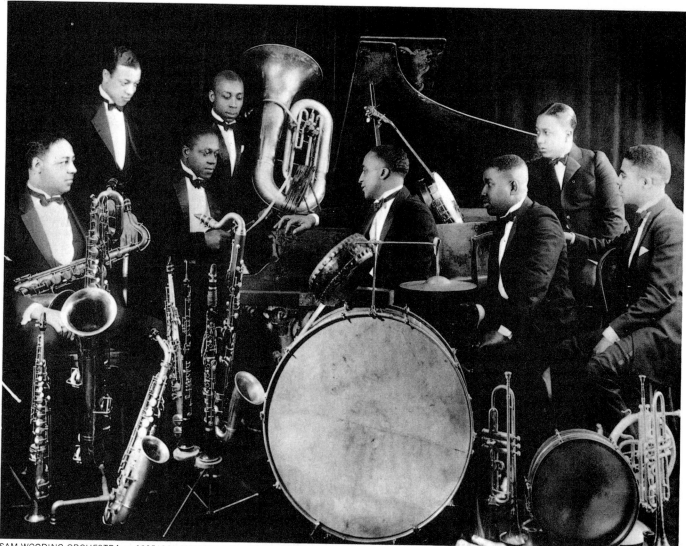

SAM WOODING ORCHESTRA, c. 1925/SCHOMBURG COLLECTION, NYPL

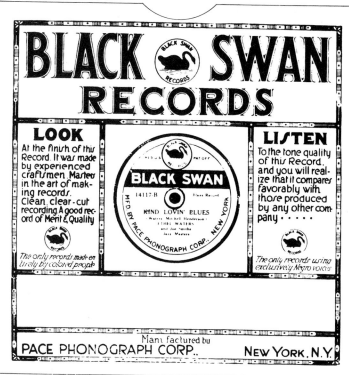

LES ZEIGER COLLECTION

FLETCHER HENDERSON, 1926/FRANK DRIGGS COLLECTION

FRANK DRIGGS COLLECTION

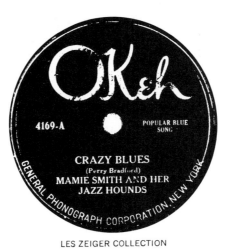

LES ZEIGER COLLECTION

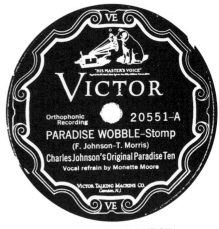

PAUL BACON COLLECTION

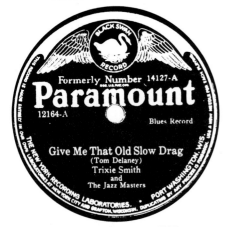

FRANK DRIGGS COLLECTION

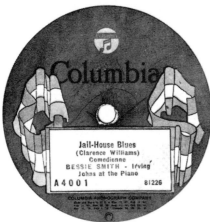

PAUL BACON COLLECTION

FRANK DRIGGS COLLECTION

FRANK DRIGGS COLLECTION

PAUL BACON COLLECTION

LES ZEIGER COLLECTION

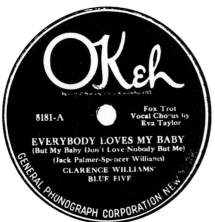

PAUL BACON COLLECTION

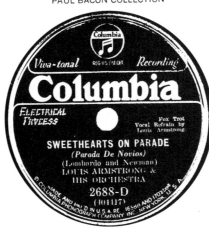

PAUL BACON COLLECTION

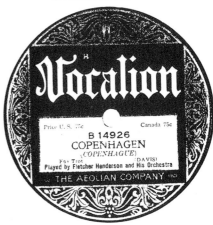

PAUL BACON COLLECTION

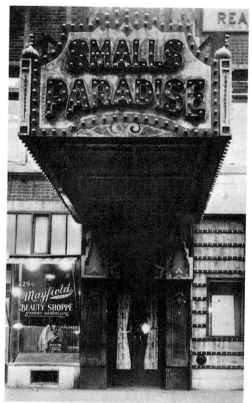

SMALL'S PARADISE, c. 1929
SCHOMBURG COLLECTION, NYPL

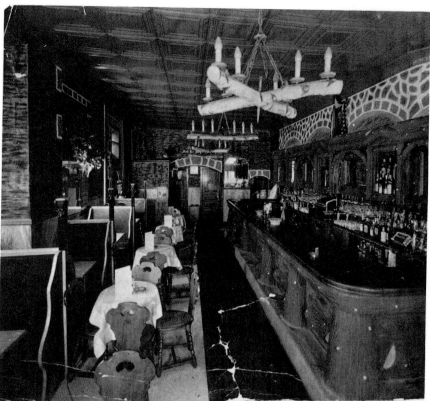

INTERIOR, HARLEM BAR, c. 1927/SCHOMBURG COLLECTION, NYPL

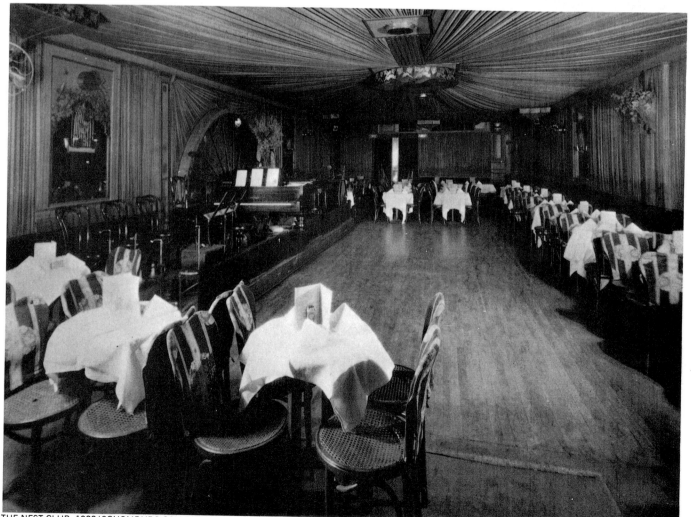

THE NEST CLUB, 1928/SCHOMBURG COLLECTION, NYPL

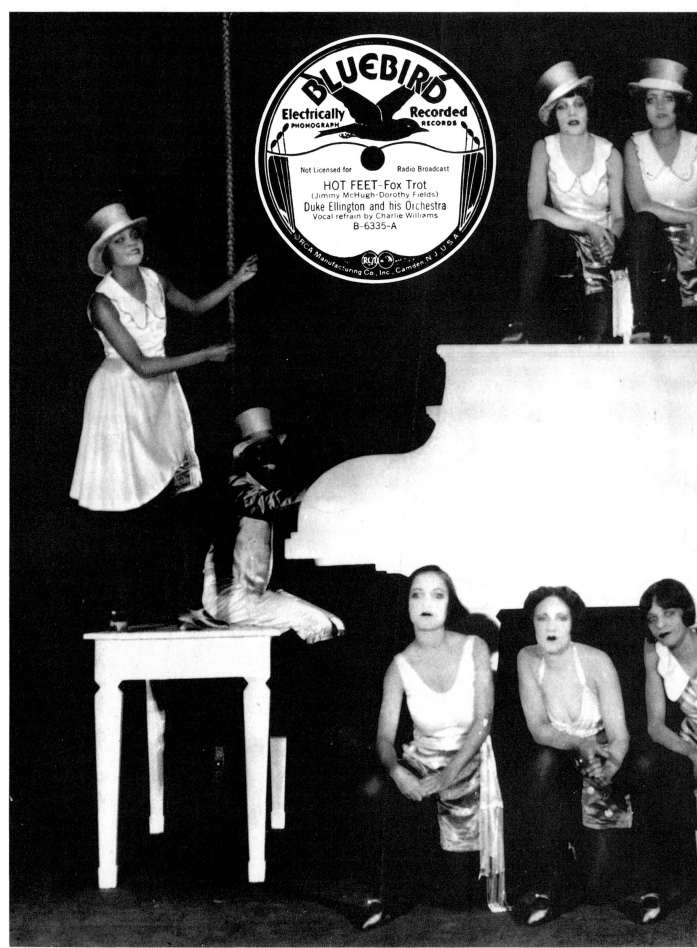

FLORENCE MILLS IN "DIXIE TO BROADWAY," 1924/BROWN BROTHERS
(INSET) RECORD LABEL, LES ZEIGER COLLECTION

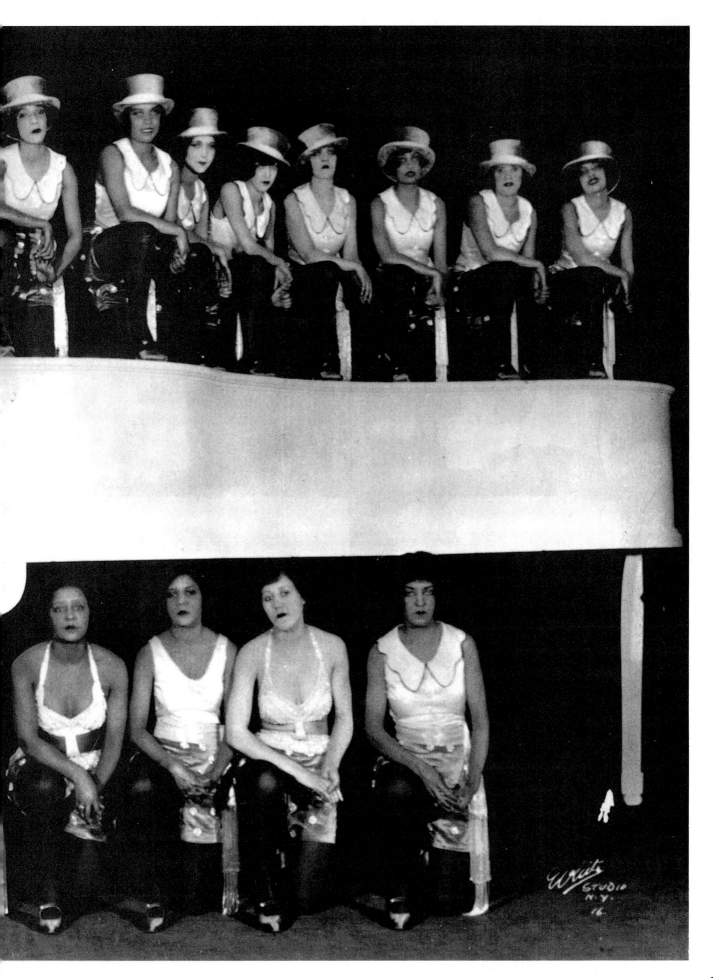

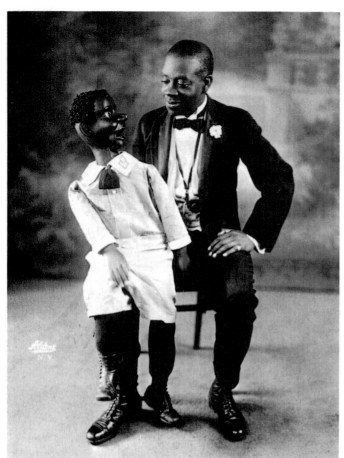

VENTRILOQUIST, c. 1929/SCHOMBURG COLLECTION, NYPL

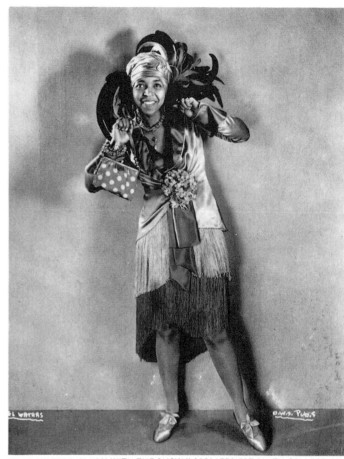

ETHEL WATERS IN "ON WITH THE SHOW," 1929/ERNEST SMITH COLLECTION

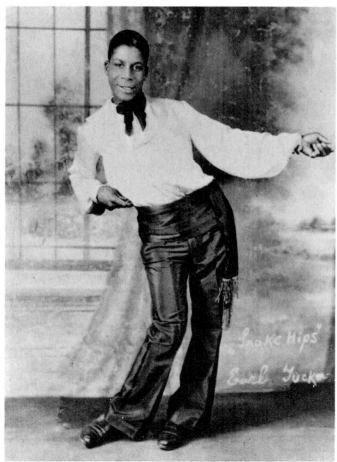

EARL "SNAKE HIPS" TUCKER, c. 1925/SCHOMBURG COLLECTION, NYPL

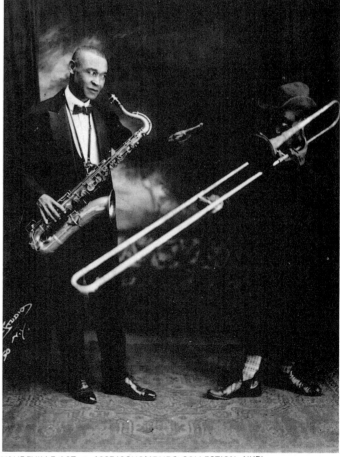

VAUDEVILLE ACT, c. 1927/SCHOMBURG COLLECTION, NYPL

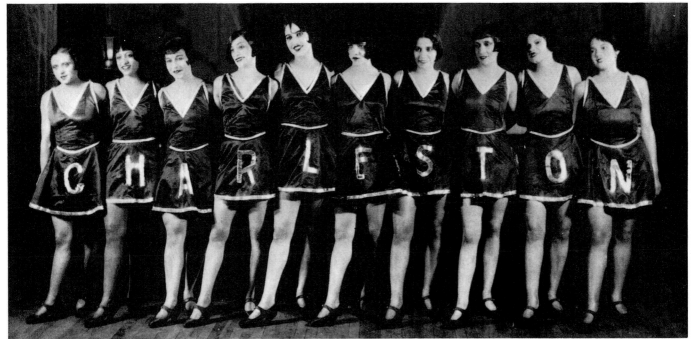

OTIS C. BUTLER/"CHARLESTON" CHORUS LINE, 1925/SCHOMBURG COLLECTION, NYPL

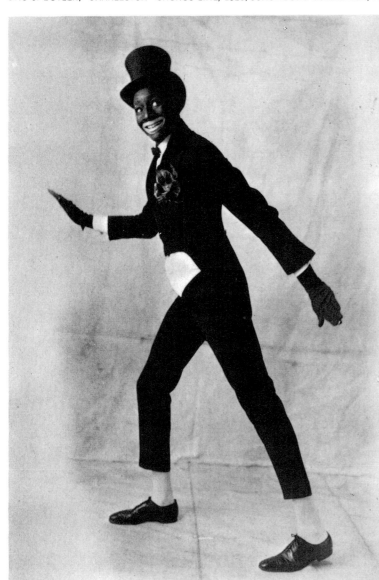

SONG AND DANCE MAN, c. 1927/SCHOMBURG COLLECTION, NYPL

ERNEST SMITH COLLECTION

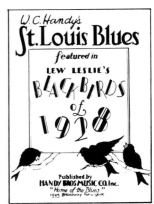

LES ZEIGER COLLECTION

ERNEST SMITH COLLECTION

ERNEST SMITH COLLECTION

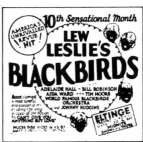

NEW YORK PUBLIC LIBRARY

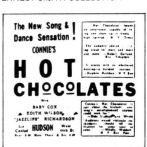

NEW YORK PUBLIC LIBRARY

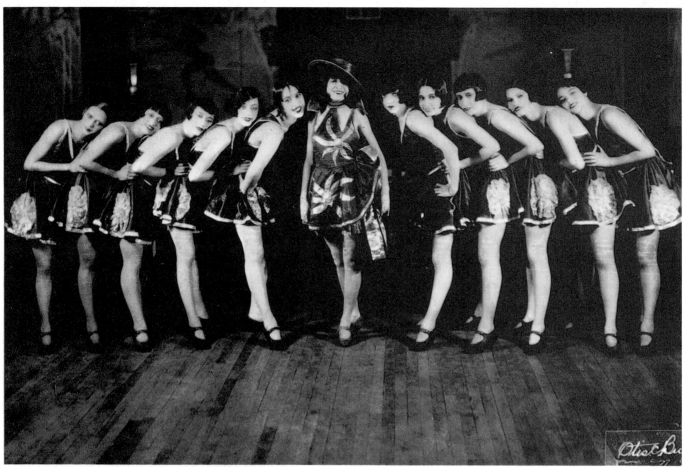

OTIS C. BUTLER/NIGHT CLUB CHORUS LINE, c. 1928/SCHOMBURG COLLECTION, NYPL

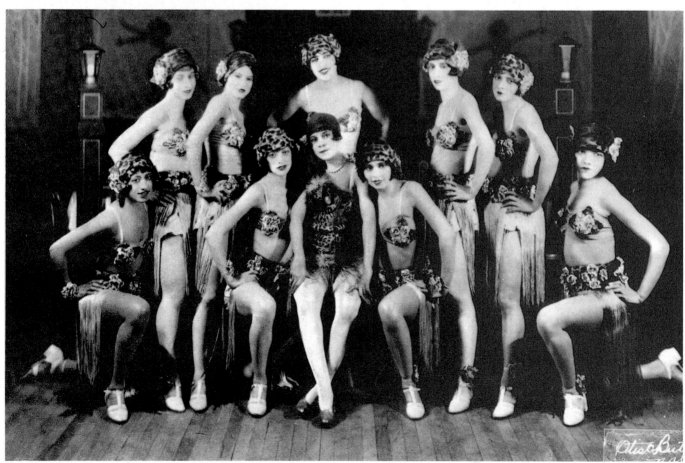

OTIS C. BUTLER/NIGHT CLUB CHORUS LINE, 1929/SCHOMBURG COLLECTION, NYPL

DEPRESSION & HARD TIMES 1930-1939

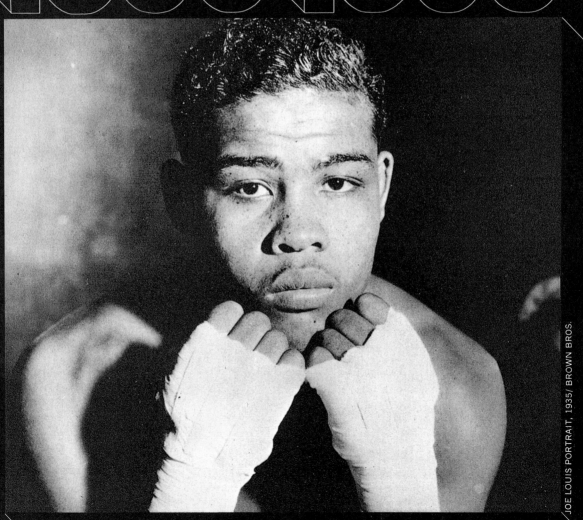

Population Rises Steadily; Illness Takes Heavy Toll; Unemployment and Low Wages
Result from Race Prejudice
Churches Prove Great Factor
West Indian and Southern Negroes Adjust Rivalries
Gold Star Mothers to Be Jim-Crowed
"Tree of Hope" Loses Prestige As Job Getter
Duke's Music for Amos 'n' Andy
Father Divine Tells Meeting He Will Defeat False Leaders
Troops Guard Harlem: Mayor Pleads for Peace
Powell Says Men Can't Get Jobs
Powell Says Rent Too High
Louis-Carnera Bout Draws 15,000 Negroes, 1,300 Police
Italians Clash with Negroes
Choice of Tenants Urged
Jam Streets As "Macbeth" Opens
Riot Report That Mayor Hid
100,000 Celebrate Louis Victory over Braddock
Webb "Cuts" Basie in Swing Battle
White Man's Jazz No Good for Holiday?

NEW YORK HERALD TRIBUNE, FEB. 10, 1930

POPULATION RISES STEADILY: ILLNESS TAKES HEAVY TOLL; UNEMPLOYMENT AND LOW WAGES RESULT FROM RACE PREJUDICE

Squeezed into a roughly drawn triangle between St. Nicholas Avenue and the East River, running from about 114th Street on the south to 156th Street on the north, an area of less than two square miles, is the biggest Negro community in the world. It is called Harlem. Within less than fifteen years, real estate experts say, it will be displaced and scattered by rising land values. While it remains it is, perhaps the most interesting laboratory in the country in which to study the vital problem of the eventual place of the Negro in American civilization.

The attitude of the average white New Yorker to Harlem is one of tolerant amusement. He thinks of it as a region of prosperous night clubs; of happy-go-lucky Negroes dancing all night to jazz music and living during the day by taking in each other's policy numbers; of Negro artists and intellectuals wealthy on the royalties of novels or salaries from the "talkies," and of a group of "high society" Negroes, most of them with foreign white servants, living high in the fashion of some of the characters of Carl Van Vechten's *Nigger Heaven*.

The fact is that this community of 220,000 Negroes is the poorest, the unhealthiest, the unhappiest and the most crowded single large section of New York City. It has, at the present time, the most severe problem of unemployment, and those who are employed receive an average of only $18 a week. According to an averaged estimate from six independent and disinterested sources, there are not twenty persons in Negro Harlem today, out of the 220,000, who are making more than $10,000 a year. Much of the foregoing must, of course, be qualified. High as are the Harlem death rates, especially in tuberculosis, nephritis and infant mortality, they are in most cases much lower than in the rural districts from which the Negroes have come, and they compare rather favorably with death rates in other Negro urban communities.

The word "unhappiest" must be qualified. This reporter, in his brief weeks in Harlem, heard on the streets, in the shops, in the poolrooms, more deep, soul-clearing laughter than he has ever heard in a white section, rich or poor. The Negro, in the last 200 years, has taken a great deal of punishment. Has he learned to take with a laugh or a song things that would drive many white men to suicide or rebellion? This laughter, taking it for a moment as the symbol of the Negro's ability to enjoy himself, may be interpreted variously. The prevailing view of the white man is that it is a racial trait, part of an easygoing joy in life independent of economic circumstances. Most Negro leaders, on the other hand, consider it one of the modes of psychological escape developed by the black man in his period of bondage. As one brilliant Negro real estate man expressed it: "Yes, I laugh, I laugh to keep from crying."

One further qualification, with the word "poorest." There are, perhaps, immigrant white groups, small groups, poorer than the Negroes of Harlem. But they have a straight road to success, blazed by their compatriots, ahead of them. They know that with thrift and hard work no position in American business is barred to them. Whether their names be Rossano, Jonsen, Hasenpfeffer, Rabinowitz, Kulak or Panopoulos, they can work hopefully along that line.

Harlem, then, in the words of Dr. W. E. B. Du Bois, outstanding Negro intellectual leader and editor of *Crisis*, is "a community of economically depressed working people resembling hundreds of poor working groups all over the world, but with the added handicap of 'the color line,' so far as it still survives, to contend with. And in addition to this, the problem of tens of thousands of new

citizens from the rural South and the alien West Indies swarming in every year."

Running everywhere through the Negro's problem in Harlem, in health, education, religion, employment and morals, is the economic factor. Ministers, social workers, newspaper publishers, doctors, lawyers, political and fraternal leaders say the same thing. For almost all of them it can be quoted simply and verbatim: "The central problem of Harlem is economic."

What is this economic problem? Briefly, so far as it can be stated briefly, it is this: The Negro man, with his heritage of slavery, his meager training since, and his recent arrival in Harlem from the rural South, is fitted almost entirely for positions of unskilled labor. The Negro woman is fitted chiefly for domestic service. Social agencies are remedying both these things, but progress is slow. The result is a wage scale for women of about $15 a week, and for men of about $21 a week. The men are getting into the less skilled white unions slowly; the women into the garment trades. Exceptional individuals are going into all kinds of work. The skilled unions, all protestations to the contrary, are very slow in admitting colored workers. There is your average income of $18 a week and that emphasized by the fact that 63 per cent of the married women in Harlem go out to work, four times as high a percentage as among native-born white Americans.

Harlem, it has often been noted, "stays up all night." The theory is that these people who stay up all night are loafers. The fact is that a great many of them are night workers. Night work, in the subways, the sewers, the docks, the post offices, is primarily "marginal" labor and the Negro does most of it. That adds to the population of the poolrooms by day; it encourages the idea of "Who goin' to begin, not me," and it helps to further disarrange the habits of a community that, for twenty reasons not yet even mentioned already, is sufficiently disarranged.

One thing that everybody in New York should know is that 90 per cent of the night clubs in Harlem are owned by white people. Nearly 92 per cent of the speakeasies are operated by white racketeers downtown. They are half-world or illegitimate businesses. The Negroes, proprietarily speaking, are not responsible for them. The thing that hurts is that the majority of the ordinary, legitimate retail business of Harlem is in the hands of white people, mostly Southern Europeans. This is explainable on several grounds. The Negroes of Harlem, mostly recently arrived from rural communities, are not trained in these businesses. They have little capital, and the slightest business depression wipes them out. The banks (the Dunbar National always excepted) hesitate to lend the money, preferring white security. Most of the banks are perfectly fair, but they realize that they are dealing with an entirely unskilled shopkeeper.

The ordinary white response to the conditions is: "Snap out of it. Get to work." But nine-tenths of the work that white folks do is closed to Negroes. In the chief trades open they are taken on only after the supply of white labor is exhausted. They are in the true and depressing sense "marginal labor." So are the Negro women. That is why the October stock slump produced five times as much unemployment in Harlem as in other parts of the city. People who lost money fired their chauffeurs and maids. Men who employed both races tended to fire the Negro worker first. No one can get an exact estimate of unemployment in Harlem today. Four churches and social agencies give 30,000, 36,000, 25,000 and 28,000. These figures cannot be vouched for. Social agencies usually put these things a little high. But there is no question, from personal observation, that Harlem today faces a bitter unemployment situation.

The Negro is laughing and shooting pool and playing the numbers, and (the great majority) doing the day's work. He is bearing it, fighting an economic situation harsh enough to daunt the bravest heart. And with him in the fight...a growing number of Negro leaders of intelligence and kindliness and understanding, tackling an uphill, complex, apparently almost hopeless situation with persistent ability, tact and good will.　—BEVERLY SMITH

NEW YORK HERALD TRIBUNE, FEB. 11, 1930

CHURCHES PROVE GREAT FACTOR

The Negro churches in Harlem today are striking an opposition and antagonism new in Negro history. A large group of the younger men, college men, authors, doctors, intellectuals, denounce the church as a foe to racial progress. They say that the pittances of the poor go into extravagantly expensive church buildings; that the ministers' energies are divided between exhorting the parishioners to help pay off the church debt, raking over the dry bones of dead theological controversy, and lulling the Negroes into indifference to their miserable economic situation by promises of eternal happiness to come. They say, these younger men, that the energy, time and money which Negroes spend in their churches should be devoted to a constructive effort to meet the problems of this world.

On the other side of the view is that the Negro's very real and deep religious emotion is the most precious part of his heritage; that the Negro ministers constitute the most enlightened and devoted single group; and that they are true leaders who will bring the Negro out of the economic and social wilderness in which after sixty-seven years of freedom and labored progress, he still wanders.

A middle and temperate view is that of W. E. B. Du Bois, the intellectual leader and fighting champion of the Negro's rights, Harlem is perhaps "over-churched," he says. Too much money has gone into handsome, architecturally uneconomic church buildings. But the church among Harlem Negroes is at the same time a great established institution, a place not only for worship but for amusement, self-help, social uplift, and, in a measure, for education. There is no other agency at the present time which could replace it. The Negro today, as Dr. Du Bois says, is "in no position to scatter philanthropy" or to establish great social and scientific organizations for the improvement of his own race. The church is here, it is functioning, it is doing real good, it is immensely significant in Harlem life today, whatever changes the future may bring."

The rural Negro, coming to Harlem from the South, finds in the church something familiar, something like "back home." Finding himself lost and bewildered, the church is a place where he can find friends and companionship. The sermons and the hymns strike old chords. Seventy-five per cent of the Negroes in Harlem have migrated here—50 per cent from the South and 25 per cent from the West Indies—and they want and get the religions they used to have at home. This emphasis on the "ol'-fashioned 'ligion" is at once a strength and a weakness in the Negro churches. On the one hand, it gives the Negro pastors a powerful hold on and appeal to their parishioners. On the other hand, it tends to perpetuate among Negroes, the younger men say, what might be called a *Sklavenmoral*— a forgetfulness of present miseries in the rosy hope of the gold-paved streets of Kingdom Come. Also, it undoubtedly tends to intensify interchurch interdenominational rivalry.

About fifty-five churches in Harlem have their own buildings, while about seventy-five so-called "churches" are small groups or sects meeting in storefronts or residences.

The white reporter, whatever his religious views, interviewing the Negro preachers, cannot help being impressed with the strong personal magnetism of most of them. They are men of extraordinary personality, of unusual native eloquence. They have a personal power that, for better or for worse, transcends logic.

The Catholic, Protestant Episcopal and Moravian churches are attended chiefly by West Indians, because these were their denominations under Latin or English rule in the islands. The overwhelming majority of American Negroes are Methodist or Baptist. As A. Clayton Powell, one of the finest of the Harlem ministers, says, quoting Booker T. Washington: "When you meet an American Negro who's not a Methodist or a Baptist, some white man's been tampering with his religion."

Of the seventy-five smaller "churches," existing precariously

in homes and stores, some are pastored by primitive but sincere cotton-field preachers, some by astute and grasping charlatans preying on the ignorant and superstitious, some by religious fanatics with new and outlandish creeds. The number of superstitious cults, some of them verging on the voodoo, is disproportionately high, but it is being cut down, intelligent ministers say, by a gradual process of education. Most of these cults are characterized by high-sounding names and fraudulent management. Many are financed and engineered by unscrupulous white people. Bonafide Mahometan missionaries operate in Harlem and make some converts, but the number is relatively small. Several bogus Hindu religions, like some of the quack "Hindu" medicines, have a fleeting appeal to Harlemites, who usually withdraw after being fleeced.

There are also numerous fraternal orders having a total membership of about 25,000, with considerable overlapping, cutting the number of individuals down to about 10,000. Nevertheless, it is a very powerful group, capable of doing enormous social good. But, complain the younger intellectuals, the fraternal orders actually do almost nothing. They spend their money, these people say, on club houses, gaudy regalia (purchased from white people), national conventions and parades. They actually retard the Negro, it is charged, by taking his time in the evenings, when he should be learning a profession or a skilled

trade; the conventions keep him from his work and make him lose his job; the dues and regalia charges exhaust his slender savings. At the same time, in these organizations the Negro is able to achieve self-expression, to orate, to play politics, to employ his splendid social gifts and to have a whale of a good time. They are also, like the church, a release and a refuge.

"The reason these fraternal meetings last so long at night," said one Negro fraternal leader, "is that all week the colored man, in his job under a white man, has had little things that make him mad and that he can't talk out loud about. These things pile up inside of him. And when he gets on the fraternity floor among his own folks at the meeting, that all just biles out of him in laying down the law and asserting his rights to his own brethren. It's his turn to tell other folks where they get off. And how he does tell 'em."

—BEVERLY SMITH

❖ ❖ ❖

NEW YORK HERALD TRIBUNE, FEB. 14, 1930

WEST INDIAN AND SOUTHERN NEGROES ADJUST RIVALRIES

If the Negro population of Harlem were translated to a fertile isle in the mid-Pacific, it would still have its racial problems. Most whites think of it merely as "the

Black Belt"—a homogeneous group of Negroes, the largest in the world, living together in full harmony and understanding. As a matter of fact the Negro section of Harlem is a melting pot with as strange and varied a brew as that of white New York. About 50,000, or nearly 25 per cent, of the Negroes in Harlem have come from British, French, Dutch, Portuguese or Danish civilizations in the Caribbean region. These are referred to generally as West Indians. The largest element comes from the British West Indies. Each group has brought along its own accent, wholly different from that of the American Negro. There are small sections in Harlem where Spanish or French are spoken almost exclusively in the homes.

Each national element, as W. A. Domingo has said in his article in the *Survey*, "is divided from the others by tradition, historical background, and group perspective." The West Indian Negro in general is less exuberant than his American cousin, more serious, more ambitious and more aquisitive. Sometimes he considers himself as rather "above" the American Negro, but in this he is repaid with interest, because the American Negro has a strong individuality and pride of his own. He is also a distinctly American product, and shares the white American's scorn for foreigners of any kind. Sometimes he calls the West Indians "aliens," or "Cockneys" or "pessimists." He

has also a gift of humor and derisive laughter, which the West Indian often lacks. But this intraracial ill feeling has diminished notably in the last few years. The quota law has cut down the heavy immigration from foreign dependencies, thus dulling the edge of economic rivalry. At the same time the more intelligent members of each group have had a chance to come together and understand each other.

The Negro section of Harlem also has a hundred subtle differences of viewpoint between Southern Negroes from different states and of different racial mixture. In the steady healing of these differences there is a hopeful omen for the solution of the graver problem between white and colored.　　—BEVERLY SMITH

❖　❖　❖

AMSTERDAM NEWS, FEBRUARY 19, 1930

GOLD STAR MOTHERS TO BE JIM-CROWED

The Gold Star mothers who begin May 30 their pilgrimages to the cemeteries of France and Belgium, where their sons lie who made the supreme sacrifice in a "war for democracy" as guests of the United States Government, are to make the trips on separate steamers because of color differences, advices from the War Department revealed last week.

The ignorant and prejudiced South is again catered to in this case of unjustifiable segregation when the officials in making plans for the trip decided to separate the two racial groups due to the fact that such a large group of the mothers and widows "came from the South."

Several protests have been sent to the War Department, among them being a letter by Alderman Fred R. Moore asking that all pilgrims be sent overseas on the same boat and at the same time. Quartermaster General B. F. Cheatham is in charge of the tours, and in his reply to Alderman Moore stated that his petition would be given full consideration.

The pilgrimages will begin in May and will continue during the summer months for two years. Congress has appropriated funds for the tours, which will allow the mothers and widows of American soldiers buried overseas to visit their graves. A period of two weeks abroad is allotted each pilgrim and all expenses will be paid.

❖　❖　❖

NEW YORK HERALD TRIBUNE, JUNE 8, 1930

"TREE OF HOPE" LOSES PRESTIGE AS JOB GETTER

The dying old elm known as "the tree of hope" which stands before the Lafayette Theater in Harlem is faced with an embarrassing loss of traditional prestige. During the last few weeks a number of Negro actors rubbing its bark shiny in an effort to find immediate work

on the stage or screen have become disgruntled with the tree's results, and yesterday a member of an unemployed song-and-dance act charged openly in Seventh Avenue that the spell of "the tree of hope" had been broken. He had rubbed a limb, he said, until the leaves wouldn't grow but still he hadn't a sign of a money-paying position. He declared he was through with bothering around a tree.

Two other individuals, he pointed out, also had been making pilgrimages daily to the tree for three weeks and were still giving it the rubbing treatment and were still without employment. However, although this is considered by many to be damaging to the magic elm's reputation, there are many more who refuse to surrender their faith in its work-finding ability. According to "Onions" Jeffrey, one-time star of "Shuffle Along": "It's not the tree that's to blame. It's the hot weather. If you ask me what is the matter, I'd say it's a strange thing that during the wintertime when its cold there's nobody here to keep the old tree company, but just let the sun come out hot and you'll find it crowded about with a terrible rabble. These song-and-dance-act people don't fool the tree. 'The tree of hope' knows that when the summertime comes there's a lot of folks in Harlem that don't intend to work. That's the reason the tree doesn't pay any attention to their rubbing." And between the two schools of

thought, the matter rests. The old elm tree has rapidly become the most famous tree in Harlem. Not far from it is Connie's Inn, nearby is a fish market, and two pool-rooms are on its same corner on Seventh Avenue. Shiloh Baptist Church is just across the block.

Ten years ago, it is said, a dancing show was discharged by a bankrupt manager from a theater then located nearby. The actors gathered under this tree, hoping some day to receive back pay, and they collected there so often to interview the manager on the topic that the Negroes began calling the tree "the tree of hope." Eventually they were paid, the legend says, although some declare the sum amounted to about $6.43 apiece. From that time on, the tree, because of nearness to many playhouses, has become a gathering for all the theatrical professionals in the Negro world. In the summertime, each day from 4 o'clock in the afternoon until 4 o'clock in the morning, singers and dancers and clowns and comedians meet there to tell yarns and "lies," as "Onions" says, until now the place has become in reality an employment agency without a manager. The place is frequented by such producers as Leonard Harper, who stages many dances for the Connie's Inn show; Clarence Robinson, of the Cotton Club, and by Charlie Davis and Addison Carey, who specialize in dancing acts.

A great many performers in night clubs in New York have been selected from the crowd under "the tree of hope," and from there were chosen members of the cast "Hot Chocolates" and "Blackbirds." A number of the angels in "Green Pastures," too, have in their time rubbed on the tree, hoping for luck. In fact, "Onions" declares "The Emperor Jones" himself stood there one day and wished to become an emperor. Jules Bledsoe, "Old Man River," passed the place yesterday afternoon and stopped on his way to the Lafayette Theater, where he is now appearing, to speak to the crowd about the elm. "Did you ever rub the tree?" "Onions" asked him. "I don't know," answered "Old Man River," "But I expect so. I did so much wishing on the avenue I don't see how I could have missed it." Mamie Smith has been there, as has Paul Robeson, "Jazz-lips" Richardson, Black Bill and Kid Chocolate, the boxers. The Kid often "rubs" the tree before a fight.

"Ham Tree" Harrington, a comedian, said: "The tree has worked wonders. I have known tap-dancing people who were out of pocket money to tell the tree, 'Old Tree, we want to do some tapping in Baltimore,' and I've heard blues singers tell it they wanted a singing engagement in Portland, and that was all there was to it. Soon the telegrams would come engaging them for those positions." The rubbing ritual gradually developed after the tree became known as "the tree of hope." According to the custom now, the actor must rub it a specified number of times for each specified desire. "Old Man River" told those about it yesterday that somebody should take better care of it and see that it occasionally was watered. He laughed at those who said they doubted its power. Joking with them, he stood under "the tree of hope," saying he hoped sometime to sing in opera.

❖ ❖ ❖

AMSTERDAM NEWS, JULY 9, 1930

DUKE'S MUSIC FOR AMOS 'N' ANDY

According to Irving Mills, "the Negro is the rightful exponent of jazz, and its development and exploitation have been the basis on which all white musicians have built their experiments." Irving Mills is a white man who is the manager of Duke Ellington and his famous Cotton Club Orchestra. Mills has been in the music business for many years, being a member of the firm of Mills Music, Inc., music publishers. Mills is a songwriter and a singer who has gained considerable fame for himself on the phonograph discs. He discovered Duke Ellington when that personage arrived from Washington, and with a five-piece orchestra made his debut at the Kentucky Club here. Mills signed Ellington, and after years of work and study he developed this organization into one of the most talked-of musical combinations in

the world; today the Duke man and his band are said to rate on a par with Paul Whiteman, Vincent Lopez, Ben Bernie and many others in the realm of modern music as a result of Mills' work and managerial ability.

Mills personally supervises every orchestration and arrangement the band plays. He arranges the bookings and directs the exploitation in general. He selects the records made for the various phonograph companies and is master of the destinies of Ellington. The success of Duke Ellington and his band has fulfilled Mills' prediction with regard to the Negro's rightful claim to the origination and evolution of jazz. This is based on the fact that many of the big bands use Ellington orchestrations and arrangements in their rendition of the popular dance tunes. Ellington is the ace of rhythm jazz leaders, and his barbaric style of music is backed by a jungle atmosphere that has made this type of music a sensation.

Ellington and his orchestra, besides being the chief attraction of Harlem for five years at the Cotton Club, has gained laurels in Florenz Ziegfeld's "Show Girl." Maurice Chevalier personally selected the band to play for him at his two weeks' concert at the Fulton. The crowning point of Ellington's career was reached last week when Radio Pictures signed the band to appear in their picture featuring Amos 'n' Andy, the radio stars.

THE NEW YORK NEWS, NOVEMBER 10, 1934

FATHER DIVINE TELLS MEETING HE WILL DEFEAT FALSE LEADERS

Never spake a man such Words of Wisdom, as spake Our Revered and Majestic Lord, Father Divine, on this Fourth Day of November, in the presence of the Honorable Albert Wald, Senator of New York State, his staff and friends, and thousands of others, from every walk of Life, Followers and Worshipers of Father Divine. Truly man's intellect and understanding are not to be compared with God's, for the highest expression of man's wisdom, compared to that of God, is a tiny spring to a great ocean. Though it appeared to be floating in air, it was really attached to a Rolls-Royce sedan, and as this car moved slowly on its way, a quietness that could be definitely sensed, came over the racing traffic of a "rush hour."

The thousands who filled the Streets were not long in recognizing that in this car rode Father Divine in Person, Who has been recognized by twenty million the World over as the Prince of Peace, The Everlasting Father, and Mighty GOD. As they recognized His Presence, many dashed into the Street to get a fleeting glimpse of Him, and to receive

copies of His Mottoes, which were distributed free, from Father's car.

The atmosphere itself was filled with Peace and Harmony, as always in the Presence of Him. From a chilly day, the weather had suddenly moderated into a soft warm evening, and the Cosmic Forces of Nature were at rest, while for the time being at least, contentment seemed to reign in the hearts of all the people. Closely following Father's Car, came several Packards and other cars carrying His immediate Staff, then ten or more loaded buses displaying the Words "Father Divine's Peace Mission," followed by an interminable line of automobiles and trucks carrying signs and banners.

Simultaneously with the movement of the automobiles, an unending line of marchers, four abreast, poured out of 115th Street and up Lenox Avenue, preceded by a brass band—with the banners of Peace proudly flying, and great signs and placards held aloft, declaring to the World that Father Divine is GOD—that GOD Alone shall Reign—and that all prejudice, hatred, discrimination, races, creeds and colors must cease. It was the beginning of another mighty Demonstration in cooperation with an Organization that had sought Father's Support. He had cooperated with the Communists and others at various times, but on this occasion He was cooperating with

Professor Sufi Abdul Hamid, Leader of an Organization working for the elimination of prejudice, segregation and discrimination. The Newspapers had recently carried reports of Professor Hamid's arrest for picketing stores showing discrimination in the employment of help, but he was found not guilty of any violation, and released. It was said that fifty witnesses appeared in his defense.

Professor Hamid had arranged a political mass Meeting at Rockland Palace, 155th Street and Eighth Avenue, in addition to the Street Parade, and at this Meeting all Candidates for Office in the approaching Election had been invited to present their platforms, that the people might know exactly what they stood for. Naturally, a large audience was expected, with Father as the Magnet to draw the people, but it is safe to say that neither Professor Hamid himself, nor the Candidates who were present, expected anything like the great Demonstration that took place. Long before the thousands of marchers neared the Rockland Palace, the great Auditorium was filled to capacity with eager Followers, waiting for Father's Personal Appearance.

As Father stepped upon the stage He was greeted with a shout and a demonstration that shook the Building, and caused the Officials and Candidates to stand, in awe, as ten thousand hands reached toward Father and a great sea of banners waved.

THE NEW YORK TIMES, MARCH 21, 1935

TROOPS GUARD HARLEM: MAYOR PLEADS FOR PEACE

Crowds of restless Negro residents and thousands of curious white visitors thronged Harlem's sidewalks last night under the sharp watch of more than 500 policemen, but there were no new outbreaks such as kept the district in turmoil all Tuesday night and early yesterday morning. Of the 100 or more white men and Negroes who were shot, stabbed, clubbed or stoned during the rioting of Tuesday night, only a handful remained in Harlem hospitals. These, however, were on the critical list. Up to last night there was only one death as a result of the rioting. While the police seemed certain that they had enough men in the district to put down any new uprising of the hoodlum element that looted stores and broke more than 300 shopwindows during the rioting, the Merchants Association of Harlem telegraphed to Governor Lehman that the police force was inadequate and made a plea for "military assistance."

Mayor La Guardia, in an early statement at City Hall, said: "The unfortunate occurrence of last night and early this morning was instigated and artificially stimulated by a few irresponsible individuals," and appointed a committee to begin an investigation into the rioting and into the "causes of the disorder." He also sent into the Harlem district last night two patrol-wagon-loads of circulars appealing to the law-abiding element to keep their heads and to assist public officials in getting at the source of the trouble. Patrolmen left thousands of these circulars (large pamphlets printed on white paper) in the Harlem stores for distribution by shopkeepers.

Four men described by the police as ringleaders of the rioting were held in $2,500 bail each by Magistrate Stanley Renaud in Harlem Court for hearing tomorrow on charges of inciting to riot. Three of the four are white men. They were represented by a woman lawyer who said she was assigned by the International Labor Defense. She would not give her name to reporters.

The sole fatality in the rioting was James Thompson, 19 years old, a Negro of 202 St. Nicholas Avenue. He died in Harlem Hospital at 9:25 a.m. yesterday after he was shot in the chest by Detective Nicholas Campo, of the West 100th Street police station, who said Thompson was one of the men who looted the A & P store at 138th Street and Lenox Avenue early yesterday morning.

Four patrolmen and four detectives were on the list of injured, but apparently none of them was in serious condition last night. In most cases they were hit by flying bricks and stones while the race riot was at its height at midnight

Tuesday, but were able to go home after receiving treatment. One hundred and twenty-one prisoners were taken by the policemen during and after the rioting on various charges, chiefly inciting to riot, burglary (looting of stores), disorderly conduct and carrying concealed weapons. In magistrate's court most of them were held for further hearing, but several were sentenced immediately to from five days to six months. Heavy police guards composed of men on foot, mounted and on motorcycles, surrounded the buildings as Negro friends of the prisoners assembled to attend the arraignments. There was considerable grumbling, some shouting of threats, but no violence. Motorcycle convoys accompanied the vanloads of prisoners around the city.

All day long Harlem's sidewalks, stoops and apartment-house windows were alive with resentful Negroes. They moved in restless and endless streams along Lenox and Seventh Avenues and up and down 125th Street, where the trouble started Tuesday afternoon on a false rumor that a Negro boy had been brutally beaten by employees in the Kress five-and-ten-cent store. Police officials, however, appeared certain, despite the obvious air of tenseness and hostility that prevailed, that there would be no further outbreaks. They have enough men on hand, they believe, to put down any new uprising—roving emergency squad

cars, patrolmen marching in pairs every few hundred feet and mounted men in groups of two and three at strategic points.

Harlem's Negro leaders seemed divided on the cause of the riot. Some flatly blamed the Communists, others said the Communists merely stepped in and took advantage of the rioting after it started. All seemed to agree, however, that the "basic cause is economic maladjustment; segregating and discrimination against Negroes in the matter of employment." A group of Harlem's Negro leaders and some white men interested in the welfare of the race, at a meeting in the home of the Rev. A. Clayton Powell, Jr., at 666 St. Nicholas Avenue, issued a statement to that effect. Dr. Powell said a mass meeting may be held in Madison Square Garden soon to acquaint New Yorkers with conditions under which Harlem Negroes live.

Statements issued by Communist organizations (some of them inflamed the mobs on Tuesday by issuing pamphlets to the effect that a Negro boy was beaten in the Kress store) tried to fix the whole blame for the trouble on the policemen. They maintained that the police were unjustifiably brutal in keeping down the crowds. Witnesses, however, said the police kept cool, even when they were stoned by enraged hoodlums; that snipers started the shooting.

Lino Rivera, 16 years old, of 272 Manhattan Avenue, a Puerto Rican boy who was ejected from the Kress store at 256 West 125th Street at 4 o'clock Tuesday afternoon after one of the floorwalkers had seen him take a ten-cent penknife from a tray, was a dejected

figure at his home last night. Despite inflammatory Communist handbills charging that he had been brutally beaten, the boy was unmarked. He was overwhelmed by the fact that his desire for a ten-cent knife had precipitated the riot and resultant bloodshed. His mother, a widow, harangued him in Spanish in the presence of reporters; said she was ill as a result of the incident. Even after newspapers printed interviews with the boy, quoting him to the effect that he had not been beaten in the store, the rumor persisted in Harlem that a Negro boy had been killed; that the victim was an 11-year-old boy whose "body was taken out of the store as freight."

District Attorney Dodge announced that the grand jury will investigate the riots, and if the evidence was forthcoming, would seek indictments on charges of inciting to riot and for assault. He said he was acting at the request of Mayor La Guardia. "My purpose," he told reporters, "is to let the Communists know that they cannot come into this country and upset our laws. From my information Communists distributed literature and took an active part in the riot."

The rioting started about 4 p.m. on Tuesday, began to spread from the vicinity of the Kress store at 6 p.m. when the first of the Communist handbills appeared, and reached its height by midnight. Roving bands of Negroes, with here and there a sprinkling of white agitators, stoned windows, set fire to several stores and began looting.

By 1:30 a.m. the worst of the rioting was ended, but sporadic outbreaks occurred up to 4 a.m., and emergency cars and motorcycle squads carrying patrolmen armed with riot guns quickly put down these disturbances and were troubled thereafter only by men sniping from rooftops. They cleared these off, and stationed men on the roofs to prevent further sniping.

There were no disturbances of any size yesterday, merely one or two trouble calls with which the flying squads had no trouble. One came from the grocery store of Isaac S. Pekin at 371 Lenox Avenue in the afternoon. Two Negro boys entered his shop and began throwing canned goods about. When he called for police a crowd of 500 men and women assembled around the store, but dispersed when the radio cars appeared. Last night the district was calm, but still tense. Three emergency trucks rolled down Seventh and Lenox Avenues and down 125th Street at intervals, and radio cars and motorcycle cars maintained steady patrol. Four patrolmen had to be stationed at 125th Street and Seventh Avenue to regulate the pedestrian traffic because the influx of curious whites jammed the sidewalks.

The visitors gasped when they saw the shattered store windows along Seventh and Lenox Avenues and along West 125th Street, and as they noticed shops where merchants had boarded their display windows against possible recurrence of the rioting. Last night observers counted twelve glaziers' trucks in the district, with workers busy replacing the broken shopfronts. Negro proprietors had large whitewashed signs on their windows announcing that "This shop is run by COLORED people." Several white store owners took the cut and covered their windows with signs announcing that "This store employs Negro workers."

Many representative Negro leaders in Harlem, in discussing the background of the riot and what led up to it, said that the question of finding employment for Negro workers in Harlem stores was really the cause of the trouble. The Communists, they maintained, merely stepped in after the trouble started, and took advantage of it.

❖ ❖ ❖

NEW YORK POST, MARCH 27, 1935

POWELL SAYS MEN CAN'T GET JOBS

"White folks in the lead." That has been the answer for years when one Negro queried a fellow Negro in Harlem: "How's things going in town?" This native jest indicated the feelings of the majority of Harlemites regarding their position in New York. An increasingly impenetrable wall has sprung up around Harlem, especially during the last five years. It is a wall of subtle prejudices, veiled discrimination and faintly concealed antagonism: a wall created on one side by a few Simon Legrees and bolstered up on the other by the modern honorable Uncle Toms. This situation is no different in Harlem than in any other locality in this "land of the free and home of the brave." To understand, therefore, why Harlem Negroes especially resented this wall and voiced this resentment Tuesday a week ago, it is necessary to look over one's shoulder for a moment. You may look over your left or your right.

New York has stood as a symbol of all the better things that modern life could afford. To it flowed Jews, Irish, Italians, Germans and, from the Southland, Negroes; and so it is not surprising to find that 80 per cent of the population of Harlem was born in the South. To Harlem by the tens of thousands they came, they saw, they conquered. So we find that the Jews own New York, the Irish run it, but the Negroes enjoy it. Harlem became a Mecca for the Negro — the pilgrimage to which made his life complete. The new Negro basked in the sunshine of what he thought was freedom. It was a community, the residents of which enjoyed it thoroughly. They enjoyed Harlem so much that it became a symbol throughout the world—a symbol of pleasure. To the average outsider Harlem came to be considered as a place where Negroes never slept, where chicken and watermelon and corn whiskey flowed as the proverbial milk and honey, and where life was just one big hi-de-ho—a romp for a race in rompers!

But Gabriel played his trump and in 1930 the croupier called his number—it was red! Since then the world has been blue in the face trying to get out of the red. True Black Harlem had always been at the bottom of the pile. Many of us ofttimes thought that Civic Virtue was standing not on a woman, but on a group of 300,-000 Negroes. Each winter since 1930, the Negro at the bottom of the pile felt that his burden was getting heavier. This past year Harlem was completely snowed under. One out of every twenty residents of New York City is a Negro. There are around 300,000 black, brown and yellow folk. One-half are not working, the other half is existing on the crumbs from the table.

The jobs for Negroes, even in the better days, were never the best—bellhops, waiters, porters, red caps, elevator boys, kitchen mechanics and pot wrestlers, with here and there a shipping clerk or a typist; but at least they were able to maintain a substantial pot of fatback and greens and also suck the succulent bones of contentment—pig feet.

Today, emphatically, there are no jobs for Negro men. I know many employment agencies in Harlem whose records prove this. Let me quote Mr. George E. Voting, of 150 West 138th Street: "Last year I placed 475 women and three men." Jobs formerly held by Negro men in the hotels and restaurants are now entirely

in the hands of whites. The American Federation of Labor continues, in the face of the protests of liberals throughout the country, to refuse to allow Negroes membership in the great majority of their unions. Negro women, however, continue to obtain "jobs." They are being hired now for $25 a month as "mothers' helpers." A mother's helper ends up by becoming cook, housemaid, nursemaid and laundress. Last week a lady phoned asking if I had a "nice colored woman who could cook and typewrite for $35 a month."

An employment agency was recently forced to turn down an employer seeking a woman to work full time, including two nights a week, for three dollars a week. On the files of a certain social service agency in Harlem there is a case of a graduate of one of the finest commercial schools in the Midwest, who has received her B.S. degree in commercial science and who was working up until a few weeks ago for $5 a week and considered herself lucky.

For the doubting Thomases, a visit to Prospect Avenue and 161st Street or Southern Boulevard and Westchester Avenue, both in the Bronx, should prove that the slave market still exists. Here, lined along the walls each morning, can be found dejected, tattered young and old Negro women, many of them mothers, begging to be employed. Garrulous, mercenary females haggle with them over the price per hour, driving their bargains as shrewdly as slave traders of old, often lur-

ing these women for 12 and 15 cents an hour.

What about the Federal Relief jobs? That, my friends, is what Harlem wants to know. In the field of drama—that field in which Negroes because of their natural talents have been so prominent—the Civil Works Administration refuses to hire Negroes. Out of the thirty or more productions under the CWA only one employs Negroes, and that is exuberantly entitled "Meek Mose." I forgot, one Negro has a stellar role in the production of "Julius Caesar"—the part of the slave.

The CWA has a professional division. How many of Harlem's 135 doctors and 100 dentists are working in that division? The answer is very simple—not one! Yet, I am personally acquainted with a D.D.S. from Tufts College who was assigned by the CWA last winter to dig ditches in the Bronx for twelve dollars a week.

The Federal Nursery Project has established nursery schools in every section of New York for the last two years. Full knowing that Harlem mothers are forced to work more than in any other community of this city, yet they have consistently refused to open a nursery to care for their little waifs who are forced to live the lives of adults before they have begun to live as children. After much protest on the part of community leaders, the Federal Nursery Project said they were willing to open a nursery in Harlem, but insisted upon an all-

white staff, saying that there were no trained Negroes to man such a school. Mrs. Cecilia Saunders, executive secretary of the Harlem Y.W.C.A., immediately furnished them with a list of some twenty names of B.A.'s and M.A.'s in child psychology. The next excuse offered was that there was no building in Harlem that was either sanitary or fireproof. Even though the fire department has okayed several buildings in the community, no further word has been received from the executives.

The Emergency Home Relief Bureau is staffed and manned by a group of so-called liberals, but they wear the round laurel wreath of liberalism upon their square heads, and I think there is an old adage, something about square pegs in round holes. I shall show later specifically that Negroes meet with great discrimination in the administration of home relief. One unofficial commentator of the Harlem scene sums up the entire relief system in relation to the Negro by saying the EHRB, the TERA, the CWA, the PWA, etc., are "nothing but a Greek alphabet." The average man or woman of Harlem does not know all about the various relief projects sponsored by the Federal, state and local governments, but he does know a lot of things about unemployment and discrimination in other fields because they are so obvious. He knows that: There are thirteen public schools in Harlem. The great majority of the teachers are white. There was

no Negro principal until last month when Mrs. Ayers was appointed. Last winter while men stood idly and starvingly by, two and one-half miles of Harlem's beloved boulevard—Seventh Avenue—was repaved by a crew of all whites.

The Harlemite does know that he spends annually $113,000,000 for food, $17,000,000 for clothing (figures furnished by R. D. Turner, Belclair Market, West 145th Street). But until last year only thirteen Negroes were employed on 125th Street out of the 2,791 employees. Over $4,000,-000 is spent annually for electricity and gas in Harlem, while the public utilities employ only three Negro maids and two inspectors. The same situation is true of the other utilities: the telephone and transportation systems. The Fifth Avenue Coach Company has refused countless times to see Negro committees. The city-owned Independent subway refuses with a few exceptions to allow Negro employees to rise above the level of station and toilet attendants. Three hundred thousand Negroes want one voice in the State Senate and in the national House of Representatives, but the legislative bodies of New York continue to gerrymander this community.

The schools of Harlem are understaffed and overcrowded, and P.S. 89 and 5 have new names. P.S. for those schools means Public Sewers. Those schools have outside toilets; the entire structures are nothing but tinderboxes. The lunchrooms are as clean as the worst outhouse.

The Harlem Hospital, the only city-owned hospital that will con-

descend to allow Negro doctors to work in it, has only thirty Negroes out of a staff of more than one hundred. Colored nurses are forced to eat in separate dining rooms from the whites. I have seen a Negro patient in the dead of winter with the temperature hovering around zero, bleeding from head to foot, with his wounds freshly sewed up, thrown out bodily because he was drunk. The hospital is so overcrowded that patients are placed in the halls, and yet next door there is an annex as large as the main building, costing hundreds of thousands of dollars, which is almost completed, but no work has been done upon it for the last year. Commissioner Goldwater's attitude is one of definite noncooperation. He constantly turns a deaf ear to the pleas of members of this community.

The entire Fusion administration of Mayor La Guardia is a fusion for Fascism. During his campaign, Ben Howe told a group of representative Negroes that they could not tell him how to run Negroes, that he had managed ten thousand of them in Alabama. Queried about this, the "liberal" La Guardia replied in so many words that he could do nothing about it. Since he has been mayor of this city he has refused consistently to see various delegates and committees from Harlem and has even ignored letters requesting an audience.

This is what the man and the woman of Harlem knows, and this knowledge is the fundamental cause of what has been errone-

ously called New York's worst riot in twenty-five years. It was not a riot; it was an open, unorganized protest against empty stomachs, overcrowded tenements, filthy sanitation, rotten foodstuffs, chiseling landlords and merchants, discrimination on relief, disfranchisement, and against a disinterested administration. It was not caused by Communists, which is even apparent to the Washington (D.C.) *Post*, which on Saturday, March 23, had a headline which read: "Harlem Riot Due to Hunger, Not Reds."

It was not a protest against the shutting up of Father Divine's Kingdom. The people who were in the disturbance were not interested in Father Divines. It was not a protest against the police investigation of the policy racket. Witness a man, tall, strong and well built, carrying through the murkiness of the Harlem morning two pieces of twelve-cents-a-pound salt pork that he had taken from a butcher's broken window. Witness two young lads—one of them just finished high school—furtively sneaking home as the noise of March 19 subsided, lugging two sacks of rice and sugar. Witness a young man step through the window of Wohlmuth's Tailoring Establishment at 134th Street and Lenox Avenue, dressed on that cold, rainy night in nothing but a blouse, pants and an excuse for shoes. He comes out a moment later wearing a velvet-collar Chesterfield

and a smile upon his face—first overcoat this winter.

A great majority of these were men and women who have worked and held decent jobs in the past, but who have no reason or self-discipline when their bellies are rubbing their backbones.
—A. CLAYTON POWELL, JR.

❖ ❖ ❖

NEW YORK POST, MARCH 28, 1935

POWELL SAYS RENT TOO HIGH

Hand-to-mouth living has been the rule in Harlem Town for many years. Nothing keeps my fellow Negroes' noses closer to the economic grindstone than the tribute levied by Harlem landlords. It is impossible for the sepia-tinted citizens of New York ever to get out of their economic ruts as long as the costs of housing remain as they are. Rents in the Harlem area are about 20 per cent higher than in other communities of similar accommodations. The overlords of Harlem are the landlords, and with very few exceptions they have worked out a standard of operating which is, roughly: The worse the accommodations, the poorer the people, the higher the rents.

Up on Sugar Hill, Harlem denizens regale themselves in modern dwellings where the costs are only about 12 per cent more than the low-grade tenements. On the other hand, the folk on Lenox Avenue shorten their life spans in filthy flats in which they must render to Caesar a rental 30 per

cent above the average for similar housing in other sections of New York. On Sugar Hill, that district stretching roughly from 145th Street to the Polo Grounds, with St. Nicholas Avenue as the main artery, Harlem's would-be "sassiety" goes to town. 'Midst paneled walls, parquet floors, electric refrigeration, colored tile baths, luxurious lobbies, elevators and doormen resplendent in uniforms, they cavort and disport themselves in what is called "the best *ofay* manner." The group is composed of civil service employees, professional men and their families, social workers, the big names of Harlem's theatrical life, numbers overlords and that mysterious group of the well-groomed and the well-fed who never work.

With the exception of the Rockefeller-built Dunbar Apartments on West 149th Street and the Dorrence Brooks on West 138th Street, the Sugar Hill apartment houses have a monopoly on Harlem's groups of the steadier wage earners. There are other exceptions, of course, the most notable being West 136th to 139th Streets between Seventh and St. Nicholas Avenues, where the self-appointed elite live comfortably and in some cases luxuriously. These private houses were built by the late Stanford White. These $20,000 homes were bought by Negroes during the "Black Scare" of 1919 for four and five thousand dollars. These people are dwellers within the so-called upper bracket of Harlem. They pay the high rents and meet their

mortgages by taking in lodgers, for only a handful of Negroes, even in these would-be opulent districts, have incomes which allow them to live without fear and trembling on the first of the month.

Looking down into the heart of old Harlem Town, we find the salt of the earth living in the world's worst tenements. Without exception, the tenements of Harlem are filthy. Landlords refuse to make janitors keep their houses clean, and how can they ask them to when he hires the man and his family for nothing per month except a basement to exist in and tells them to clean six floors, take care of the sidewalk and back yard, haul the garbage, stoke the furnace and make the minor repairs? There are hovels along 133rd Street where one hall toilet serves a floor of four apartments for as many as twenty-five people, no private bathrooms or public bathtubs. Some owners have installed bathtubs in the kitchens. Along Fifth Avenue, from 135th Street to 138th Street, is one of the worst spots. Here are flats with the old-fashioned toilets, which are usually so broken that the refuse flushes down on the floor below. Gaping holes in the skylights allow cold air to sweep down the staircase freezing the toilets so that for weeks during the winter they cannot be used. You can imagine the litter in the back yards each morning. Go further and remember these yards are rarely cleaned. What is worse, these hovels have no heat, only coal grates. When the coal book from the Home Relief Bu-

reau expires, the dwellers comb the neighborhood for fuel. Janitors in the surrounding district have to stand guard over coal deliveries until they are moved in. During December I saw five tons of coal that had been deposited in front of Lenox Avenue and 113th Street vanish in boxes, pails, paper bags—quicker than you could say Fiorello La Guardia—that is, if you weren't too weak or too starved.

These hovels, these breeders of crime, these embassies of death and sickness, rent for twenty-five dollars per month for four or five boxes, called rooms, with occasional sunshine in only one of the rooms, and this is the lowest rent in Harlem! Even these rents are prohibitive and met only by staging rent parties to which the public comes, plays, dances, eats and drinks. Parents of good character are forced to welcome lodgers to their homes whom they have never seen, known or heard of and who, when they depart suddenly, will not be heard from. So that the maximum number of rooms may be rented out, an entire family usually sleeps in one room. Some families are lucky if they cannot only rent a room at night, but also get a night worker to occupy during the day the same room, same bed, same sheets and be bitten by the same bugs. The luckiest family is that one which has a bathroom and rents the tub out for a bed, covering it with boards. Many of these filthy, packed cesspools are owned by the Astor, Browning and Rockefeller estates.

Slum clearance started with a flourish, but it was only a gesture. There are three Negro companies

organized to sponsor housing projects; one headed by the Hon. Charles Mitchell, former Minister to Liberia, has been trying to get its project through for two years. However, the Federal Government "no speakee English" at the appearance of a black face. But Negroes are slightly wary of "housing for the workers." They have seen the Paul Laurence Dunbar project, built by John D. Rockefeller, Jr., for the workers, turn out to be one of the more expensive spots in Harlem. Many pause and wonder why the same apartments built at the same time by the same Rockefeller money on the Grand Concourse, are identical in everything except the price.

Well, you may ask, why don't Harlemites move? Harlemites are moving as fast as districts are opened up for them. Witness, however, the recent eviction of Negroes who had dared to move into the apartments on Prospect Avenue, Bronx, even though the landlord invited them. Harlem cannot build up while she cannot spread out further. What then for the families which cannot pay the high rents nor obtain relief? Down into the ground they have gone, into the cellars and basements they have scurried. Fully ten thousand of the Harlem citizenry now live in cellars: dark, damp, cold dungeons. Here they exist in squalor worse than that of the sharecroppers—for the Arkansas fieldhands at least have sunshine and fresh air. Families "live" in these basements, most

of which have not even been re-modeled into the semblance of a flat; floors of cracked concrete, walls of whitewashed rock, slits for windows, no toilets except the tin can in the corner with a sheet hanging over it, no running water in some, no partitions to separate from the eyes of the curious young the various functions of this thing we call living, no furni-ture—sleeping on springs or slats, sitting and eating on boxes, chil-dren without shoes.

The dwellers within these gates have evolved a new social scheme or rather a new social "odor" that should smell pretty bad to the executives of the great estates that own the properties. Barred from employment in the 125th Street five-ten-and-twenty-five-cent stores, these cellar dwellers have organized their own five-ten-and-twenty-five-cent standards of living. In these cellars are restau-rants serving meals for ten and fif-teen cents; barbers will cut your hair for twenty cents, beauticians wave it for thirty cents, tailors will put a crease everlasting in your one and only for twenty cents. —A. CLAYTON POWELL, JR.

❖ ❖ ❖

NEW YORK HERALD TRIBUNE, JUNE 23, 1935

LOUIS-CARNERA BOUT DRAWS 15,000 NEGROES, 1,300 POLICE

Fifteen thousand Negroes, it was estimated by police officials, were in the throng of 60,000 who at-tended the international heavy-weight bout between Joe Louis, of Detroit, and Primo Carnera, of Italy, in the Yankee Stadium last night.

They helped to make the crowd one of the most unusual fight gatherings New York has seen. They came from Harlem just across the river, from Brooklyn, from Detroit, where Louis lives; from Chicago, where he fought his way to sudden fame in less than a year; from Boston, Phila-delphia, Washington and way sta-tions, all desirous of seeing the most publicized and spectacular heavyweight of their race since Jack Johnson fought James J. Jeffries at Reno twenty-five years ago.

The crowd was in an excited and expectant mood. Whipped to frenzied interest by the paeans of praise for the murderous punch, defensive skill and all-around fighting prowess of the beardless youth of twenty-one who won the national amateur championship fifteen months ago and made his professional debut last Fourth of July, the customers turned out to see the first significant mixed heavyweight bout that has been staged in New York in modern times, since the turn of the cen-tury, if not longer.

Harry Wills, who came closest to being a challenger, although he was never permitted a shot at Jack Dempsey's title, was past his prime when he fought Luis Firpo in a no-decision bout in Jersey City in 1924, and he was much further in his decline when he was knocked out by Jack Sharkey in Brooklyn. These were the last mixed heavyweight bouts here until Louis entered the ring against the Italian.

The crowd of 60,000 and the estimated receipts of $340,000 were, respectively, the largest at-tendance and the largest gate for a nonchampionship bout here since Schmeling and Paulino Uz-cudun met in the same stadium, six years ago. Because it was a mixed bout, and the officials here have long looked upon mixed heavyweight bouts with mixed emotions, Police Commissioner Lewis J. Valentine made the most elaborate precautions ever under-taken by the police at a sporting event in this city. He assigned an army of 1,300 police for duty in and around the arena. There were emergency squads with hand grenades and tear-gas bombs, also four patrol wagons stationed a block from the stadium. Three hundred extra detectives aided the regular Bronx detail by min-gling with the crowd inside and outside. In command was Assist-ant Chief Inspector John J. Sulli-van. Also on duty this tumultuous night were two motorcycle ser-geants and ten motorcycle police, five mounted sergeants and fifty-four mounted men; 816 patrol-men afoot under seven captains, nine lieutenants and five ser-geants, with Valentine himself in supreme command. All because a fighting youngster named Joe Louis, né Joseph Louis Barrow from Alabama, has captured the fancy of the boxing public as no other heavyweight since Demp-sey himself.

Mike Jacobs, one-time silent

adviser of Tex Rickard and promoter of this mixed bout which Rickard himself might not have touched, beamed with pleasure at the social and financial success of his enterprise. He saw the mayors of three cities, our own Mayor La Guardia, Frank Hague of Jersey City and Mayor Ellenstein of Newark, also the customary gathering of bigwigs from the political arena, the judiciary, the stage and screen, the sporting field.

Negro celebrities from the political, sporting, business and theatrical world were conspicuous around the ringside. There were Ferdinand Q. Morton, civil service commissioner; Hubert Delany, tax commissioner; Dr. C. B. Powell, Harlem's X-ray specialist and chairman of the board of Victory Life Insurance Company; Assistant State Attorney General Harry Bragg; Elmer Carter, editor of *Opportunity* magazine; Assemblyman William T. Andrews; Walter White, secretary of the National Association for the Advancement of Colored People; Dr. Louis T. Wright, New York police surgeon and only Negro fellow of the American College of Surgeons; the Rev. Adam Powell, Jr., assistant pastor of Harlem's Abyssinian Baptist Church; Fritz Pollard, one-time All-American back at Brown University; Claude Hopkins and Duke Ellington, orchestra leaders; Police Lieutenant Samuel Battle; Fire Lieutenant Wesley Williams; Cecil Cook, one-time American quarter-mile champion from Syracuse University; Dr. Binga Dis-

mond, one-time Big Ten 440-yard champion at the University of Chicago; George Gregory, captain of one of Columbia's championship basketball teams; Dr. Willis Cummings, former Pennsylvania cross-country captain; Dr. Thornton Wood; Aldermen Charles Bradford, and Conrad and U. Johnson; Dr. Wiley Johnson; Dr. Arthur Paine; and of course Jack Johnson and Harry Wills.

Negro visitors included Congressman William Mitchell of Chicago; Professors Ralph Bunche, Emmett Dorsey and Abram Harris, of Howard University, Washington; Carl Murphy, editor of the Baltimore *Afro-American*; William C. Vann, editor of the Pittsburgh *Courier*; and Robert Abbott, editor of the *Chicago Defender*, of Chicago. They were house guests over the weekend on Strivers' Row and on Sugar Hill.

NEW YORK HERALD TRIBUNE, OCT. 4, 1935

ITALIANS CLASH WITH NEGROES

The first shots of the Italo-Ethiopian war were echoed in New York City yesterday as Negroes and Italians engaged in several patriotic skirmishes, creating serious tension and causing grave anxiety to officials of the police department, Harlem and the Little Chicago section of Brooklyn. Last night the atmosphere of unrest in Harlem became so heavy that the police department's old

emergency reserve system was invoked for the first time since the taxi and elevator strikes of last year. The greatest concentration of police power was in Harlem and Brooklyn, although every precinct received its supply of reserves.

From the time the first newsboys began to shout through the streets of Harlem that Italian airplanes had destroyed Ethiopian towns, the anger of resident Negroes mounted hour by hour. Outside the entrances to Italian fruit stores and vegetable markets in Harlem, chalk inscriptions appeared, reading: "Italians. Keep Out." Street-corner demagogues shouted to their listeners that "Africa is the black man's home."

Warfare developed between Italian and Negro pupils at P.S. 178. It all began Wednesday afternoon when an argument between two twelve-year-old boys, one a Negro, the other an Italian, grew into a fight, and the fight ended in victory for the Negro. Smarting under his defeat, the Italian boy gathered fifteen sympathizers and waited outside the school gate at 8:30 a.m. yesterday. As each Negro boy came to school he was seized and beaten by the Italians. The process of mayhem was proceeding with vigor and dispatch when a teacher, Albert C. Tweedy, surprised the assailants and broke up the system. They ran away to their classes, leaving before the horrified gaze of Mr. Tweedy four ice picks, a sawed-off billiard cue,

four home-made clubs and a base-ball bat. Since one-third of the school's enrollment of 2,200 are Negroes and one-third are Italians, the growing jingoistic spirit in the student body presented to the school authorities a problem of no mean proportions.

Just before 3 p.m., when the school day ended, the teachers were alarmed to see a crowd of 500 Italian and Negro parents forming outside the entrance to the school. Three o'clock struck, but the children were not dismissed. Outside on the street the parents glared at each other, and just as the first fists began to fly the screams of police sirens rang out and fifteen patrol cars, an emergency crew and fifty uniformed men arrived on the scene. Then, and only then, school was out. It took the police nearly an hour and a half to break up the acrimonious groups of parents and the bunches of fighting children and to start the Italians and Negroes moving in separate directions.

The hostility between Italians and Negroes in Harlem came to a head outside the King Julius General Market at 176 Lenox Avenue, between 118th and 119th Streets. At 4 p.m. Louis and Sal Apuzzo, proprietors of the butcher department, and Nick Augustino, owner of the vegetable and fruit concessions, began to grow uneasy at the crowd forming outside their store. A tall Negro in a dark blue shirt, a red tie and a

gray tweed coat was shouting: "Harlem is for the Negro. Drive the Italians out of Harlem. Drive the white man out of Harlem. The white man is a monster who preys on the black man. We're Ethiopian and I'm proud of it. We must fight the battles of our brothers overseas." And so on. The indignation of the Negroes against the terrified Italians inside the butcher shop increased, mounting to fever heat when a Negro woman went inside and ordered a large ham. Louis Apuzzo started to wrap up the ham, keeping one eye on the group outside. Suddenly there was a concerted rush at the door. The ham was wrenched from the customer's grasp and she herself was hustled out on the street by the furious invaders.

There were ten Negro clerks in the King Julius store, and five Italians. All of them seized knives and cleavers. One of them telephoned to the police. Outside, a lone patrolman, whose name later was given as Chaimowitz, rushed up to the entrance with drawn revolver. The Negroes scattered, but formed again and were discussing what to do when three radio cars, an emergency crew, twenty-five patrolmen and fifteen detectives drew up to the curb. Within a few moments the crowd, which numbered about 200, dispersed and drifted up Lenox Avenue in small groups. At 123rd Street and Seventh Avenue its members formed again and then proceeded down toward the West 123rd Street police station, near Eighth Avenue, to protest some-

thing which never was fully resolved. The general belief was that they were protesting the drawing of Patrolman Chaimowitz's revolver. They happened, however, to select the time when the police were changing tours, and as they approached the door of the station house a large squad of policemen came marching out and lined up on the sidewalk in a double column. The two groups stared at each other. The Negroes hesitated. The police paused. Then Captain George Mulholland gave an order. The police versions of the order were "Disperse the crowd" and "Clear the street." Bystanders declared that Captain Mulholland said: "Get these bums out of here." At any rate, the police charged and the Negroes turned and fled. On the south side of the street, 200 feet east of the police station, Charles Linous, who was carrying the red, orange and green flag of Ethiopia, found himself cornered by a brownstone stoop. Later Patrolman John J. Reilly said that Linous had swung the staff of an Ethiopian flag as a weapon and had broken the officer's hand. Linous, however, said that the policeman broke his own hand beating Linous in the back room of the station house after the Negro's arrest. He gave his address as 63 East 115th Street, and said he had served in the Senegalese forces of the French army in the World War.

❖ ❖ ❖

NEW YORK HERALD TRIBUNE, JAN. 29, 1936

CHOICE OF TENANTS URGED

Care in selection of tenants was emphasized in recommendations of the Harlem Housing Committee, appointed last fall by Langdon W. Post, chairman of the New York City Housing Authority, to consider plans for Harlem River Houses, low-rental project for Negroes to be built at 151st Street and the Harlem River, in its first report to Mr. Post yesterday. It was important to obtain the most desirable tenants for the project, the report pointed out, because if the experiment should fail, many would consider it proof that the Harlem slums and their dwellers were not ready to benefit by low-cost housing, and any further development might be hampered. The report, drawn up by a subcommittee, discussed methods of obtaining desirable tenants and explained the peculiar difficulties of the problem in Harlem. Any effective measures to ease the housing problem in Harlem would cost about $100,-000,000, the committee estimated.

"When we put against that need the less than $5,000,000 present allotment," the report said, "we realize that this first project cannot begin to accomplish solution of the Harlem slum situation, but that it is important in establishing proof to the government that Harlem offers a rich field for further expenditures in housing." The committee kept in mind three cardinal considerations. First, that the project must pay for itself; second, that it must keep its rate of depreciation average for the type of project; and third, that the general character of tenants must be such as to insure harmony between the tenants and the management. From every source, the committee recommended, information about each applicant for an apartment should be gathered, concerning the size and health of the family, its income, its credit standing, the regularity of employment of the breadwinner, and the family's social history. The lower in the social and economic scale that a family was, the report noted, the more desirable it should be as a tenant.

Because of discrimination against Negroes in legitimate employment, said the committee, many Negroes who might apply for apartments were engaged in illegal enterprises, such as bootlegging, the numbers game, drug peddling and gambling. These persons were often better able to pay, the report said, than the elevator operator or porter, but they should not be admitted to the development "because they might exploit the tenants from within."

The report recommended that a Negro should be appointed to whatever agency, Federal or municipal, which would operate the houses. Harlem River Houses will be built by a grant of $4,700,000 from the PWA and include forty-six units providing dwelling for 552 families in 1,950 rooms. Most of the apartments will be three- and four-room units, rents to be $6 or $7 a month a room.

❖ ❖ ❖

THE NEW YORK TIMES, APRIL 15, 1936

JAM STREETS AS "MACBETH" OPENS

A festival spirit accompanied by Hollywood floodlights and a brass band of eighty pieces came to Harlem last night to celebrate the opening of the most ambitious venture of the Negro division of the Federal Theater Project—a transplanted version of Shakespeare's "Macbeth," with an all-Negro cast. Fully an hour before the curtain rose at the Lafayette Theater on Seventh Avenue, between 131st and 132nd Streets, the brass band of the Monarch Negro Elks, dressed in bright uniforms, assembled in front of the theater for an open-air concert.

As the hour grew near for the performance, Police Lieutenant Samuel Battle and twelve policemen, including two on horses, found it almost impossible to open a way to the lobby. All northbound automobile traffic was stopped for more than an hour. From trucks in the street, floodlights flared a circle of light

on the lobby, and cameramen took photographs of the arrival of celebrities. Mrs. Hallie Flanagan, national director of the Federal Theater Project, and Philip W. Barber, regional director, were interviewed for the newsreels as the milling crowd covered every inch of the sidewalks in front of the theater. As the curtain rose, the box-office men revealed that the theater was filled to capacity and about 100 men and women were standing.

At the conclusion of the performance Orson Welles, who adapted and staged the play, was virtually dragged out of the wings by members of the company and forced to take a bow. There were salvos of applause as numerous bouquets of flowers were handed over the footlights to the leading players.

❖ ❖ ❖

AMSTERDAM NEWS, JULY 18, 1936

RIOT REPORT THAT MAYOR HID

Answering the public's demand to get the word-by-word report of the Mayor's Commission which investigated conditions in Harlem following the March, 1935, rioting, the *Amsterdam News*, in this issue, puts into print every word of this report which Mayor F. H. La Guardia has insistently refused to release, although His Honor has had it in his possession since March 19, 1936. From time to time, segments of this 35,000-

word document have reached the public, but this is the very first time that anyone, outside the commission itself, and the mayor, has been able to read the report. Word for word, paragraph by paragraph, some of the findings of the commission will be found to be nothing new—no facts that Harlemites and New Yorkers have not known, or could not have known long before the riots of March 19.

Here, however, these conditions are reviewed and uttered by a commission having the sanction of the head of the city government, and conclusions are made, not only by the social workers and reformers, but by the "salt of the earth," the man in the street, the men and women who feel most the rigors of starvation, the spiked heels of the police, and the crushing load of high rents and discrimination in employment most.

The commission, headed by Dr. Charles Roberts, 233 West 139th Street, and consisting of both whites and Negroes, lawyers, preachers, civic and public servants, reviewed the occurrences of the March afternoon when a teen-age boy, Lino Rivera, stole a pocketknife from a 125th Street five-and-ten-cent store. It tells again of the combination of circumstances which made people believe the young Negro boy had been beaten to death, and of how the police, first, inefficiently, and next, ruthlessly, tried to meet the excitement of the people.

The report tells how the commission could not locate a "com-

mittee of women shoppers" which the police said it had allowed to go into the basement of the store to verify that the boy had not been killed, and infers that no such committee of shoppers ever existed. It records how the police told inquiring Negroes that the Rivera affair was none of their business and how honest decent citizens were chased away from both the store and the nearby police station when they tried to get the truth.

On the question of the crowd-inciting leaflets issued by the Young Liberators and which were supposed to play a prominent part in fanning the riot flames, the commission notes that the leaflets did not hit the streets until 7:30 p.m. and, therefore, the group "were not responsible for the disorders and attacks on property which were already in full swing. Already a tabloid in screaming headlines was telling the city that a race riot was going on in Harlem," the report states.

Speaking on the part the Communists played in the rioting, the commission declares: "While one, in view of the available facts, would hesitate to give Communists full credit for preventing the outbreak from becoming a race riot, they deserve more credit than any other element in Harlem for preventing a physical conflict between whites and Negroes."

Long-felt hostility to the police, resentment at the inability to get economic opportunities in the midst of plenty, were some of the

reasons for the rioting, the report states, and then detailedly it records its findings.

It reports that Negroes, who long felt that they could not get adequate and sympathetic assistance from welfare agencies, found no improvement of conditions when the city home-relief bureaus were established. The nearness of the relief situation to the rank and file of the people was shown at the public hearings held at the Seventh District Municipal Courthouse, 447 West 151st Street. These were the most hectic meetings, the spectators crowded the place, they demanded to be heard, they booed and heckled home-relief functionaries. They frightened city and commission, and in the end, the commission had to call off the open hearings.

"Today, extra-police stand guard on the corners and mounted patrolmen ride through the streets of Harlem," the closing chapter says after briefly reviewing the cause of the rioting. "To the citizens of Harlem," it continues, "they (the police) symbolize the answer of the city authorities to their protest of March 19. To Harlem this show of force simply signifies that property will be protected at any cost; but it offers no assurance that the legitimate demands of the citizens of the community for work and decent living conditions will be heeded. Hence, this show of force only tends to make the conditions which were responsible for the occurrence last March 19 more irritating. And so long as these conditions

persist, no one knows when they will lead to recurrence, with possibly greater violence, of the happenings of that night."

Then the commission goes down the list of its recommendations. It makes recommendations seeking to prevent the present broad-gauged discrimination against Negroes in employment. It suggests immediate improvement in relief administration, and future adjustments concerning relief police. It makes recommendations on education and recreation, specifically asking for new school buildings. It asks that colored doctors be admitted to all city hospitals, that Harlem Hospital be given a cleaning out. It requests for a citizens' committee to hear citizens' complaints against the police. Some of these recommendations the mayor has attempted to answer at recent public meetings, mostly by saying that he has already done the things the commission asked to be done. But the mayor has never made public the report, and his police commissioner has openly stated that he will keep his armed police army in Harlem, and if he had more men to spare, he would send them up here.

The original membership of the committee included Dr. Charles Roberts, chairman; Oswald Garrison Villard, white liberal publisher, vice-chairman; Mrs. Eunice Hunton Carter, secretary; Hubert Delany, tax commissioner; Countee Cullen, poet; A. Philip Randolph, president of the Brotherhood of Sleeping Car Porters; Municipal Judge Charles E. Toney.

The white members of the committee included William Jay Schieffelin, trustee of Tuskegee Institute; Morris Ernst and Arthur Garfield Hayes, prominent attorneys; Colonel John J. Grimley of the 369th Infantry; and Father McCann.

❖ ❖ ❖

THE NEW YORK TIMES, JUNE 22, 1937

100,000 CELEBRATE LOUIS VICTORY OVER BRADDOCK

Throngs estimated by the police at 100,000 persons swarmed into the streets of Harlem last night to celebrate the victory that made Joe Louis world champion. With fishhorns and cowbells, drums and rattles, the crowd began a demonstration said by observers to be without parallel in the history of the Negro neighborhood. Persons who did not join the marching and dancing on the pavements and the sidewalks took part in the festivity by shouting from their windows. Others ripped telephone books and newspapers to shreds, showering the pieces into the air in the fashion of confetti. Nearly 1,000 policemen stood guard over the celebrants, intervening at times to keep traffic moving. The crowd was too good-humored, patrol-

men said, to require other supervision.

Two drums and a yellow, white and green banner, described as the flag of Abbyssinia, formed the nucleus of a parade on Seventh Avenue that drew an estimated 10,000 marchers. Lenox Avenue witnessed a similar demonstration. Cafés and grills were crowded. Men and women, girls and boys jumped aboard taxicabs a dozen at a time. One cab was abandoned at Seventh Avenue and 130th Street because its tires went flat under the weight of riders. White persons caught in the jam were not molested, as far as the police could learn, but were the subject of much joshing, a favorite form of greeting for white men being "Howdy, Mr. Braddock."

❖ ❖ ❖

DOWN BEAT, FEBRUARY, 1938

WEBB "CUTS" BASIE IN SWING BATTLE

The much heralded Battle of Swing between Chick Webb's and Count Basie's bands took place Sunday night, January 16, at the Savoy Ballroom. The affair drew a record attendance and hundreds were turned away at the box office, with the crowds tying up traffic for several blocks in that vicinity. Applause for both bands was tremendous and it was

difficult to determine which band was the more popular.

Nevertheless, the ballot taken showed Chick Webb's band well in the lead over Basie's, and Ella Fitzgerald well out in front over Billie Holiday and James Rushing. The battle took place after Benny Goodman's concert at Carnegie Hall, and many of Benny Goodman's band, including Gene Krupa, Lionel Hampton, Jimmie Mundy, Hymie Scherzer and others were present. Mildred Bailey, Red Norvo, Teddy Hill, Willie Bryant, Eddy Duchin, Duke Ellington and Ivie Anderson were also on hand.

Feeling ran very high between the supporters of the two bands, and it was a fight to the finish. Both bands played magnificently, with Basie having a particular appeal for the dancers, and Webb consistently stealing the show on the drums. Ella Fitzgerald caused a sensation with her rendition of "Loch Lomond," and Billie Holiday thrilled her fans with "My Man." When Ella sang she had the whole crowd rocking with her. James Rushing had everybody shouting the blues right along with him. Handkerchiefs were waving, people were shouting and stomping, the excitement was intense.

A highlight of the evening was reached when Duke Ellington was persuaded to play some piano and sounded so good that Basie's band picked it up and swung right along with him. General consensus of opinion agreed that both bands played magnificently, making the decision a close one. There

was good feeling all around, and it was decided that there would be a return battle in the near future.

❖ ❖ ❖

DOWN BEAT, AUGUST, 1938

WHITE MAN'S JAZZ NO GOOD FOR HOLIDAY?

It's a mystery to us why the true story of the Basie-Holiday split never came to light in print. The music mags all hinted that there was more to it than met the eye, but that was as far as they would carry it.

Billie Holiday is still singing with Artie Shaw, but it is a damn shame she has to waste her talents with a band of that caliber. Understand, in spite of Cliff Leeman's pseudo-sizzle cymbal, Artie has a swell outfit, but they don't show off Billie any. Naturally they play white man's jazz and that's no backing for Billie's singing, which, even during its more commercial moments, has a definite "race" flavor. When she had Count Basie behind her, the girl was right. Now she's as incongruous as a diamond set in a rosette of old cantaloupe rinds and coffee grounds. —TED LOCKE

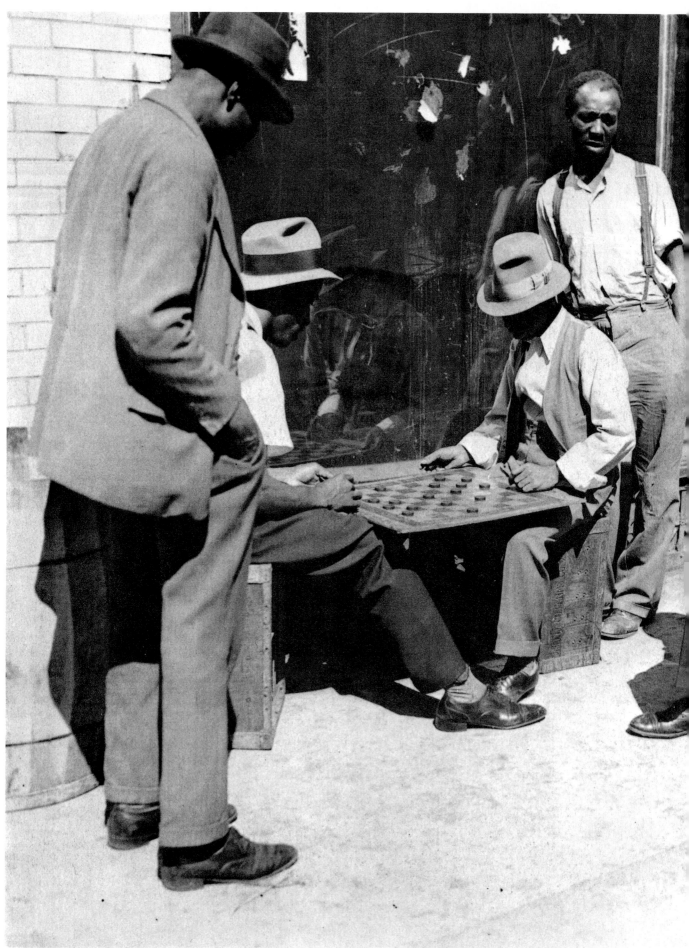

CHECKERS ON LENOX AVE., 1935/UPI

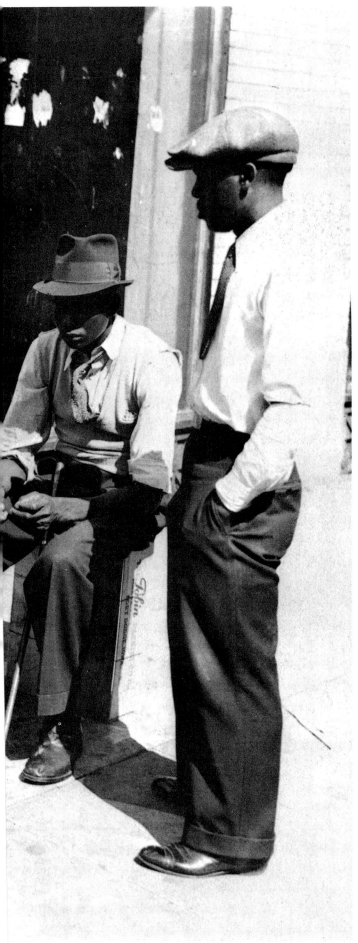

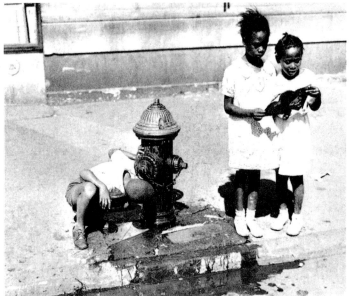

KIDS AT HYDRANT ON LENOX AVE., 1935/UPI

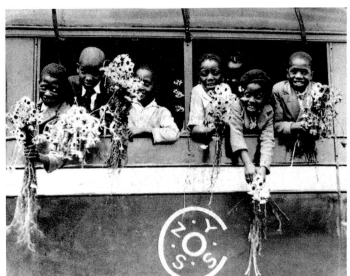

AFTER A DAY IN THE COUNTRY, c. 1932/CHILDREN'S AID SOCIETY

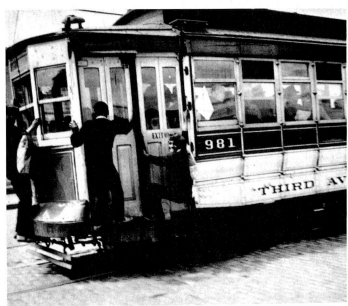

HITCHING A RIDE, c. 1934/ UNDERWOOD AND UNDERWOOD

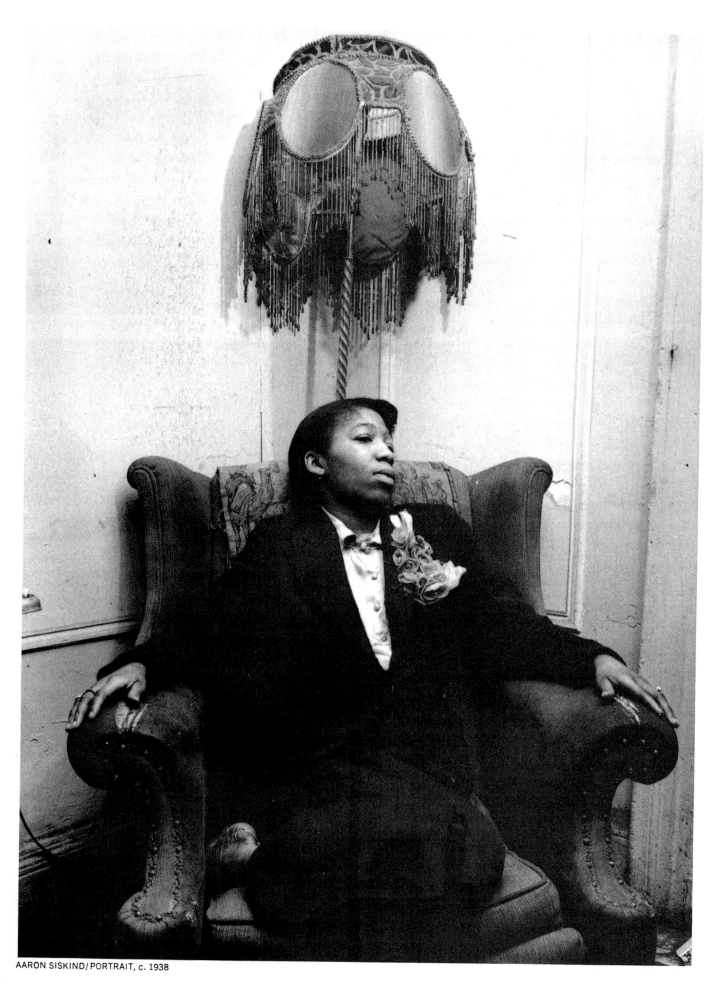

AARON SISKIND/PORTRAIT, c. 1938

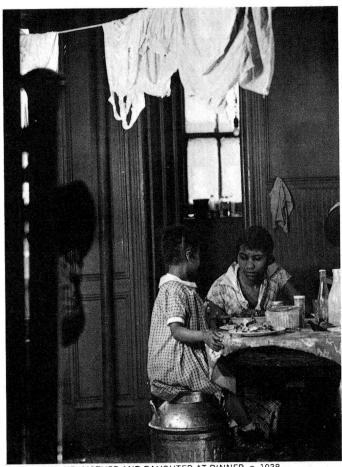

AARON SISKIND/MOTHER AND DAUGHTER AT DINNER, c. 1938

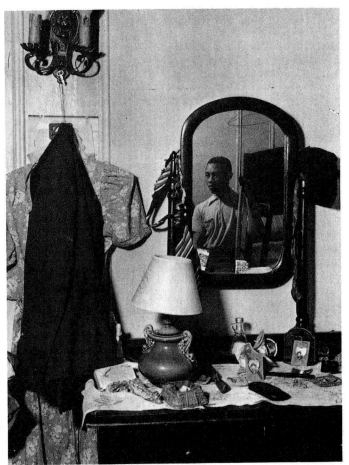

AARON SISKIND/BEDROOM INTERIOR, c. 1938

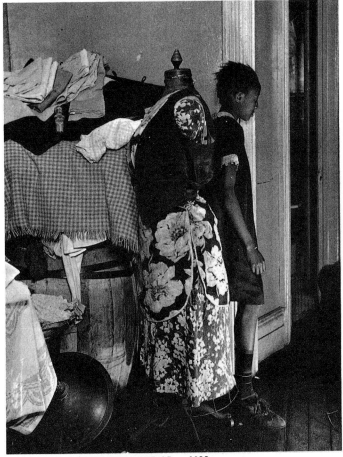

AARON SISKIND/TENEMENT INTERIOR, c. 1938

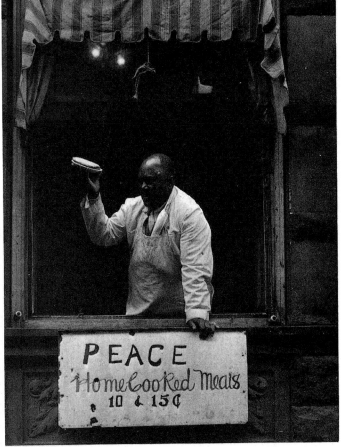

AARON SISKIND/HOME COOKED MEALS, c. 1938

151

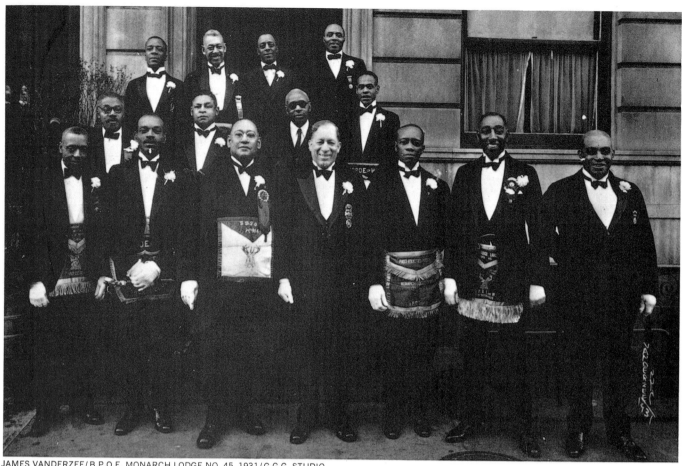

JAMES VANDERZEE/B.P.O.E. MONARCH LODGE NO. 45, 1931/G.G.G. STUDIO

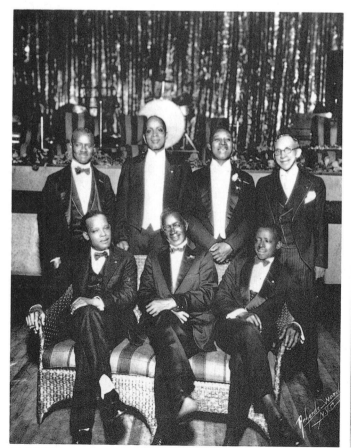

CLUB PORTRAIT, c. 1931/SCHOMBURG COLLECTION, NYPL

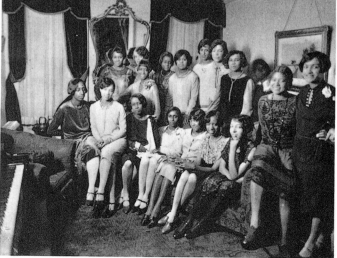

ALPHA KAPPA ALPHA SORORITY, 1931/SCHOMBURG COLLECTION, NYPL

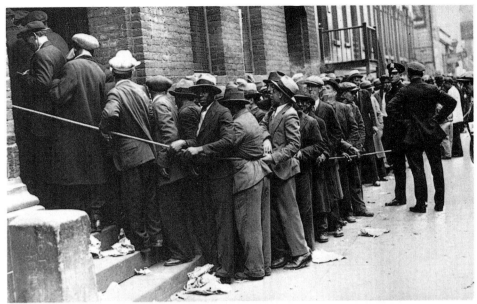

UNEMPLOYMENT REGISTRATION, 1931/UPI

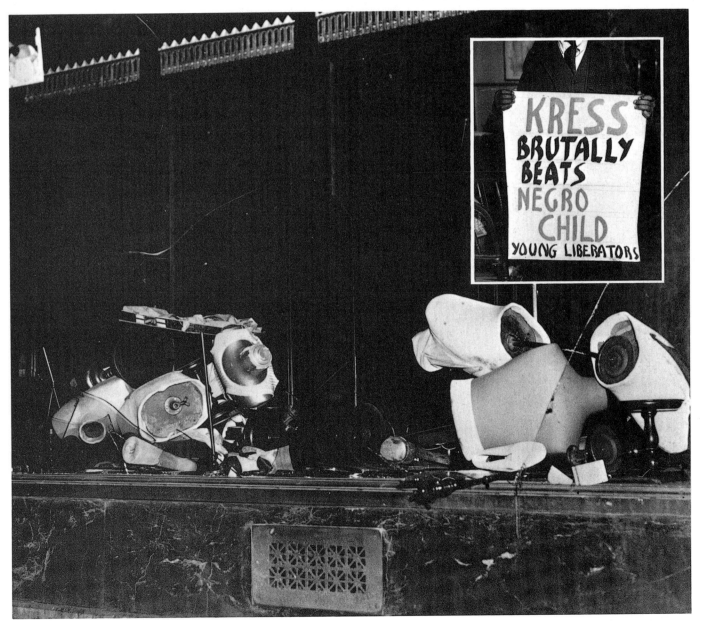

STORE FRONT AFTER THE RIOT, 1935/UPI
(INSET) PROTEST POSTER, MARCH RIOTS, 1935/UPI

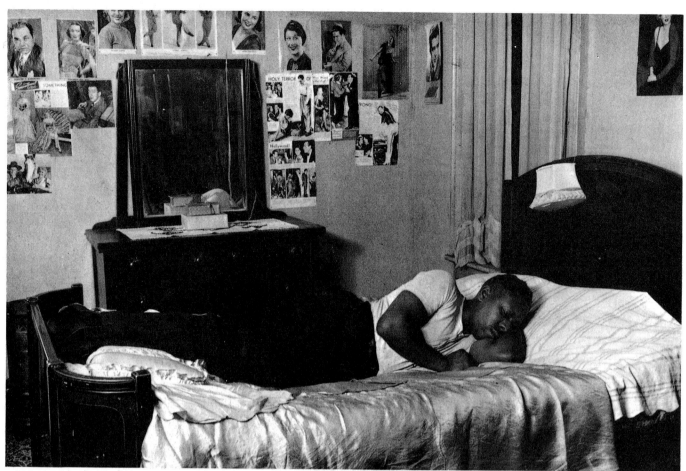

AARON SISKIND/SLEEPING WITH WHITE PIN-UPS, c. 1938

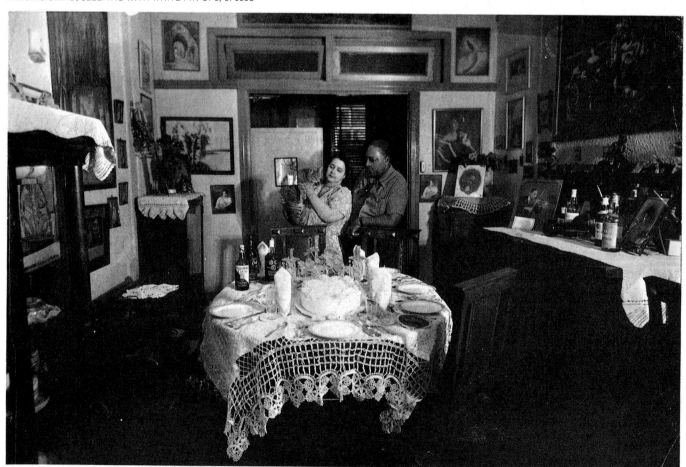

MR. AND MRS. JAMES VANDERZEE, 1930/G.G.G. STUDIO

SUGAR HILL, EDGECOMBE AVE., 1938/SCHOMBURG COLLECTION, NYPL

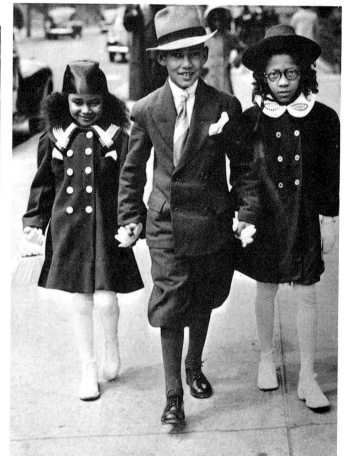

CHURCH IS OUT, c. 1939/SCHOMBURG COLLECTION, NYPL

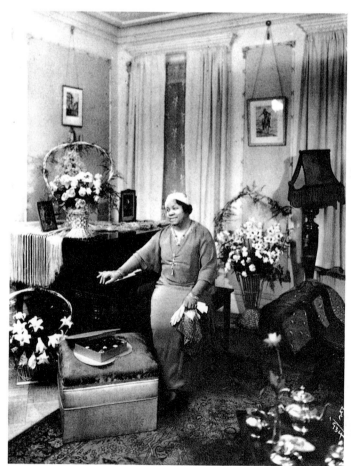

JAMES VANDERZEE/AT HOME, 1934/G.G.G. STUDIO

ATTENDING THE BALL, 1935/UPI

MISS AGGIE FRANCIS, MR. ALLEN MUNDY,
ARRIVING AT BALL, 1935/UPI

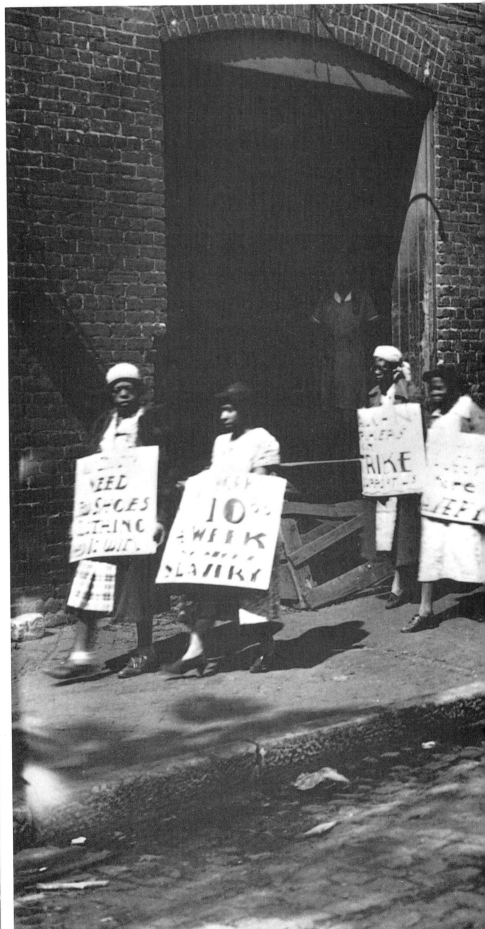

ETHIOPIAN WAR PROTEST, c. 1936 / UPI

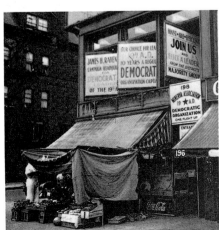

DEMOCRATIC HEADQUARTERS, c. 1935
SCHOMBURG COLLECTION, NYPL

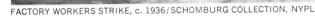

FACTORY WORKERS STRIKE, c. 1936 / SCHOMBURG COLLECTION, NYPL

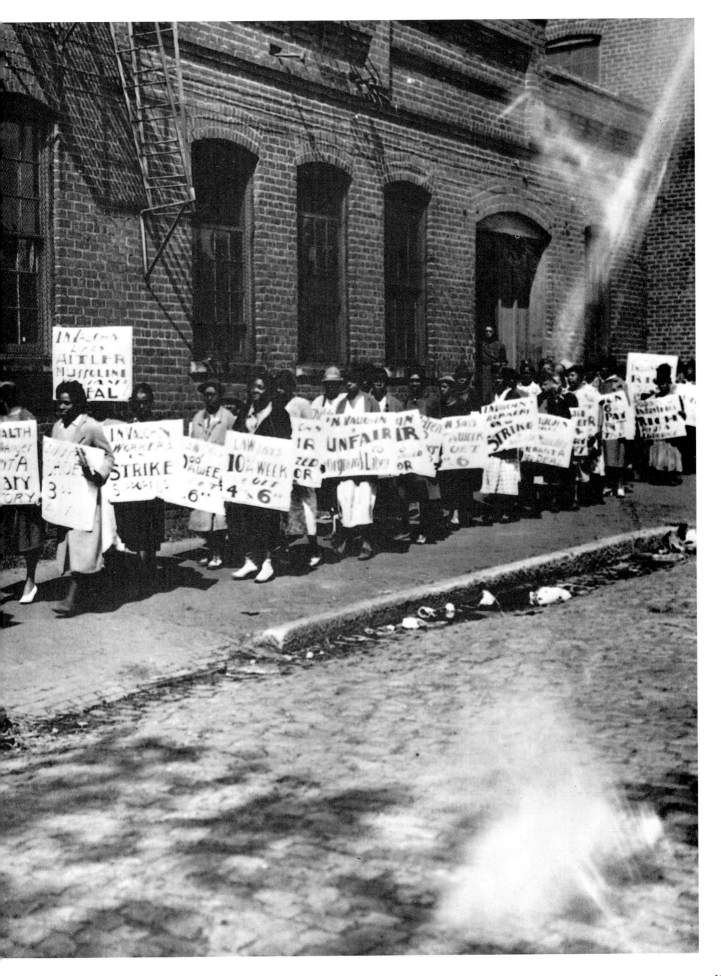

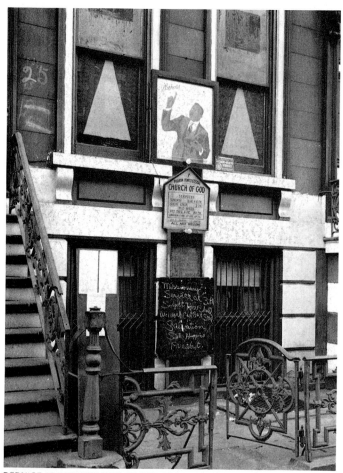

BERNICE ABBOTT/CHURCH OF GOD, 25 EAST 132ND ST., 1936
MUSEUM OF THE CITY OF N.Y.

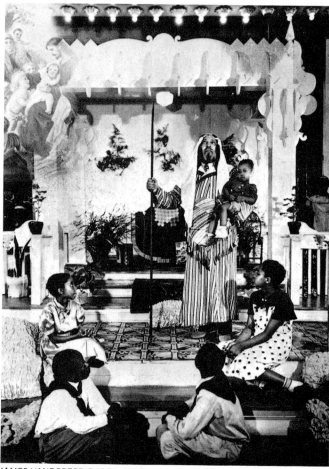

JAMES VANDERZEE/DADDY GRACE, 1938/G.G.G. STUDIO

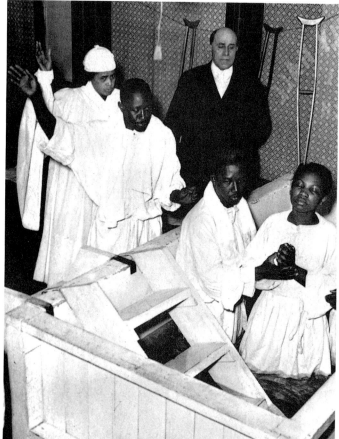

BAPTISM AT PENTECOSTAL FAITH CHURCH OF ALL NATIONS, 1934/UPI

ABYSSINIAN BAPTIST CHURCH, WEST 138TH ST., 1936

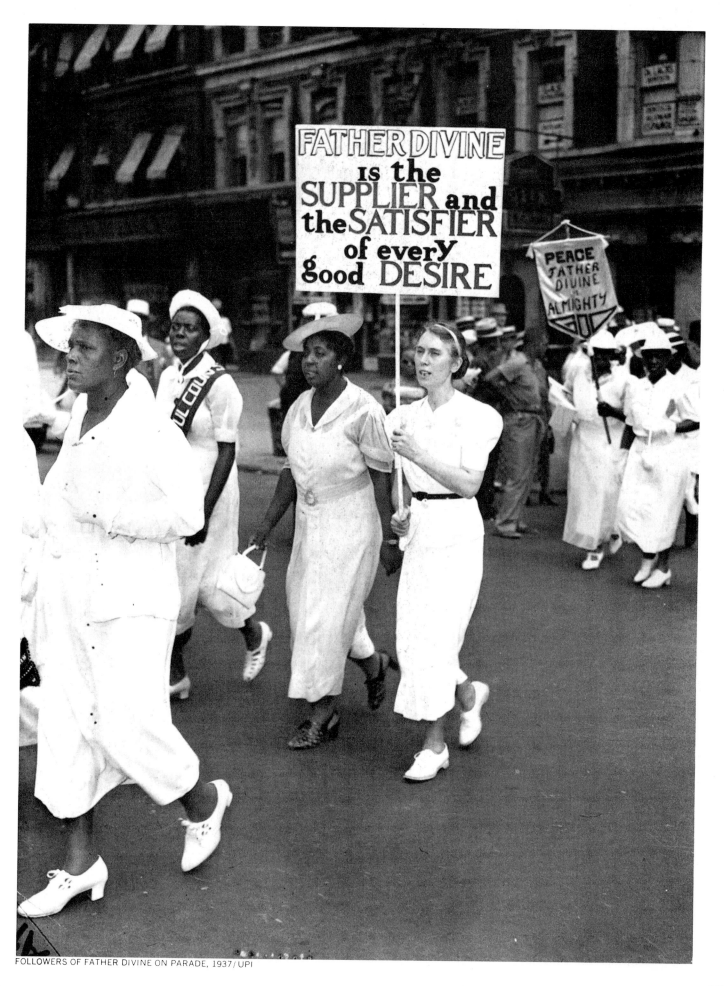

FOLLOWERS OF FATHER DIVINE ON PARADE, 1937/UPI

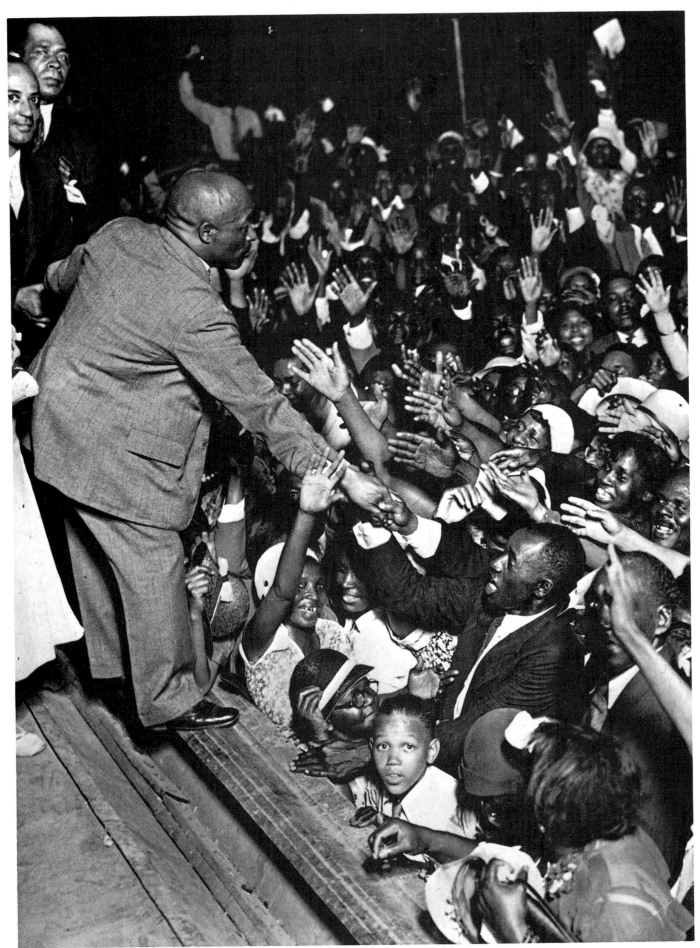

GREETING FATHER DIVINE, 1938/N.Y. DAILY NEWS PHOTO

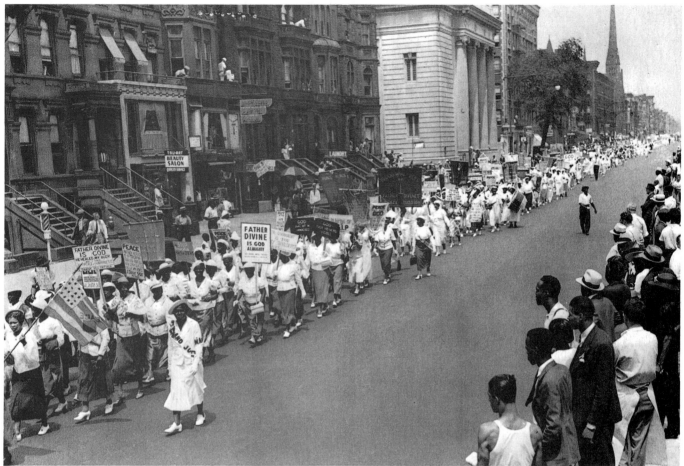

FOLLOWERS OF FATHER DIVINE ON PARADE, 1938/UPI

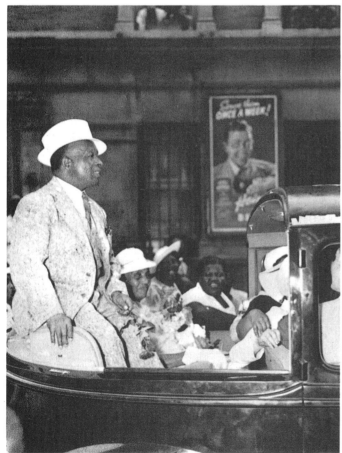

FATHER DIVINE, 1938/UPI

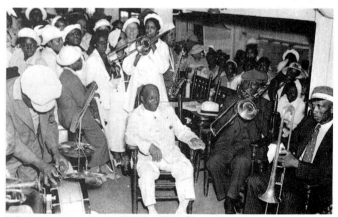

FATHER DIVINE AND FOLLOWERS, 1937/UPI

FATHER DIVINE WITH DUSENBERG, 1938/N.Y. DAILY NEWS PHOTO

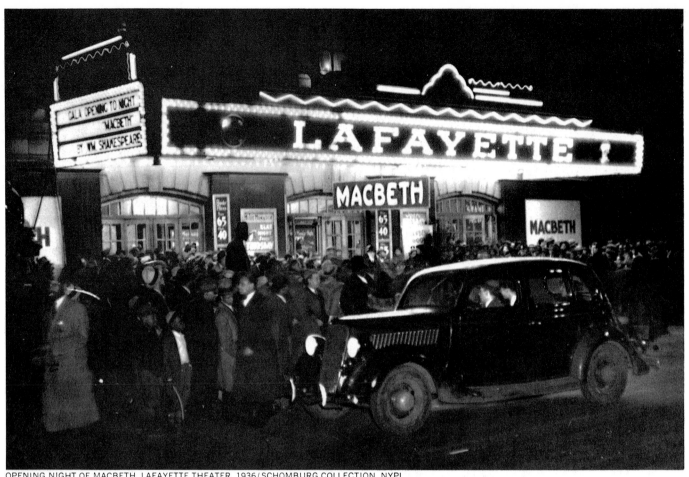

OPENING NIGHT OF MACBETH, LAFAYETTE THEATER, 1936/SCHOMBURG COLLECTION, NYPL

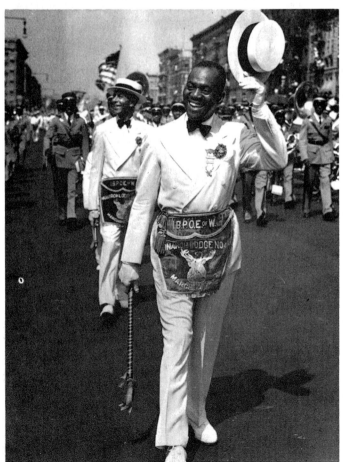

BILL ROBINSON LEADING ELKS' PARADE, 1939/UPI

REX INGRAM IN "HAITI," LAFAYETTE THEATER, c. 1936
SCHOMBURG COLLECTION, NYPL

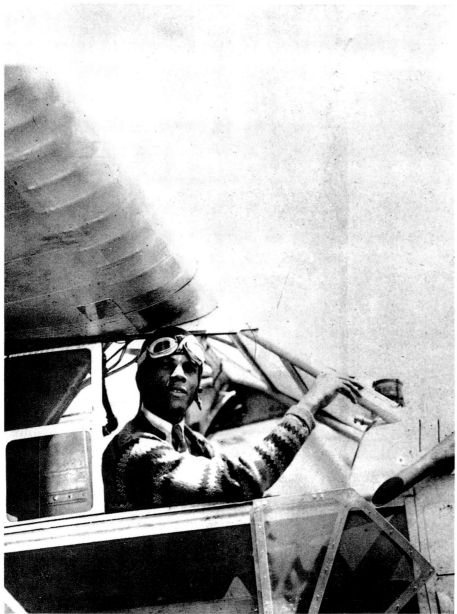

LT. HUBERT JULIAN IN COCKPIT, c. 1935/UPI

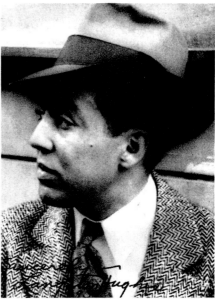

CARL VAN VECHTEN/LANGSTON HUGHES, 1937
SCHOMBURG COLLECTION, NYPL

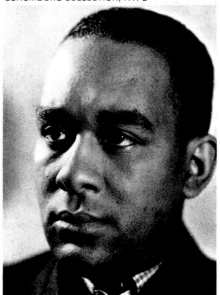

RICHARD WRIGHT, c. 1939
SCHOMBURG COLLECTION, NYPL

PAUL ROBESON, 1930/SCHOMBURG COLLECTION,
NYPL

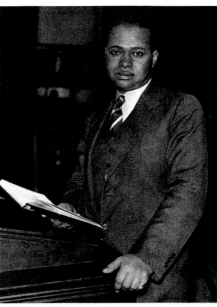

COUNTEE CULLEN, 1932/N.Y. DAILY NEWS PHOTO

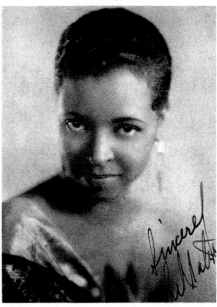

ETHEL WATERS, 1932/ERNEST SMITH COLLECTION

163

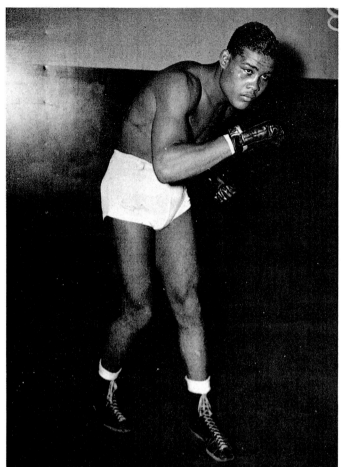

JOE LOUIS IN TRAINING, c. 1935/BROWN BROS.

JAMES VANDERZEE/NEW YORK BLACK YANKEES, 1934/G.G.G. STUDIO

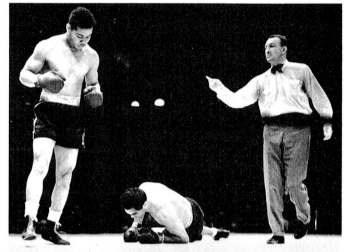

LOUIS KO's SCHMELING IN 2:04 OF FIRST ROUND,
JUNE 23, 1938/WIDE WORLD PHOTOS

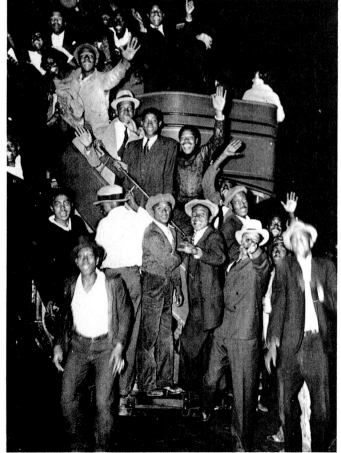

HARLEM CELEBRATES LOUIS' VICTORY, 1936/UPI

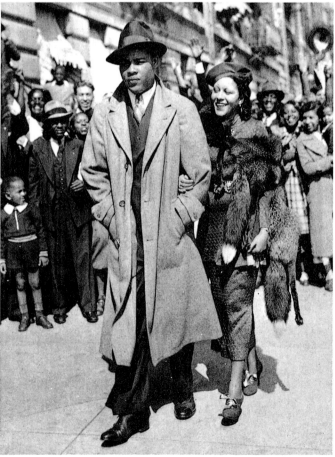

JOE AND MARVA TROTTER LOUIS WALKING IN HARLEM, 1935/UPI

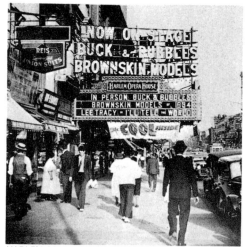

HARLEM OPERA HOUSE, WEST 125TH ST.,
1934/CULVER PICTURES, INC.

BUCK AND BUBBLES, c. 1934
SCHOMBURG COLLECTION, NYPL

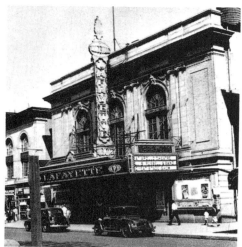

TREE OF HOPE AND LAFAYETTE THEATER, 1935/UPI

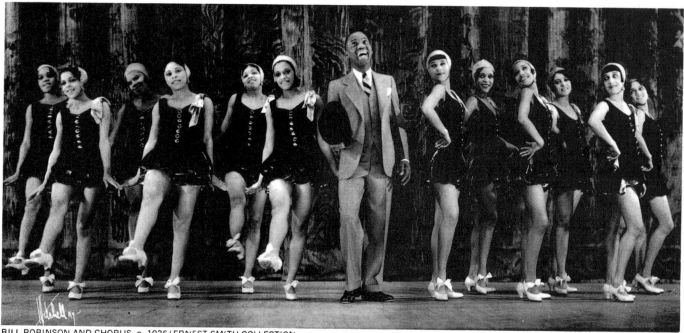

BILL ROBINSON AND CHORUS, c. 1936/ERNEST SMITH COLLECTION

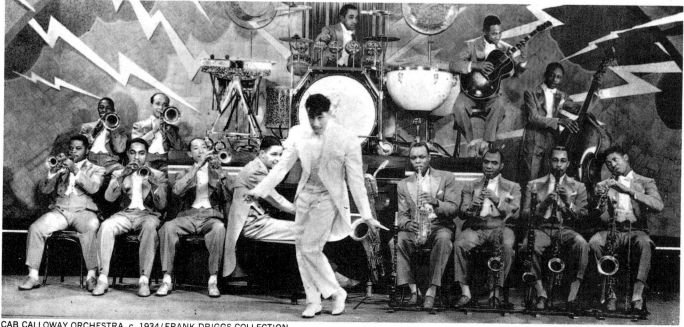

CAB CALLOWAY ORCHESTRA, c. 1934/FRANK DRIGGS COLLECTION

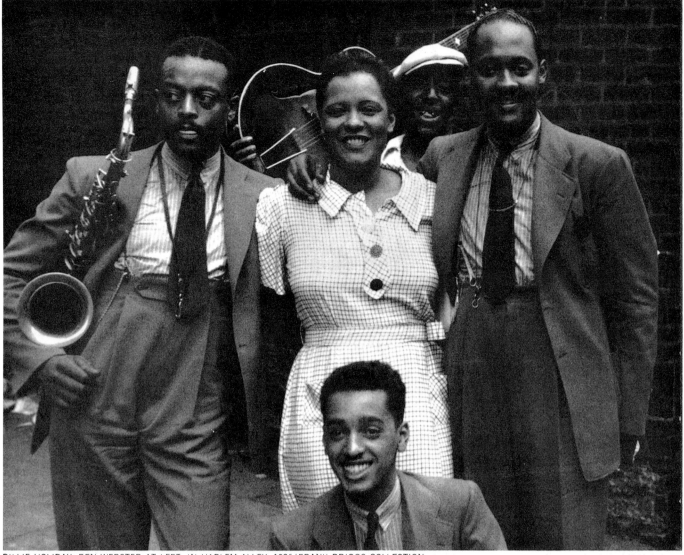

BILLIE HOLIDAY, BEN WEBSTER AT LEFT, IN HARLEM ALLEY, 1935/FRANK DRIGGS COLLECTION

LESTER YOUNG, c. 1938/HARRIS LEWINE COLLECTION

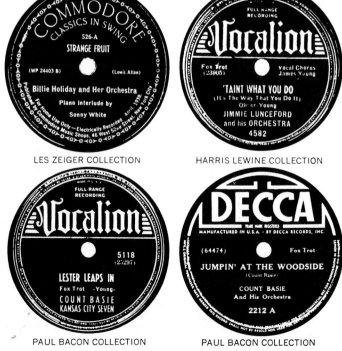

LES ZEIGER COLLECTION

HARRIS LEWINE COLLECTION

PAUL BACON COLLECTION

PAUL BACON COLLECTION

FATS WALLER, c. 1935/ BROWN BROS.

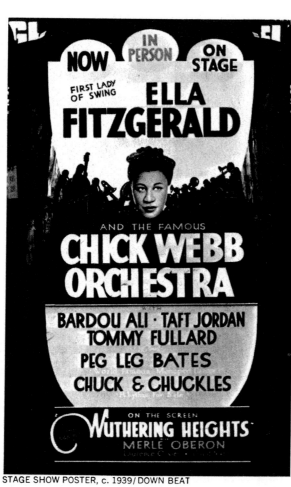

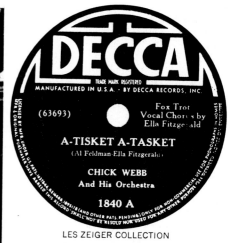

LES ZEIGER COLLECTION

IVIE ANDERSON, c. 1933
ERNEST SMITH COLLECTION

STAGE SHOW POSTER, c. 1939/ DOWN BEAT

CHICK WEBB, 1936/ BROWN BROS.

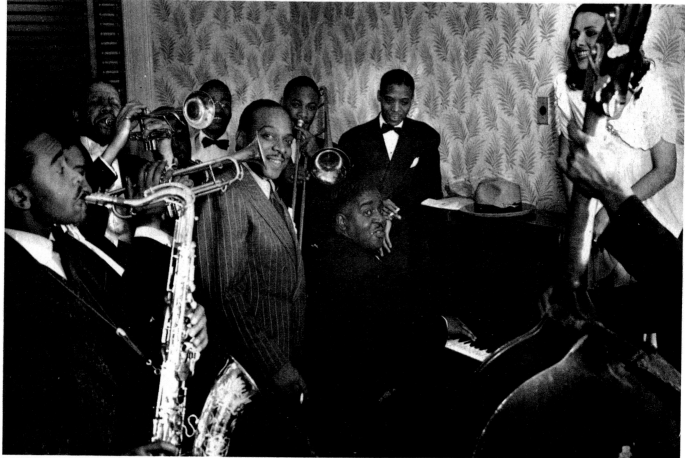

COUNT BASIE, PETE JOHNSON, RED ALLEN, DON BYAS, ETC. AND LENA HORNE ATOP PIANO, 1938/ DOWN BEAT

FLETCHER HENDERSON ORCHESTRA, 1935/FRANK DRIGGS COLLECTION

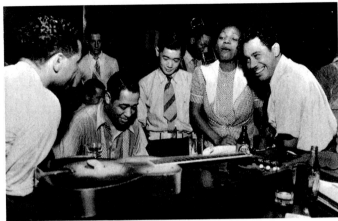

HARRY LIM'S JAM SESSION, c. 1938/ERNEST SMITH COLLECTION

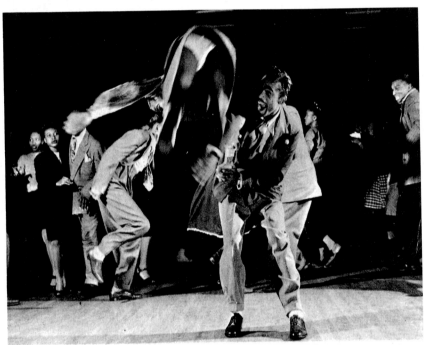

JITTERBUGGING AT THE SAVOY, c. 1939/SCHOMBURG COLLECTION, NYPL

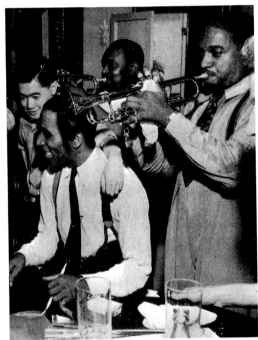

HARRY LIM'S JAM SESSION, c. 1938
ERNEST SMITH COLLECTION

PAUL BACON COLLECTION

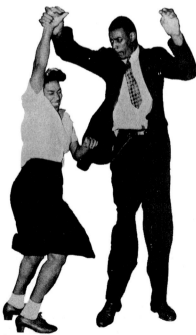

LINDY HOPPERS, SAVOY BALLROOM, c. 1937
SCHOMBURG COLLECTION, NYPL

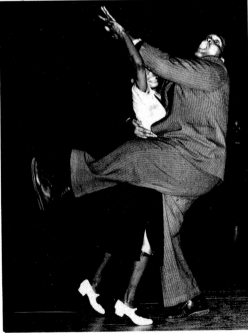

AARON SISKIND/AT THE SAVOY, c. 1938

WAR, HOPE & OPPORTUNITY 1940-1949

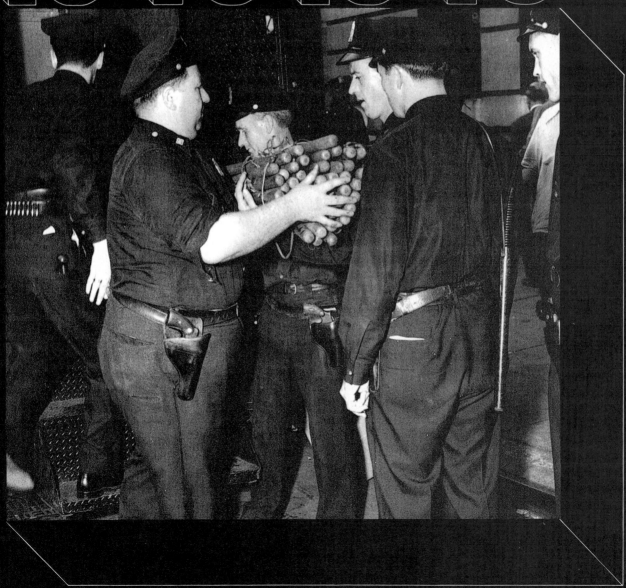

Negroes Not Backing War Effort Fully
Roosevelt's FEPC Holds Hearings
Harlem Barred to Servicemen
March Threat by Randolph
War Jobs Wide Open to Negroes
Housing Project Okayed Despite Protests
195 Hurt, 500 Held in Looting
Harlem Must Share Riot Blame
Mrs. Roosevelt on the Negro
Adam Clayton Powell, Jr. Becomes First Congressman
Marijuana Peddlers Captured in Harlem
Harlemites Worry About Postwar Era
Fear Davis Case Will Split Negro Vote
Boy Gang Slaying Laid to Three in Harlem
State FEPC Outgrowth of Riots, Relief and Reform
Housing Holds Harlem's Hope
38,402 Crowd Polo Grounds
Ethics Code Set Up by Harlem Stores
Profiles: Bop

THE NEW YORK TIMES, APRIL 1, 1941

HARLEM BUSES ATTACKED

Windows in three buses owned by the New York Omnibus Company and operated in the Harlem district were smashed by missiles thrown shortly after 11 o'clock last night by youthful sympathizers with the campaign of three Harlem organizations to end discrimination against the employment of Negro drivers and mechanics by the bus company. The vandalism followed a protest meeting at the Abyssinian Baptist Church, 138th Street, between Seventh and Lenox Avenues under the auspices of the United Negro Bus Strike Committee, the Harlem Labor Union and the New York Coordinating Committee. Two thousand persons attended the meeting. When it broke up, most of the audience headed for home. Some others gathered at Lenox Avenue street corners and waited for buses to pass. One southbound bus and two northbound buses sped by and were struck by missiles. Fifty policemen appeared and dispersed the crowd. One arrest was made.

❖ ❖ ❖

THE NEW YORK TIMES, APRIL 20, 1941

TWO BUS LINES AGREE TO EMPLOY NEGROES

An agreement to employ Negroes on buses owned and operated by the Fifth Avenue Coach Company and the New York City Omnibus Corporation was signed yesterday morning in the offices of the companies at 605 West 132nd Street.

The agreement was signed by representatives of the Transport Workers Union, the United Negro Bus Strike Committee and the bus companies. The pact followed a boycott campaign against the companies organized by the Greater New York Coordinating Committee for Employment, the Harlem Labor Union and the National Negro Congress.

Under the terms of the agreement the Transport Workers Union will waive seniority rights for all except ninety-one drivers furloughed by the companies. After these ninety-one are re-employed, according to the agreement, the next 100 jobs on buses are to be given to Negroes.

In addition, the agreement provides that the next seventy men to be hired in the maintenance division will be Negroes. Thereafter, Negroes are to be hired alternately with white workers until 17 per cent of the companies' employees are Negro. It was estimated that this is the proportion of Negroes in the city. After the agreement was signed, picket lines that had been established at the principal bus stations in Harlem since the end of March were discontinued. The campaign for the agreement was marked by violence on March 31, when windows of three buses owned by the New York Omnibus Company and operated in the Harlem district were smashed by missiles thrown by sympathizers with the movement.

❖ ❖ ❖

THE NEW YORK AGE, NOVEMBER 15, 1941

POWELL WINS COUNCIL SEAT

The long-cherished dream of Negroes electing a member to the City Council was realized Tuesday night with the election of the Rev. Adam Clayton Powell, Jr., pastor of the Abyssinian Baptist Church, Republican-endorsed American Labor-City Fusion candidate. The new council will contain 26 members.

The conclusion of the Manhattan count was packed with thrills as the final tallies were posted on the huge bulletin board in the Armory. Singularly enough, the close came on Armistice Day, the day when hostilities in World War I ceased in Europe. The end of the count also caused political leaders to sit up and take notice of the Negro electorate which went to the polls on Tuesday, November 4, determined to elect a Negro city councilman under the proportional-representation system which thus far has robbed Negroes of representation in the councils of the city's legislative-making body. When the Board of Aldermen was abolished four years ago, it also ended the appearance of two Negroes in the city's law-making body, for there were always two Negro aldermen. As population centers shifted a third Negro alderman was to be seen not as a possibility, but as a probability. P R robbed Negroes of such representation.

When the Manhattan canvassers opened the ballot boxes to count the vote on November 5 the big surprise was the remarkable

strength shown by the Rev. Adam Clayton Powell, Jr., who immediately was listed as the third-highest candidate, with 45,875 first-choice votes. High man was Councilman John P. Nugent with 56,915, and second was Councilman William Carroll with 52,008. Attorney Herman Stoute, the other Negro candidate, ranked eighth, with 25,041 first-choice votes. The combined first-choice votes of the two Negro candidates were 69,420.

When the voters went to the polls on November 4, there was hardly anyone in Manhattan who had not heard of the Rev. Adam Clayton Powell, Jr. Starting as the American Labor and City Fusion candidate in September, Rev. Powell had 1,800 volunteer workers known as the People's Committee, working for him in the various Harlem districts. They maintained eight headquarters and distributed literature and other material to make Negroes "Powell-conscious."

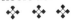

THE NEW YORK TIMES, NOVEMBER 16, 1941

HOME-MADE GUN SEIZED

A home-made gun and two rival gangs of Harlem Negro youths, the Mutineers and the Royal Knights, figured in a street fight that sent two Negroes to Harlem Hospital and caused the arrest of five others early yesterday. Ages of the prisoners ranged between 14 and 16 years, and both wounded youths were 17.

The police said two of the youths, after attending a party in a house on West 133rd Street near Fifth Avenue, went out into the street, where they met four others. An argument began over the respective merits of the two gangs, and three shots were fired. When the first two Negroes fell, the others, said to belong to the Mutineers, escaped.

A search by the police resulted in the five arrests, and in the discovery of a home-made gun under the mattress in the bed of a 16-year-old who, the police said, had made the gun. It had a barrel fourteen inches in length, consisting of brass tubing, mounted on a wooden stock, shaped like that of a pistol, and about an inch and one-half from the butt the barrel was taped to the stock so that it fitted at the notch, and there was a rubber band stretched around the barrel to the rear of the stock. Apparently the hammer had been taken from a toy cap pistol. The police said the gun was fired by bringing back the hammer with the thumb.

Harold X. McGowan, assistant district attorney, said after the youth's arraignment in Felony Court: "Too bad such ingenuity was not put to a practical purpose." The weapon was sent to Police Headquarters for examination by ballistic experts.

THE NEW YORK AGE, JANUARY 17, 1942

NEGROES NOT BACKING WAR EFFORT FULLY

Negroes in America are not one hundred per cent sold on the war effort of the nation and will not be until they are given some of the rights of democracy which have been denied them in the past. This was the consensus of opinion which came to light Saturday afternoon at a session of the National Coordinating Committee at the Harlem Branch Y.M.C.A. Attending the session were delegates representing twenty national Negro organizations and institutions. With Hubert T. Delany, committee chairman, presiding, Judge William H. Hastie was presented. Hastie asked the opinion of the group on their theories about Negro thought on the war. This question produced an embattled controversy among some of the race's most prominent leaders. So much confusion ensued that the chairman suggested a vote to be taken. Prior to the vote, Arthur Spingarn took the floor and mentioned that he knew what the vote of the gathering would be, but that he hoped they would overlook some of the injustice's practiced against Negroes and throw their support behind the President's war program.

THE NEW YORK AGE, FEBRUARY 21, 1942

ROOSEVELT'S FEPC HOLDS HEARINGS

Dr. Malcolm S. MacLean, president of Hampton Institute and newly appointed chairman of President Roosevelt's Fair Em-

ployment Practices Committee, presided for the first time over the committee when it opened special hearings held in the Bar Association Building, 42 West Forty-fourth Street, on complaints of discrimination in employment of Negroes and other minority groups.

The hearings begun Monday morning were still in progress when the New York *Age* went to press on Tuesday, with Eugene Davidson, field representative of the committee, presenting evidence which had been assembled at the regional office of the committee, 122 East Forty-second Street. Among prominent officials and persons who testified before the committee on Monday were Mayor Fiorello La Guardia, Lieutenant Governor Charles H. Poletti, the Rev. John Boland, chairman of the New York State Labor Relations Board; Henry W. Pope, Welfare Council; Dr. Robert W. Earle, Greater New York Federation of Churches; Rabbi J. X. Cohen, American Jewish Congress; G. P. Bronisch, Loyal Americans of German Descent; and Julius L. Goldstein, Non-Sectarian Anti-Nazi League.

Lieutenant Governor Poletti told the committee that "the picture is very dark in New York State. I think we have loads of discrimination.... It's going to be a tough job to eliminate it."

Reviewing State laws relating to discrimination, he said he thought the authorities should abandon all attempts to appease the situation, and urged that the

Commission of Labor be granted authority to hold hearings and issue subpoenas to compel private agencies to disclose their records.

"I often say politically imprudent things," Mayor La Guardia said. "I'm not afraid. I'll say this now. Many of your labor unions won't take a black man in. What are you going to do about a situation like that?"

He continued talking on the subject of discrimination in employment but said it was not essentially the problem of local communities. "It's a national problem," the mayor declared. "We can't do the job locally if the national government is going to go on showing race prejudice in many of its bureaus."

Citing his own administration, where Negroes are given jobs on their merit and not because of the color of their skin, he declared: "You've got to have an executive with guts."

❖ ❖ ❖

NEW YORK WORLD-TELEGRAM, AUG. 11, 1942

HARLEM BARRED TO SERVICEMEN

Army and Navy alarm over the number of fighting men who have contracted venereal diseases on leave in New York caused Police Commissioner Valentine yesterday to order the greatest vice campaign in the city's history. The order was accompanied by unprecedented action by the two armed services.

Unwilling to await results of the police cleanup, the Army and Navy took these steps:

1. Declared Harlem, the area regarding which many complaints were made, out of bounds for white servicemen.

2. Obtained permission from Mayor La Guardia to set up prophylactic stations wherever they may desire throughout the city in police stations, firehouses and health centers for soldiers, sailors, marines and coast guardsmen. These stations will be manned and equipped by Army and Navy medical personnel.

❖ ❖ ❖

THE NEW YORK AGE, SEPTEMBER 19, 1942

MARCH THREAT BY RANDOLPH

Declaring that "heads of government respond only to pressure" and that "Negroes must fight for what they get," A. Philip Randolph, international president of the Brotherhood of Sleeping Car Porters and national director of the March on Washington Movement, was the principal speaker at the Movement's second New York mass meeting Friday night. The Golden Gate Ballroom, Lenox Avenue and 142nd Street, was crowded when Mr. Randolph ascended the speaker's stand. In detail, Mr. Randolph traced the history of the March on Washington Movement, its conferences with Mayor La Guardia and Mrs. Roosevelt which led up to the march being called off after a second conference, in which President Roosevelt and important members of the Cabinet met with a group of Negro leaders and discussed issues, which resulted in

the President's Executive Order 8802 and creation of the FEPC. Attacking the recent transfer of the FEPC to the War Manpower Commission, Mr. Randolph served notice that the March on Washington Movement will "leave no stone unturned to preserve the integrity and organizational entity of the President's Committee on Fair Employment Practices." In winning the Executive Order for Negroes, Randolph declared that "the March on Washington Movement has learned that the Federal Government itself has become the carrier of the germ of race discrimination and segregation" and that "the Government and the President will respond to pressure and that the organization of the Negro masses can exercise pressure."

Denying that the March on Washington is abandoned, Mr. Randolph declared emphatically that "I have no doubt that a march on Washington will have to be made during the war to let the President and white America know that the Negro is not going to take a licking from Jim Crow lying down." Referring to the war effort, Mr. Randolph said that "Negroes made the blunder of closing ranks and forgetting their grievances in the last war. We are resolved that we shall not make that blunder again...If the President wants us to stop our agitation, then let him stop discrimination. Negroes have been pushed around long enough. We are not going to continue to take it, and we don't give a damn who doesn't like it."

In some quarters, he said, "the statement is made that Negroes

should be all-out for the war to lick Hitler in Europe. Our answer is, we are. We are also all-out for the war to lick the hell out of Hitlerism in America." Scorning Negroes who are afraid to fight for their rights, Mr. Randolph said that "rather would we die upon our feet fighting for our rights than to exist upon our knees begging for life. For life without rights is an illusion. Nor are Negroes alone scared. The white people in the South are scared that Negroes won't remain scared. If 5,000 Negroes were to march on the city hall of any Southern city, it would shake up the entire South, and bring about a new day in race relations."

❖ ❖ ❖

THE NEW YORK AGE, JUNE 12, 1943

WAR JOBS WIDE OPEN TO NEGROES

The pressure of increased war production is at last showing a decided effect on war employers in the willingness with which they are now accepting Negroes. The Brooklyn Urban League's Industrial Department now has on hand more well-paying and varied kinds of job orders than it has had since the war began. The machine-tool and small-parts manufacturers in Brooklyn are calling for mostly unskilled women, Negroes included, and pay salaries of $20 to $35 a week for day work, and $25 to $45 for night work. Any woman 18 years old and up who is not fat and has citizenship proof is acceptable. War factories making radio and electrical equipment are placing

the most orders for female workers—the usual rate for beginners is about 65 cents an hour. For people with some training in this work some jobs are offering to start them at $40 a week and up. The National Youth Administration course in radio work is one of the best and pays you $40 a month to take it. This is an unusual opportunity for Negro workers to learn a profitable trade. The airlines about New York City are also in need of workers and are accepting Negroes. Women are being used as trainee mechanics, plane clerks and cleaners. Salaries are not as high as other war jobs, averaging $100 a month for women, but there is a much better chance of holding your job after the war. They also want men as auto mechanics, trainee air mechanics and parts cleaners. There are countless job orders on hand at the Brooklyn Navy Yard for all kinds of workers — "learners" (for youngsters 16–18), unskilled and skilled workers of all kinds except painters. Salaries for these jobs run from about $27 a week to $120 a week at the highest.

Not only have war plants been cracking under the strain, but so have the nondefense industries. Chain-store supermarkets such as Safeway, Bohacks and A & P have expressed willingness to hire Negro women as counter and sales clerks; more restaurant and relatively fewer clerical opportunities are available. Although qualifications for women are lenient, restrictions on men are growing faster and stronger—the best jobs being limited to those

with two or more children; men over 38 or those with 4-F Army classifications. Some proof of citizenship is still required for most war work.

❖ ❖ ❖

THE NEW YORK AGE, JUNE 12, 1943

HOUSING PROJECT OKAYED DESPITE PROTESTS

After prolonged debate and discussion, the form of contracts and plans for the $50,000,000 Stuyvesant Town housing project to be constructed by the Metropolitan Life Insurance Company on the East Side were approved Thursday by the Board of Estimate, by a vote of 11 to 5. The chief objection voiced by more than a score of speakers was that the contract contained no clause that would prevent the Metropolitan from discriminating against Negroes in renting. As a matter of fact, the company said that it had no intentions of renting to Negroes and warned that if it was forced by the city to include such an assurance, it would abandon the project.

❖ ❖ ❖

NEW YORK POST, AUGUST 2, 1943

195 HURT, 500 HELD IN LOOTING

A wild outbreak of riot and pillage swept the streets of Harlem last night and during the hours of darkness today, and it was not until long after daylight that police were able to restore a semblance of order. Four men were killed in the mob violence and looting, which was suppressed in one section, only to break out in another. Forty policemen and 155 civilians were listed by police as injured, and many more casualties of the wild and lawless night received minor injuries. A crowd of Negroes at 9 a.m. today overturned an automobile parked on Lenox Avenue between 136th and 137th Streets and set fire to it. In latest police figures, the number of persons arrested from crimes ranging from disorderly conduct to burglary, larceny and felonious assault, was over 300. Soon after midnight, the cells in the four police stations in Harlem were so jammed with prisoners that a special precinct was set up in the armory at 94th Street and Park Avenue, and within a few hours its floor was crowded with prisoners, many of them carrying loot which they had stolen from stores.

Men and women with bleeding and bruised heads and bodies crowded the emergency wards of Harlem hospitals, where physicians and Red Cross workers, called in for emergency duty, were almost overwhelmed by work. Crowds of as many as 3,000 persons gathered throughout the night, and police who were sent out to break them up were showered from windows and roofs with bottles, stones and bricks. Before daylight the business section of Harlem was a litter of broken glass and merchandise which looters had pulled from windows and dropped on the sidewalk and in gutters when police came along.

Clothes, furs, dirty wash, canned goods, milk bottles, loaves of bread and smashed liquor bottles littered the streets, and police were kept busy carting these goods to station houses until the owners could claim them. A few hours after midnight the disorders had become so widespread that Mayor La Guardia, after futile appeals for order by radio and sound truck, ordered a cordon of police thrown around all the west part of Harlem from Fifth to Eighth Avenues and from 100th Street to 155th Street. From all over the city police poured into the section all night, and by 3 a.m. there were 5,000 uniformed men and 1,000 detectives on duty in Harlem.

At 7:50 a.m. the situation was still so bad that Mayor La Guardia broadcast an emergency message to the city saying that "shame has come to our city and sorrow to a great number of our decent, splendid, law-abiding citizens residing in Harlem." He pleaded with the people to get off the streets and go home, and he warned the hoodlums and criminals: "We mean business."

"This is not a race riot," he said, pointing out that there were no organized attacks by Negroes on whites, or any effort by white mobs to invade the section. The mayor said he would make another broadcast from City Hall at 9:45 or 9:50 a.m.

The latest serious disturbance reported by police occurred at 7 a.m., when a crowd of 3,000

gathered at 145th Street and Eighth Avenue. Almost 50 policemen were rushed there and they found a uniformed Negro soldier, who had been drinking. urging the crowd: "Let the cops have it." A shower of bricks and bottles met the policemen, who broke up the crowd and arrested a number of prisoners.

All four men killed in the riots were Negroes. One was shot when he attacked a policeman who caught him looting a store. Another was found dead in a hallway, shot through the chest. A third was shot on the street, and a fourth was killed by a policeman while pillaging a grocery store. So many policemen were struck by missiles thrown from windows and roofs that Police Commissioner Valentine ordered all his men to wear their steel air-raid helmets, and firemen who answered two false alarms during the night, were ordered to wear their helmets also. Military policemen were sent into Harlem early today and they took away in trucks all soldiers they found on the streets. The Army was not asked to help stop the rioting, however, for at 3 a.m. all policemen in the city were put on emergency duty, doing an eight-hour tour, followed by eight hours in reserve at station houses and then eight hours more on patrol.

The trouble started at 7:30 o'clock last night in the dingy lobby of the Hotel Braddock at 126th Street and Eighth Avenue. Sometime ago the police raided the hotel, and since then policemen have been stationed in the lobby twenty-four hours a day. Patrolman James Collins, of the 135th Street station, on duty last evening, tried to arrest a thirty-three-year-old woman for disorderly conduct. As he seized her a crowd began to collect, and Collins said that a Negro military policeman, Private Robert Bandy, of the 730th Regiment, stationed in Jersey City, attacked him. Bandy, the policeman said, wrested his night stick from him and hit him on the head with it, knocking him to the floor. As the soldier turned and ran Collins fired a shot after him, hitting him in the back. Collins got up and arrested the soldier, and in a few minutes other police arrived to help him.

They got him away from the crowd and took him to Sydenham Hospital, where both Bandy and Collins were treated. The Harlem grapevine spread with amazing swiftness the news that a Negro soldier had been shot and was at the hospital. Within an hour a crowd of 3,000 persons had gathered in front of the hospital, while another crowd of about 1,000 went to the West 123rd Street station, apparently under the impression that the soldier had been taken there. When the crowd began gathering at the hospital, police got Bandy out of there as soon as he had been given emergency treatment. He was taken to Bellevue Hospital, under arrest for felonious assault. Mayor La Guardia was notified as soon as the trouble began developing, and he drove to the West 123rd Street Station. The crowd booed him when he appealed to them to go home, and they jeered contingents of police who soon began arriving from other parts of the city.

The real trouble, however, did not develop from either of these crowds, but from scattered individuals and small groups that took advantage of the excitement to loot stores and throw bottles, stones and bricks at policemen. All reports indicated that these Negroes were attacking the police as symbols of authority rather than as white men, for there were very few reports of attacks upon white persons not in uniform. When the crowds refused to disperse at the mayor's order, and reports of window smashing and thievery continued to pour into all Harlem station houses the mayor ordered all traffic except food and milk trucks kept out of the section between 110th and 155th Streets and Fifth to Eighth Avenues. Policemen were stationed at all streets entering this district, with orders to turn back all cars, cabs and even Fifth Avenue buses. The milk and food trucks which were allowed to enter were given police guards.

The mayor quickly called into conference such Negro leaders as Walter White, secretary of the National Association for the Advancement of Colored People; Ferdinand Smith, secretary of the National Maritime Union; Dr. Max Yergan, president of the National Negro Congress; and Hope Stevens, attorney. At 12:51 a.m. the mayor broadcast over WABC and WOR to the people of Harlem, explained the trouble at the Hotel Braddock and appealed: "Please get off the streets and go

home and go to bed. Unless you do that, we may have serious trouble." Dr. Yergan and Smith echoed his words, but though the crowds began to thin out after midnight, the outbreak of hoodlumism grew worse. Police patrolling the streets were showered with stones and bottles from tenement windows and roofs, and gangs roamed the main streets, smashing windows and grabbing whatever they could find in the stores.

One eyewitness of many lootings, Ralph Ellison, managing editor of the *Negro Quarterly*, said that only stores owned by white persons were looted. Places owned and operated by Negroes were not touched by the rioters, he said, just as they were spared in the recent race riot in Detroit. "The hoodlums quickly sized up the situation and took advantage of it to smash windows and attempt to loot," the mayor said. The worst trouble, he said, was on 117th Street between Seventh and Eighth Avenues, and along Lenox and Seventh Avenues from 117th to 118th Streets.

Walter White, who toured Harlem early today, said that in his opinion most of the trouble was caused by youths and young men, but he commended the police and the mayor. "There is a great difference here from the conditions in Detroit," he said. "In Detroit the mayor was weak and the police inefficient. Neither condition prevails here."

At 12:37 a.m. four truckloads of Negro military police, escorted by motorcycle policemen, arrived at the West 123rd Street station. The thirty-two soldiers immediately went out on the streets and gathered in soldiers on leave in Harlem. The soldiers were put into the trucks and taken away. At 3:30 a.m. Police Duty Chart No. 2 was ordered into effect by Commissioner Valentine. The order put all policemen in the city on an eight-hour tour of duty, followed by eight hours on reserve in police stations, another eight hours on duty and then eight hours off. The police held in reserve were subject to immediate call. All members of the force on vacation above the rank of lieutenant were recalled. Most business places in Harlem closed earlier than usual, and at 2 a.m. Valentine issued an order closing every bar in the section. He ordered all bars and liquor stores closed until further notice.

At 8 a.m. an order was issued to policemen to wear their steel air-raid helmets while on duty. That step was taken after a number of policemen had been hit on the head by missiles. Firemen whose duty ended at midnight were held at firehouses for another eight hours, and false alarms kept them busy throughout the hours of darkness. Early today the cells in all Harlem stations were jammed to capacity by persons arrested for disorderly conduct, burglary, felonius assault and other crimes growing out of the rioting.

AMSTERDAM NEWS, AUGUST 7, 1943

HARLEM MUST SHARE RIOT BLAME

We have just witnessed a most tragic incident in Harlem. Six citizens have been killed, hundreds have been injured, including 40 or 50 policemen, and more than 1,000 have been arrested for looting, vandalism and assault. It is regrettable, but more than likely all Harlem will be blamed for the occurrence. Yet, it is true that a vast majority of the people of Harlem hate hoodlumism and most vigorously condemn it in any form. It would be interesting to observe how a judge, a prosecutor and a jury made up of Harlemites would handle the looters and vandals. On the other hand, Harlemites are not unmindful of the fundamental causes that make such an affair as that which occurred last Sunday night and Monday morning possible.

Harlem is a most unfortunate community. Those who have written about it, talked about it, as well as those who have presumed to speak for it, have never —that is, until quite recently— told the true story of Harlem. As part of a great city that has always had to keep up its front, Harlem has sung and danced when it should have been working and praying. In the late nineteen twenties and the very early thirties, novelists, poets, newspaper columnists and producers com-

bined to portray Harlem as Negro Heaven. Numerous stories have been told of the glamour and beauty of Harlem, and Harlem has become known throughout the world as the Negro capital of America. In every city of any size, its Negro community became a Harlem, and people everywhere, both here and abroad, grew to think of Harlem as a place of unlimited opportunity for Negroes.

Native Harlemites, who knew better, aided the conspiracy by pretending that they believed Harlem was heaven. They bragged about having been born here, about not having been further south than the Bowery, all land beyond the Hudson River being the Hinterland, and about how every night spent outside Harlem was just another night camping out. Newcomers to Harlem soon discovered that Harlem was not heaven, but they, too, pretended that it was so, lest they might be called hicks and small-towners who didn't know the ways of the big city.

Harlemites could explain away the "hot bed," wherein a landlady rents a room to two lodgers, one sleeping by day and the other by night, with only enough time left in between to turn the sheet. Harlemites blamed it on the local congestion. Harlemites could explain away the diet of hot dogs and soda pop, or why milady never keeps much food in the icebox. They call it convenient. They insist it is easier to run to the store to buy a stick of butter four times a week than to buy a pound once a week. Harlemites explain away why they wear odd clothes, no

stockings, no hats. insisting that it's a fad or a new style. They call it big time to pay the rent by the week, instead of monthly as their leases require. Anything that doesn't sound big or look big can't touch them.

It's time now for Harlem to quit kidding itself. Harlem is part of a great city, but Harlem is far behind. It has been given a grand build-up in song and story, but Harlem never has lived up to its reputation abroad. Not even in the days of the "golden era," sometimes called the "renaissance," was Harlem on a sound economic or political footing. Harlem is, and has been for years, in a bad way. It has refused to face the facts.

Because of its reputation throughout the rest of the country, because its residents have been built up in the minds of the world, Harlem has had to keep up a front to preserve its prestige. But it seems that the sham can no longer go on. Most of Harlem's trouble, thus, must be blamed on Harlem, because Harlem is in a bad way for good leadership. Some of the men and women are sincerely doing the best they can to improve conditions, but too many are insincere, opportunistic, honest but dumb, or out-and-out phonies.
 —JULIUS J. ADAMS

❖ ❖ ❖

AMSTERDAM NEWS, NOVEMBER 6, 1943

MRS. ROOSEVELT ON THE NEGRO

Writing in the October issue of *Negro Digest* in an article entitled "If I Were a Negro," Mrs. Roosevelt said, among other things: "If I were a Negro I would take

every chance that came my way to prove by quality and ability, and if recognition was slow I would continue to prove myself, knowing that in the end, good performance would be acknowledged." Mrs. Roosevelt added that she would accept advances, "though I would not try to bring those advances about more quickly than they were offered."

We are indeed sorry that Mrs. Roosevelt, a self-appointed champion of the oppressed, wrote these words. We are sorry because, more than any other American, she has been accepted by Negro Americans of all classes, as a courageous, honest spokesman for the rights of people, regardless of their race, religion or national origin. Therefore, when she advises Negroes to continue to plod along fighting to win the war, though recognition is slow, she is putting herself in the same boat with other so-called liberals and "friends of the Negro" who now go round saying: Forget the injustices meted out to you. Just go ahead, take it on the chin, and fight for the four freedoms.

The tragedy of Mrs. Roosevelt's statement and the statements of other would-be liberals and champions of democracy is that they don't understand what is happening in the United States. First, the Negro hasn't planned not to participate in the war. In fact, he would participate much more if it wasn't for the fact that he is discriminated against in the armed forces, in war industry and in many other ways. Two Negro combat divisions trained for more than a year are still marking time at Fort Huachuca and at Camp Young, California, because somebody in the Army doesn't want

Negro combat troops overseas. Thousands of Negro workers are denied jobs in industry, thereby slowing down war production because of a lack of workers. In fact, if the draft were run honestly, if Negroes were not discriminated against in the armed forces and in industry, in all probability there would be no talk of drafting pre-Pearl Harbor fathers.

Second, American Negroes have been forced into a position of having to fight now for their rights as citizens. What little they have gained since the outbreak of the war is a result of their own efforts. The FEPC, for example, was set up solely because the Administration feared that some 50,000 Negroes would march on Washington, and the Administration being concerned not about the Negroes, but about what Hitler, Goebbels and friends would say in Berlin. In other words, the U.S. Negroes have been forced against their will to speak out in wartime for even some of their elementary rights as citizens.

Third, American Negroes want nothing as such. But they rightfully demand their rights as citizens. And they know that when their own Government as well as other citizens deny them their rights, any war waged for democracy by our own country cannot be entirely an honest war.

Fourth, any people worth their salt should and must fight for their rights, especially when those rights are legal. It is indeed strange that our own Government should encourage oppressed peoples in the conquered countries to fight for their freedom, yet not only deny real freedom to American citizens but admonish them to wait and take things slowly because they are colored.

Fifth, U.S. Negroes well remember promises made to them during the First World War. They also remember what happened to them after the world had been saved for democracy.

Finally, the Administration has always played ball with the Southern congressmen, avowed and outspoken enemies of all colored Americans. The Administration has played ball with the Southerners because the Administration considers political expediency more important than democratic action in behalf of American citizens.

Of course, because of her reputation as a friend of the Negroes and her many statements in their behalf, Mrs. Roosevelt has come in for many scathing, ungentlemanly and insulting attacks by the Southerners. Now, however, we wonder if Mrs. Roosevelt's regrettable article about Negroes was just another attempt by the Administration to curry the favor and support of the Southerners? '44 and the election is, you know, right around the corner. What price democracy!

❖ ❖ ❖

THE NEW YORK AGE, AUGUST 5, 1944

ADAM CLAYTON POWELL, JR. BECOMES FIRST CONGRESSMAN

As the New York *Age* went to press at 3 a.m. Wednesday, votes were still being counted in Harlem's polling places as a result of the most bitter primary fights held in years. History was in the making because as a result of the primary contests, the first Negro congressman in New York was elected in the primaries without the necessity of an election contest in November.

The Rev. Adam Clayton Powell, Jr., pastor of the Abyssinian Baptist Church, who was the Democratic and American Labor party candidate and was also seeking nomination in the Republican primary against Sara Pelham Speaks, Republican candidate, made a clean sweep, defeating Mrs. Speaks in the Democratic primary by a vote of better than four to one. In the Republican primary, Rev. Powell sprang a surprise by defeating Mrs. Speaks by about 256 votes.

Official returns were not available and could not be determined until the last election-district return was in, but in the Republican contest, with 62 out of 119 districts reporting, the vote was: Powell, 3,338; Speaks, 784. The unofficial plurality for Powell in the Republican contest, no districts missing, was 236 but the total voting figures were unavailable, since they were unofficial.

❖ ❖ ❖

THE NEW YORK AGE, FEBRUARY 10, 1945

MARIJUANA PEDDLERS CAPTURED IN HARLEM

A small clique of marijuana dealers, composed of two women and two men who are reported to have

ings, said he would send a recommendation to Police Commissioner Wallander that Maddock be fittingly rewarded for his excellent work in attempting to break up the violent warfare between the groups of young gangsters.

"Each of these youthful gangs has its membership graded according to age as Tiny Tims, kids, cubs and seniors," the assistant district attorney told the court. He went on to say that the detective's investigation had uncovered that besides the use of daggers, bayonets and ice picks in their attacks on rivals, the young criminals had frequently used "zipper guns" as weapons. The latter he described as pistol-like affairs from which toy airplanes are discharged by jet propulsion, using .22-caliber cartridges. But the young gangsters, he charged, turn them into weapons by taping short pieces of iron pipe along the tops, through which .22-caliber bullets are discharged. Some of the young thugs, he further charged, used "zipper guns" in the clashes that attended the killing of the two youths, one of the bullets wounding a girl passer-by.

❖ ❖ ❖

AMSTERDAM NEWS, JUNE 23, 1945

STATE FEPC OUTGROWTH OF RIOTS, RELIEF AND REFORM

When the Ives-Quinn Act, establishing the New York State Commission Against Discrimination, becomes effective on July 2, and the total power and influence of the state and its citizens move toward the elimination of discrimination in employment on the ground of race, color, creed or national origin, the American public should recall the long and patient struggle that has been waged by the constructive forces of New York to achieve this most desirable goal. No attempt should be made to detract from the brilliant and patriotic leadership provided by Governor Thomas E. Dewey, the leaders of the State Legislature, hundreds of public-spirited citizens, and the members of the State Temporary Commission who held hearings throughout the state to determine the facts and prejudices which upheld the structure of discrimination in employment because of color, race, creed or nationality.

Enactment of the Ives-Quinn bill demanded and received all the courage, patience and good judgment that governor, state legislators, employers, labor unions and plain citizens could muster and get behind an effort, which, to say the least, was and is leadership of higher type in the broadest application of the principles of democracy, social justice and equal opportunity for all. Much credit, however, is due to related conditions and efforts by other men of good will within the recent past. It can be said that the humanitarian conscience of New York State began to express itself under the administrations of the late Alfred E. Smith. This humanitarian or social conscience gained strength under the leadership of Governor Franklin D. (later President) Roosevelt, and Herbert H. Lehman, to come forth a fully developed expression of the will of the state under the courageous and moral leadership of Governor Dewey.

The so-called race riot on the night of March 19, 1935, and the subsequent public hearings conducted by the Mayor's Committee, the findings and recommendations of which have never been published, had much to do with stirring anew the conscience and mind of the people of the state. Many lives and much property had been destroyed because the Negro citizens of Harlem had long endured the hardships of the depression, with their bad housing, almost total unemployment, juvenile delinquency, inadequate health and hospital facilities, and other evils spawned by race prejudice and discrimination of the crudest forms. The city and state never quite got over Harlem's night of terror. Many citizens felt that something should be done to eliminate the causes of such an outburst of passion and resentment. In June, 1937, an enabling act was passed by the State Legislature establishing the New York State Temporary Commission on the Condition of the Urban Colored Population. This body of representative white and Negro citizens held public and closed hearings in every large city where the Negro population warranted it.

The scope of the commission was wide and the range of sub-

jects included investigation into the employment policies of insurance companies, public utilities, department stores, banks, boards of education and public schools, hospitals, city and state civil service, and almost every type of service which employed large numbers of persons. The policies of labor unions were also examined. Housing and health facilities, including restrictive covenants which establish ghettoes, were critically investigated. At the end of 1937, it was thought that there was much more to be done, and another appropriation was made and the commission continued in 1938. At long last a series of bills were drafted and presented to the legislature, but with the exception of one or two emasculated measures, the State Legislature turned thumbs down on the work of its own commission. Therefore, sporadic and half-hearted efforts were made to solve the problems disclosed by the sweeping investigation, but New Deal home relief and prosperity chilled the ardor of some reformers.

But by 1939 the war clouds were gathering ominously and the nation's rearmament program took up the labor slack in some sections of the country. The Japanese struck at Pearl Harbor and the Russians were fighting a deadlocked war on the longest battlefront in modern history. The nation needed the man-hours of every available citizen, regardless of sex. The armed forces were draining off the best manpower

material; the war plants, coal mines and heavy industries were calling louder and louder for manpower to produce the goods with which the United Nations could and would finish the job of winning the war.

The March on Washington Movement and its president, A. Philip Randolph, seized the opportunity to demand jobs and more jobs in every branch of industry. The pressure of this organization and other groups was instrumental in getting President Franklin D. Roosevelt to issue the famous Executive Order 8802, on June 25, 1941, reaffirming the policy of the Federal Government that full participation in the defense program of the nation was a part of the nation's plan for defense in the emergency and that such participation should be had regardless of race, color, creed or national origin.

In the meantime, Governor Lehman established the Committee on Discrimination in Employment under the State War Council. This committee did much effective work in tracking down discrimination in employment against Italians; Jews, Catholics, Negroes and other minority groups. It went into war-plant areas and gathered invaluable information which became a part of the total national effort to destroy bigotry within the ranks of the nation's own citizens during its darkest hours of national peril.

Standing on the threshold of victory over the enemies of the nation, and victory over bigotry in the state of New York in the enactment of the Ives-Quinn law, United States citizens can look back upon a magnificent record

of achievement in social planning in the Empire State. The victory which is being celebrated in the establishment of the Commission Against Discrimination was largely made possible by the Fair Employment Practices Committee (FEPC), which at the same time stands as a guiding light for the Congress of the nation to follow in the effort to legislate prejudice, discrimination and bigotry in employment out of American life.

A. M. WENDELL MALLIET

❖ ❖ ❖

NEY YORK HERALD TRIBUNE, MARCH 15, 1947

HOUSING HOLDS HARLEM'S HOPE

In little oases of modern sun-lit apartments, built as public and quasi-public projects amid Harlem's slums, are planted the city's hopes for recapture of this broad quarter of Manhattan from its squalor and blight. It would take billions to replace all of Harlem's filthy, broken-down, overcrowded tenements and brownstones at present sky-high building costs. Officials are plugging for as much as they can get from city, state and federal treasuries. But they look for subsidized public housing—built for the lowest-income groups—as only a transfusion into a sick body. This is but one of three phases of the attack on decadent Harlem.

They hope that when costs are stabilized, public housing, com-

bined with a stepped-up building program sponsored by life insurance companies and savings banks, will arrest deterioration, set sections of Harlem on the upgrade and induce speculative builders to come in. A field in which they hope to promote activity of small private investors is rehabilitation of the better tenement buildings. Due to the money shortage, most of the public housing for Harlem is still in the realm of planning. But the clear pattern of neighborhood revival contemplated in the long-range program, coupled with related community public works, is seen in the map.

The eleven projects embraced in the program, both public and quasi-public enjoying certain tax exemptions, would give Harlem 12,295 low- and moderate-rent apartments, accommodations for some 50,000 persons. This is the way the figures break down: Two projects are complete and in operation by the New York City Housing Authority. They are Harlem River Houses, of 577 apartments, finished in 1937, at Seventh Avenue and 153rd Street, and East River Houses, of 1,170 units, finished in 1941, at First Avenue and 102nd Street. Three others are being built by the authority with money lent by the state, and a fourth by the Metropolitan Life Insurance Company, for a total of 4,148 apartments. The Savings Banks Trust Company has a suspended project and the city four others, with a potential capacity of 6,400 families, which have been stymied by skyrocketing building costs.

Nearest to readiness for occupancy of the four Harlem projects under construction is Riverton Houses, the "Met" development for 1,232 families laid out in a six-block area running from 135th Street to 138th Street between Fifth Avenue and Harlem River Drive. Like the model city houses, Riverton's thirteen-story elevator apartments occupy only about 25 per cent of the total acreage, allowing a maximum of room for parks and playgrounds and assuring ample light and air to tenants. This is in contrast with the old tenements directly across Fifth Avenue, some built on 80 and 90 per cent of the land. The project is about one-quarter finished, and the first two of the seven buildings are expected to be complete this spring. When Metropolitan invited applications last October, a year after work began, some 15,000 families put in their bids. The lucky ones will pay $44 to $57 a month for three rooms or $52 to $66 for four rooms, with utilities included.

Adjoining Riverton Houses on its southern margin is the city-state project Abraham Lincoln Houses, which is in transition from the demolition to foundation-laying stages. Lincoln will have 1,717 apartments in fourteen buildings, replacing ancient rat-infested dwellings in the six blocks embraced by 132nd and 135th Streets, Park and Fifth Avenues. Assisted by state and city subsidies, the Housing Authority will rent these apartments for $23.20 for two rooms to $37.10 for six.

The juxtaposition of the city and Metropolitan projects was no accident. Lincoln shields the higher-rent Riverton apartments from the slums to the south. The normal expectation is that future redevelopment should replace or restore the old stuff in two blocks on Riverton's exposed west flank.

Harlem Hospital fills the other block. In this manner the city, which has exempted part of Riverton's real estate taxes as its contribution to its moderate rentals, has helped protect the heavy investment of private funds.

James Weldon Johnson Houses, named in memory of the Negro educator, poet and composer, is another city-state project, on the same pattern as Lincoln, for which concrete foundations are being poured on a site extending from 112th Street to 115th Street, Third Avenue to Park Avenue. It will have 1,310 family units. Only two blocks to the west of Johnson Houses the city has begun demolition for a third cluster of tall elevator apartments, Stephen Foster Houses. This site, covering six square blocks, runs from Fifth Avenue to Lenox Avenue.

Typical of rehousing problems taxing the authority's funds, resources and patience is the necessity for relocating 2,037 families and ninety-eight commercial tenants who were still on the site a few days ago. The Foster development will house only 1,320 families, about two-thirds of those now jammed into the slums on the site. After exhausting all other possibilities, the authority may find funds to refurbish boarded-up tenements to accommodate some of these dispossessed people during the progress of the Foster job. An interesting feature of the Foster site is its location only two blocks north of Central Park. Removal of the six blocks of substandard slums north of West 112th Street will make the two-block strip between

112th and the park suitable for improvement by private capital. The initial step in the reclamation of a potentially desirable residence community overlooking Central Park will thus have been taken.

As a result of Governor Dewey's assurance to Mayor O'Dwyer in Albany Wednesday that he will recommend to the Legislature an additional $135,000,000 expenditure for housing loans, the authority will be able to take off the shelf plans for Carver Houses. Carver Houses, slated to house 1,419 families in an area bounded by Park and Madison Avenues, 106th and 109th Streets, is one of the four other Harlem public housing projects which had been tentatively agreed upon but set aside because funds were lacking for construction and site work. The proposed bond issue also will supply the necessary money to proceed with work on the St. Nicholas Houses, a project for 1,807 families, between Seventh and Eighth Avenues, 127th and 131st Streets, according to the mayor. Another city-state job, the Triborough Bridge Houses, for 1,394 families, at Franklin D. Roosevelt Drive, 120th Street and First Avenue, will temporarily remain in its "proposed" state, the mayor said.

The Savings Banks Trust Company has an ample site, most of it clear of buildings, for its proposed Colonial Village of 1,500 apartments south of the Polo Grounds. There is not much prospect of early advancement of the project, however, for soaring costs have

made it impossible for the bank to meet the terms of an agreement with the city to house Harlem's apartment seekers at $12.50 a room. The city's capital improvements program for the current year has been cut to projects of proved essentiality, which means that a number of big construction jobs Harlem has awaited through the war years will not be undertaken for three or four years at best.

—MURRAY SNYDER

❖ ❖ ❖

AMSTERDAM NEWS, AUGUST 2, 1947

38,402 CROWD POLO GROUNDS

A glittering array of the best talent in organized Negro baseball played before the largest crowd to see a Negro sporting event in the East in history—38,402 paid —in the Polo Grounds Tuesday night as the Negro American League All-Stars blasted out an 8 to 2 victory over the Negro National League All-Stars in the second annual "Dream Game" between the two rival loops. The victory evened the series started last year in Griffith Stadium, Washington, D.C., where the National Leaguers won.

An announced paid attendance of 38,112 at the East-West Classic at Comiskey Park in Chicago last Sunday plus that Tuesday night at the Polo Grounds added up to a grand total of 76,514 persons attending Negro sports events over a two-day span. In Chicago and New York less than 2 per cent of the crowds were white! As in Chicago, big-league scouts were on hand to observe at first hand the players most like-

ly to move into the majors, and Tuesday night they saw plenty. The Birmingham Black Baron stars, shortstop Art Wilson and second baseman Lorenzo (Piper) Davis; Cleveland Buckeyes' Sammy Jethroe, a fleet-footed outfielder; and Ernest (Spoon) Carter, right-hand pitcher from the Memphis Red Sox, all of the American League, were the top stars of the classic.

It was a colorful, gay and happy throng that started the trek to the Polo Grounds as early as 6 o'clock. By 7:30 p.m. every subway train at the 155th Street stop was disgorging human cargoes heading into the devouring turnstiles of the Polo Grounds. Buses were packed to the walls, moving in and out of a regular parade of taxicabs and private cars up Eighth, St. Nicholas and Seventh Avenues and through the side streets, all racing into a common vertex at 156th Street and Eighth Avenue. Adding to the mob was the fact that Primary Election Day closed all taverns and liquor stores from 3 until 10 p.m., and the thousands who might otherwise have been content to hang around their favorite joints came out to the ball game in person. It was a well-behaved crowd, and not a fight or disturbance was recorded. New York socialites rubbed elbows with politicians, ministers, schoolteachers, students, barmaids and bartenders, housewives, former athletes, singers, dancers, butchers, barbers, night club owners, and all the human flotsam, and *that* goes to make up the individual collectively known as "Gus Fan."

—DAN BURLEY

185

THE NEW YORK TIMES, JANUARY 28, 1948

ETHICS CODE SET UP BY HARLEM STORES

Pickets were withdrawn yesterday from the 125th Street area of Harlem when merchants who are members of the Uptown Chamber of Commerce agreed to "a code of ethics."

A "pledge to consumers" also will be placed before all merchants who are not now members of the Uptown Chamber, a spokesman for that organization said. In addition to an agreement to promote efficient Negro employees of the area stores that had been made "unofficially" between merchants and the protesting bodies, the pledge included the following: To mark prices clearly on all merchandise, to "identify seconds and irregulars" and to price the same accordingly; to acquaint customers with store policies on refunds and exchanges; to abide by good business standards and to abandon all misrepresentation as to quality and classification in the sale of merchandise. The stores will "extend courteous treatment to our customers," and to abide by an employment policy "strictly consistent with the provisions of the State Commission Against Discrimination" as to the hiring, training and upgrading of employees regardless of color, race or creed. A decision was also reached "to cooperate with local—Harlem—newspapers," and to "cooperate with the recognized civic and charitable organizations of Harlem to promote the well-being of the community." A merchant-consumer board will be set up to arbitrate disputes arising out of transactions in stores that sign the agreement.

THE NEW YORKER, JULY 3, 1948

PROFILES: BOP

Bebop, according to its pioneer practitioners, is a manifestation of revolt. Eight or ten years ago, many Negro jazz musicians, particularly the younger ones, who were sometimes graduates of music conservatories, began to feel, rightly or wrongly, that the white world wanted them to keep to the old-time jazz. They held the opinion that the old jazz, which they called "Uncle Tom music," was an art form representative of a meeker generation than theirs. They said that it did not express the modern American Negro and they resented the apostrophes of critics who referred to them, with the most complimentary intent, as modern primitives playing an almost instinctive music. A lurid and rococo literature grew up around jazz, the work of writers who were delighted by the idea that this music began in New Orleans sporting houses, which was a notion that, whatever its merits, aroused no responsive spark in the younger Negro musicians. Among the dissidents was Gillespie. "That old stuff was like Mother Goose rhymes," he says. "It was all right for its time, but it was a childish time. We couldn't really blow on our jobs—not the way we wanted to. They made us do that two-beat stuff. They made us do that syrupy stuff. We began sayin', 'Man, this is gettin' awful sticky.' We began gettin' together after hours at Minton's Playhouse, on a Hundred and Eighteenth Street." Another who attended the after-hour sessions at Minton's was Thelonious Monk, a somber, scholarly twenty-one-year-old Negro with a bebop beard, who played the piano with a sacerdotal air, as if the keyboard were an altar and he an acolyte. "We liked Ravel, Stravinsky, Debussy, Prokofieff, Schoenberg," he says, "and maybe we were a little influenced by them." Fuller, a graduate of New York University's school of music, dropped in at Minton's now and then; and Joe Guy, a trumpet player, and Kenny Clarke, a drummer, played there for a while. Perhaps the strongest influence, though, was Yardbird Parker, who had never heard of Schoenberg and says that he developed most of his ideas about bebop on his saxophone in his mother's woodshed in Kansas City. "Bebop is what I brought from Kansas City," he says. Fuller's comments on the new music are more general. "Modern life is fast and complicated, and modern music should be fast and complicated," he says. "We're tired of that old New Orleans beat-beat, I-got-the-blues pap." It was at Minton's that the word "bebop" came into being. Dizzy was trying to show a bass player how the last two notes of a phrase should sound. The bass player tried it again and again, but he couldn't get the two notes. "Bebop! Be-bop! Be-bop!" Dizzy finally sang. —RICHARD O. BOYER

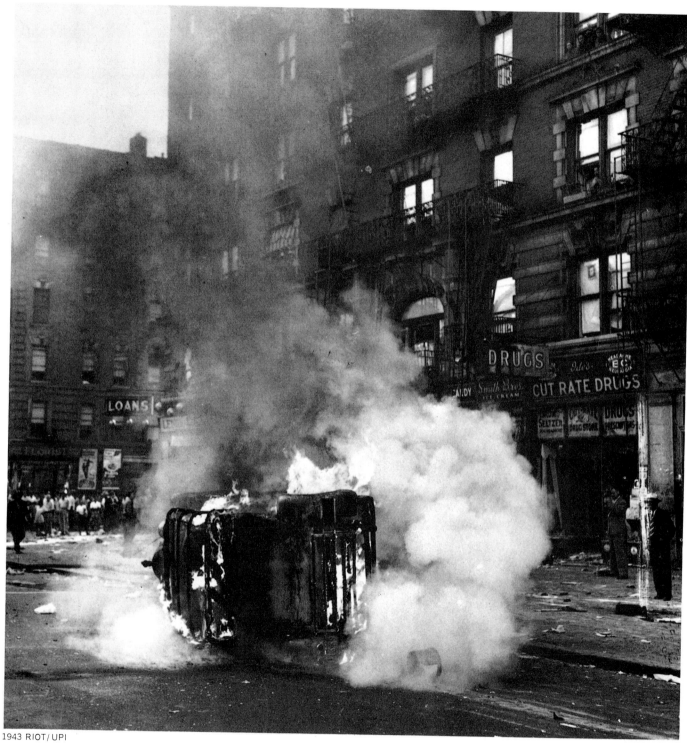

1943 RIOT/UPI

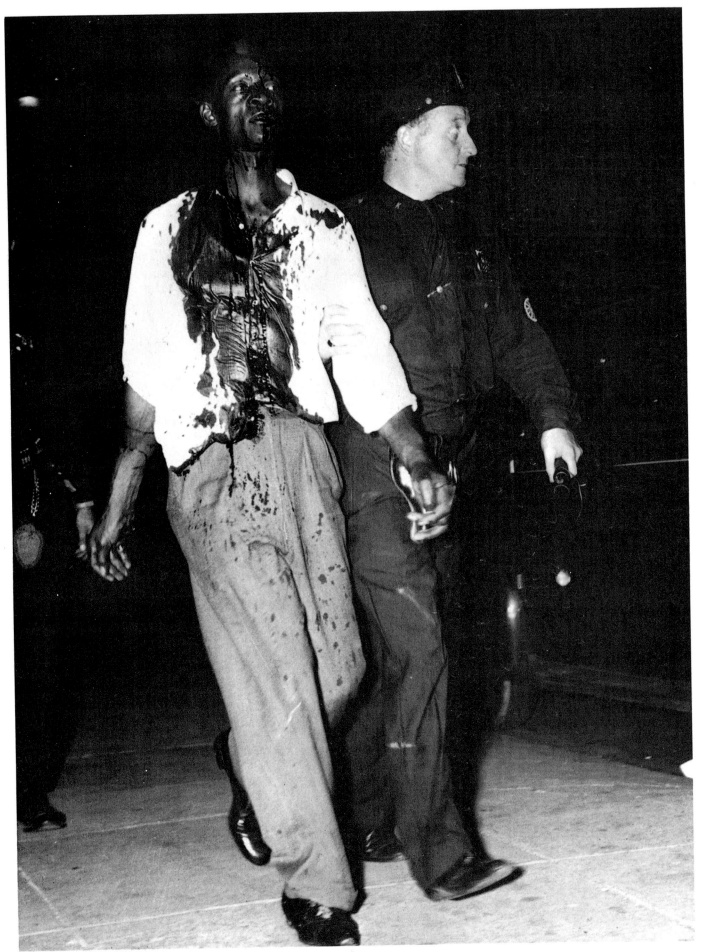

1943 RIOT/UPI

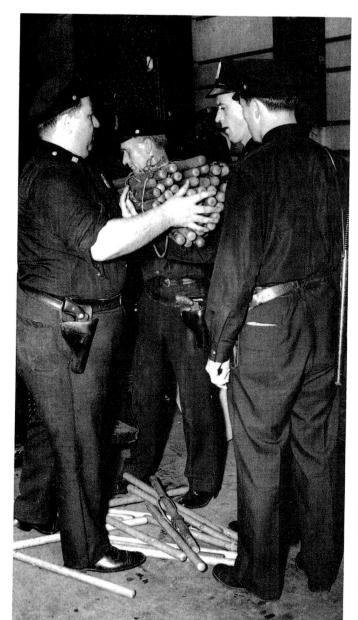

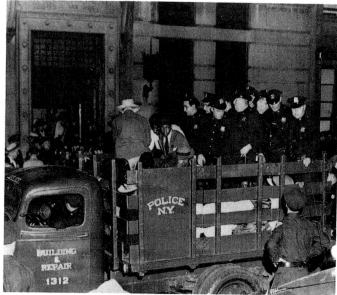

1943 RIOT/UPI

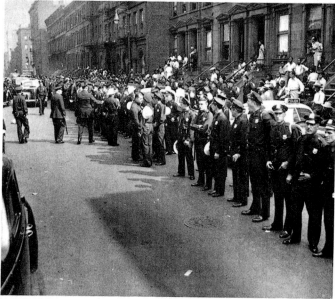

1943 RIOT/UPI

1943 RIOT/SCHOMBURG COLLECTION, NYPL

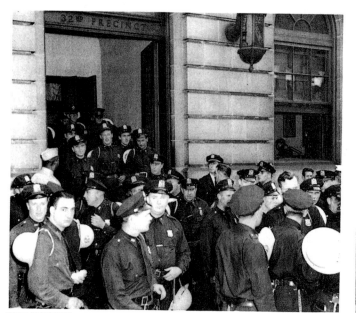

1943 RIOT/UPI

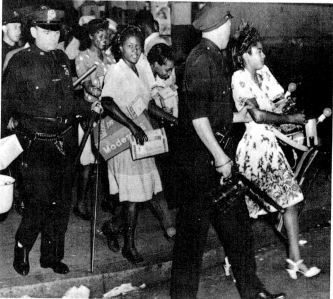

1943 RIOT—LOOTERS/UPI

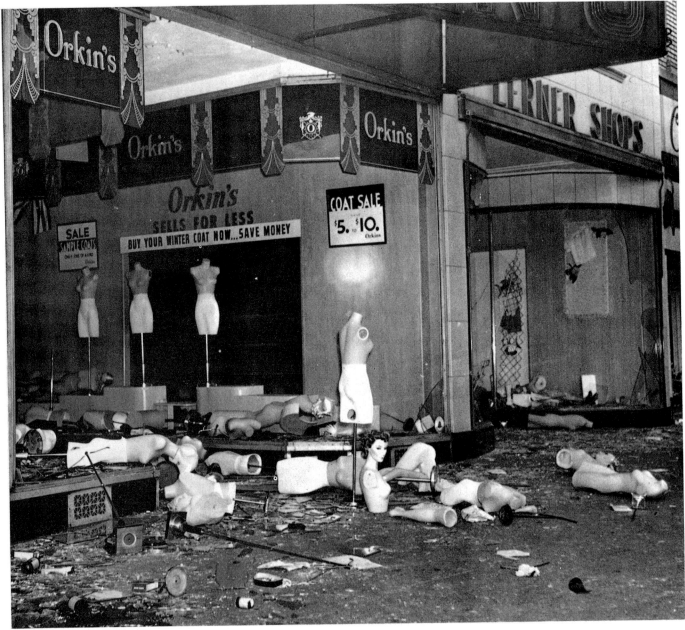

1943 RIOT—THE DAY AFTER/UPI

1943 RIOT/UPI

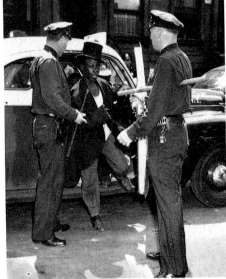

1943 RIOT/UPI

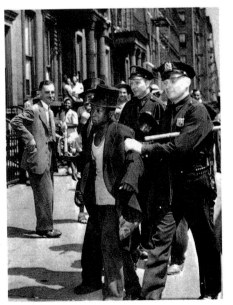

1943 RIOT/UPI

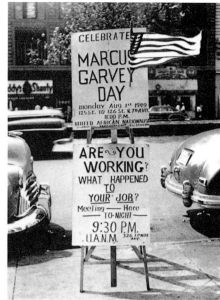

JOHN VACHON/GARVEY DAY SIGN, 1949
MUSEUM OF THE CITY OF N.Y.

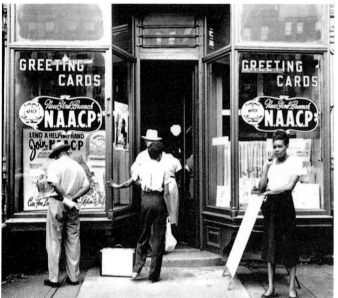

JOHN VACHON/NAACP OFFICE, c. 1945/MUSEUM OF THE CITY OF N.Y.

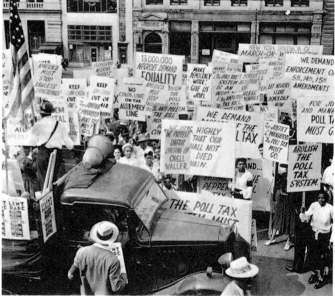

"MARCH ON WASHINGTON MOVEMENT," 1942/CULVER PICTURES, INC.

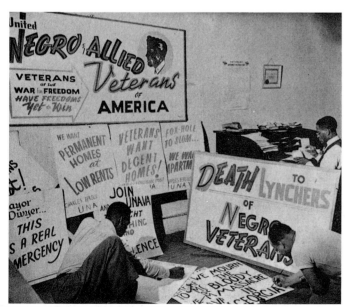

SIGN MAKING FOR PROTEST MARCH, 1948/CULVER PICTURES, INC.

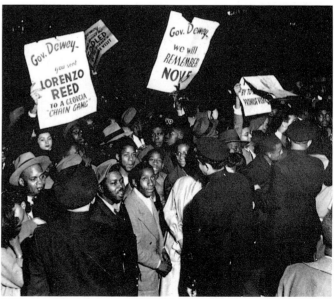

GORDON PARKS/ANTI-DEWEY PROTEST, 1948/LIFE MAGAZINE

TODD WEBB/125TH ST. STOREFRONT CHURCH, 1946

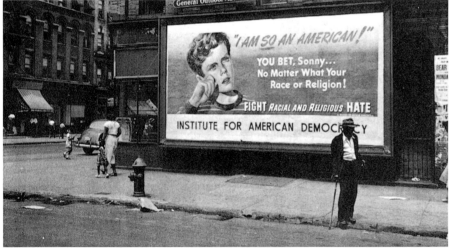

JOHN VACHON/BILLBOARD, 1948/MUSEUM OF THE CITY OF N.Y.

GORDON PARKS/GRAFFITI, 1948/LIFE MAGAZINE

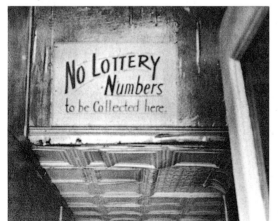

JOHN VACHON/HALLWAY SIGN, 1948
MUSEUM OF THE CITY OF N.Y.

HELEN LEVITT/GRAFFITI, c. 1945

HELEN LEVITT/GRAFFITI, c. 1945

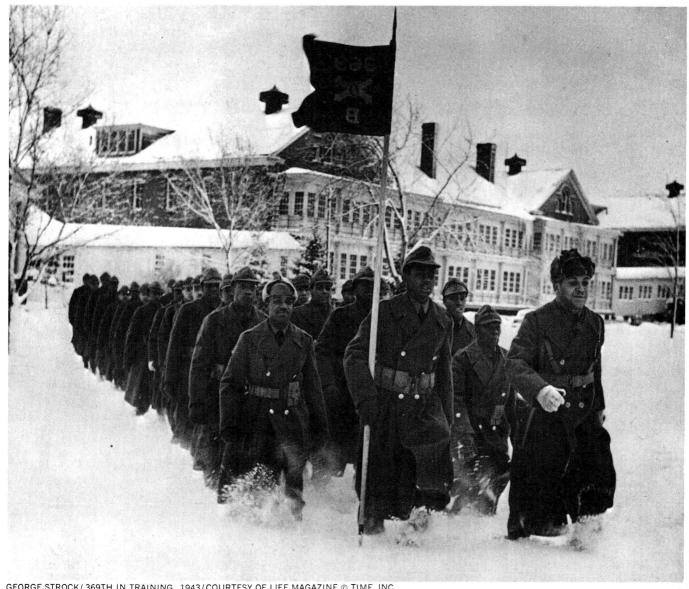

GEORGE STROCK/369TH IN TRAINING, 1943/COURTESY OF LIFE MAGAZINE © TIME, INC.

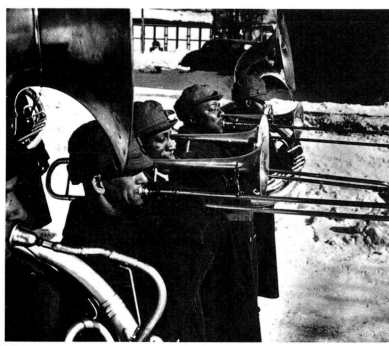

GEORGE STROCK/369TH INFANTRY BAND, 1943
COURTESY OF LIFE MAGAZINE © TIME, INC.

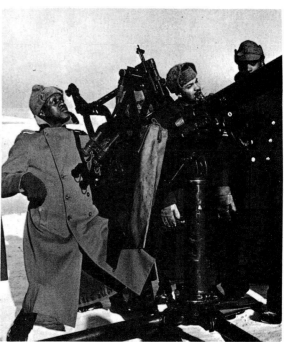

GEORGE STROCK/369TH ANTI-AIRCRAFT BATTERY, 1943
COURTESY OF LIFE MAGAZINE © TIME, INC.

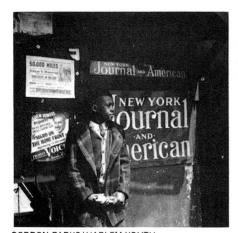

GORDON PARKS/HARLEM YOUTH,
1943/LIBRARY OF CONGRESS

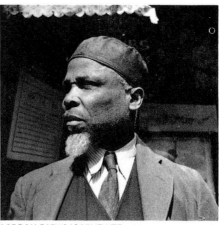

GORDON PARKS/GARVEYITE,
1943/LIBRARY OF CONGRESS

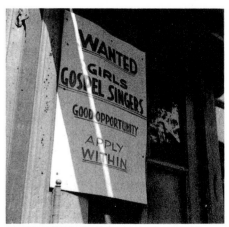

GORDON PARKS/WANTED—GOSPEL SINGERS,
1943/LIBRARY OF CONGRESS

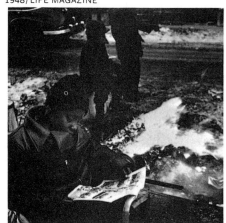

GORDON PARKS/GIRL WITH PLANT,
1948/LIFE MAGAZINE

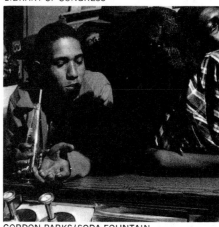

GORDON PARKS/STREET VENDOR, 1943
LIBRARY OF CONGRESS

GORDON PARKS/POLICEMAN, 1943
LIBRARY OF CONGRESS

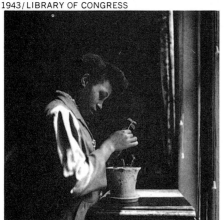

GORDON PARKS/READING COMICS,
1948/LIFE MAGAZINE

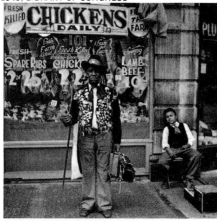

GORDON PARKS/SODA FOUNTAIN,
1948/LIFE MAGAZINE

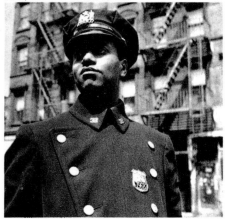

GORDON PARKS/JUKE BOX DANCING,
1948/LIFE MAGAZINE

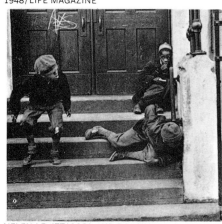

HELEN LEVITT/COPS AND ROBBERS, c. 1945

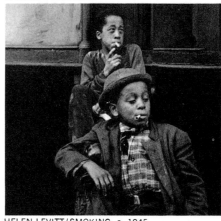

HELEN LEVITT/SMOKING, c. 1945

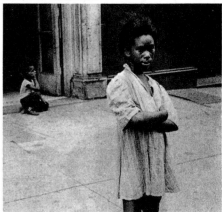

HELEN LEVITT/SIDEWALK PORTRAIT, c. 1945

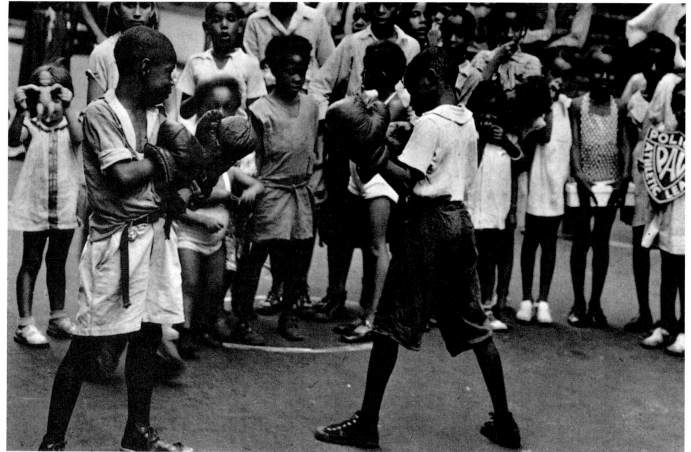

PAL BOXING MATCH, c. 1942/SCHOMBURG COLLECTION, NYPL

GORDON PARKS/BARTENDERS' UNION MEMBER,
1943/LIBRARY OF CONGRESS

JOHN VACHON/SITTING AND WAITING, 1948
MUSEUM OF THE CITY OF N.Y.

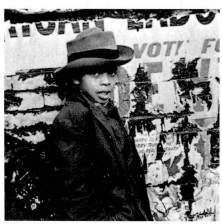

HELEN LEVITT/YOUNG MAN WITH HAT, c. 1948

GORDON PARKS/GANG LEADER, 1948
LIFE MAGAZINE

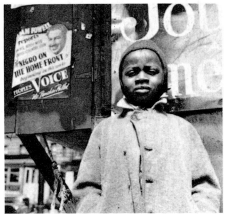

GORDON PARKS/HARLEM YOUTH, 1943
LIBRARY OF CONGRESS

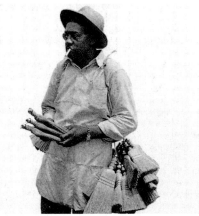

TODD WEBB/BRUSH MAN, 1946

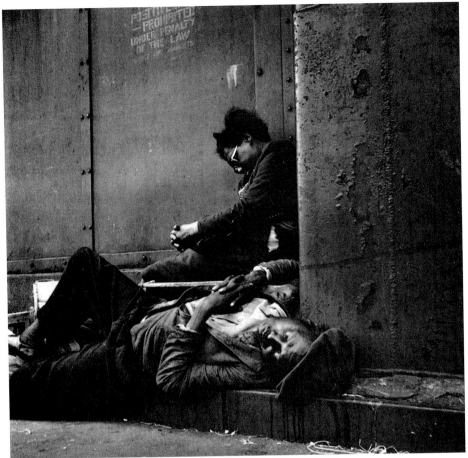

GORDON PARKS/SLEEPING IT OFF, 1948/LIFE MAGAZINE

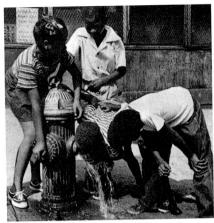

JOHN VACHON/KIDS AT HYDRANT, 1948
MUSEUM OF THE CITY OF N.Y.

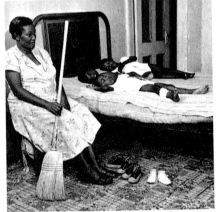

JOHN VACHON/MOTHER AND CHILDREN, 1948
MUSEUM OF THE CITY OF N.Y.

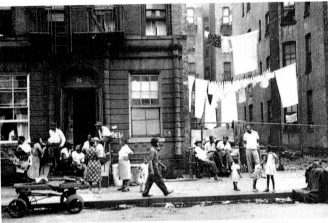

JOHN VACHON/STREET SCENE, 1948/MUSEUM OF THE CITY OF N.Y.

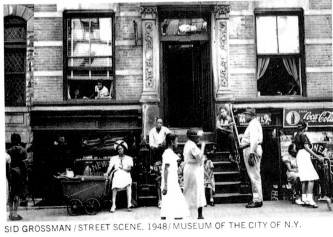

SID GROSSMAN/STREET SCENE, 1948/MUSEUM OF THE CITY OF N.Y.

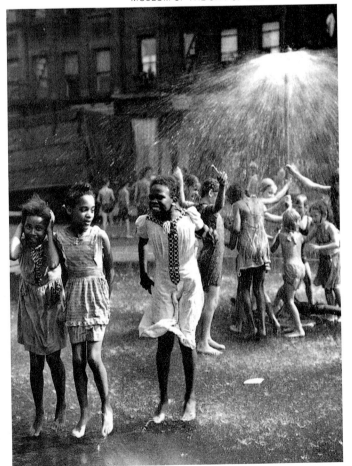

TODD WEBB/STREET SPRINKLER, 1946

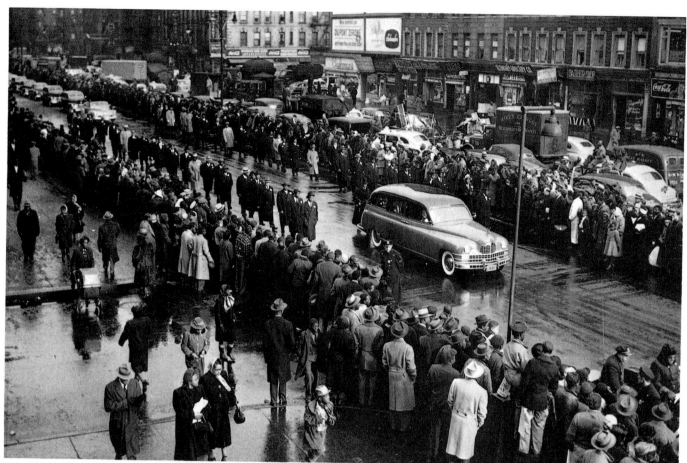

BILL ROBINSON'S FUNERAL, 1949/UPI

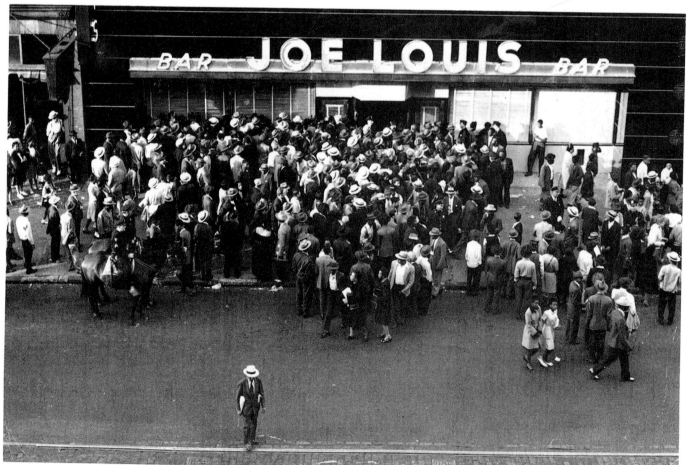

RICHARD SAUNDERS/JOE LOUIS RESTAURANT OPENING, 1946/BLACK STAR

CANADA LEE IN "ANNA LUCASTA," 1944/SCHOMBURG COLLECTION, NYPL

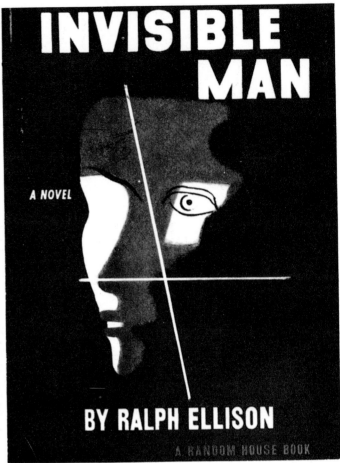

INVISIBLE MAN

A NOVEL

BY RALPH ELLISON

A RANDOM HOUSE BOOK

E. McKNIGHT KAUFFER/DUST JACKET, 1947/RANDOM HOUSE, INC.

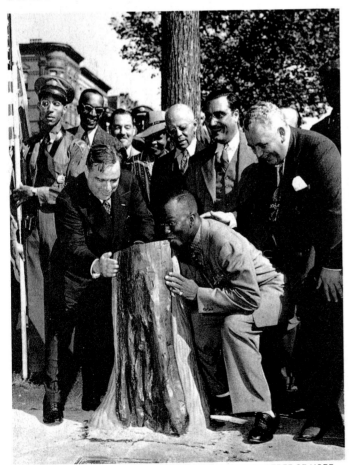

MAYOR LAGUARDIA AND BILL ROBINSON REPLANTING THE TREE OF HOPE, 1941/UPI

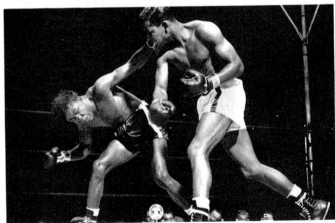

SUGAR RAY ROBINSON DECISIONS KID GAVILAN, 1948/BROWN BROS.

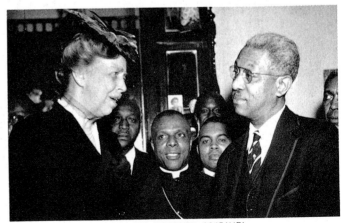

MRS. ROOSEVELT WITH REV. B.C. ROBESON, 1945/UPI

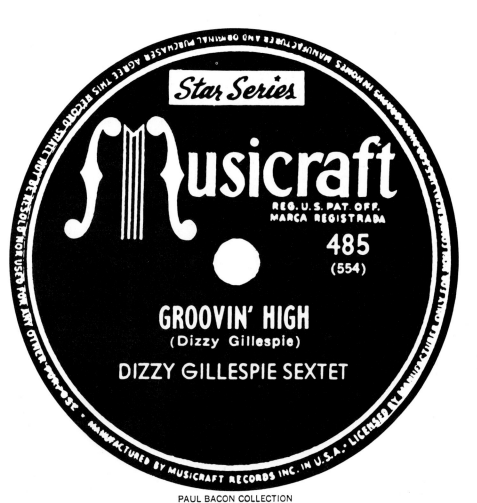

Star Series

Musicraft
REG. U.S. PAT. OFF.
MARCA REGISTRADA
485
(554)

GROOVIN' HIGH
(Dizzy Gillespie)

DIZZY GILLESPIE SEXTET

PAUL BACON COLLECTION

JOHN BIRKS "DIZZY" GILLESPIE, 1946
HARRIS LEWINE COLLECTION

CHARLES "YARDBIRD" PARKER, 1945
BROWN BROS.

GJON MILI/OSCAR PETTIFORD, 1944

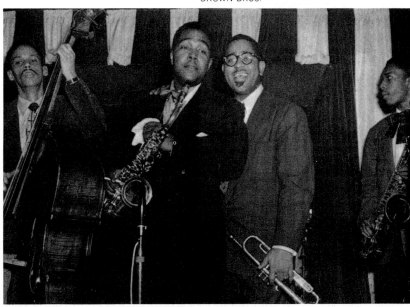

LEFT TO RIGHT, TOMMY POTTER, CHARLIE PARKER, DIZZY GILLESPIE AND JOHN COLTRANE,
1949/DOWN BEAT

199

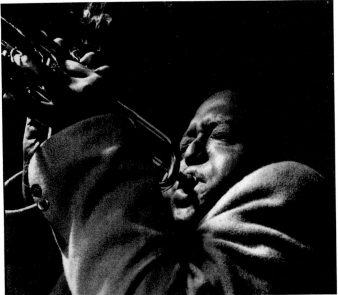

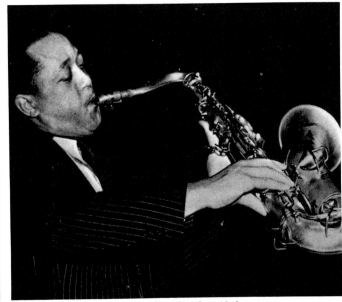

HERMAN LEONARD/THEODORE "FATS" NAVARRO, c. 1946
CHARLES STEWART COLLECTION

HERMAN LEONARD/LESTER "PREZ" YOUNG, c. 1942
CHARLES STEWART COLLECTION

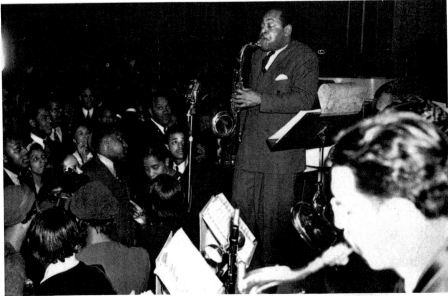

HERMAN LEONARD/THELONIOUS MONK, c. 1947
CHARLES STEWART COLLECTION

COLEMAN HAWKINS PLAYS WEDDING DATE, 1940/UPI

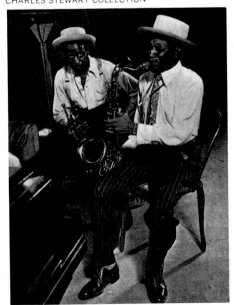

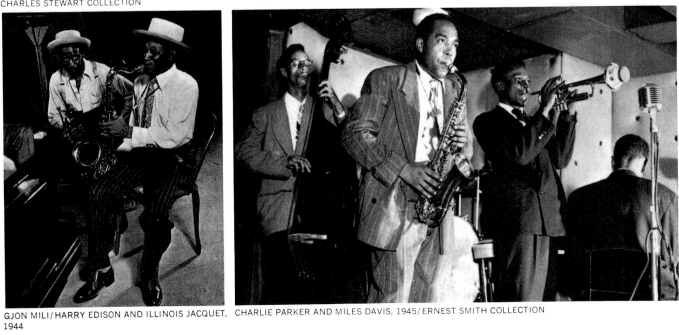

GJON MILI/HARRY EDISON AND ILLINOIS JACQUET,
1944

CHARLIE PARKER AND MILES DAVIS, 1945/ERNEST SMITH COLLECTION

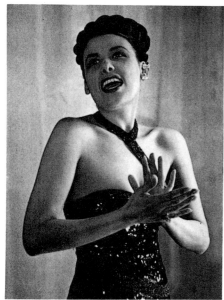

LENA HORNE, 1948/DOWN BEAT

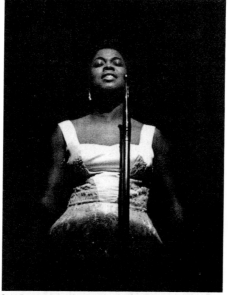

CHARLES STEWART/SARAH VAUGHN, c. 1949
DOWN BEAT

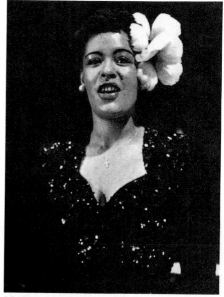

BRADLEY SMITH/BILLIE HOLIDAY, 1944
FRANK DRIGGS COLLECTION

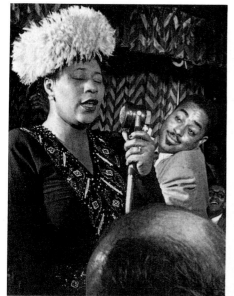

ELLA FITZGERALD AND DIZZY, 1947/DOWN BEAT

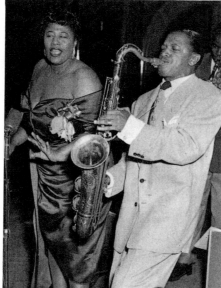

"POPSIE"/ELLA WITH ILLINOIS JACQUET,
1947/DOWN BEAT

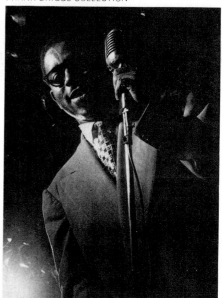

HERMAN LEONARD/DIZZY SINGS, 1948
CHARLES STEWART COLLECTION

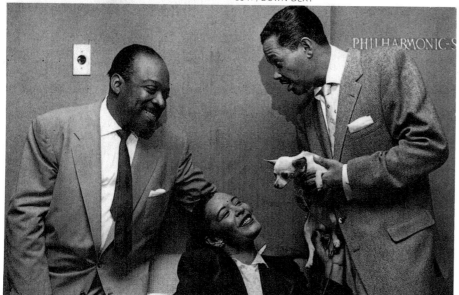

LEFT TO RIGHT, COUNT BASIE, BILLIE HOLIDAY AND BILLY ECKSTINE, 1948/DOWN BEAT

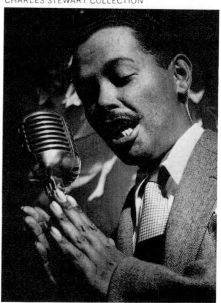

HERMAN LEONARD/BILLY ECKSTINE, c. 1946
CHARLES STEWART COLLECTION

201

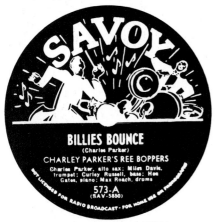

SAVOY

BILLIES BOUNCE
(Charlie Parker)

CHARLEY PARKER'S REE BOPPERS

Charlie Parker, alto sax; Miles Davis,
trumpet; Curley Russell, bass; Hen
Gates, piano; Max Roach, drums

573-A
(SAV-5850)

PAUL BACON COLLECTION

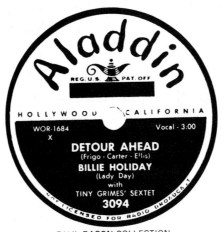

Aladdin

REG. U.S. PAT. OFF.

HOLLYWOOD CALIFORNIA

WOR-1684
X Vocal - 3:00

DETOUR AHEAD
(Frigo - Carter - Ellis)

BILLIE HOLIDAY
(Lady Day)
with
TINY GRIMES' SEXTET

3094

NOT LICENSED FOR RADIO BROADCAST

PAUL BACON COLLECTION

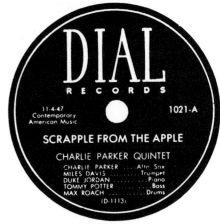

DIAL
RECORDS

11-4-47 1021-A
Contemporary
American Music

SCRAPPLE FROM THE APPLE

CHARLIE PARKER QUINTET

CHARLIE PARKER Alto Sax
MILES DAVIS Trumpet
DUKE JORDAN Piano
TOMMY POTTER Bass
MAX ROACH Drums

(D-1113)

PAUL BACON COLLECTION

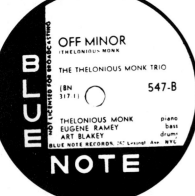

OFF MINOR
(THELONIOUS MONK)

THE THELONIOUS MONK TRIO

(BN 547-B
317-1)

THELONIOUS MONK piano
EUGENE RAMEY bass
ART BLAKEY drums

BLUE NOTE RECORDS, 767 Lexingt. Ave. NYC

BLUE NOTE

PAUL BACON COLLECTION

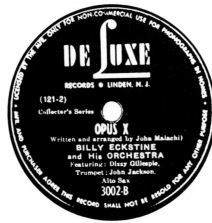

De Luxe
RECORDS • LINDEN, N.J.

(121-2)
Collector's Series

OPUS X
(Written and arranged by John Malachi)

BILLY ECKSTINE
and His ORCHESTRA

Featuring: Dizzy Gillespie,
Trumpet ; John Jackson,
Alto Sax

3002-B

PAUL BACON COLLECTION

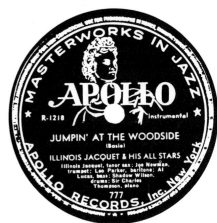

MASTERWORKS IN JAZZ

APOLLO

R-1218 Instrumental

JUMPIN' AT THE WOODSIDE
(Basie)

ILLINOIS JACQUET & HIS ALL STARS

Illinois Jacquet, tenor sax; Joe Newman,
trumpet; Leo Parker, baritone; Al
Lucas, bass; Shadow Wilson,
drums; Sir Charles
Thompson, piano

777

APOLLO RECORDS, Inc. New York

PAUL BACON COLLECTION

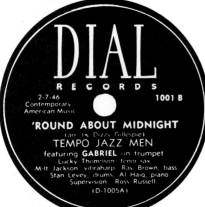

DIAL
RECORDS

2-7-46 1001 B
Contemporary
American Music

'ROUND ABOUT MIDNIGHT
(arr. by Dizzy Gillespie)

TEMPO JAZZ MEN

featuring GABRIEL on trumpet
Lucky Thompson, tenor sax
Milt Jackson, vibraharp; Ray Brown, bass
Stan Levey, drums; Al Haig, piano
Supervision Ross Russell

(D-1005A)

PAUL BACON COLLECTION

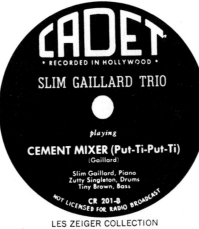

CADET
• RECORDED IN HOLLYWOOD •

SLIM GAILLARD TRIO

playing

CEMENT MIXER (Put-Ti-Put-Ti)
(Gaillard)

Slim Gaillard, Piano
Zutty Singleton, Drums
Tiny Brown, Bass

CR 201-B
NOT LICENSED FOR RADIO BROADCAST

LES ZEIGER COLLECTION

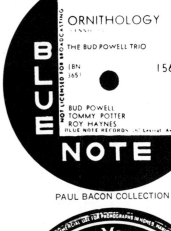

ORNITHOLOGY

THE BUD POWELL TRIO

(BN 1566-B
3651)

BUD POWELL piano
TOMMY POTTER bass
ROY HAYNES drums

BLUE NOTE RECORDS, 767 Lexingt. Ave. NYC

BLUE NOTE

PAUL BACON COLLECTION

APOLLO

C-2157 Spiritual

WHAT COULD I DO

MAHALIA JACKSON

178

APOLLO RECORDS, Inc. — NEW YORK

PAUL BACON COLLECTION

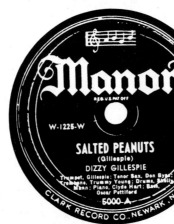

Manor
REG. U.S. PAT. OFF

W-1225-W

SALTED PEANUTS
(Gillespie)

DIZZY GILLESPIE

Trumpet, Gillespie; Tenor Sax, Don Byas;
Trombone, Trummy Young; Drums, Shelly
Mann; Piano, Clyde Hart; Bass,
Oscar Pettiford

5000-A

CLARK RECORD CO., NEWARK, N.J.

PAUL BACON COLLECTION

RAINBOW MUSIC SHOP
102 WEST 125th ST. N.Y.C.

DISTRIBUTORS FOR

APOLLO

(R 1000) Instrumental

WOODYN' YOU
(John Gillespie)

Coleman Hawkins and Orchestra

FEATURING:
Coleman Hawkins (Tenor Sax)
John (Dizzy) Gillespie (Trumpet)
Clyde Hart (Piano)
Oscar Pettiford (Bass)
Max Roach (Drums)

751

PAUL BACON COLLECTION

FRUSTRATION & AMBIVALENCE
1950·1959

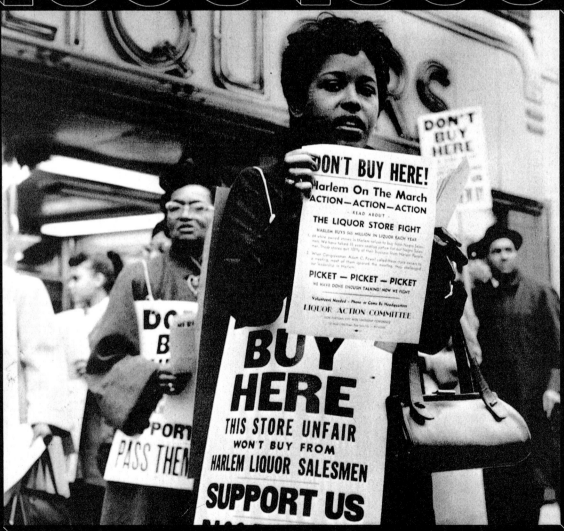

Narcotics Ring Smashed by Police
More "Militancy" by Negroes Urged
Harlem Left Out Of A-Bomb Shelter Plans
Fine Jobs Gained by Harlemites
Harlem Hails Sugar Ray
Harlem Losing Ground As Negro Area
Crime Wave? Who's Speaking?
War Against Rats Pushed
Fires Force Negro to Sell Long Island Home
Who Protects Prostitutes?
Inside Story of Numbers Racket
Racial Bias and The Numbers Racket
Gang War in West Harlem Halted by Cops
Daddy Grace to Use Fire Hose on 300
Prayers on Steps of Harlem Hospital
Negroes Spend Million on Queens Homes
Nkrumah: We're Brothers
21 Negro Pupils Kept Home
Harlem Seething with Unrest
Stores Must Buy from Negro Salesmen
Harlem Is About "Planned Out"
Housing Fight: Revolt Spreads
Harlem Tensions Cited in Flare-Up

THE NEW YORK TIMES, JUNE 2, 1950

NARCOTICS RING SMASHED BY POLICE

After a month of painstaking work by three young detectives, the police rounded up yesterday morning a Harlem ring of twenty-two men and women who are charged with selling narcotics to teen-agers, and even elementary school children. When the fourteen men and eight women—most of them in their twenties—were arraigned in the afternoon in Felony Court, Assistant District Attorney Paul J. Reilly said: "This is merely the start of a long-range investigation that will bring into this court a great number of defendants." All except one of the defendants were charged with selling heroin, or having it on hand to sell, and all except that one were held in high bail, or no bail at all, for hearings later. Magistrate Ambrose J. Haddock said, before setting the bond so high, that none of the defendants could raise it: "I believe this crime is worse than murder." Both the prosecutor and magistrate praised the three detectives of the Narcotics Squad who had broken up the alleged ring and who were in court as complainants against their prisoners.

THE NEW YORK TIMES, SEPTEMBER 14, 1950

MORE "MILITANCY" BY NEGROES URGED

Discrimination against Negroes in industry is increasing and must be met with "aggressiveness and militancy," Milton P. Webster, vice president of the Brotherhood of Sleeping Car Porters, A.F.L., told delegates attending the seventh biennial convention of the union yesterday. Speaking at the Theresa Hotel, the union executive asserted that Negroes were relegated to "black men's jobs, where the work is hard, the hours are long and the pay is poor." He said that reform would be brought about only when Negroes themselves "carry the ball against racial discrimination."

Mr. Webster scoffed at those who point to Joe Louis, Jackie Robinson and Dr. Ralph Bunche as "examples of Negro progress," declaring that they represent only "isolated incidents." He said the reason discrimination existed was that "the people who run this country don't want it stopped. Being white in this country is a fine thing, no doubt about it," he declared. "Being black is an awful thing. The Negro has the same problem that all other workers have, plus the fact that he is black." Mr. Webster paid tribute to John L. Lewis, who, he said, "has only to wiggle his ears and no coal is mined." Only "power and money talk in this country," he continued, and the Negro "will get from this country what he is prepared to take and pay the price for.

"They brought us here in chains," he said. "We're still in chains and we must break them ourselves."

❖ ❖ ❖

AMSTERDAM NEWS, JANUARY 6, 1951

HARLEM LEFT OUT OF A-BOMB SHELTER PLANS

Some people are saying that Harlem must be A-bomb proof. At least the subtle suggestion is that it must be, since no air-raid shelters are planned for the immediate vicinity. Five large shelters, each equipped with first-aid stations, canteens, restrooms and sleeping quarters to accommodate 5,000 to 26,000 persons for long periods of time, are planned. None of these shelters are to be near the heart of Harlem, which is generally said to be around Seventh Avenue and 125th Street. The proposed shelters would be under Second Avenue from 80th to 91st Streets, and 21st to 61st Streets; 76th Street from west of First Avenue to the East River; Sixth Avenue, from 12th to 30th Streets, and 42nd Street from Third Avenue to east of First Avenue, Sidney H. Bingham, chairman of the Board of Transportation said this week.

Other shelters are proposed under Second Avenue from 4th

to 20th Streets; in IND stations at 181st and 190th Streets; in IRT stations at 168th, 181st and 191st Streets; and on the proposed Second Avenue trunk under 34th Avenue, Queens, from Vernon Boulevard to 48th Street.

Most Harlemites would have to walk, run or drive, the latter virtually impossible, to one of the shelters during the brief period of warning before an A-bomb burst. Most of these shelters would be a mile away. There is, however, belief that some IND stations, several of which are located in Harlem, would offer "splinter" protection during an A-bomb attack, but not absolute protection.

❖ ❖ ❖

AMSTERDAM NEWS, MARCH 31, 1951

FINE JOBS GAINED BY HARLEMITES

Turning the spotlight of business success on Harlem reflects many examples of Negroes holding positions of responsibility that even a decade ago were unknown. Harlemites waged a long, hard battle for the right to hold decent jobs with firms thriving in their own community. Leaders climbed upon soapboxes and demanded the jobs. Picket lines symbolized untiring efforts to win jobs. Those who cracked the bias ring first, performed their jobs well and others were able to follow. Until now, most reputable firms cluster-ing on and around 125th Street are largely staffed by capable, well-trained Negroes.

But not all firms held out so long against hiring and upgrading Negro employees. Long ago a few firms gave Negroes positions of responsibility and good salaries when it wasn't considered a necessity or even advisable. One such firm is Thom McAn Shoe Company, which as far back as 1928 employed Negroes in managerial capacities. Another was Blumstein's Department Store, which rapidly increased its Negro sales force before many other stores.

Negroes are still kept, to a large degree, from holding white-collar jobs in business elsewhere in the city. But this hiatus in opportunity is partially filled by several Negro-owned firms with assets totaling millions of dollars. These firms offer unlimited opportunities for advancement, training and good salaries to their many Negro employees. In these firms are found some of our most highly trained business executives. Most of them held lowly jobs before they joined these firms. They now have bright futures with unlimited opportunity for advancement.

But the story of Negroes' advances in business in Harlem does not end with Negro-owned businesses. On 125th Street can be found Negro bank tellers, clerks and executives. There are Negro clothes designers, buyers, milliners, engravers, stenographers, sales forces and managers of all descriptions.

❖ ❖ ❖

THE NEW YORK TIMES, SEPTEMBER 13, 1951

HARLEM HAILS SUGAR RAY

Thousands of persons who had waited patiently in Harlem's streets, taverns and homes for word of the outcome of the fight between their idol, Sugar Ray Robinson, and England's Randy Turpin, transformed their favorite ringman's bailiwick into a screaming, cheering, back-slapping backdrop for their pent-up emotions last night. Shouts of "Sugar wins," "Our baby" and "Can't beat that man" rent the air as milling throngs pressed about a hotel in anticipation of Ray's arrival to greet them from a second-floor balcony, as has been his custom in the past, following victories.

The crowd in the area of the hotel and Sugar Ray's nearby tavern had become so dense two hours before the start of the fight that ten patrolmen were augmented by twenty additional men. Police estimated the crowd at more than 10,000. Pedestrian and traffic lanes leading to 125th Street, the heart of Harlem, were jammed with shouting people. Vehicles, bumper to bumper, moved at a snail's pace. While awaiting the arrival of their hero, the crowd in front of the hotel swayed, sang and danced to the rhythm of a band.

❖ ❖ ❖

NEW YORK HERALD TRIBUNE, APRIL 6, 1952

HARLEM LOSING GROUND AS NEGRO AREA

A decrease of 30.3 per cent in the Negro population of Harlem since 1947 was reported yesterday following a six-month survey by radio station WLIB, which aims its programming toward the New York Negro community. The report said that recent slum clearance programs and the corresponding growth of public and private housing projects have had an "earthquake effect" on the city's Negro population. Since 1947 a total of 182,000 persons have left Harlem and resettled in other parts of the metropolitan area, according to the survey. Other findings were: 1. Income and Wages: The income of the average Negro family has trebled since 1940, with the average middle-class heads of families earning $3,200 a year. 2. Savings: More than $12,000,000 on deposit in postal savings accounts in three Harlem branch post offices. 3. Employment: 95.7 per cent of all employable Negroes were working as of August 1951, and more Negroes were on Civil Service jobs than ever before. 4. New Homes: More than 200,000 New York Negroes in new homes. More than 26 per cent of all New York City housing project apartments occupied by or being read-ied for occupancy by Negro families. 5. Education: High school attendance highest in history. College enrollment up ten times over 1940. 6. Insurance: Negroes own thirteen banks, seventy-four credit unions, twenty savings-and-loan associations and 204 insurance companies nationally. Fifty-two of these companies have assets of more than $100,000,000. 7. Buying Habits: Nationally advertised brand-name products preferred almost exclusively.

❖ ❖ ❖

AMSTERDAM NEWS, MAY 10, 1952

CRIME WAVE? WHO'S SPEAKING?

Downtowners are reading this week that Harlem "after dark is neither as lurid nor dangerous as rumors say." This has prompted me to thinking that rumors and life are more often like oil and water than like ham and eggs.

I am white. I am a regular reporter for the *Amsterdam News.* I get around Harlem. Since I live about twenty blocks below 110th Street, I suppose I am what this article refers to as a "downtowner." Still, I have been in and around Harlem since 1936, when I attended high school in the area. More recently, as a reporter, I have had occasion to be in and out of innumerable houses, churches, pubs, offices, meeting halls, restaurants, nighteries, and, yes, police precincts in the community. I have walked through streets wide and well lighted, and streets dark and rather narrow.

In all that time, I have not been robbed, rolled, mauled, cheated, attacked or insulted. Nor have I ever been filled with especial fear as I crossed from one side of 110th Street to the other on my way uptown—unless, that is, I was crossing against the lights. Now, although it would be unjust to the community to say it had no distinctive features, I have never found crime to be one of them. Naturally, if I spent all my time at the Twenty-eighth Precinct, I might get that impression. I am quite aware of the fact that since 1939, there has apparently been a concerted campaign, in whispers and in some portions of the press, to scare whites away from Harlem.

In the recent past some newspapers, for instance, have scanned police reports, only to list with extraordinary diligence all homicides, minor assaults, burglaries and rapes which ever have been thought to have been committed by Negroes. These stories used to receive a place of honor in the papers not often assigned to similar crimes by non-Negroes. Harlem was grotesquely travestied as an inscrutable ghetto of brutalized semihumans, tortured by dope, disease and ignorance. The Negro press, too, has sometimes been guilty of magnifying the unsavory aspects

of life in the community. Screaming headlines often contradicted the matter of thoughtful editorials.

There are slums in Harlem, falling ceilings and rats and broken stairs, and families crowded into tiny rooms. Nobody likes to live in them. And people in Harlem are fighting for decent housing in the neighborhod organizations, in the NAACP, in the Urban League, in a hundred places. People in Harlem fight for a decent way of life. But the twisters will say that slums have brutalized the people, sent them to drug addiction and crime. Never once, in all the tenements I have visited, have I come into contact with anyone except human beings who want a decent dwelling, a decent job, a decent life.

—RICHARD LINCOLN

THE NEW YORK TIMES, JUNE 20, 1952

WAR AGAINST RATS PUSHED

The rat problem in Harlem, where two-thirds of the city's rat attacks on infants occur, was discussed yesterday by two dozen civic leaders, social workers and representatives of city departments at a meeting of the People's Civic and Welfare Association at the Harlem Branch of the Young Men's Christian Association. Clinton A. Garvin of the Health Department said 90 per cent of the rats' food was garbage, and

that the key to rodent control lay in the control of garbage from its origin in the kitchen to its collection by a sanitation department truck. His allegation of laxity by tenants and building superintendents in disposing of garbage was borne out by Deputy Fire Chief Edward H. Karsten of the Fifth Division who said he had seen many dumbwaiter shafts filled several stories deep with refuse.

Glester Hinds, chairman of the civic group, said part of the trouble lay in the fact that Harlem had more than its share of absentee landlords who cared about nothing but filling their buildings with rent payers. Many of the superintendents hired by this type of landlord, he said, were floaters who were nominally responsible for one or more buildings but who took the jobs merely so they could tell the police they were gainfully employed in case they should be arrested for vagrancy or gambling. Hope Stevens, an attorney, observed that many of the poor and underprivileged people in the area were fearful of making complaints or did not know how to go about it. Mr. Hinds described a cooperative clean-up campaign on 134th Street, which was seen later to have been extraordinarily successful. For many of its thirteen years, the association has been enlisting the aid of resident leaders on particularly dirty streets in rallying the inhabitants to take cleanliness into their own hands. The visual education of seeing their own street clean for the first time has a strong effect on many persons, Mr. Hinds said.

THE NEW YORK TIMES, JANUARY 22, 1954

FIRES FORCE NEGRO TO SELL LONG ISLAND HOME

A Brooklyn Negro businessman, whose partly completed home in a predominantly white area here was the scene of two fires in eight days last November, announced today he had been "forced" to abandon hope of moving in. The $16,000 home has been put up for sale.

Through Dr. Eugene Reed, an official of the Central Long Island Branch of the National Association for the Advancement of Colored People, Clarence Wilson, the prospective occupant, said that a local bank had refused to grant a promised mortgage because of the fires. The police have listed the blazes, which caused nearly $1,000 in damage, as "suspicious," and are still investigating.

Dr. Reed said Mr. Wilson's main reason for selling the house was the "safety of his children." Calling the sale a "shameful victory for the forces of hate and bigotry," Dr. Reed said that Mr. and Mrs. Wilson were afraid their small sons might be harmed if they moved in. If the couple were childless they would continue their "brave stand" for a "principle," Dr. Reed added.

AMSTERDAM NEWS, AUGUST 7, 1954

WHO PROTECTS PROSTITUTES?

Every girl who makes her living hustling for tricks along Eighth Avenue and the other streets in Harlem has a pimp. Sometimes she has to share him with a half-dozen other prostitutes but she doesn't mind this, because a pimp is a necessity. He is to a female hustler what gasoline is to an engine. He keeps her on her toes and he keeps her ticking. At least three of the Cadillac-riding pimps on the avenue have going stables of four and six "wives-in-law" who are out there night and day, bringing in the business that will pay the apartment rent and meet the monthly payments on the car loan.

In fiction a pimp is a pretty boy with handsome features and winning ways who might be madly loved by several women who don't mind paying through the nose just to keep in his good graces. White novelists who do their researching in libraries, and starry-eyed young Negro reporters who get their information from novels on so-called Negro life, still think a pimp is a super lover that is "kept" because he can make those hustling human icebergs feel like honest-to-goodness women. But Eighth Avenue pimps don't operate that way.

The most successful pimp in the busines today isn't pretty. He has his hair conked twice a month for $12, including the tip. He is overweight because he likes pig's knuckles and Spanish rice, and he has a soft spot in his heart for big cars done in loud colors. He keeps a roll of folding money because he knows how to handle the hustlers that are working for him. He has been known to smack a girl's teeth in because she tried to hold out a lousy ten bucks after a full night's work. But he has also been known to keep a girl's room rent going while she was in a "little trouble" which kept her on the Island for nearly six months.

His contacts with the "right people" are terrific. Bartenders along the avenue don't push his girls around. Hotel clerks don't try any shaking down. This top pimp is a king-size operator, and his "wives-in-law" work and follow orders without ever asking any unnecessary questions. His system works. This is the third straight year that he has draped a pretty long car alongside the curbs of Eighth Avenue and his hustlers paid the bills.

There is no romance in the picture. Hard-boiled prostitutes need pimps because peddling love on street corners is a risky business and a girl can work better with a man in her corner. He is there to stake her bail money when she needs it, and to whip her head when she becomes careless and indifferent on the block. Whores in Harlem need protection, too, and it is an open secret that some police officers have a closer working relationship with them than is provided for in the official manual of regulations. Girls with the right connections may be picked up for routine questioning any night, but they may also be "cut loose" before they are taken into the station house and booked. A "loaded" producer, a hustler who has a reputation for turning a sizable quota of tricks each night, might be roughed up and shaken down by a prowl-car team but she is never arrested.

Why doesn't she squawk? Why doesn't she swear out a formal complaint? Why doesn't she break up this vicious and foul form of bribery? Because her business is hustling in the streets. It is the one profession that she knows and she isn't willing to do anything that is going to queer up the flow of bucks. So the prostitutes in Harlem continue to make payments on long yellow Cadillacs and low-slung Packards and special-built Plymouths and any other make of car that their pimps may want to buy.

They keep on reaching down in their bosoms or their stockings or in the bottom of their shoes for hush money to give to cops and detectives. They need smart pimps, hepped cops and detectives to stay in the business of turning tricks. —VERNON SINCLAIR

AMSTERDAM NEWS, AUGUST 21, 1954

INSIDE STORY OF NUMBERS RACKET

A small, penny-ante game brought from the West Indies thirty-one years ago today is Har-

lem's biggest business. It has its effects on nearly every major activity that is carried on in Negro communities, and is played by close to 75 per cent of the adult population of the Negro communities of New York City. The game has caught on rapidly in other areas also, so today there are more white players throughout New York than there are Negro players. The numbers game, whether the straight figure or single action, has grown so tremendously until today that it has a bigger take and employs more people than the nation's largest aircraft plants.

In New York City more than 20,000 people, mostly Negroes, make their livelihood directly from the highly organized policy business. The big bulk of the take, however, is in the hands of two major white mobs, the East Harlem group and a New Jersey syndicate. The annual play of this fascinating industry runs into the billions of dollars, and protection funds run higher than $50,000,-000 a year. No system has yet been devised by Police Commissioner Adams, or any other police official, which can stop this activity. These are the basic findings of this newspaper after some six months of study and investigation into Harlem's biggest and yet potentially most explosive racket.

Numbers, or policy, as played in Harlem today, ranges from a one-cent bet on a single three-digit figure to where many of the

larger gamblers invest as much as $100 on a single favorite figure in their yen to beat the gambling instinct at a payoff of 600–1. Single action pays 8 for 1. The gambler's chances are 999–1 that he will beat the bank. The game operates on the horse-race results, which are sent via electronic devices or phoned from the race tracks to the bet-collecting drops. Whenever horses are running anywhere in the country, and there is a race a day, the numbers game is in operation. Only on Sunday does the game fully stop operations.

One figure from each of three selected races flashes out for single-action play. A time lapse of between half an hour and an hour is desired to allow runners to get more action down. A good runner, who works less than four hours a day, makes an average of from $30 to $100 a day. Single action is paid off after each race, while the three-digit winners receive their winnings after the last race has been tabulated. Daily throughout the streets of Harlem and other communities thousands of persons line up in bars, candy and grocery stores, in apartment hallways and on street corners, to catch the lead, the middle or the last figure.

Between five and seven p.m. daily, the number one question asked on subways, buses, in apartments and on the streets, is "What was the figure today?" by thousands of working people who were at work and unable to learn how their favorite dream or pet number made out.

But numbers is a racket, and against the law. Daily, however, several hundred thousand persons take their chances at breaking the law in a vain attempt to get some extra money to purchase that long-desired luxury. Few get out more than they put into it.

Numbers is the poor man's horse-race betting, for instead of going to the race track and putting a $2 bet on a horse, he places a nickel, dime or whatever he can spare on "the figure." To him, it is harmless play.　—LOUIS SEATON

❖ ❖ ❖

AMSTERDAM NEWS, AUGUST 28, 1954

RACIAL BIAS AND THE NUMBERS RACKET

It was shortly after the stock market crash in 1929, old-timers will tell you, that the late Dutch Schultz and Jimmy Hines mobs realized that a fortune lay in the Harlem numbers racket, and began to move in. Until then, the bulk of the numbers take lay in the hands of the Negro numbers barons. Since that era the real big Negro policy barons, like the Ison brothers, Pompez, Miro, Francis, Holstein and others, have dwindled down until today there are no more than one or two real Negro numbers bankers in the multi-billion-dollar-a-year racket.

Today there are some 150-odd Negro controllers, who send the major portion of their business to New Jersey, upstate in Westchester County, or to the East Side, to the big white bankers.

The situation is something like this: out of every dollar put into the numbers, 25 per cent goes to the numbers writer, who is usually a Negro; 10 per cent to the controllers, a majority of whom are Negro; and the remaining 65 per cent to the banker, in nearly all cases white, who pays off the hits and protection funds in most instances. The banker and controller seldom touch the actual policy play, and thus elude the prejudiced arm of the law. With the numbers being Harlem's biggest business, running into several hundred thousands daily, one can readily see why the Harlem economic status is getting lower. The bulk of the money leaves the area.

Who are the big bankers? They are part of the controlling wing of the highly organized yet vicious game. Few of the Negro controllers themselves know who the real big bankers are. On the streets, numbers men will whisper the names of "Stretch," "Joe," "Sharkie," "The Gimp," and others. They will also say that these guys have "good political protection" from high in Tammany Hall, and are in with the cops.

In Harlem, where numbers has become an integral part of society like horses and poker in the white sections, cops do not have a hard time. They, in most instances,

know who the people are who are in the business. It thus becomes a question of race, graft, and who and when to make the arrest. Past precedence shows that this happens whenever there is "a big downtown newspaper scare" making Harlem a crime-ridden area—a new top cop wants to make the headlines and an outstanding arrest record—a numbers runner or controller seeks to change or add to his territory—a rookie or newcomer enters the area—or when somebody tries to cross the mob. The victim is usually a Negro runner, controller or player. Hundreds of murderers, dope peddlers and addicts, sex maniacs and common thieves continue to run wild as cops fill their books with numbers arrests and point "with pride" to them.

Whether there is a police drive against policy or not, daily these persons, Negro and whites, continue to defy the law and follow the gambling instinct in them. They feel that it is harmless, and are rather incensed when arrests are made of their writer or controller. Self-styled prophets and fortunetellers give tips on the numbers for a fee, and dream books continue to be one of the best sellers on newsstands. The numbers man today is not looked upon by the average citizen as a criminal, but like the insurance man—a good friend. Numbers men are even regarded, in many instances, as key figures in the Negro communities. Many churches and other worthwhile community projects are greatly aided by anonymous policy contributions. Yearly, however, more than

7,000 Negroes, some innocently, are arrested and given a record because of the numbers racket. Few whites, although there are more white players and bankers, are ever arrested. Something is lacking.

—LOUIS SEATON

❖ ❖ ❖

AMSTERDAM NEWS, SEPTEMBER 24, 1955

GANG WAR IN WEST HARLEM HALTED BY COPS

A 15-year-old boy was beaten and stabbed in the chest by four of 50 youths last Monday night in a teen-age gang brawl at Old Broadway and 129th Street, police reported, that threatened to explode into a race riot between Negroes and Puerto Ricans. Detectives of the Amsterdam Avenue station, prowling the area, arrived in time to thwart what might have been one of Harlem's biggest and bloodiest gang wars and race riots, police said.

❖ ❖ ❖

AMSTERDAM NEWS, JULY 28, 1956

DADDY GRACE TO USE FIRE HOSE ON 300

Some 4,000 followers of Bishop C. M. Grace this week converged on 125th Street and Eighth Ave-

nue for the 30th Annual Convocation of the House of Prayer. The convocation will end Sunday with the Bishop, who is better known as Daddy Grace, presiding over a fire-hose baptismal followed by a parade.

Starting at 11 a.m. Sunday, the mass baptism, at which an estimated 300 persons will officially become followers of Daddy Grace, will be held at 20 West 115th Street. Elder Price said a fire hose was being used at the baptism as "a matter of convenience. In the South," he said, "we have pools to baptize people in. We don't have them here. So, the fire hose is used."

—CHARLES HERNDON

❖ ❖ ❖

AMSTERDAM NEWS, AUGUST 4, 1956

PRAYERS ON STEPS OF HARLEM HOSPITAL

The *Amsterdam News* exposé of conditions at Harlem Hospital reached a dramatic highlight Saturday as 1,500 persons from some of Harlem's largest churches gathered on the steps of the hospital and invoked the aid of the Almighty in the 20-year struggle for a new hospital.

The prayer services, which were held on the steps of the hospital and overflowed into the Lenox Avenue block in front of the building, were led by the Rev. R. T. Hudson, pastor of the Ephesus Church. The Rev. Hudson was joined in the religious ceremonies by the Rev. George C. Violenes of Christ Community Church, the Rev. Benjamin C. Robeson of Mother AME Zion Church, the Rev. H. R. Hughes of Emmanuel AME Church, and Father Julian F. Dozier of St. Andrews, all of whom offered prayers for those confined to the hospital, and for the mayor and city officials who have the power to grant the community a new hospital.

❖ ❖ ❖

AMSTERDAM NEWS, JUNE 15, 1957

NEGROES SPEND MILLION ON QUEENS HOMES

Negroes have purchased an estimated 11,000 Queens County homes to the tune of more than one million dollars during the last five years, and though white real estate brokers are said to secure better mortgage commitments from banks, Negro brokers are thriving, too, an *Amsterdam News* study showed this week. Leading Negro brokers in Queens, plus an executive from the top white realty firm, say the consensus is that white brokers enjoy closer bank cooperation. Negro buyers are said to be giving a major portion of their business to white firms.

"Ten years ago," said Mrs. Corita V. Roane, owner of Corita V. Roane Real Estate Brokerage, "white brokers would put Negroes in their cars and rush them over to my office, saying they couldn't afford to show them houses. Now, they are competing for Negro business."

All brokers concurred that Negroes were buying about 99 per cent of the property. "I'm always running into a street that I thought was all white, and seeing Negro children," said Mrs. Roane. "Negroes are buying what they want, but not necessarily what they need," said Mrs. Lois J. Allen, part owner of Allen and Edwards, Realtors, 168-18 Liberty Street. "Mortgages are at a maximum," she went on. "Many people are trying to keep up with the Joneses and the result is inflation," she said.

All Queens real estate brokers are suffering from the slack in the G.I. market, former backbone of the trade. All agreed that the white brokers have the inside track. "We don't have any mortgage problems due to our size," said Larry Gold, white manager of the Merrick road office of Trojan Unlimited, one of the largest and most successful real estate organizations in Queens. It has five branch offices in Queens alone, and sold 1,000 homes last year. Trojan offers a small mark-up on their properties. Volume business allows this.

"Banks have mortgage quotas," explained Mr. Gold. "They

can only take so many of a certain type. We give them all they need in one shot. It's easier for them to do business that way," he went on. Mr. Gold also told of Trojan's executive in charge of the mortgage division, a former bank vice president with 15 years' banking experience.

The mortgage bonus system is another complaint among some Negro brokers in Queens. A broker, usually white, with good bank connections, secures a mortgage for another, usually Negro, broker. The Negro then kicks back $200 to the white broker. The buyer, of course, is the real loser. "I recognize that the mortgage bonus is another evil of the business," said Mrs. Allen. "But this is a thing that Negroes could correct themselves. No one makes a Negro buy a house he can't afford or go to a bank that won't give him a fair deal."

Another Negro broker said that some Negroes pay as much as $2,000 more than the regular price so that they can get a mortgage. Most popular homes being sought by Queens Negroes range from $14,000 to $16,000 in Hollis, St. Albans and Springfield Gardens.

Schoolteachers, city employees and nurses are buying most of the homes in these areas. The two-family house is in high demand. Many of these owners rent out a floor. Most Negroes buying homes in Queens show intelligence and excellent discretion when house-shopping, realtors say. And when they move into a neat neighborhood, they tend to

keep their property in good repair. Many Negroes fail to realize that $2,500 to $3,000 is needed before house-shopping becomes sensible, the real estate men say. Some judge houses by size rather than quality.

Houses located in Jamaica and South Ozone Park are the most reasonably priced. One-family homes in Jamaica range from $8,000 to $12,000. In South Ozone Park, they range from $10,000 to $14,000. New homes are being constructed in Hempstead and Lake View. Most are ranch-style houses averaging $16,500. They usually include six rooms, including three bedrooms. Split-levels and Cape Cods are also going up. It takes about three years for a neighborhood to change its complexion. White families with young children are usually the first to move out as Negroes move in. Older folks with grown families move slower.

—JESSE DE VORE

❖ ❖ ❖

AMSTERDAM NEWS, AUGUST 2, 1958

NKRUMAH: WE'RE BROTHERS

"Back at home we think of the people of Harlem as our brothers and we can assure them of a warm welcome whenever they choose to visit the land of their forefathers." These were the words of Dr. Kwame Nkrumah, Prime Minister of Ghana, as he gave his official thanks to the thousands of Negro citizens of the city who turned out to welcome him back to Harlem. He termed the reception "spontaneous and spectacular." His reception was marred, however, by the booing of Dr. Ralph Bunche at a Harlem reception by African nationalists. An estimated 10,000 persons jammed into the 369th Field Artillery Armory, 142nd Street and Fifth Avenue, while another 20,000 persons viewed him as he rode through the streets of Harlem waving to the sparse crowds from an open-air car enroute to the Armory. Late afternoon rains had apparently cut down the size of the crowds. Appealing to the feeling of kinship between Harlem citizens and the people of Africa, the Ghana leader called upon doctors, lawyers, engineers and businessmen "to come and help us build our country."

❖ ❖ ❖

THE NEW YORK TIMES, SEPTEMBER 9, 1958

21 NEGRO PUPILS KEPT HOME

Two groups of parents kept twenty-one Negro children home when school opened yesterday, threatening court tests of the Board of Education's zoning regulations. Spokesmen for both groups, one in Manhattan and one in Brooklyn, charged that the school zoning system operated

like Virginia's pupil-placement law, maintaining segregation. Both groups of parents contend that their children have been assigned to nearly all-Negro schools that are inferior to other schools. They asked that their children be assigned to integrated schools out of their neighborhoods.

The rebelling group in Manhattan consists of parents of fifteen children who had been assigned to Junior High Schools 120, 136 and 139. The parents have obtained a teacher who will give the children the regular seventh-grade curriculum while the case is being settled in court, according to their attorney, Paul B. Zuber. Mrs. Carrie Haynes, spokesman for the area's Parents Committee for Better Education in Harlem, said classes would be held in the Emmanuel Sunday School at 126th Street and Third Avenue. Mrs. Haynes said, "We're not letting up until we get a decent program on the junior high school level. There's only one way to do it: in the courts." Mr. Zuber said it had been three years since the Public Education Association found that segregated education was inferior, but the Board of Education, he said, has not moved to provide equal opportunities.

A spokesman for the Board of Education said that if the children did not return to school, attendance officers would be notified and legal action taken against the parents. —LOREN B. POPE

❖ ❖ ❖

AMSTERDAM NEWS, JULY 4, 1959

HARLEM SEETHING WITH UNREST

New York's more than one million Negroes were virtually in revolt this week, taking action into their own hands in bold moves ranging from economic boycotting of stores which refuse to buy from Negro salesmen, refusing to pay rent on rat-infested slums, refusing to send their children to inferior schools, protesting service on bus lines, and open defiance of their white political bosses. The apparently unplanned but well-coordinated series of "revolts," all coming at one time, left Harlem in the most hostile and serious mood it has been in since the early thirties when uptowners took matters into their own hands, through an economic boycott to force the major breakthrough in job opportunities.

In politics, the revolt whirled around the head of Tammany Hall's leader, Carmine DeSapio, in a move which saw Harlem's once most powerful political leader Herb Bruce return to the political wars after years of retirement, to join hands with representative Adam Clayton Powell and J. Raymond Jones against DeSapio in a move which could result in a resounding defeat for DeSapio this fall, and end his political career.

On the economic front, the NAACP was leading a boycott of liquor stores which refuse to buy from Negro liquor salesmen. This move has already brought seven

white liquor stores to their knees, and appeared certain to become Harlem-wide before the end of the week. A spokesman for the NAACP openly admitted that as soon as the whiskey stores have been brought in line, the same effective lines would be drawn around other business enterprises practicing economic discrimination against Negroes.

On the housing front, six thousand tenants of nearly forty of Harlem's rat-infested homes have gone on a "rent strike" and are refusing to pay rent to landlords until corrective action is taken to rid their buildings of rats.

On the school front, Harlem schools closed with a hard core of protesting parents urged on by Congressman Powell, vowing that they will not let their children return to "inferior Harlem schools" next September 14.

And still on another front, Negroes were knocking on the door of City Hall and demanding better bus service uptown, and threatening a boycott of the Fifth Avenue bus lines which run through Harlem.

The mood and manner of the "revolution" was one of stern but stubborn defiance of the "status quo." There was no violence, no hint or threat of violence. There was only the stubborn countenance of groups of people who were saying to themselves, "I'm sick and tired of the way things are going."

No one person, group or organization could be held responsible for the "revolution." It appeared that the series of revolts came

through spontaneous efforts on the part of various groups "to do something" about their situation on all fronts. For example, Congressman Powell and the refusal of Tammany Hall to designate a Negro to run for the General Sessions court brought on the political revolt. It was the local branch of the NAACP which initiated the economic revolt in the liquor stores, and it was the death of a Negro child from rat bites which set off the rent strike. But wherever one group appeared to take action, it was immediately supported by another group which was fighting on some other front. And toward week's end the various "battle lines" through and around Harlem were rapidly being consolidated into one solid front for better social, economic and political living conditions.

❖ ❖ ❖

AMSTERDAM NEWS, JULY 4, 1959

STORES MUST BUY FROM NEGRO SALESMEN

In one of the most far-reaching economic moves in Harlem during the past 20 years, seven white liquor stores this week signed agreements with the NAACP declaring that they will no longer do business with wholesale liquor houses which refuse to let Negro salesmen handle their business.

The agreements were signed after the Labor and Industry Committee of the New York branch of the NAACP threw a surprise air-tight picket line around three of the liquor stores and threatened to do the same with the other four.

The Labor and Industry Committee of the NAACP is headed by labor leader Odell Clark and Leonard Faust, co-chairman, who organized the surprise move and were backed up all the way by L. Joseph Overton, president of New York branch, who personally appeared with Clark and others on the picket lines.

The seven liquor stores agreed to send the signed agreement to all liquor distributors from whom they buy their whiskey. The agreement reads as follows: "Due to mounting community pressure, expressed primarily through the New York branch of the NAACP, you are hereby informed that forthwith I will refuse to continue doing business with any wholesaler who will not send as a representative a Negro salesman. This salesman, being a Negro, will reflect the economic interest of the local community on which I depend for a successful operation of my business."

With the seven stores having already signed the agreement, NAACP officials said they did not anticipate any difficulty getting all other stores in Harlem to sign also. They added that they expected to get this done without further picketing, since the word has already been passed around as to the effectiveness of the picket line. They said any store

refusing to sign the agreement will be promptly picketed.

During the time picket lines were thrown around the three stores, only two customers crossed the line to buy liquor. In both cases they had their bottles smashed by irate onlookers who were thoroughly in sympathy with the pickets. The NAACP, however, condemned such action. The issue turned on the fact that many of the white liquor stores in Harlem's plush 50-million-dollar retail liquor market make enormous profits selling liquor to Negroes, but refuse to buy this liquor from Negro salesmen.

—LES MATTHEWS

❖ ❖ ❖

AMSTERDAM NEWS, JULY 4, 1959

HARLEM IS ABOUT "PLANNED OUT"

"Harlem is still a ghetto and it's time the churches take an active part in the proposed planning of Harlem. The people of Harlem should be ignited, aroused and become aggressive. Harlem has had so many plans that its just about planned out.

"There are too many tomorrows," said the aggressive and outspoken Rev. David Licorish when Commissioner George Gregory, chairman of District 10 Planning Board, recognized him. Before Rev. Licorish fired the

Zoning meeting of the Planning Board, Commissioner Gregory painted a beautiful Harlem of the future to the audience, which was seated in the air-conditioned meeting room at the Bowery Savings Bank at 700 St. Nicholas Avenue, Thursday evening.

Commissioner Gregory, a former university basketball captain, stressed community pride and cautioned the guests to take a big view of Harlem. He painted a future Harlem to the audience which would include a bridge spanning the Hudson River, linking 125th Street to the outside world, new hotels, shopping and cultural centers, restaurants and fine residential apartments. "Harlem is desirable real estate," the commissioner continued, and he was supported by Planning Commissioner James Felt, who said that a future New York will stress buildings adequately spaced in order to give more light. Commissioner Felt said the majority of old cities were badly planned and the new zoning laws will make Harlem a better place to live in, but it will take time. Many attending wanted action now.

❖ ❖ ❖

AMSTERDAM NEWS, JULY 11, 1959

HOUSING FIGHT: REVOLT SPREADS

A Harlem slumlord faced his day in Housing Court Thursday as the result of a momentous rent strike staged by tenants of four buildings in West 116th Street. The strike coordinator announced that a mass rally will be held in Dewey Square, 110th Street and Lenox Avenue, this Saturday, July 11, at 7 p.m., to broadcast a report of the strike's effectiveness.

Jesse Gray, executive director of the Lower Harlem Tenants Council, strike coordinator, also said that seventeen other member houses of the Council are currently on strike, with tenants withholding rental payments until violations are corrected. "The worst conditions among these units," he said, "exist in two houses, at 105 West 114th Street."

"One of the most gratifying effects of our action so far," Mr. Gray said, "is that some landlords in the block, West 116th Street, between Lenox and Seventh Avenues, have already voluntarily started cleaning up their hallways. Also, the Tenants Council has received fourteen new member houses since the strike, that's a rate of two a day. There are others waiting to join." The other fifteen struck houses, Mr. Gray said, are in an area bounded by Fifth and Eighth Avenues and 110th and 117th Streets.

Disgusted because the front door of their apartment building is falling apart, water from toilets leading from one apartment into another, and rats running around freely, eight tenants, representing twenty-eight families at 365 West 118th Street, handed their landlord a strong ultimatum this week.

THE NEW YORK TIMES, JULY 15, 1959

HARLEM TENSIONS CITED IN FLARE-UP

Hulan E. Jack charged last night that the flare-up between two policemen and an angry crowd in Harlem Monday was an outgrowth of "rising race tension" in that area. Mr. Jack, Manhattan borough president, declared that the tension stemmed from an increasing resentment by Harlem's residents over "inadequate housing, poor schools, unsanitary conditions and low-paying jobs. The people of Harlem are in an angry mood," he said, "and the city's got to do something about it." At the same time Police Commissioner Stephen P. Kennedy, declaring that "we are not going to stand for mob violence anywhere in the city," assigned eighty-eight extra men to the West 123rd Street Precinct, scene of the incident.

Asked whether he was blaming Mayor Wagner's administration for what he termed "the terrible neglect and abuse of Harlem," Mr. Jack replied: "I am blaming no individual and no administration. I say more has to be done to meet and work with the people on the community level, to make them feel as though they're part of the city."

❖ ❖ ❖

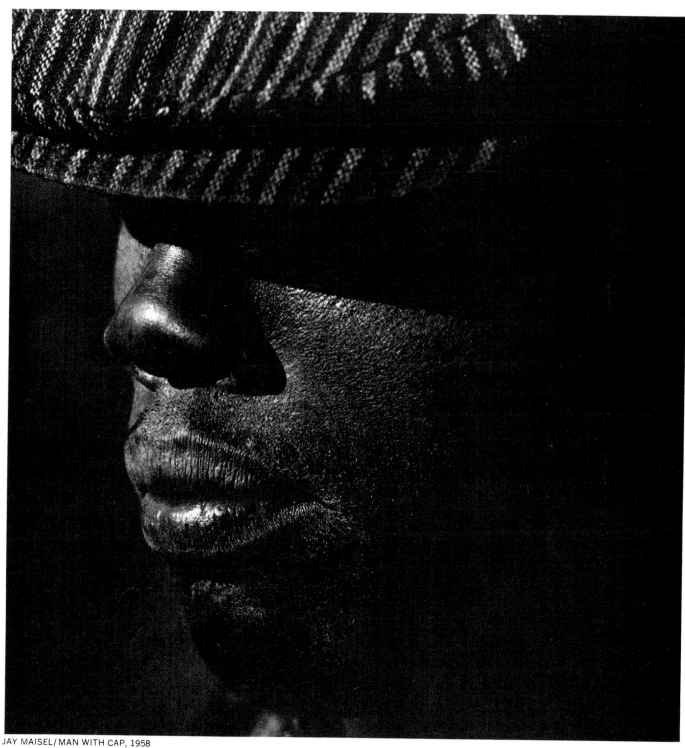

JAY MAISEL / MAN WITH CAP, 1958

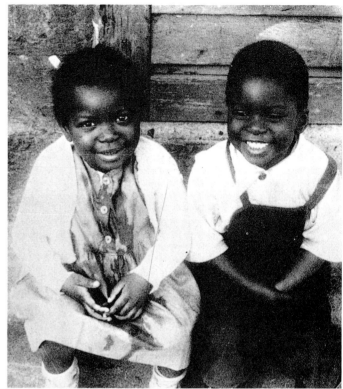

JAY MAISEL/KIDS, 1956

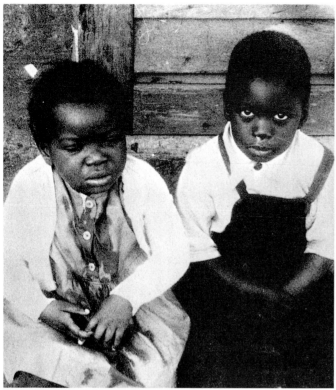

JAY MAISEL/KIDS, 1956

JAY MAISEL/IN THE PARK, 1957

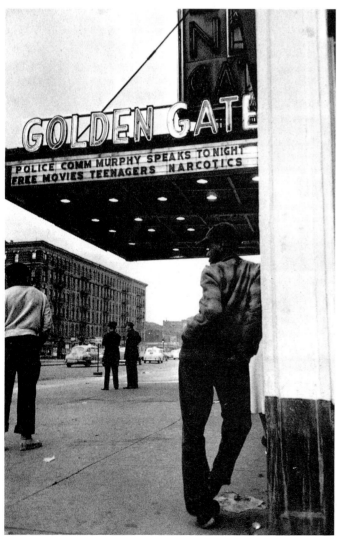

RALPH MORSE/NARCOTICS MEETING, 1952
COURTESY OF LIFE MAGAZINE © TIME, INC.

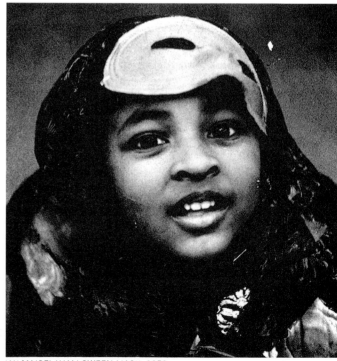

JAY MAISEL/HALLOWEEN MASK, 1956

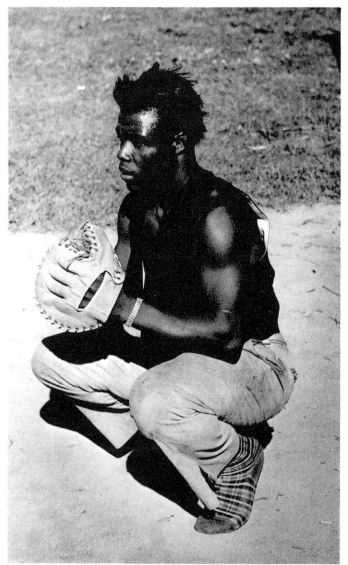

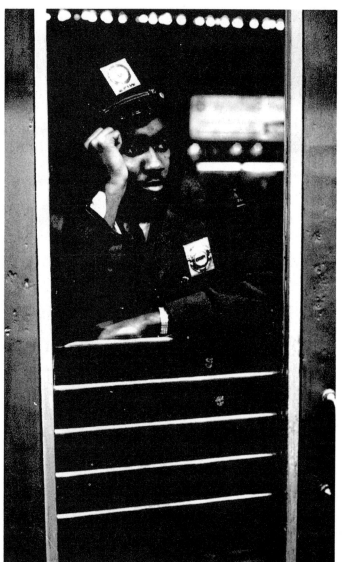

JAY MAISEL/CATCHER, 1957

JAY MAISEL/SECURITY GUARD, 1958

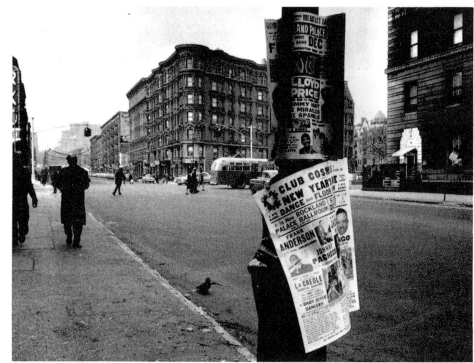

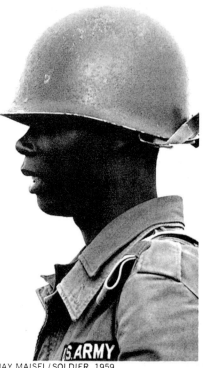

BRUCE DAVIDSON/POSTERS, 1959/MAGNUM PHOTOS

JAY MAISEL/SOLDIER, 1959

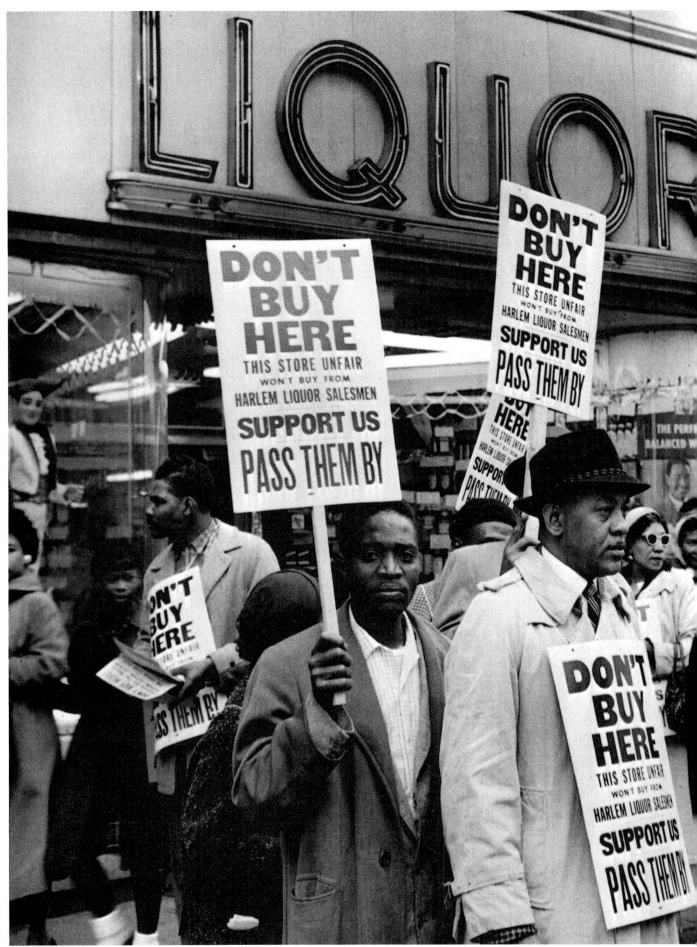

RICHARD A. MARTIN/"PASS THEM BY," 1959

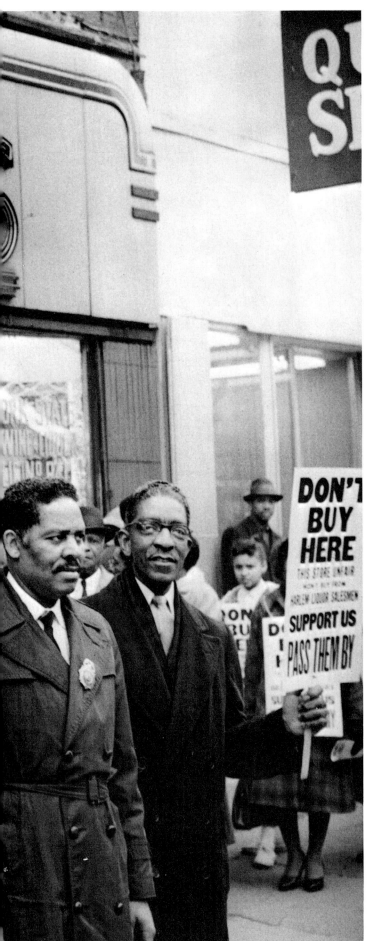

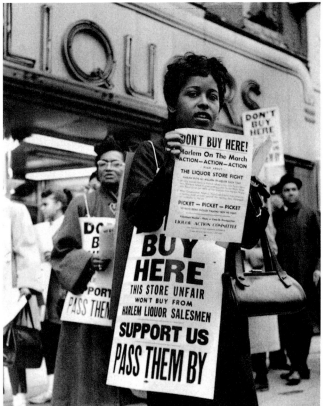

RICHARD A. MARTIN/"PASS THEM BY," 1959

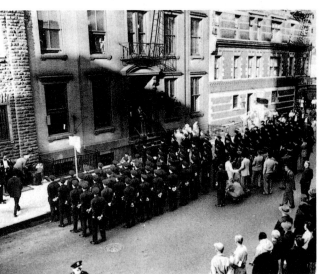

ADDITIONAL POLICE ASSIGNED TO HARLEM, 1954/UPI

WILLIE MAYS STEALS, 1951/WIDE WORLD PHOTOS

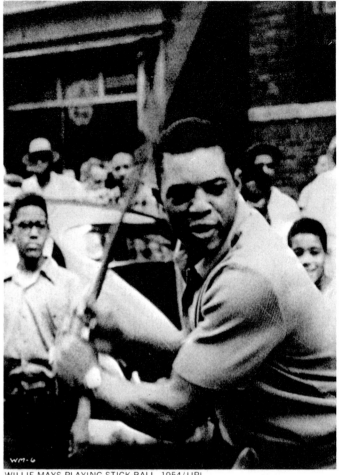

WILLIE MAYS PLAYING STICK-BALL, 1954/UPI

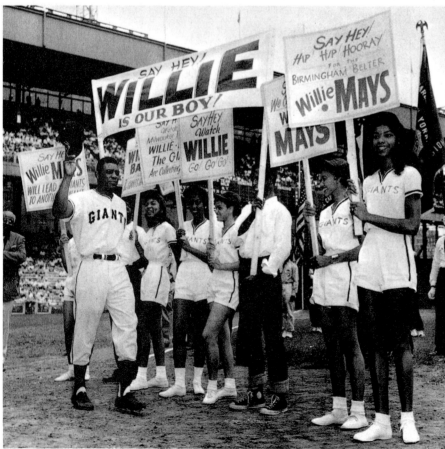

WILLIE MAYS' DAY, 1954/UPI

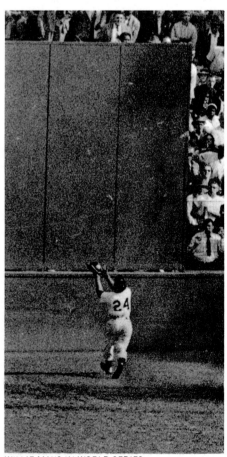

WILLIE MAYS IN WORLD SERIES,
1954/WIDE WORLD PHOTOS

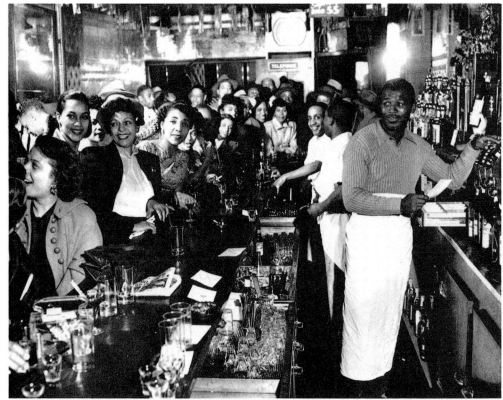

SUGAR RAY TENDING BAR, 1953/UPI

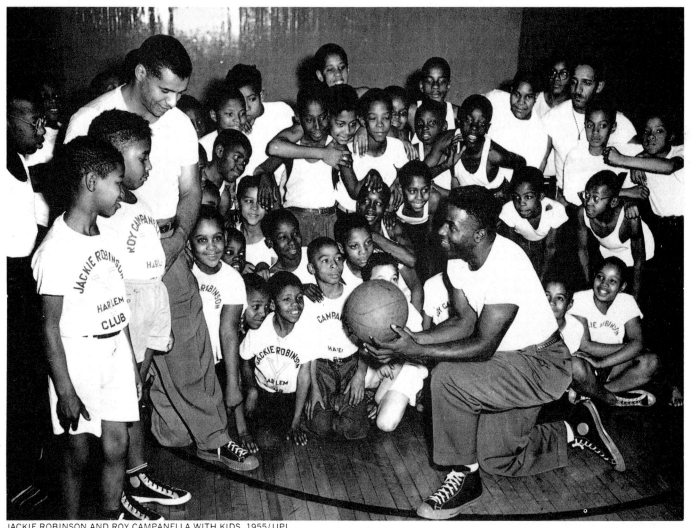

JACKIE ROBINSON AND ROY CAMPANELLA WITH KIDS, 1955/UPI

1. HILTON JEFFERSON; 2. BENNY GOLSON; 3. ART FARMER; 4. WILBUR WARE; 5. ART BLAKEY; 6. CHUBBY JACKSON; 7. JOHNNY GRIFFIN; 8. DICKIE WELLS; 9. BUCK CLAYTON; 10. TAFT JORDAN; 11. ZUTTY SINGLETON; 12. RED ALLEN; 13. TYREE GLENN; 14. MIFF MOLE; 15. SONNY GREER; 16. JAY C. HIGGINBOTHAM; 17. JIMMY JONES; 18. CHARLES MINGUS; 19. JO JONES; 20. GENE KRUPA; 21. MAX KAMINSKY; 22. GEORGE WETTLING; 23. BUD FREEMAN; 24. PEE WEE RUSSELL; 25. ERNIE WILKINS; 26. BUSTER BAILEY; 27. OSIE JOHNSON; 28. GIGI GRYCE; 29. HANK JONES; 30. EDDIE LOCKE; 31. HORACE SILVER; 32. LUCKEY ROBERTS; 33. MAXINE SULLIVAN; 34. JIMMY RUSHING; 35. JOE THOMAS; 36. SCOVILLE BROWNE; 37. STUFF SMITH; 38. BILL CRUMP; 39. COLEMAN HAWKINS; 40. RUDY POWELL; 41. OSCAR PETTIFORD; 42. SAHIB SHIHAB; 43. MARIAN McPARTLAND; 44. SONNY ROLLINS; 45. LAWRENCE BROWN; 46. MARY LOU WILLIAMS; 47. EMMETT BERRY; 48. THELONIOUS MONK; 49. VIC DICKENSON; 50. MILT HINTON; 51. LESTER YOUNG; 52. REX STEWART; 53. J. C. HEARD; 54. GERRY MULLIGAN; 55. ROY ELDRIDGE; 56. DIZZY GILLESPIE; 57. COUNT BASIE

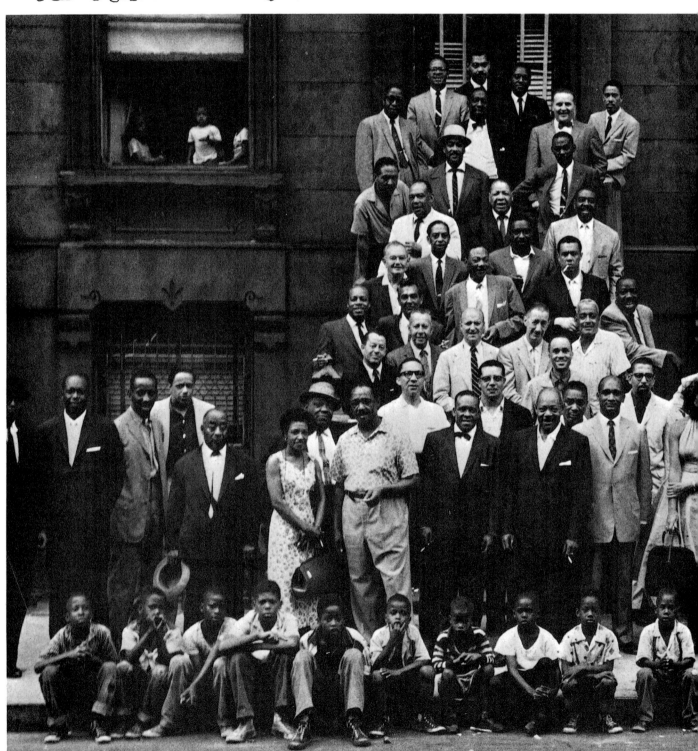

ART KANE/"THE GOLDEN AGE OF JAZZ," 1959/ESQUIRE, INC.
(DIAGRAM) ESQUIRE, INC.

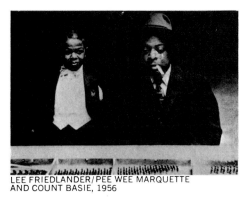

LEE FRIEDLANDER/PEE WEE MARQUETTE
AND COUNT BASIE, 1956

HARRIS LEWINE/THELONIOUS
MONK STAMP, 1958

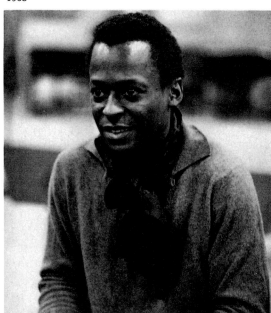

LEE FRIEDLANDER/DON CHERRY AND ORNETTE COLEMAN,
1958

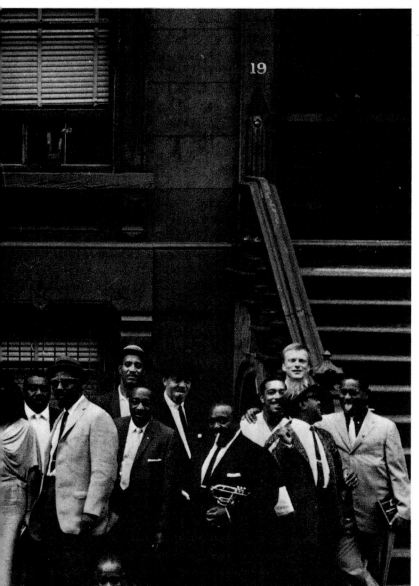

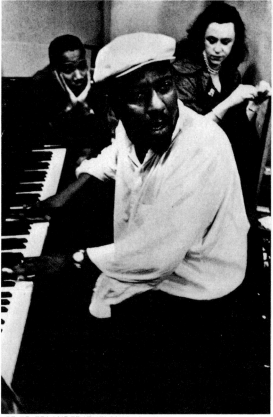

MILES DAVIS, 1959/COLUMBIA RECORDS, INC.

LEE FRIEDLANDER/THELONIOUS MONK
AND THE BARONESS, 1958

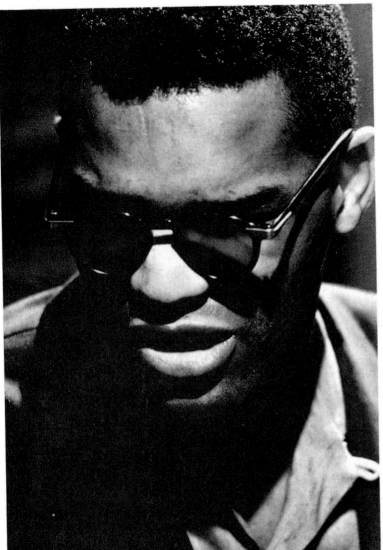

LEE FRIEDLANDER/RAY CHARLES, 1957

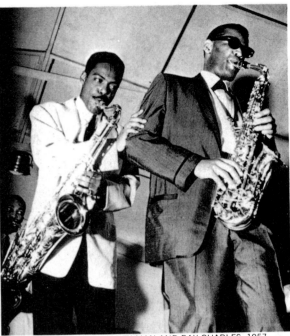

LEE FRIEDLANDER/DAVID NEWMAN AND RAY CHARLES, 1957

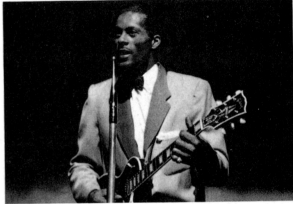

JAY MAISEL/CHUCK BERRY, 1957

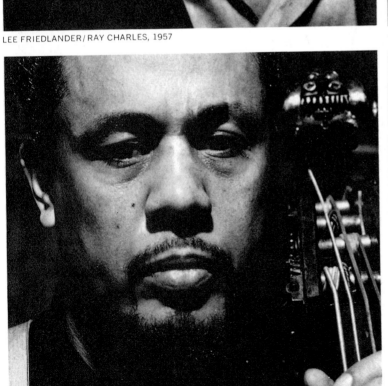

LEE FRIEDLANDER/CHARLIE MINGUS, 1958

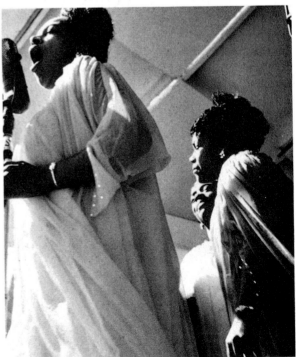

LEE FRIEDLANDER/CLARA WARD SINGERS, 1959

MILITANCY & IDENTITY 1960-1968

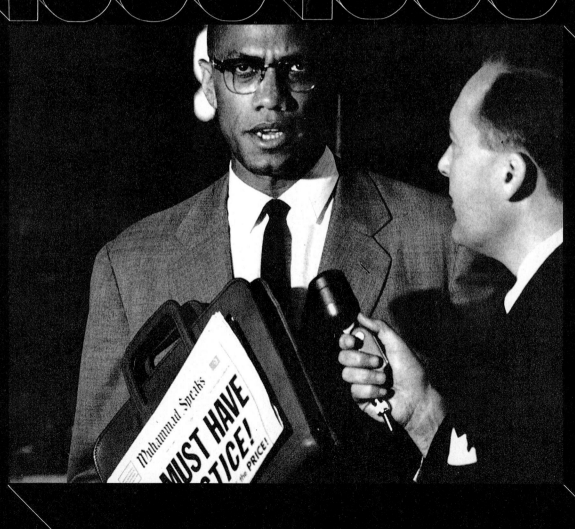

"Rise in Racial Extremism Worries Harlem Leaders"
Muslims Ask Leaders to Rally
8,500 Crowd Armory to Hear Muhammad
Castro in Harlem
Russian Goes to Harlem
Negroes Allege Merchants' Plot
Core Plans Fight on Latent Racism
New York's Racial Unrest: Negroes' Anger Mounting
Area in Harlem to Seek Renewal
Zuber Charges Hunter School Discriminated Against Child
America! Look in the Mirror!
Malcolmn X Likens Slaying to "Chickens Coming Home to Roost"
HARYOU Eyes Social Revolution
Charge Columbia with Racial Bias
Negro Boy Killed: 300 Harass Police
Thousands Riot in Harlem Area; Scores Are Hurt
Violence Flares Again in Harlem; Restraint Urged
A Mother Moans "Why! Why! Why!"
Three Violent Days
Malcolm X Speaks
Malcolm X Shot to Death
Harlem's Pay Day No Gay Time As Strike Shrinks Pocketbooks
More Jobs Urged To Relieve Ghettos
Black Panthers Open Harlem Drive
Family in Harlem Bundles Up Indoors, Too
Scattered Violence Occurs in Harlem and Brooklyn
Harlem Youth Exhibit Loot, Taken "to Get Back At Whitey"
Harlem Backed Columbia Students
Community Reacts to Another Killing

THE NEW YORK TIMES, JANUARY 25, 1960

"RISE IN RACIAL EXTREMISM WORRIES HARLEM LEADERS"

Increasing racial extremism in Harlem is causing grave concern among many of the more moderate Negro leaders. This has been particularly true since the visit to Harlem last November of Sékou Touré, President of the new African Republic of Guinea. Organized by black nationalists, the visit was marred by incidents that one Negro leader described as a "disgrace to Harlem."

Moderate Negro leaders stated that the extremists were developing their agitation against a background of dissatisfaction with the rate of improvement in the lot of most of the Negro people. They said also that there was an insistent demand for greater unity in community leadership.

❖ ❖ ❖

AMSTERDAM NEWS, MAY 28, 1960

MUSLIMS ASK LEADERS TO RALLY

"If the Negro leaders fear they will alienate themselves from the favor and support of their liberal-minded so-called white friends by attending this Freedom Rally, simply because it is sponsored 100 per cent by black people in Harlem, how can they continue to expect to be accepted as spokesmen by the fast-awakening black masses?" Muslim minister Malcolm X asked reporters this question as he boarded a plane at La Guardia Field for Boston where he was to lecture before the Boston University School of Theology.

The giant 6-hour outdoor Harlem Freedom Rally is scheduled for this Saturday, May 28, at Seventh Avenue and 125th Street, from 1 p.m. to 7 p.m. The New York Muslims have encouraged the Harlem leaders to participate in the Freedom Rally and "let the people of Harlem hear you voice your personal opinion on the problems that confront them, and to know that you understand their plight and identify yourself personally with their struggle. "Your participation in this Freedom Rally does not mean your endorsement of any other person or groups. It means only that you are interested in the crying needs of our community and that you are taking this opportunity to let the people of Harlem know they are not without true leaders and fearless spokesmen," Malcolm X said.

❖ ❖ ❖

AMSTERDAM NEWS, AUGUST 6, 1960

8,500 CROWD ARMORY TO HEAR MUHAMMAD

Elijah Muhammad, spiritual leader of thousands of Muslims throughout the U.S., called members of both political parties "hypocrites" during a 2½-hour speech to more than 8,500 persons at the 369th Armory Sunday. The head of the growing nation of Muhammad's Temples of Islam said "when one group argues among themselves as to whether another group deserves basic Civil Rights, this is hypocrisy."

As the Negro's answer to such hypocrisy, Muhammad called on all Negroes to unite, and stop begging and licking the boots of White America, adding that the white man just "kicks you in the mouth instead of helping you. I am not asking you to choose me as your leader, but you need to choose a man who is unafraid to speak out the truth," said the fiery Muslim, who pointed out that the white man is doing everything to keep Negroes from hearing about Islam because he knows that 20 million Negroes united into a nation of Islam, together with 500 million Muslims of the world, would be a threat to him.

❖ ❖ ❖

CASTRO IN HARLEM

Fidel Castro moved to Harlem last night after having stalked angrily from the Shelburne Hotel to complain in person at the United Nations against the treatment he said he was getting in New York. He shifted his quarters six miles from the United Nations headquarters despite a United States offer of accommodations at the Commodore Hotel, Lexington Avenue and Forty-second Street, which apparently would have cost the Cubans nothing. Dr. Castro said the Theresa Hotel in Harlem had asked the Cubans first. The Cuban Premier went to Secretary General Dag Hammarskjold with a protest against what he described as "unacceptable cash demands" by the management of the Shelburne, at Lexington Avenue and Thirty-seventh Street. After three hours of discussion with United Nations and State Department representatives, aides to Dr. Castro announced that the Premier and the rest of the Cuban delegation had made arrangements to move into the Theresa Hotel at Seventh Avenue and 125th Street.

RUSSIAN GOES TO HARLEM

Premier Khrushchev visited Harlem yesterday to pay an informal call on Fidel Castro, whom he praised as a "heroic man." The Soviet Premier, abruptly ending the comparative isolation of his first hours in New York at noon, swept out of his headquarters at the Soviet United Nations Mission, 680 Park Avenue, at Sixty-eighth Street, and headed north in a motorcade for Harlem. His impromptu visit to the Cuban Premier marked only the beginning of a day in which Mr. Khrushchev cut a broad swath through New York. He spent twenty-two minutes with Dr. Castro in the Cuban's suite on the ninth floor of the Theresa Hotel, Seventh Avenue and 125th Street. Thousands of spectators and hundreds of policemen gathered about the hotel. It was the biggest event on 125th Street since the 1958 funeral of W. C. Handy, who wrote "St. Louis Blues."

NEGROES ALLEGE MERCHANTS' PLOT

White businessmen were accused yesterday of conspiring to prevent Negro merchants from doing business in a prime shopping area in Harlem. Several Negro community leaders made the accusation during and after a four-hour closed hearing before the City Commission on Human Rights at 80 Lafayette Street. They charged that the whites had a "gentlemen's agreement" that had virtually closed the 125th Street shopping area between Seventh and Eighth Avenues to Negro-owned businesses.

The Negroes declared that it had been a "long-time practice of the whites to throttle any attempt by a Negro to establish a going business in the area." They indicated that they would organize a boycott against the white businessmen if the alleged practice was not stopped.

NEW YORK'S RACIAL UNREST: NEGROES' ANGER MOUNTING

Nailed over the door of the Church of God and True Holiness on Harlem's 135th Street is a freshly painted sign that reads: "Protest Meeting Every Monday —8:30 P.M." A Negro lawyer, waving his hand at the sign as he passed it the other day, declared:

"See that? See that? That thing expresses my sentiments exactly. Only, I would change it to read 'Protest Meeting Every Monday, Tuesday, Wednesday, Thursday, Friday, Saturday, and Sunday.'"

The sign and the lawyer's amendments to it are symbols of a rising discontent in the Negro districts of the metropolitan area. The resentment among the 1,500,000 black residents in the city and its suburbs, long built up, has found an outlet. Negroes and their supporters have taken to the streets in an assault on racial segregation and discrimination.

In scenes similar to those in Birmingham, Alabama; Jackson, Mississippi, and other centers of racial strife, sit-ins, hunger strikes, selective-buying campaigns, boycotts and freedom marches have taken place. Hundreds of praying, chanting demonstrators have been jailed. Scattered violence has broken out. Some say more violence is inevitable. Suddenly, it seems, the Negro is mad at everybody.

"The mood of the Negro is one of impatience, anger and insistence," asserts Percy E. Sutton, a Harlem lawyer who has participated in sit-ins, picketing and civil rights rallies. "He seeks a final breakthrough, a final toppling of the walls of segregation and discrimination. He has learned, much to his sorrow, that he can't get these things by promises—but he's got to go out and get his equality—that it won't come to him."

❖ ❖ ❖

THE NEW YORK TIMES, JULY 15, 1963

CORE PLANS FIGHT ON LATENT RACISM

An "undercurrent of racism" exists in the North and must be brought to the surface so that it can be dealt with, James Farmer, national director of the Congress of Racial Equality, said yesterday. Part of CORE's objective is to bring this racism into the open, he said in a television interview. "You've got to bring it out and then work to solve it. In the South, where racism is on the surface, it is being confronted directly."

❖ ❖ ❖

THE NEW YORK TIMES, SEPTEMBER 20, 1963

AREA IN HARLEM TO SEEK RENEWAL

A neighborhood study by residents of the St. Nicholas Park area of Harlem has shown that most want to stay in Harlem and work for better conditions. The study, sponsored by the St. Nicholas Park Housing and Planning Council, a group comprising local churches and community organizations, will be presented to the Board of Estimate Monday in a local plea to designate the area for urban renewal. Neighbors interviewed neighbors in the study. The volunteer interviewers were trained in special courses at local churches.

Most residents were firm in their belief that the major need of the area was for adequate low-income housing. The average family income was found to be $4,286, confirming this need, the study said. One indication that the residents wanted to stay in the area, the study said, was that the population had remained 69 per cent stable for the last five years, compared with 55 per cent for all of Manhattan.

❖ ❖ ❖

THE NEW YORK TIMES, SEPTEMBER 20, 1963

ZUBER CHARGES HUNTER SCHOOL DISCRIMINATED AGAINST CHILD

Paul B. Zuber, the Harlem lawyer prominent in civil rights cases, filed a suit in Federal Court here yesterday, charging the Board of Higher Education with discriminating against his own daughter and other Negro children. Mr. Zuber charged that his 5-year-old daughter, Patricia, and other youngsters had been denied "equal opportunity" to enter the Hunter College Elementary School, which admits a limited number of intellectually gifted children. The president of Hunter College, Dr. John J. Meng, was

also named a defendant in the suit. The college is a city-operated institution.

Mr. Zuber lives at 2816 Eighth Avenue in Harlem, and has an office at 315 West 125th Street. The school is at 695 Park Avenue, at Sixty-eighth Street. Mr. Zuber won the legal battle for public school desegregation two years ago in New Rochelle, N.Y. In his suit yesterday, he said: "The defendants have so constructed the attendance area lines for applicants to the kindergarten and first grade as to intentionally exclude those areas in the county of New York where Negroes live."

❖ ❖ ❖

AMSTERDAM NEWS, NOVEMBER 30, 1963

AMERICA! LOOK IN THE MIRROR!

Death accompanied by irony adds exquisite pain to loss already painful. In Texas we lost—irrevocably and forever—our young and vigorous President.

Out of Texas we have had General Walker stalking into Mississippi; we have had our Ambassador to the United Nations spat upon; we have had Fred Korth, and Bobby Baker, and oil-depletion reserves, and Mexican-labor questions.

From Texas we have our new President. It is too late for squeamishness. What needs be said must be. We have witnessed, we who are citizens of the United States, and those from the South, the whirlwind which we have been sowing, lo, these many years. Each stunned soul who is asked says, "No, not here, not in the United States, I do not believe our President is dead."

And why not here? We have tolerated for years the flying of a separate flag, revered by some far more than the stars and stripes. We have witnessed lawlessness (sometimes in the hands of those who are the law) walk an easy path from New Orleans to Arkansas, Oxford and Jackson, to a bloody massacre on a Sunday morning in a Birmingham church. As surely as there is a cattle prodder, a police dog, a fire hose; as surely as there are names like General Walker, or Faubus, or Beckwith, or "Bull" Connor, or Wallace; as surely as the FBI cannot solve one of fifty bombings; as surely as there are bartenders allowed in high-security areas by local police; just as surely was it fated that blood would flow on the streets of Dallas.

We look around for someone to blame, and all we can do is to look in the mirror. Or is it better said that we can look to Texas. From Texas we have our new President. From him we need and want both answers and leadership. Does he fly two flags over his Texas house—or his Texas heart? Or is his one and only loyalty to the stars and stripes?

—GERTRUDE WILSON

❖ ❖ ❖

THE NEW YORK TIMES, DECEMBER 2, 1963

MALCOLM X LIKENS SLAYING TO "CHICKENS COMING HOME TO ROOST"

Malcolm X, a leader of the Black Muslims, yesterday characterized the assassination of President Kennedy as an instance of "the chickens coming home to roost." Accusing Mr. Kennedy of "twiddling his thumbs" at the killing of South Vietnamese President Ngo Dinh Diem and his brother, Ngo Dinh Nhu, Malcolm X told a Black Muslim rally at the Manhattan Center that he "never foresaw that the chickens would come home to roost so soon."

He added: "Being an old farm boy myself, chickens coming home to roost never did make me sad; they've always made me glad." His remarks on the Kennedy assassination were made at a point when the auditorium was open to questions and comment from the floor. There was loud applause and laughter.

❖ ❖ ❖

AMSTERDAM NEWS, JANUARY 4, 1964

HARYOU EYES SOCIAL REVOLUTION

An 18-month survey of conditions in Harlem will call for a "bold social revolution" for the

74,000 youth of Central Harlem with appropriations of millions by the city and federal governments and private foundations if the community is to grow and prosper, the *Amsterdam News* learned this week. The boards of directors and special consultants for the Harlem Youth Opportunities Unlimited, Inc. (HARYOU) and the Associated Community Teams (ACT) are to meet on January 3–4, to go over final discussions of the 300-page document for submission to the government and private agencies by January 15.

The HARYOU report, which was prepared as a result of $23,-000 federal grant and another $100,000 from the city, and the ACT demonstration project, financed through a $200,000 federal grant and another $100,000 from the city, will call for a major action project which a spokesman said will be a "revolution without weapons."

AMSTERDAM NEWS, FEBRUARY 22, 1964

CHARGE COLUMBIA WITH RACIAL BIAS

The City Commission on Human Rights this week said an inquiry will be conducted into alleged discrimination by Columbia University in acquiring buildings in the Morningside Heights area. Madison Jones, CCHR executive director, said his office was gathering additional facts in the case follow-ing the information received in a letter last Friday from the Fort Washington-Manhattanville Reform Democrats charging that Negroes and Puerto Ricans were being pushed off the Morningside Heights area where Columbia University owns several buildings.

❖ ❖ ❖

THE NEW YORK TIMES, JULY 17, 1964

NEGRO BOY KILLED; 300 HARASS POLICE

An off-duty police lieutenant shot and killed a 15-year-old Negro boy in Yorkville yesterday when the youngster allegedly threatened him with a knife. After the shooting, about 300 teen-agers, mostly Negroes, pelted policemen with bottles and cans. Before order had been restored by 75 steel-helmeted police reinforcements, a Negro patrolman attempting to disperse the screaming youths was hit on the head by a can of soda. He was taken to Lenox Hill Hospital, where his condition was later reported as good.

The shooting occurred at 9:20 a.m. outside a six-story white brick apartment house at 215 East Seventy-sixth Street, opposite Robert F. Wagner Junior High School, where summer school classes were in progress. The dead boy was James Powell, a student at the school, who lived at 1686 Randall Avenue, the Bronx. The police said the youth had been shot twice, in the right hand and in the abdomen, by Lieutenant Thomas Gilligan of Brooklyn's 14th Division.

❖ ❖ ❖

THE NEW YORK TIMES, JULY 19, 1964

THOUSANDS RIOT IN HARLEM AREA: SCORES ARE HURT

Thousands of rioting Negroes raced through the center of Harlem last night and early today, shouting at policemen and white people, pulling fire alarms, breaking windows and looting stores. At least 30 persons were arrested. There was no estimate on the number of injured. Scores of persons with bloodied heads were seen throughout the eight-block area between Eighth and Lenox Avenues and 123rd and 127th Streets, where most of the rioting occurred.

The riot grew out of a demonstration in front of the West 123rd Street police station protesting the slaying of a Negro youth by a white police lieutenant last Thursday.

The demonstration followed a rally at 125th Street and Seventh Avenue, where speakers decried the shooting of the boy, 15-year-old James Powell, by Lieutenant Thomas Gilligan in Yorkville.

THE NEW YORK TIMES, JULY 20, 1964

VIOLENCE FLARES AGAIN IN HARLEM; RESTRAINT URGED

Violence broke out in Harlem for the second time within 24 hours last night, and at least 19 persons were injured. Groups of Negroes roamed through the streets, attacking newsmen and others. Negroes standing on tenement roofs showered policemen in steel helmets with bottles and bricks, and the police answered by firing warning shots over the attackers heads. The new disturbances, which ended early today, were less severe and less widespread than the racial rioting and looting Saturday night and early yesterday, during which a Negro man was killed and more than 100 persons were injured. They developed after appeals by Acting Mayor Paul R. Screvane, Police Commissioner Michael J. Murphy and prominent Negro leaders for restraint and respect for law and order.

❖ ❖ ❖

AMSTERDAM NEWS, JULY 25, 1964

A MOTHER MOANS "WHY! WHY! WHY!"

"Why, why, did he have to kill him," sobbed an anguished mother whose son was mortally wounded by an off-duty policeman last Thursday opposite Robert Wagner Junior High School on East Seventy-sixth Street. "He was my son, Oh, God!" She again broke into convulsive sobs and had to be consoled by a friend who begged her not to go on this way.

Mrs. Annie Powell has a bad heart. She spent three months last spring in a hospital as a result of her delicate condition. On the morning her son, James Powell, who was taking remedial reading courses this summer at Robert Wagner Junior High School, was slain, Mrs. Powell left her home in the Bronx to go downtown Manhattan on a business matter. It was not until about 10:30 a.m. that she knew about the tragedy that was to shatter the narrow world she had lived in since her husband passed away three years ago. "He was a nice boy, and they had to kill him like a dog," she said between tears.

❖ ❖ ❖

AMSTERDAM NEWS, JULY 25, 1964

THREE VIOLENT DAYS: SATURDAY NIGHT, SUNDAY NIGHT

"What in hell are they doin' down there?" asked the gin-and-coke at Hilda's 19th Hole, 145th Street and Bradhurst Avenue Saturday Night. "Who knows, man. Bus us another taste," muttered the empty glass as Jimmy Smith "Kicko" rocked solid from the too-loud box and young tall wriggled for days in heightening weekend revelry. Such was the less than monumental impact of the first hostilities of Summer Riot '64 in a part of Harlem that is a step or two removed from the shiek-paper magazine-featured land of 125th Street and Seventh Avenue.

At the pressure point it was different. The insistent whir of sirens, the urgent glimmer of the PD cars, ruby-red revolving lights, the plangent crash of plate glass, the frightful crash and swoosh of the roof-launched Molotov cocktail, the tightly clenched night stick, the crowd sounds—taunts and jeers—and the suddenly charging cops. At 125th Street and Seventh Avenue, a police barrier—part of the barricade restraining the rioters from storming the 123rd Street precinct again—had been knocked down. A six-foot teen-ager yelling "Come on!" was followed warily by several others as he attempted to storm through the temporarily open space. A white helmeted cop shoved him 20 feet back through his oncoming friends as four other patrolmen rushed in and hustled him toward the precinct.

THREE VIOLENT DAYS: MONDAY NIGHT

Three husky, helmeted Tactical Police Force cops with clubs half raised rushed toward this reporter, who was watching the action from the sidewalk in front of the Sunset Theater on 125th Street. "Move on!" they barked to me, and "They're going to

throw more bottles." Your reporter and another Negro newsman did what the tense, alert patrolmen ordered. They moved on. Just then a flying bottle hit the pavement and a mob of about 100 youths scampered.

"Murderers!" shouted a few in the crowd. Three TPFs grabbed a youth. He was pummeled to the ground and then manacled. The boy, who could be about 18 years old, was dragged across the street. His head banged against the top of the prowl car as he was forcibly pushed into it. Another fuse was ignited and the cops knew it. They formed a solid line to hold back the surging crowd. Suddenly I saw a patrolman, who covered his companions while the youth was hauled away, raise his left hand to his face. A drinking glass shattered at his feet about the same time. The cop was hit. This all happened about 10:30 p.m. Monday. It was the third night of the explosive situation in Harlem that was triggered by the slaying of a 15-year-old youth by an off-duty police lieutenant. The mood was angry, ugly and definitely bitter. There was no doubt in my mind that tonight would be another chapter in the long, hot summer of discontent.

❖ ❖ ❖

AMSTERDAM NEWS, FEBRUARY 6, 1965

MALCOLM X SPEAKS

Minister Malcolm X broke his silence on criticisms of his former associates in the Black Muslim movement this week and charged that "my death has been ordered by higher-ups in the movement."

He made his comments in an interview with this newspaper during which he charged that an attempt was made on him last week in Los Angeles as he was leaving a hotel after a speech there and at his home here in East Elmhurst on January 22. "They came at me three seconds too soon, and I was able to rush back into the house and called the police. I came out with my walking stick and the men were gone," Malcolm said. Malcolm said the police searched the neighborhood, but there was no trace of the would-be assailants.

❖ ❖ ❖

THE NEW YORK TIMES, FEBRUARY 22, 1965

MALCOLM X SHOT TO DEATH

Malcolm X, the 39-year-old leader of a militant black nationalist movement, was shot to death yesterday afternoon at a rally of his followers in a ballroom in Washington Heights. Shortly before midnight a 22-year-old Negro, Thomas Hagan, was charged with the killing. The police rescued him from the ballroom crowd after he had been shot and beaten. Malcolm, a bearded extremist, had said only a few words of greeting when a fusillade rang out. The bullets knocked him over backward.

Pandemonium broke out among the 400 Negroes in the Audubon Ballroom at 166th Street and Broadway. As men, women and children ducked under tables and flattened themselves on the floor, more shots were fired. Some witnesses said 30 shots had been fired. The po-

lice said seven bullets had struck Malcolm. Three other Negroes were shot.

About two hours later the police said the shooting had apparently been a result of a feud between followers of Malcolm and members of the extremist group he broke with last year, the Black Muslims. However, the police declined to say whether Hagan is a Muslim.

❖ ❖ ❖

THE NEW YORK TIMES, JANUARY 8, 1966

HARLEM'S PAY DAY NO GAY TIME AS STRIKE SHRINKS POCKETBOOKS

Every Friday and Saturday the people who live in the 800 furnished apartments in the 40 Harlem tenements owned by Samuel Weisstein go to his pleasant office at Lenox Avenue and 126th Street to pay their rent for the next week. But yesterday, on the first payday since the transit strike began, they were staying away. "That means it's bad," said Marvin Cooper, a lawyer who works there. "The basic philosophy of poor people is that rent is the primary thing they pay."

It was like that in all of the city's blighted districts, but the slump was more noticeable in bustling Harlem. Its main stem, 125th Street, which starts to swing on Friday afternoon when

factory workers, domestics, porters and the other people who work downtown get off the subway with money in their pockets, was almost deserted yesterday.

A man named William Taylor walked into a large liquor store to buy a half-pint of whiskey. He was the only customer in the place. "I'm a porter," he said. "I haven't been to work all week. There's no point to it. Cost you $4 or $5 a day just for the taxi. My wife does housework out on Long Island. She can't get there. We got $100 laid by," he went on. "When that's gone we going to just have to rough it. The whiskey? That takes the sting out."

❖ ❖ ❖

THE NEW YORK TIMES, JANUARY 22, 1966

MORE JOBS URGED TO RELIEVE GHETTOS

The state's leading political figures gathered yesterday to propose new plans for the regeneration of the ghettos of Harlem and East Harlem. For three hours Mayor Lindsay, Senators Robert F. Kennedy and Jacob Javits, and Representatives William Fitts Ryan and Adam Clayton Powell whisked in and out of a crowded auditorium where community

leaders had been collected by Manhattan Borough President Constance Baker Motley. Virtually every speaker concluded that the most pressing problem for the Negro was lack of jobs. The conference was held at the Young Women's Christian Association, 361 West 125th Street.

Representative Powell, who announced that Federal legislation would soon be introduced creating a unified and expanded job retraining program, said: "Harlem's most critical problem is hard-core unemployment. What we black people need is jobs; we need green in our pockets."

Senator Kennedy, citing President Johnson's recent pledge to "rebuild whole areas of our cities," declared that "priority in employment on these projects should go to residents of areas in which they are undertaken."

❖ ❖ ❖

AMSTERDAM NEWS, SEPTEMBER 3, 1966

BLACK PANTHERS OPEN HARLEM DRIVE

Black men must unite and overthrow their white "oppressors," but must do it "like panthers, smiling, cunning, scientifically—striking by night and sparing no one," Max Stanford, a member of the Black Panthers, told some 250 cheering persons at a student Non-Violent Coordinating Committee rally Monday. Stanford, leader of the newly organized Black Panther group in Harlem, made his extremist remarks as he

spoke at a SNCC rally at the Mt. Morris Presbyterian Church with Stokely Carmichael, chairman of SNCC, and William Epton, head of the leftist Harlem branch of the Progressive Labor Party.

In a manner reminiscent of the early days of the Black Muslims, six members of the Black Panther party, wearing black shirts, black pants with the panther emblems, stood guard at the platform, and white newsmen were asked to leave the church before Stanford spoke. The rally was billed as a SNCC fund-raising affair with persons charged $1 to enter, but the "panthers" seemed more in control.

Carmichael, who received a standing ovation when he got up to speak, criticized the U.S. role in Vietnam and called upon Negroes to unite with non-whites all over the world. In militant bitter language, the 25-year-old SNCC leader called for Negroes to unite and take over their own communities, and hinted that Negroes should have bombed the ghettoes long ago. Stanford said the U.S. "could be brought down to its knees with a rag and some gasoline and a bottle, which are the basic ingredients of a fire bomb. He also called for support from the militants in a boycott of two Harlem schools on September 12, which he said are almost all Negro, do not teach any subject well and do not teach Negro history at all. "This fight is going to be won on the street, so come into the streets with us," he said.

 1960-1968

FAMILY IN HARLEM BUNDLES UP INDOORS, TOO

"It's too cold to get up and too cold to sleep," said Mrs. John Grant as she held her month-old granddaughter in the narrow stream of warmth that spread from her kitchen stove, four pots steaming on its range and the oven going. "It's too cold to go out and too cold to stay here," she said with a small smile and pressed the swaddled baby to her coat.

For the five days since Sunday, when the heat in the house at 1472 Fifth Avenue gave way to the toe-numbing chill, the Grant family has clustered together in the kitchen, separated from constant subfreezing weather by a cracked window reinforced with rags. Mrs. Grant sat in the lukewarm sanctuary yesterday dressed in boots, two sweaters, an overcoat and a fur hat. Her three daughters and a 4-year-old grandson, Edward, were similarly dressed in jackets, coats and hats as they huddled around her and their other two sources of comfort and relief: the stove and, next to it, the television set.

The Grant family is one of thousands in the city who have had to suffer the lack of heat and hot water during the present cold wave. Some of them have sought refuge in hotels or the armories that have been opened to those without heated homes, but Mrs. Grant and her family say they cannot flee and have had to evolve a survival technique.

❖ ❖ ❖

SCATTERED VIOLENCE OCCURS IN HARLEM AND BROOKLYN

Sporadic violence erupted in Harlem and Brooklyn's Bedford-Stuyvesant section last night after news of Dr. Martin Luther King's assassination spread in the two predominantly Negro communities. Mayor Lindsay, who went to Harlem in an effort to quiet the outbreaks, was caught in the midst of an unruly crowd and had to be hustled into a limousine by bodyguards. Police reinforcements, including elements of the riot-trained Tactical Patrol Force, were rushed into both communities. Two arrests were reported in Brooklyn and ten in Harlem. A television crewman was said to have been injured by flying glass. There were numerous instances of rock-throwing, looting and arson reported both in Brooklyn and in Harlem, starting around 11 p.m. and continuing early today. Gangs of youth in both areas were reported roaming through the streets, now and then taunting policemen and firemen on duty. The police fired several volleys of shots in the air to disperse crowds along Brooklyn's Fulton Street and Harlem's 125th Street at about 12:30 this morning.

Mayor Lindsay learned of the assassination while attending the opening of the play *The Education of H*Y*M*A*N K*A*P*L*A*N* at the Alvin Theatre on West Fifty-second Street. He was informed of the slaying at the end of the first act and immediately left the theater to return to Gracie Mansion. From there he went to Harlem at about 10:30 p.m., where he expressed his sorrow to crowds of Negroes gathered at Eighth Avenue and 125th Street. Mr. Lindsay then attended a meeting of Harlem leaders at 312 West 125th Street. At about 11 p.m., Mr. Lindsay left the meeting accompanied by a group of Harlem residents and began walking along 125th Street toward Seventh Avenue. At 126th Street and Seventh Avenue the crowd, growing more hostile, began pushing and shoving. Several Negro officials, including City Human Rights Commissioner William Booth and Deputy Chief Inspector Eldridge Waith, tried to keep the crowd orderly. Several Negroes, shouting angrily, prevented Mr. Lindsay from speaking. Police and citizens tussled on the sidewalk. Then a limousine, belonging to Manhattan Borough President Percy Sutton, rushed to the scene and Mr. Lindsay was pushed into the car by his bodyguards. The car sped away. The Mayor returned to Harlem about 1 a.m. today by car. He criss-crossed the community and returned to Gracie Mansion an hour later.

❖ ❖ ❖

THE NEW YORK TIMES, APRIL 8, 1968

HARLEM YOUTHS EXHIBIT LOOT, TAKEN "TO GET BACK AT WHITEY"

While a memorial march honoring the Rev. Dr. Martin Luther King Jr. moved yesterday along Seventh Avenue in Harlem, an 18-year-old Negro youth at the corner of 122nd Street showed off a navy-blue double-breasted cashmere blazer to several admirers. "That's a beautiful blazer, a boss piece of stitching," one admirer said. "I've been making payments on one like that for weeks." The youth with the jacket smiled broadly. "I picked this one up for little or nothing," he said. The group laughed, understanding that the garment had been snatched from a clothing store during the looting that followed the slaying of Dr. King on Thursday.

Desire, need and an eagerness to "get back at whitey" were the primary reasons expressed by those who acknowledged they had looted clothing, food, liquor and appliance stores here. One young anti-poverty worker who was pummeled by other youths when he tried to convince them they should not risk death "for a damn cheap suit in a credit house along 125th Street" said later: "What whitey don't understand is that America is a damn rich country and she flashes this richness in the brother's face and tells him, 'It ain't for you.' The brother gets out and grabs a bit of it now and then—I wish he'd learn to grab himself a lot instead of a little.'"

❖ ❖ ❖

AMSTERDAM NEWS, MAY 4, 1968

HARLEM BACKED COLUMBIA STUDENTS

The Harlem community rallied to the aid and defense of the Black Columbia University students who took over Hamilton Hall in unprecedented numbers. Harlem mothers made sure students ate well. Daily, since the more than 150 Black student protestors laid siege, Harlemites visited with them behind their barricaded doors, advised them, gave them moral support, food and money to buy food. Speaking for many others, one Harlem mother said while standing in the rain during a Black student rally in front of Hamilton Hall the second night students occupied the building:

"Rain or no rain, I don't care. We must support these young people. They went out on the limb for us. That's part of the reason they're here now. I for one am coming back and bringing them hot, nourishing food."

❖ ❖ ❖

AMSTERDAM NEWS, JUNE 15, 1968

COMMUNITY REACTS TO ANOTHER KILLING

The assassination of Senator Robert F. Kennedy drew more response from the black community than that of any other prominent white American since the tragic death of the senator's brother, the late President Kennedy. Afro-Americans of all walks of life were shocked, dismayed, angered, anguished and troubled over the latest shooting, and one so close to the death of the late Dr. Martin Luther King. The views of the average man in the street were varied—as expected—but they all expressed a common denominator of worry and fear about the times that now surround us.

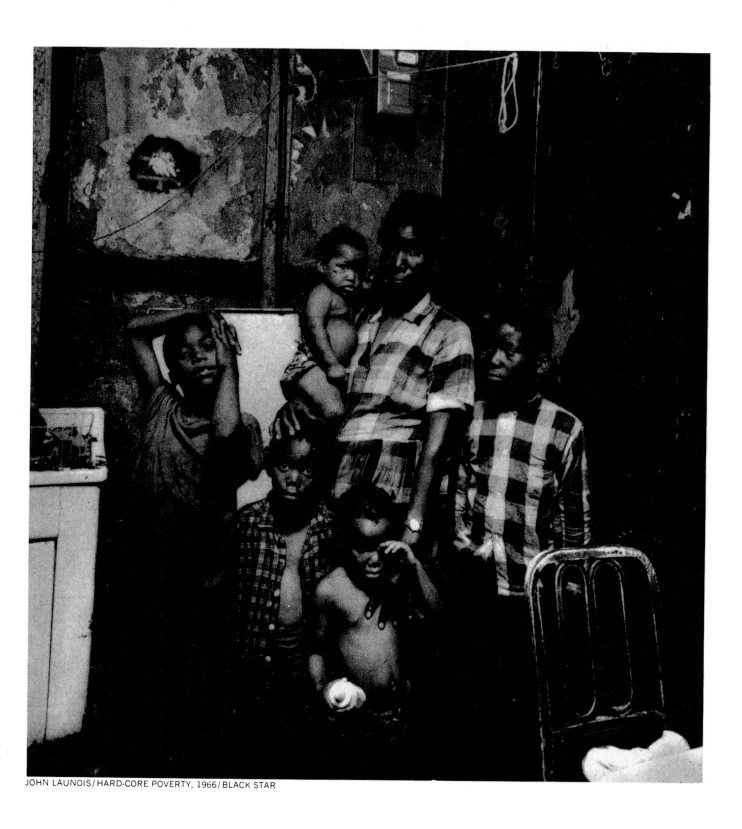

JOHN LAUNOIS/HARD-CORE POVERTY, 1966/BLACK STAR

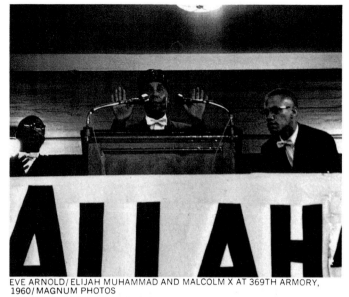

EVE ARNOLD/ELIJAH MUHAMMAD AND MALCOLM X AT 369TH ARMORY, 1960/MAGNUM PHOTOS

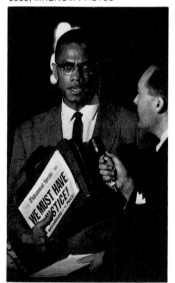

LEROY LUCAS/MALCOLM X, 1961

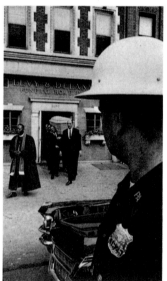

JAMES POWELL'S FUNERAL, 1964/UPI

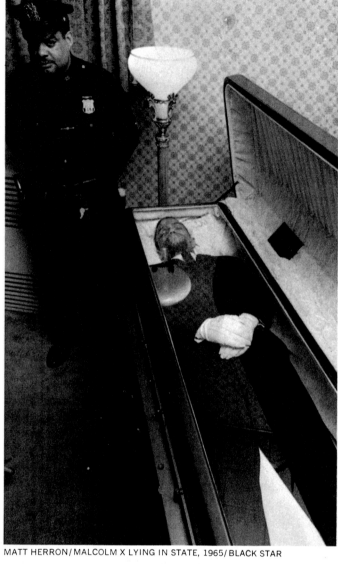

MATT HERRON/MALCOLM X LYING IN STATE, 1965/BLACK STAR

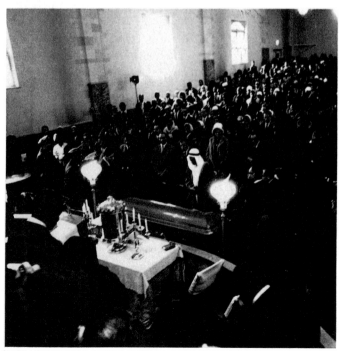

MATT HERRON/MALCOLM X FUNERAL, 1965/BLACK STAR

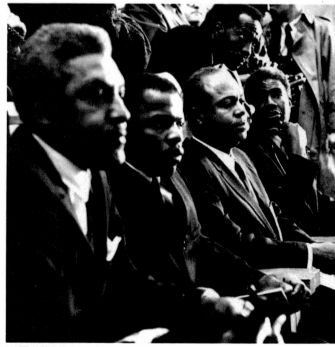

MATT HERRON/MALCOLM X FUNERAL, (LEFT TO RIGHT: RUSTIN, LEWIS, FARMER AND DAVIS) 1965/BLACK STAR

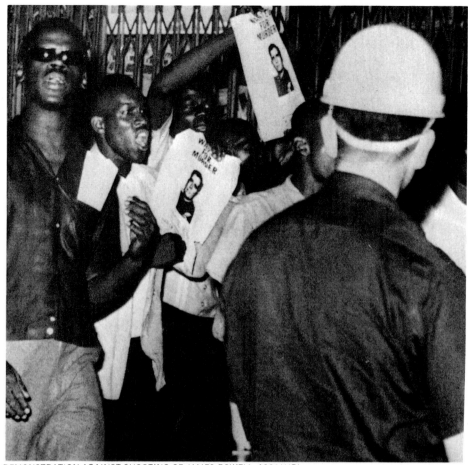

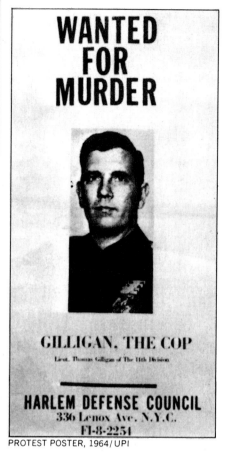

WANTED
FOR
MURDER

GILLIGAN, THE COP

Lieut. Thomas Gilligan of The 11th Division

HARLEM DEFENSE COUNCIL
336 Lenox Ave. N.Y.C.
FI-8-2254

DEMONSTRATION AGAINST SHOOTING OF JAMES POWELL, 1964/UPI

PROTEST POSTER, 1964/UPI

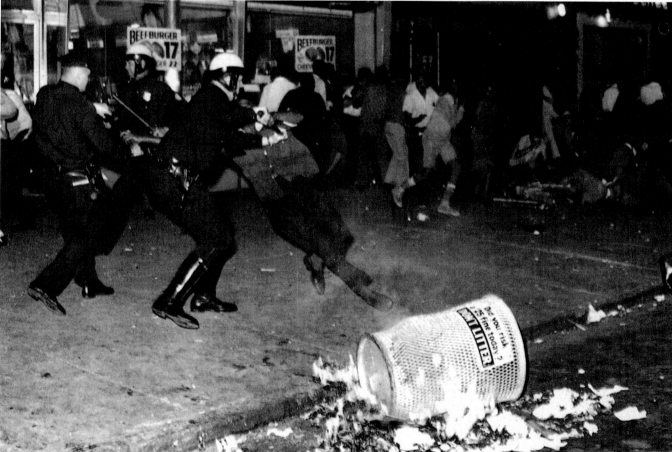

POLICE AND DEMONSTRATORS, 1963/UPI

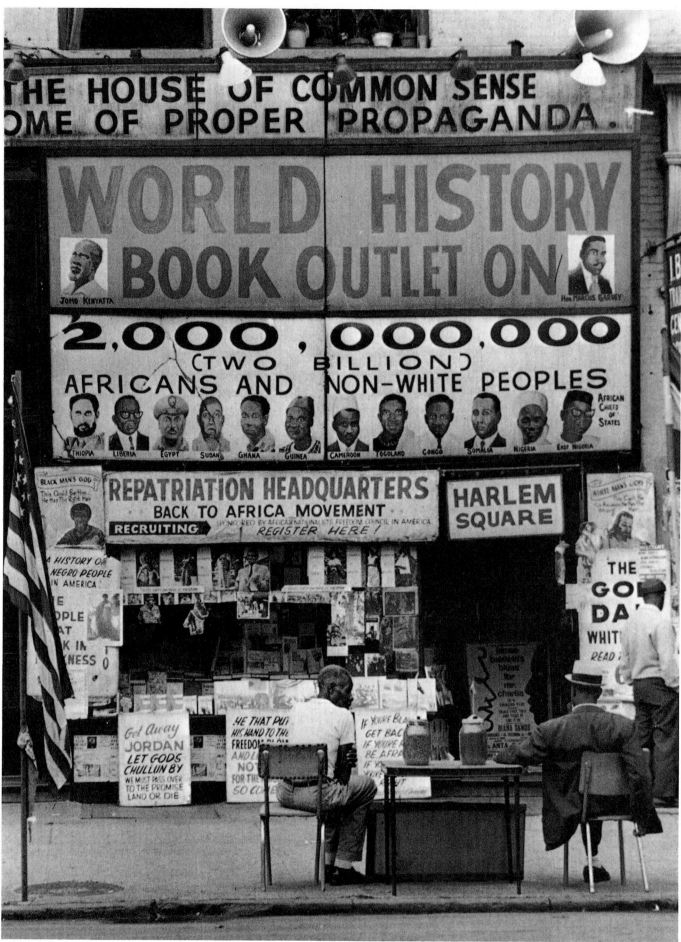

NATIONAL MEMORIAL AFRICAN BOOKSTORE, 1964/UPI

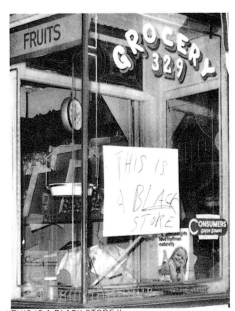

"THIS IS A BLACK STORE,"
1964/WIDE WORLD PHOTOS

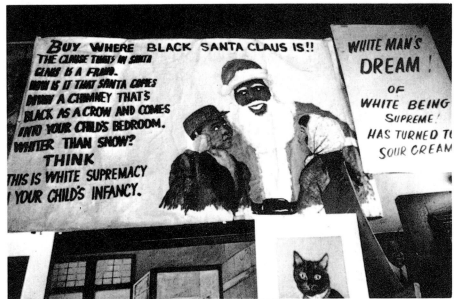

CHARLES MOORE/"BUY WHERE BLACK SANTA IS," 1964/BLACK STAR

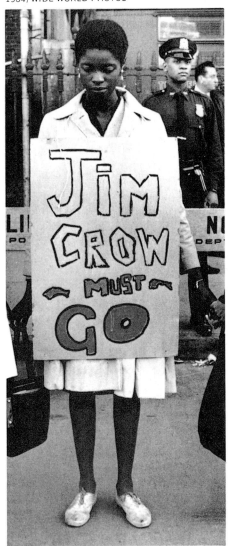

BRUCE DAVIDSON/DEMONSTRATION,
1962/MAGNUM PHOTOS

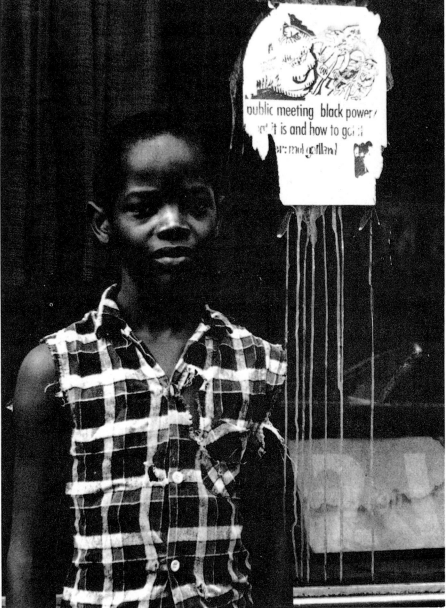

VANCE C. ALLEN/BLACK POWER POSTER, 1966

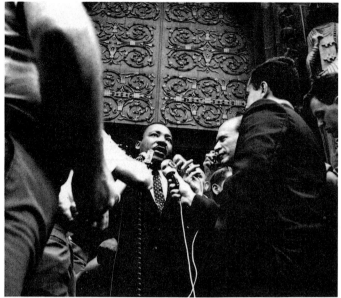

VANCE C. ALLEN/DR. MARTIN LUTHER KING, JR., 1967

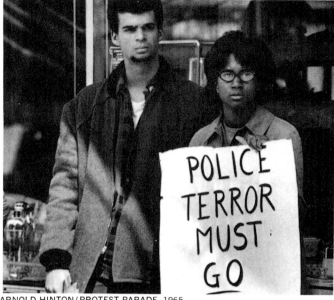

ARNOLD HINTON/PROTEST PARADE, 1965

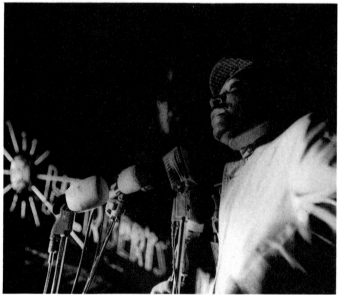

MATT HERRON/JESSE GRAY, 1965/BLACK STAR

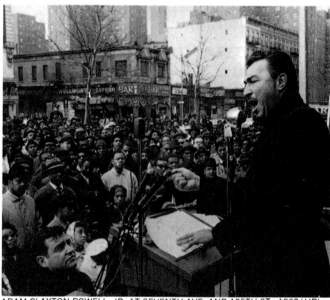

ADAM CLAYTON POWELL, JR. AT SEVENTH AVE. AND 125TH ST., 1963/UPI

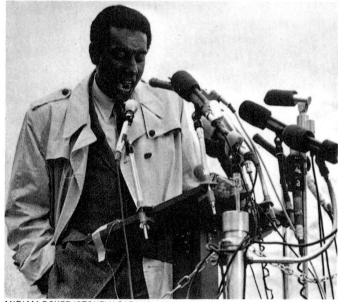

MIRIAM BOXER/STOKELY CARMICHAEL, 1967

EVE ARNOLD/PERCY SUTTON AT MUSLIM RALLY,
1960/MAGNUM PHOTOS

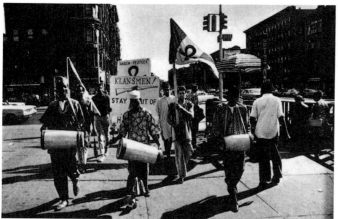

JOHN LAUNOIS/YORUBA TEMPLE MARCHERS, 1966/BLACK STAR

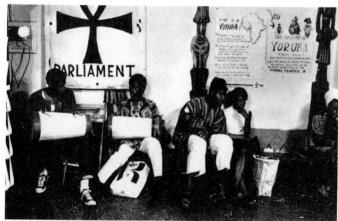

JOHN LAUNOIS/YORUBA TEMPLE, 1966/BLACK STAR

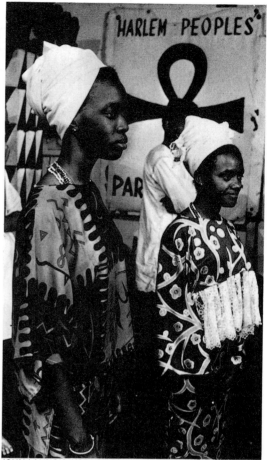

JOHN LAUNOIS/YORUBA TEMPLE, 1966/BLACK STAR

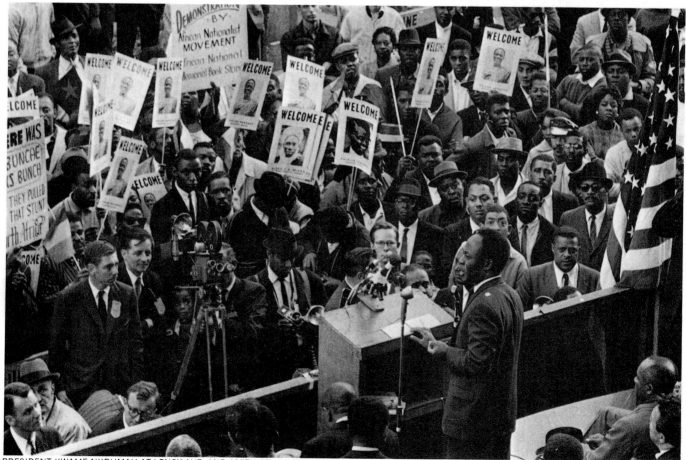

PRESIDENT KWAME NKRUMAH AT LENOX AVE. AND 125TH ST., 1960/UPI

245

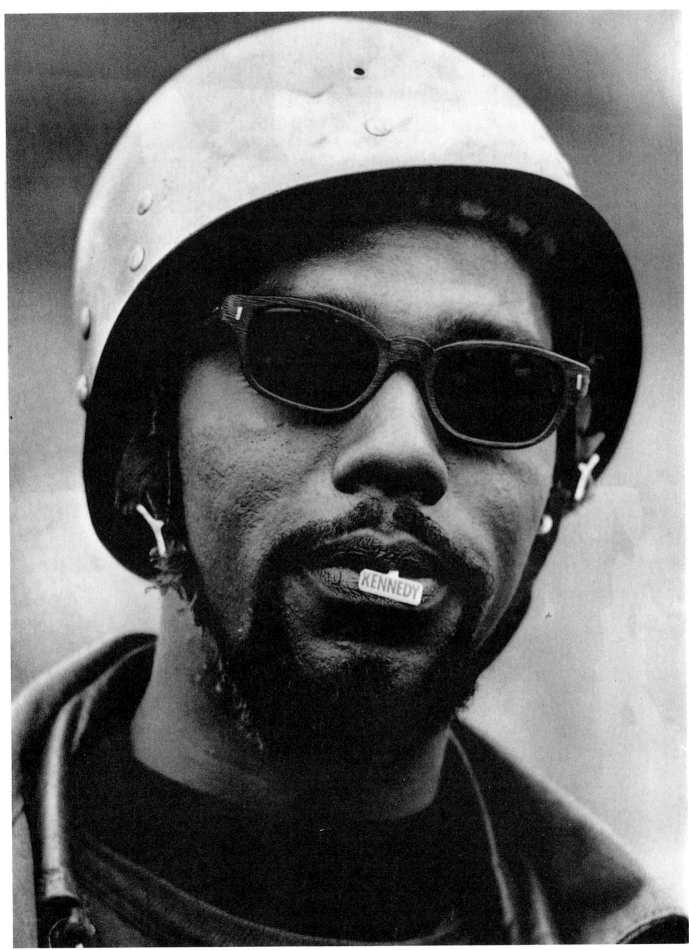

STEVE SCHAPIRO / MOTORCYCLIST, 1968 / BLACK STAR

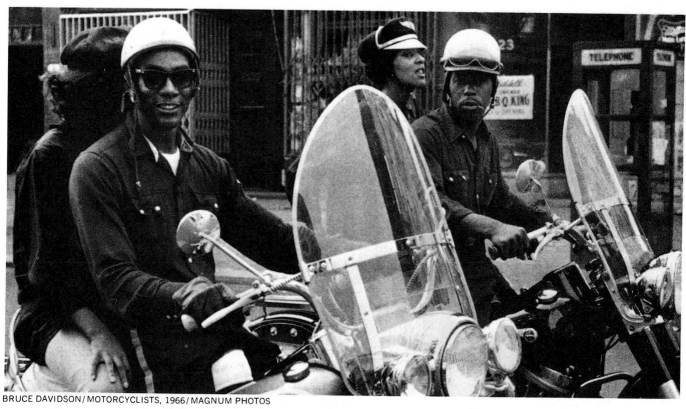

BRUCE DAVIDSON/MOTORCYCLISTS, 1966/MAGNUM PHOTOS

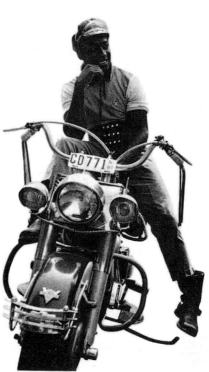

TED COWELL/POLICEMAN, 1968/BLACK STAR

BRUCE DAVIDSON/MOTORCYCLIST, 1961/MAGNUM PHOTOS

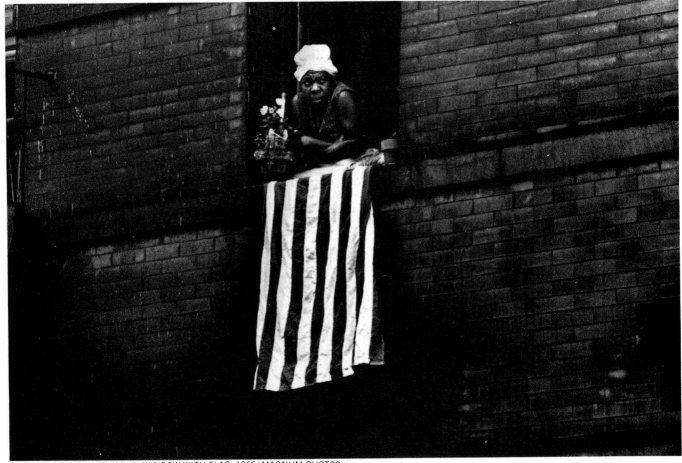

BRUCE DAVIDSON/WOMAN IN WINDOW WITH FLAG, 1966/MAGNUM PHOTOS

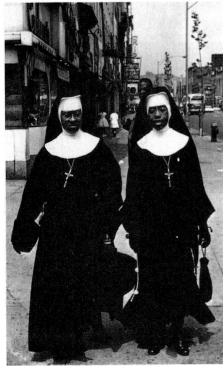

BRUCE DAVIDSON/NUNS, 1966/MAGNUM PHOTOS

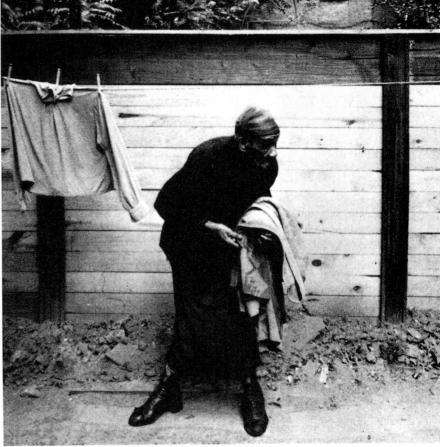

BRUCE DAVIDSON/MOTHER BROWN, 1963/MAGNUM PHOTOS

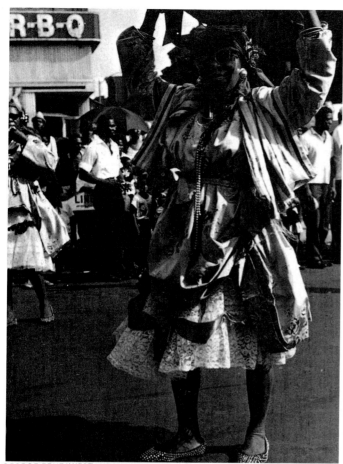

GEORGE FRYE/WEST INDIAN FESTIVAL, 1966

BRUCE DAVIDSON/KIDS IN PARK, 1966/MAGNUM PHOTOS

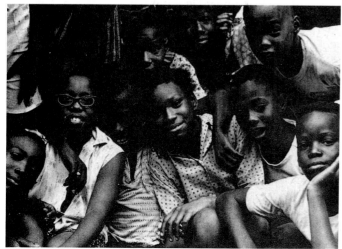

GEORGE FRYE/KIDS, 1967

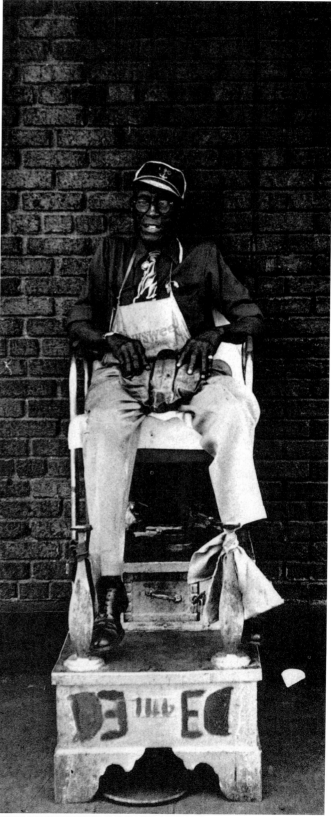

BRUCE DAVIDSON/SHOE SHINE MAN, 1965/MAGNUM PHOTOS

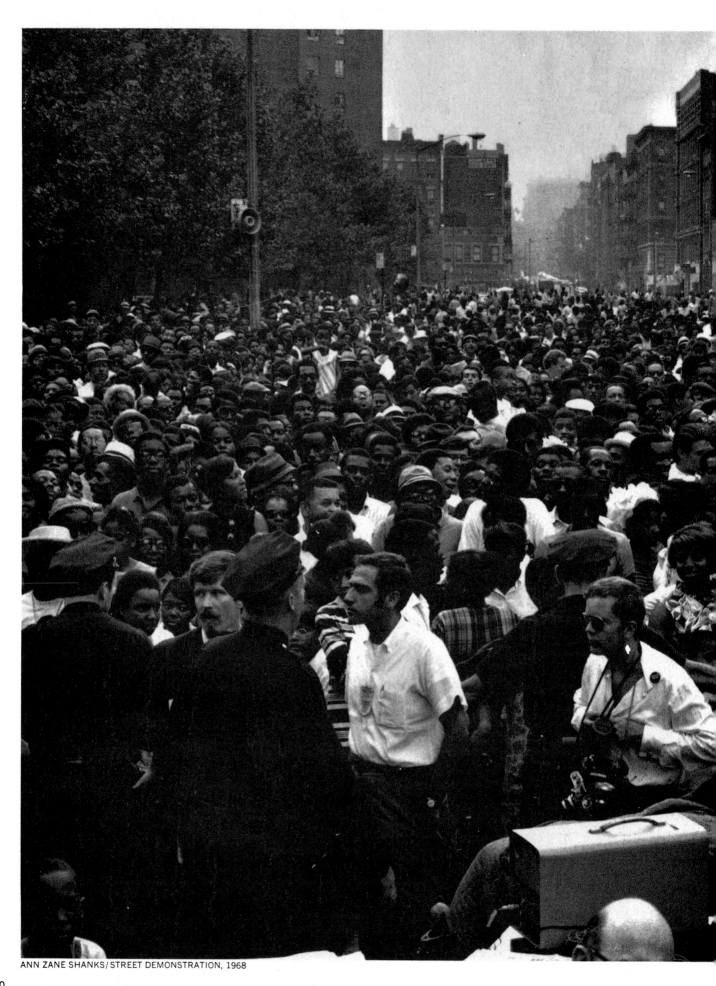

ANN ZANE SHANKS/STREET DEMONSTRATION, 1968

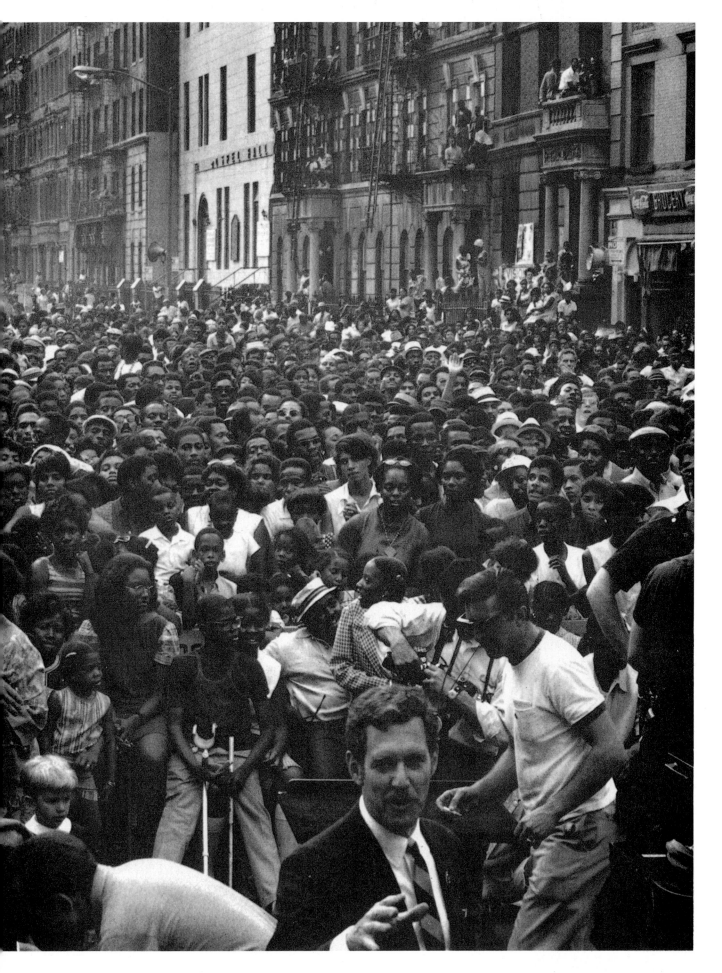

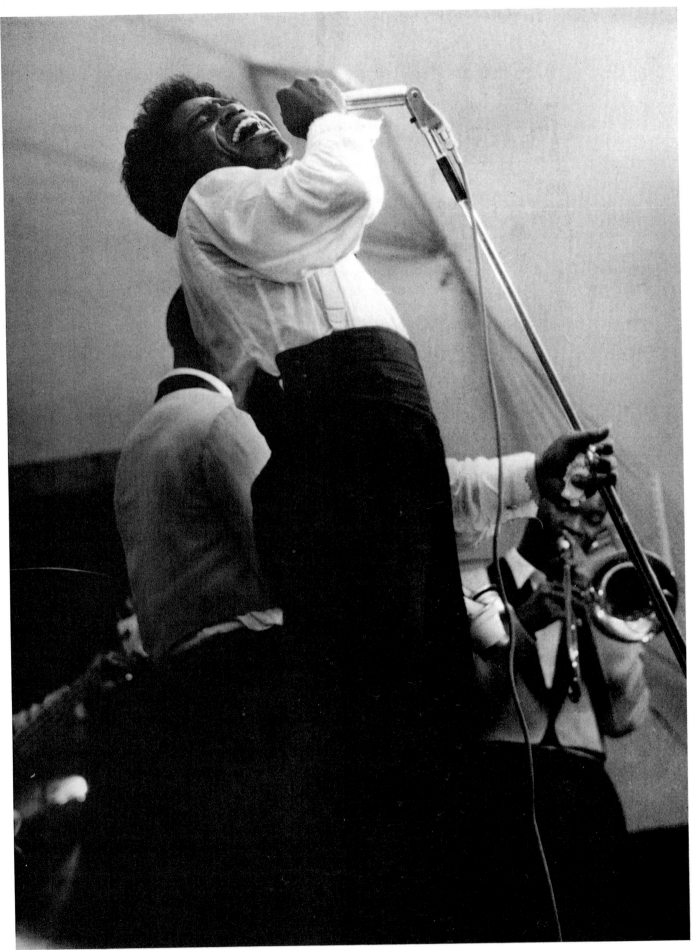

CHARLES STEWART/JAMES BROWN, 1962

ART KANE/ARETHA FRANKLIN, 1967/ESQUIRE, INC.

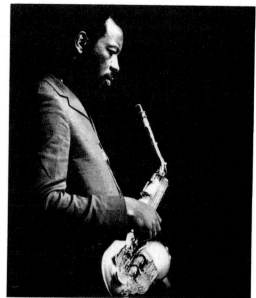

DON SCHLITTEN/ORNETTE COLEMAN, 1962

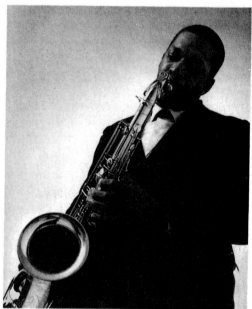

CHARLES STEWART/JOHN COLTRANE, 1961

JAY MAISEL/TWISTING IN THE PARK, 1962

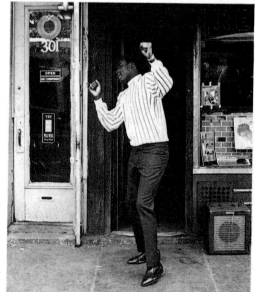

ART KANE/SOUL SINGER, 1967/ESQUIRE INC.

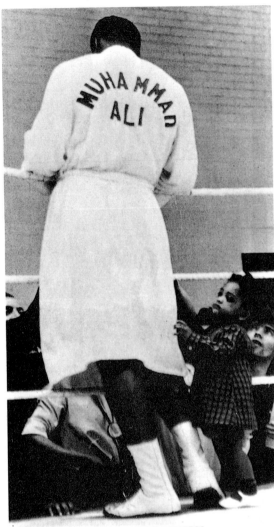

MUHAMMAD ALI, 1966/WIDE WORLD PHOTOS

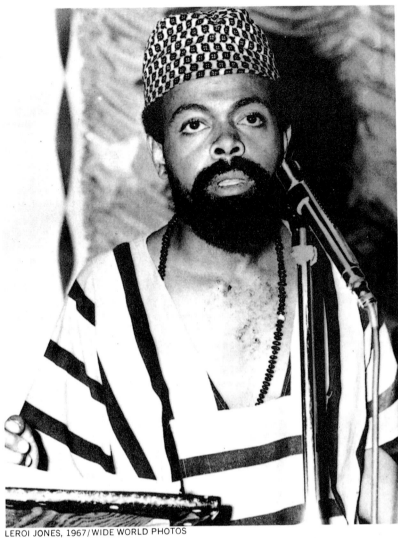

LEROI JONES, 1967/WIDE WORLD PHOTOS

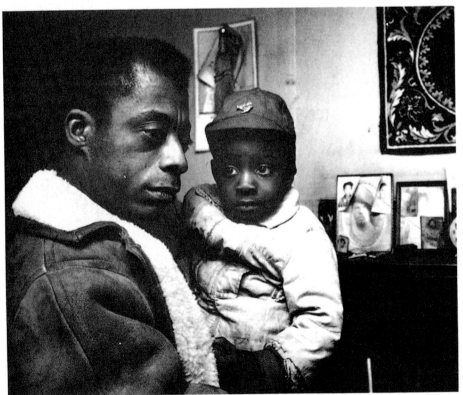

STEVE SCHAPIRO/JAMES BALDWIN WITH YOUNG BOY, 1963/BLACK STAR

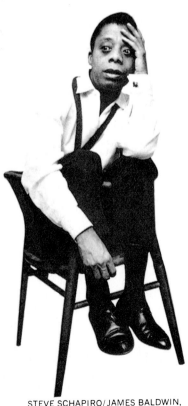

STEVE SCHAPIRO/JAMES BALDWIN,
1963/BLACK STAR

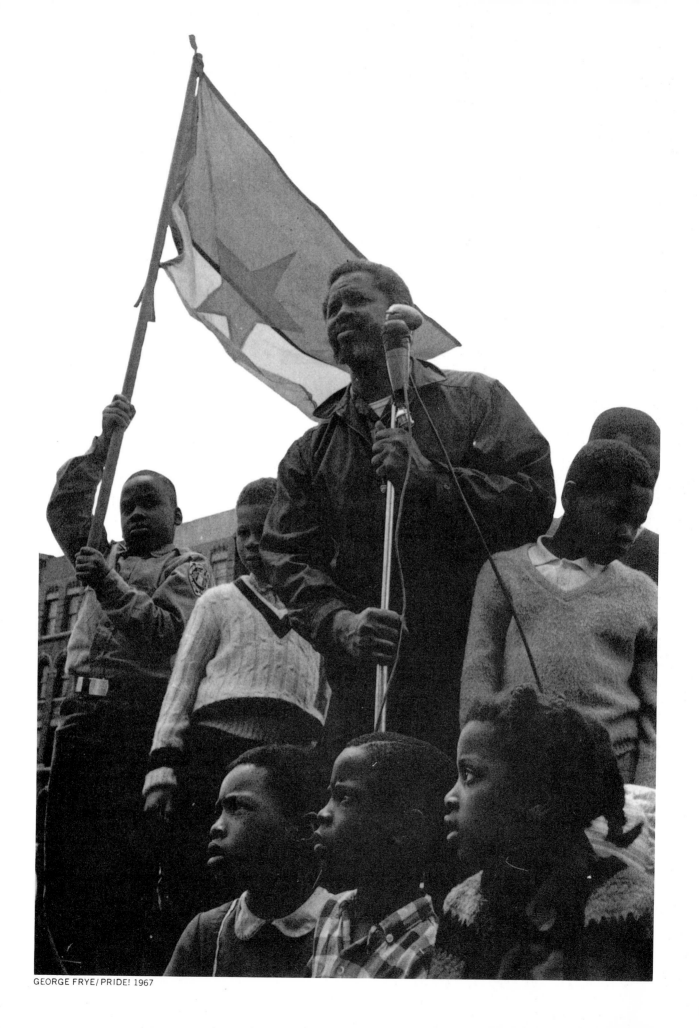

GEORGE FRYE/ PRIDE! 1967

Index